HERETICS
AND HEROES

BY THOMAS CAHILL

THE HINGES OF HISTORY

Introductory Volume:
How the Irish Saved Civilization

The Making of the Ancient World:
The Gifts of the Jews
Desire of the Everlasting Hills
Sailing the Wine-Dark Sea

The Making of the Modern World:
Mysteries of the Middle Ages
Heretics and Heroes

One additional volume is planned on
the making of the modern world.

ALSO BY THOMAS CAHILL

A Literary Guide to Ireland (with Susan Cahill)
Jesus' Little Instruction Book
Pope John XXIII
A Saint on Death Row

THE HINGES OF HISTORY

We normally think of history as one catastrophe after another, war followed by war, outrage by outrage—almost as if history were nothing more than all the narratives of human pain, assembled in sequence. And surely this is, often enough, an adequate description. But history is also the narratives of grace, the recountings of those blessed and inexplicable moments when someone did something for someone else, saved a life, bestowed a gift, gave something beyond what was required by circumstance.

In this series, THE HINGES OF HISTORY, I mean to retell the story of the Western world as the story of the great gift-givers, those who entrusted to our keeping one or another of the singular treasures that make up the patrimony of the West. This is also the story of the evolution of Western sensibility, a narration of how we became the people that we are and why we think and feel the way we do. And it is, finally, a recounting of those essential moments when everything was at stake, when the mighty stream that became Western history was in ultimate danger and might have divided into a hundred useless tributaries or frozen in death or evaporated altogether. But the great gift-givers, arriving in the moment of crisis, provided for transition, for transformation, and even for transfiguration, leaving us a world more varied and complex, more awesome and delightful, more beautiful and strong than the one they had found.

—*Thomas Cahill*

THE HINGES OF HISTORY

VOLUME I
HOW THE IRISH SAVED CIVILIZATION
THE UNTOLD STORY OF IRELAND'S HEROIC ROLE FROM
THE FALL OF ROME TO THE RISE OF MEDIEVAL EUROPE

This introductory volume presents the reader with a new way of looking at history. Its time period—the end of the classical period and the beginning of the medieval period—enables us to look back to our ancient roots and forward to the making of the modern world.

VOLUME II
THE GIFTS OF THE JEWS
HOW A TRIBE OF DESERT NOMADS CHANGED
THE WAY EVERYONE THINKS AND FEELS

This is the first of three volumes on the creation of the Western world in ancient times. It is first because its subject matter takes us back to the earliest blossoming of Western sensibility, there being no West before the Jews.

VOLUME III
DESIRE OF THE EVERLASTING HILLS
THE WORLD BEFORE AND AFTER JESUS

This volume, which takes as its subject Jesus and the first Christians, comes directly after *The Gifts of the Jews*, because Christianity grows directly out of the unique culture of ancient Judaism.

VOLUME IV
SAILING THE WINE-DARK SEA
WHY THE GREEKS MATTER

The Greek contribution to our Western heritage comes to us largely through the cultural conduit of the Romans (who, though they do not have a volume of their own, are a presence in Volumes I, III, and IV). The Greek contribution, older than Christianity, nevertheless continues past the time of Jesus and his early followers and brings us to the medieval period. *Sailing the Wine-Dark Sea* concludes our study of the making of the ancient world.

VOLUME V

MYSTERIES OF THE MIDDLE AGES

THE RISE OF FEMINISM, SCIENCE, AND ART FROM THE CULTS OF CATHOLIC EUROPE

The high Middle Ages are the first iteration of the combined sources of Judeo-Christian and Greco-Roman cultures that make Western civilization so singular. In the fruitful interaction of these sources, science and realistic art are rediscovered and feminism makes its first appearance in human history.

VOLUME VI

HERETICS AND HEROES

HOW RENAISSANCE ARTISTS AND REFORMATION PRIESTS CREATED OUR WORLD

The European rediscovery of classical literature and culture precipitates two very different movements that characterize the sixteenth century. The rediscovery of Greco-Roman literature and art sparks the Renaissance, first in Italy, then throughout Europe. New knowledge of Greek enables scholars to read the New Testament in its original language, generating new interpretations and theological challenges that issue in the Reformation. Though the Renaissance and the Reformation are very different from each other, both exalt the individual ego in wholly new ways.

VOLUME VII

This volume will continue and conclude our investigation of the making of the modern world and the impact of its cultural innovations on the sensibility of the West.

NAN A. TALESE

Doubleday

New York London Toronto Sydney Auckland

HERETICS
AND HEROES

*How Renaissance Artists and
Reformation Priests Created Our World*

THOMAS CAHILL

www.nanatalese.com

DOUBLEDAY is a registered trademark of Random House LLC.
Nan A. Talese and the colophon are trademarks of Random House LLC.

Pages 323–24 constitute an extension of this copyright page.

Book design adapted by Maria Carella
Map on page 287 designed by Mapping Specialists Ltd.
Endpaper: Pieter Bruegel, *Winter Landscape with Skaters and Bird Trap*,
Musées royaux des Beaux-Arts de Belgique, Brussels
Jacket design by Michael J. Windsor
Jacket illustration: *Landscape with the Fall of Icarus,* c. 1555 (oil on
canvas), Bruegel, Pieter the Elder (c. 1525–1569) / Musées royaux
des Beaux-Arts de Belgique, Brussels / The Bridgeman Art Library

Library of Congress Cataloging-in-Publication Data
Cahill, Thomas.
Heretics and heroes : how Renaissance artists and Reformation
priests created our world / by Thomas Cahill.— First edition.
pages cm.—(The hinges of history; volume VI)
Includes bibliographical references and index.
1. Renaissance. 2. Reformation. 3. Ego (Psychology)—History.
4. Europe—Civilization. I. Title.
CB359.C34 2013
940—dc23 2013006241

ISBN 978-0-385-49557-8

MANUFACTURED IN THE UNITED STATES OF AMERICA

1 3 5 7 9 10 8 6 4 2

First Edition

To Devlin, Lucia, Nina, and Conor,
beloved grandchildren

"Qu'est-ce que cela fait? Tout est grâce."

I cannot and I will not retract anything, since it is neither safe nor right to go against conscience.

—*Martin Luther at the Diet of Worms, April 18, 1521*

I had expected to vote against Senator Kennedy because of his religion. But now he can be my president, Catholic or whatever he is. . . . He has the moral courage to stand up for what he knows is right.

—*Martin Luther King Sr., from the pulpit of*
Atlanta's Ebenezer Baptist Church, October 31, 1960, the day
his son Martin Luther King Jr. was released from a Georgia prison,
thanks to John F. Kennedy's intervention

CONTENTS

POSTLUDE
Hope and Regret

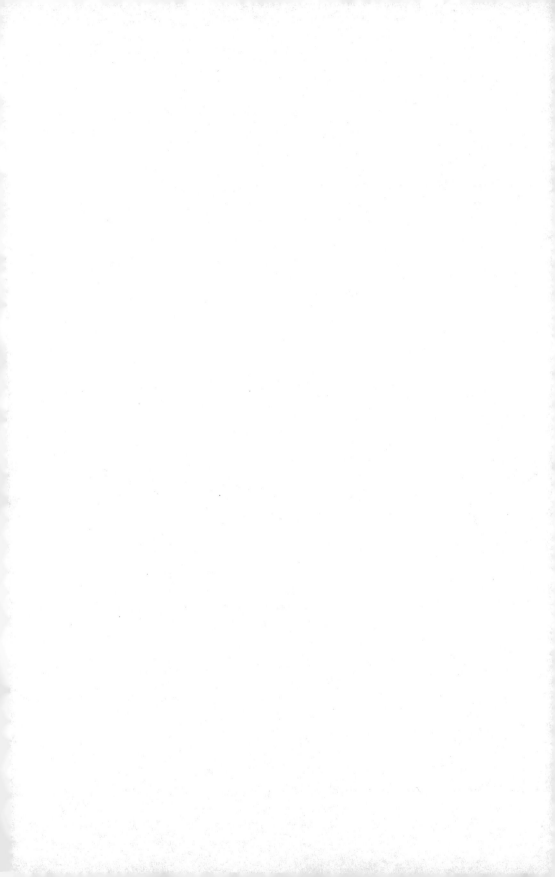

LIST OF ILLUSTRATIONS

COLOR PLATES

INSERT 1

1. Donatello, *David*, 1440s
2. Donatello, *Mary Magdalene*, c. 1457
3. Verrocchio, *David*, c. 1476
4. Verrocchio, *Baptism of Christ*, 1472
5. Leonardo, *The Annunciation*, c. 1472
6. Leonardo, *The Virgin of the Rocks*, 1482–1483
7. Masaccio, *Raising of the Son of Theophilus and Saint Peter on His Throne*, 1425
8. Masolino, *Adam and Eve*, c. 1424–1425
9. Masaccio, *Adam and Eve*, c. 1425
10. Piero della Francesca, *Resurrection*, 1458
11. Piero della Francesca, *La Madonna del Parto*, c. 1465
12. Botticelli, *Primavera*, c. 1482
13. Botticelli, *Athena and the Centaur*, c. 1482
14. Botticelli, *Venus and Mars*, c. 1483
15. Botticelli, *The Birth of Venus*, c. 1485–1487
16. Botticelli, *Madonna of the Pomegranate*, 1487
17. Michelangelo, *Pietà*, 1498–1499
18. Michelangelo, *David*, 1504
19. Michelangelo, Sistine Chapel ceiling, 1508–1512
20. Michelangelo, *The Creation of Adam* from the Sistine Chapel ceiling, 1508–1512

ILLUSTRATIONS IN THE TEXT

MAP

HERETICS
AND HEROES

PRELUDE

PHILOSOPHICAL TENNIS
THROUGH THE AGES

———— ❖ ————

In nature's infinite book of secrecy
A little I can read.

Antony and Cleopatra

His nickname is Plato, which means "broad." He's an immensely confident if unsmiling Athenian, wide of forehead, broad of shoulders, bold of bearing, who casually exudes a breadth of comprehension few would dare to question. As he lobs his serve across the net, he does so with a glowering power that the spectators find thrilling. Throughout his game, his stance can only be labeled lofty; he seems to be reaching ever higher, stretching toward Heaven while his raised shirt provides an occasional glimpse of his noble abs.

His serve is answered by his graceless opponent, a rangy, stringy-muscled man who plays his game much closer to the ground, whose eyes dart everywhere, who looks, despite his relative youth, to stand no chance of mounting a consistent challenge to our broad and supremely focused champion. And yet the challenger—his name is Aristotle, son of a provincial doctor—manages to persist, to meet his opponent with an ungainly mixture of styles. From time to time it even appears that he could be capable of victory. Certainly he is dogged in his perseverance. He begins to gain some fans in the crowd among those who prefer the improvisations of Aristotle to the unblinking gloom of great Plato.

This is a game that has been played over and over—in fact, for twenty-four centuries—before audiences of almost infinite variety. At some point long ago, the game became a doubles match, for the two Greek philosophers were joined by two medieval Christian theologians: Plato by Augustine of Hippo, who could nearly equal him in style and seriousness; Aristotle by Thomas Aquinas, nearly as styleless as Aristotle but, though overweight, ungainly, and blinking in the sun, extremely thoughtful and genial—the sort

of athlete who is always undervalued. This centuries-long philo-
sophical doubles match has entertained intellectuals in every age
and made a partisan of almost every educated human being in the
Western world.

To this day, it may be asked of anyone who cares about ideas:
Are you a Platonist or an Aristotelian? Plato certainly won the
opening set, waged in Athens in the fourth century BC; and once
he had Augustine at his side, he, if anything, grew in stature dur-
ing the early medieval centuries. But in the twelfth and thirteenth
centuries, medieval academics, such as Peter Abelard and Thomas
Aquinas—who were not only deep thinkers but gifted publicists—
were able to create a culture-wide renaissance on Aristotle's behalf.
Then, in the period we shall visit in this book, in the time of *the
Renaissance and Reformation*, the pendulum would swing once
more, as the graceful team of Plato and Augustine became the sub-
ject of nearly universal admiration, while the ungainly team of
Aristotle and Aquinas suffered scorn and devaluation.✴

Of course, these men haven't really been playing tennis (even
if some speculate that the game was first played in the Mediter-
ranean town of Tinnis in the time of the pharaohs and even if
Plato was celebrated in his day for his physical prowess). Their
styles should be accounted athletic only in metaphor, for in actual-
ity, these styles—or lack thereof—are the qualities of their literary
output. Plato is a great Greek prose stylist, never surpassed; nor
did anyone ever write more well-knit, muscular Latin than Augus-
tine. Aristotle's Greek is banal, even at times confusing; Aquinas's
Latin prose, though clear, is scarcely more than serviceable. But
these men and their philosophical heirs have surely been engaged in
utterly serious, if sporting, contests about the ultimate nature of reality; and these contests have had profound, and some-times deadly, consequences for us all.

Before Plato's arrival on the scene, the typical philosopher was a cross between a poet and a guru, dependable for pithy and memorable sayings—"Know thy-self"; "Nothing endures but change"; "The way up and the way down are the

✴ With the rise of scientific materialism, the pendulum swung back in the Aristotelian direction and has pretty much remained there, though there are those among us who still worship at the altar of Plato. The recent pope, Benedict XVI, for instance, identified himself pretty openly as a Platonic Augustinian.

same"—but quite incapable of elaborating his insight in a layered structure that could withstand criticism. Plato, father to all subsequent philosophical discourse, transformed the pursuit into a kind of science, full of sequential steps, a long course of acquired knowledge that begins in observation and ends in wisdom, even in vision.

The fluctuating phenomena of physical life, according to Plato, are only minimally real. We can never hope to understand them from the inside, for they are relative, evanescent, and mortal, here today, gone tomorrow. If we are embarked upon the ascent to wisdom, however, these sensible things can lead us upward—from the merely material world to the absolute spiritual world on which all fleeting phenomena depend. What is more fragile than the momentary existence of a flower? But we can come to understand the truth that a flower "can be beautiful only insofar as it partakes of absolute beauty."

The phenomena of our world, in Plato's teaching, are there to lead us to the absolute realities of which they are but partial, momentary expressions. These realities, which Plato called the Forms, are Beauty, Truth, Justice, Unity (or Oneness), and, highest of all, Goodness, since the other Forms are themselves but partial expressions of the ultimate reality, the Good.

Human beings are bizarre combinations of the physical and the spiritual. Each of us is like a charioteer who must control two steeds: one material, instinctive, unruly, and seeking only its own low pleasures; the other spiritual, brimming with nobility, honor, and courage. The charioteer's identity survives death, for it is spiritual, the rational principle, the soul. But the steed that is his body must perish.

Augustine is able to identify Plato's Good as the God of the Jews. God, incorporeal, existing outside time, is *summum bonum,* the Ultimate Good of Plato, containing all perfection. The human soul, though created by God and existing in time, is a spiritual principle and thus immortal. Translating Plato's philosophy to the context of Christian belief, Augustine finds that "out of a certain compassion for the masses God Most High bent down and subjected the authority of the divine intellect even to the human body itself"—in the incarnation of Jesus, the God-Man—so that God

might recall "to the intelligible world souls blinded by the darkness of error and befouled by the slime of the body."

Note that "slime." For both Plato and Augustine, human life is a gloomy business, beset by the dross of meaningless matter, mitigated only by the hard-won illumination of that one-in-a-million character, the true philosopher (for Plato), or by the illumination that God bestows on a few blessed individuals (for Augustine). On our own, in Plato's view, we are capable only of misunderstanding everything important. On our own, in Augustine's view, we are capable only of sin. But to some few, God has gratuitously granted grace that enables them to see the light and choose the good. They are the ones who will live with God eternally; all the others (most of humanity, including all the unbaptized, even unbaptized babies, and probably you, dear Reader) will spend eternity in Hell.

This is tough stuff; and no wonder it prompted some thoughtful medieval Christians to look for a path that might soften the grim austerities of the Platonic-Augustinian worldview. In the dissenting works of Aristotle, Plato's most famous pupil, they discovered a foundation on which they could build an airier, more open structure.

For Aristotle, there is no world of Forms beyond the world we know and see. The Forms are indeed universal ideas; they do not, however, exist apart somewhere but only in things themselves and in our minds. There is no absolute Beauty in some other world; there is only beauty in, say, the woman that I happen to see before me at this moment and in the idea of beauty that I and other human beings have in our minds. Thomas Aquinas championed this same approach, which came to be called moderate realism, as opposed to the position of Plato and Augustine, which came to be called extreme realism—the assertion that what is *really* real is not anything we perceive with our senses but the essences that exist elsewhere.

Not eschewing physical realities, as did Plato, Aristotle was far more open to considering seriously the inner workings of material phenomena. His observations of the natural world, therefore, form the basis of much of what we would deem the *science* of ancient and medieval thinkers. Indeed, what we call science today was for Aristotle and his followers a perfectly legitimate branch of knowledge

that they called *natural philosophy*. For both Aristotle and Aquinas, the unaided human mind is capable of perceiving reality as it is—an assertion that the pessimistic duo of Plato and Augustine have nothing but contempt for.

Beyond these very basic differences between the Platonic-Augustinian and the Aristotelian-Thomistic schools, the gulf between the two great philosophical syntheses continues to widen, as each embraces opposed positions in many areas of thought. Without elaborating on these oppositions here, we may remind ourselves that the two schools are nonetheless both designated as species of realism and that other positions are possible. Against realism of any variety stands the philosophical school of idealism, which asserts that what Plato calls the Forms are to be found *only* in the human mind. All we have are the workings of our minds—our ideas—and, according to idealists, it is illegitimate (if tempting) for philosophers (or anyone) to speak of anything outside the mind itself. Idealists of more than one variety are also called nominalists, those who assert that the concepts (or *nomina,* names) we attribute to the physical universe—lion, chair, star—are convenient labels without ultimate meaning. The most frequently encountered nominalism of our own day is called logical positivism.

I mean here merely to nod in the direction of such controversies, which could easily fill a book I have no wish to write. Though the centuries-long game of philosophical tennis may excite you at first, absorb and draw you into its ups and downs (and its sometimes surprising upsets), its mesmerizing back-and-forths can lull you into a kind of trance and finally threaten to become a serious bore. Let's just keep at the back of our minds the *poc-poc* of the philosophical tennis ball as it hits the meshed rackets of our sweating champions and turn our attention, rather, to a few of the unsettling events that in the course of the late thirteenth, fourteenth, and fifteenth centuries signal that we are on the road to the Renaissance and the Reformation.

INTRODUCTION

DRESS REHEARSALS
FOR PERMANENT CHANGE

———————— ❖ ————————

Thou hast most traitorously corrupted the
youth of the realm in erecting a grammar-
school; and whereas, before, our forefathers
had no other books but the score and the
tally, thou hast caused printing to be used;
and, contrary to the king, his crown, and
dignity, thou hast built a paper-mill!

Henry VI, Part 2

1282: THE SICILIAN VESPERS

"*Moranu li Franchiski!*" screamed the Sicilians in their peculiar dialect. "Death to the Frenchmen!"

A large, festive crowd had gathered outside the Church of the Holy Spirit, a half mile southeast of the Sicilian capital of Palermo. It was early evening of Easter Monday 1282, and the prayer service of vespers was soon to commence inside the church. An unwelcome contingent of uniformed French officials, representatives of the hated occupation forces, showed up, possibly a little tipsy on spring wine, and attempted to consort with some of the pretty, young Sicilian women in the crowd. Sicilians were a historic mixture of prehistoric peoples—called Sicani and Siculi—ancient Greeks, Orthodox Byzantines, Italian mainlanders, North African Arabs and other "Saracens," and the Northmen (or Normans) who were originally Norwegian Vikings. But the one thing they all knew they were not was *Franchiski*. The Frenchmen claimed to be checking for weapons, while surreptitiously fondling female breasts. One sergeant made the mistake of petting a young bride whose outraged husband carried a knife, which was swiftly put to use. The other Frenchmen, attempting to close ranks against the crowd, found rocks raining down on them, then blades slashing into them, as the Sicilians rose in a body.

"*Moranu li Franchiski!*" rang out as the bells of the church proclaimed that vespers was about to begin. Their message was taken up by bells throughout Palermo, as was the cry "*Moranu li Franchiski!*" All Sicily rose in revolt. "By the time the furious anger at their insolence had drunk its fill of blood," in the words of one early

chronicler, "the French had given up to the Sicilians not only their ill-gotten riches but their lives." Many thousands lay dead throughout the island, two thousand French corpses in Palermo alone.

This was no spontaneous uprising, however; it had been planned well in advance by an international consortium. King Peter III of Aragon just happened to be sailing nearby at the head of a fleet he had constructed for a crusade against Islam—or at least this is what he had told the pope when the pope expressed concern about Peter's warlike preparations. Supposedly changing course on their way to North Africa and landing instead in Sicily, Peter's forces were welcomed by the Sicilians, and he was brought with great dispatch to the Palermo cathedral, where he was crowned King Peter I of Sicily. In this way the Sicilians hoped to rid themselves of the cruel French despot Charles of Anjou, whom the pope had forced upon them. Peter's wife, Constance, was a Hohenstaufen and sole legitimate heir to Frederick Barbarossa, late, great Holy Roman Emperor of the West, whose territories included not only the German-speaking lands, the Low Countries, and Spain but much of the Italian peninsula.

The popes, who had invented the notion of a Holy Roman Emperor of the West, had come to regret investing so much power in the hands of one man. They now preferred the French royals as counterweights to the Holy Roman Hohenstaufens; thus their support of Charles. What Martin IV, pope at the time and himself a Frenchman, did not know was that Spanish Peter had built his fleet with funds sent by Michael Paleologos, Roman Emperor of the East, from his capital of Constantinople. For, as Paleologos knew, there was also another fleet, sitting in the Sicilian harbor of Messina, built by Charles for the purpose of invading Constantinople. This fleet the Sicilians set afire in their island-wide rampage, dashing Charles's bellicose intentions.

The pope, who had excellent sources of information, also knew of the existence of the fleet at Messina but had been assured by Charles that it was in aid of *his* crusade against Islam. Oh, all right then, said the pope, so long as you don't intend to use it against the Eastern emperor, whom I hope to lure into an ecumenical agreement, thus reuniting our divided churches. Whether reunification was to be achieved through talk (à la Pope Martin) or through

conquest (à la Charles), the formal schism between East and West, little more than two centuries old, still looked healable to many, if not most, European Christians. After the Sicilian Vespers, however, there would be but one more attempt to reunite Christendom—at the Council of Florence in 1439—and by then failure was the expectable outcome.

Though the bishops of East and West found themselves in substantial agreement at Florence, the monks and the ordinary Christians of the East firmly rejected reunion. Far more conscious of nationality than they had once been (if not so well versed in theological abstractions), they felt they would be giving up too much autonomy should the proposed reunion go forward. This meant that Christianity was to exist in the world in two permanent forms, Orthodox and Catholic, and that these would remain significantly different in fairly obvious ways. Such divergence could only encourage speculation that there might be even more diversity in the future—almost as much diversity, perhaps, as was to be found among the various nation-states then forming inchoately.

As A. N. Wilson has remarked, "The long dominance of the island [of Sicily] by Charles of Anjou was over. Charles, the most powerful figure in the Mediterranean, had been on the point of invading Constantinople. Egged on by a succession of French, or Francophile, popes, he had hoped not merely to regain Byzantium for the West, but also to subjugate the Eastern Orthodox Church to the authority of the papacy. With the Sicilian Vespers, there died any possibility of a universal papacy dominating Christendom. The foundations had been laid for the phenomena that shaped modern Europe—the development of nation states and, ultimately, of Protestantism."

The story of the Sicilian Vespers—and of the impossibility of successfully imposing French punctiliousness on Sicilian fluidity—has long claimed a hold on the European imagination. It was referred to in the fourteenth century by Boccaccio, whom we shall have the pleasure of consulting next. In the nineteenth century it helped fuel Italian nationalism to such an extent that Verdi wrote an opera about it. Perhaps most famously, it crept slyly into a sixteenth-century conversation in which the bluff King Henry IV of France—who, as he said, "ruled with weapon in hand and arse

in the saddle"—boasted to the Spanish ambassador of his fearsome martial capabilities. "I will breakfast in Milan, and I will dine in Rome," roared the king ahead of a planned campaign.

"Then," said the ambassador, smiling pleasantly, "Your Majesty will doubtless be in Sicily in time for vespers."

1353: HOW TO SURVIVE THE BLACK DEATH

"It's only human to have compassion for the afflicted—a good thing for everyone to have, especially anyone who once needed comfort and found it in someone else; and speaking of such need, if anyone ever needed compassion or appreciated it or delighted in it, I'm the guy."

So begins Giovanni Boccaccio in the prologue to his revolutionary collection of streetwise stories, the *Decameron,* written midway through the fourteenth century. A lifelong admirer of the elevated diction of Dante's truly divine *Comedy,* Boccaccio nonetheless makes scant attempt to imitate the sublime poetry of his literary hero. Though Dante composed his masterpiece in medieval Tuscan (which would become the chief font of modern Italian), the model for his written style was Virgil, most exalted of all Latin poets, so that Dante's tightly controlled Italian often owes more to the ancient Romans than to any of his Florentine contemporaries. The Tuscan prose of Boccaccio's characters—starting right here at the outset, in the voice of Boccaccio's own persona—can be so flatly realistic, so accidental, so resolutely conversational that it may appear at times almost to echo occasional monologues in *The Sopranos.* For readers who have previously immersed themselves in Dante's precision, a dip into what one critic calls Boccaccio's "decidedly non-canonical vocabulary" can be a shock. The meanderings of Boccaccio's characters, the ladies and gentlemen of the late Middle Ages, sometimes stray closer to the denizens of low-life New Jersey than to anything Virgilian.

But what flights of hilarity Boccaccio's earthiness brings forth! The scamps and pirates, the schemers and adventurers, the calculating merchants and their inventively adulterous wives, the priests and nuns with nothing but sex on the brain, the representatives of law and order who fail to uphold either or anything else—all these

assorted scapegraces (along with the *very* occasional saint or sage) dance through Boccaccio's pages, entertaining centuries of readers in a series of witty, quickly moving *novelle* (brief tales or short stories).

If Dante's hallowed *Comedy,* his imaginative visit to the world beyond the grave, must be ranked as the greatest of all Italian literary feats, Boccaccio's *Decameron* (or *Ten Days,* in which a hundred rollicking stories are told by seven beautiful young women and three handsome young men for their mutual entertainment) surely rates as a close second. But the latter work, only about thirty years younger than the earlier one, is so different in tone as to give any reader pause. Why does Boccaccio, fellow Florentine, unparalleled admirer and interpreter of Dante, sound so different from his acknowledged master?

One could point to the difference in subject matter (Dante treats of Hell, Purgatory, and Heaven, while Boccaccio confines himself to this life) and to the difference in diction and effect between poetry and prose, but neither of these considerations takes us far enough. The deep difference between the two maestros lies in their attitudes toward life itself, Dante always grave and serious, Boccaccio cynical and . . . disappointed. Boccaccio is so imaginative, so creative that he can use his cynicism—his worldly-wise pose of "Well, what did you expect?"—to mask his disappointment. Dante, despised and persecuted by a corrupt pope, then suffering lifelong political banishment from his beloved Florence, knew all too well the injustices wrought by both church and state; Boccaccio expects less of Florentines, as well as of all human beings, than does Dante. Whereas Dante's tripartite vision gives us as discriminating a map as we shall ever have of the moral universe and of the earthly choices we must make if we are to reach God, Boccaccio repeatedly advises us to snatch whatever pleasure we can as it presents itself, for we may not be given a second chance.

Is there a funnier scene in all of anticlerical literature than the one in which the grand abbess Madonna Usimbalda of Lombardy, learning from her tattletale nuns that the novice Isabetta has a man in her cell, dresses in the dark and sweeps out of her bedroom into the nighttime darkness of the unlit convent? Unfortunately for Usimbalda, who was "good and holy in the opinion of her nuns

and of everyone who knew her," she has failed to realize that in her haste she has draped over her head not her veil but the pants of the priest who sleeps with her. The abbess's indignant castigation of Isabetta quickly loses steam as the novice and then the other nuns notice the pants on the abbess's head, their "suspenders dangling down on either side of her face." When, however, the realistic abbess realizes what headdress she is sporting and that "there was no way of concealing her own sin from the nuns, who were all staring at her with eyes popping right out of their heads," concludes Boccaccio's storyteller,

> the Abbess changed her tune and began to speak in a completely different tone, asserting that it was impossible to defend oneself against the promptings of the flesh; so she said that everyone there was henceforth free to enjoy herself whenever possible, so long as it be done as discreetly as it had always been done. And after Isabetta was set free, the Abbess went back to sleep with her priest and Isabetta with her lover, who continued to visit her often, despite the envy of the other nuns, who, lacking lovers, consoled themselves in secret as best they could.

The abbess's belated assertion—that it is "impossible to defend oneself against the promptings of the flesh"—is Boccaccio's own rock-bottom belief, one that leads him to vilify almost all priests and religious as insufferable hypocrites. His deepest faith is expressed by Guiscardo the Page, one of Boccaccio's more sympathetic characters, who tells his prince, whose daughter he has been sleeping with, that "against the force of Love all men, whether pages or princes, are equally helpless." Like the pagan Greeks and Romans, whose writings were being rediscovered and newly revered in his day, Boccaccio fears that to go against "Nature" is to risk impairment, "for her laws cannot be defied without exceptional strength, and those who defy them often labor in vain or do much harm to themselves. I for one confess that I possess no such strength, nor do I wish for it."

Boccaccio is not just telling tales; he is pushing a point of view. "A lover's kisses," he points out, are often "much tastier than those of a husband." So whatever *cena d'Amore*, whatever supper of love

is to one's taste, Boccaccio prays "God in his overflowing mercy quickly to bestow the same thing upon me and upon every other Christian soul inclined to enjoy such a feast." And, please, lay aside any religious scruples: in one of Boccaccio's later stories, a ghost returns from Purgatory to tell a living man that, though he can expect to pay for his sins in the afterlife, his sexual peccadilloes won't be numbered among his transgressions: "Down here," counsels the ghost, "such things don't count for much."

This hardly means that Boccaccio shrugs off evil. In the story of Tedaldo, for instance, who leaves Florence when his lady love, Ermellina, turns mysteriously against him, the lover returns many years later only to find that Ermellina's patient and forgiving husband, Aldobrandino, has been sentenced to death for the murder of Tedaldo himself.

> When Tedaldo heard this he began to reflect how easy it is for people to stuff their heads full of totally erroneous ideas, thinking first of how his brothers had mourned and buried a stranger in his stead and then how an innocent man had been accused on the basis of their false suspicions and then sentenced to death on the evidence of false witnesses, and he also pondered the blind severity of laws and magistrates who, in order to demonstrate their zealous pursuit of truth, very often use cruel tortures so as to cause falsehood to be accepted for fact, claiming the while to act as ministers of God's justice, whereas in reality they are instruments of the Devil and all his iniquities.

In such a reflection we feel the heat of Boccaccio's savage indignation and his impatience with the commonly tolerated injustices of his society (which, in respect to the casual frequency of wrongful conviction at least, was not so very different from our own).

But no societal abuse raises Boccaccio's ire as much as the hypocrisy of churchmen, especially the Franciscan friars, the spiritual sons of Francis of Assisi, the greatest of all medieval saints, who less than a century and a half earlier had founded a religious order of poor beggars. In the intervening years, however, the friars had, er, evolved. "Is there a friar who does not act the hypocrite?" asks another of Boccaccio's storytellers.

Oh, scandal of this wicked world! They're not in the least ashamed of looking fat and flushed, or effeminate in their dress and accoutrements, and they strut around not at all like the doves they think they resemble but, rather, like the cock o' the walk with crest erect. And what's worse—and let's not even mention that their cells are stocked with ointments and salves, huge boxes of sweets, phials and flasks of perfume and fragrant oils, and casks overflowing with Malmsey wine and other such exotic vintages, all making their abodes look more like perfume shops or gourmet grocers than like friars' quarters—they are not ashamed to let others know they're suffering from gout, self-deceived that people are unaware that regular fasting, a spare and simple diet, and sober living keep a person lean and healthy; or if such a man should fall ill, it's not from gout, for which the commonly prescribed cures are chastity and all the things befitting the life of a simple friar. They think others do not realize this . . . and do not know that neither Saint Dominic nor Saint Francis ever owned four cloaks each but wore clothes to keep out the cold, rather than to cut an elegant figure. . . . May God see to it that they and all those simpletons who supply them with these things get what they deserve in the end!

Harrumph! If the sins of the friars seem a trifle tame compared with those of the magistrates, it must be noted that in Boccaccio the clergy come in for more criticism than do the secular authorities. It may be that in the mid-fourteenth century the well-developed structures of the church seemed far more present and oppressive than did the still-sketchy structures of the state. Whatever the case, Boccaccio never misses an opportunity to lambaste the presumptuousness of the clergy.

In the course of telling the story of Brother Alberto of Imola—a "thief, pimp, forger, and murderer" who becomes a successful preacher and sleeps with an easily flattered merchant's wife after convincing her that he is the Angel Gabriel—Lady Pampinea has occasion to rail against scams such as indulgences by which the clergy sucker the credulous: "And rather than earning Paradise as we all must do, [the clergy] act almost as if they were its very lords and owners, assigning to each person who dies, depending on how

much money he has bequeathed to them in his will, a more or less choice perch up there, and in doing this they first of all deceive themselves (if they really believe what they say), and then they deceive everyone who trusts them."

Here in the early 1350s, Boccaccio is already rubbed the wrong way by a phenomenon that will continue to grate on *i svegli*—those who are awake—till, nearly seventeen decades later, their demur, having only gained in seriousness over the course of time, will erupt in the Reformation. And there lies in the *Decameron,* as if hidden in plain view, an even more portentous tale of future eruptions, if only one were to read it aright. It is a story told by Lord Panfilo, indeed the second story told on the very first day, so Boccaccio surely means to give it a sort of spotlight.

"Once upon a time there lived in Paris a great merchant, who was also a good man, and his name was Giannotto di Civigni." Giannotto's best friend is another merchant, a "forthright and utterly trustworthy man," whose name is Abraham and who is a Jew. Now Giannotto, recognizing Abraham's "honesty and uprightness, found it most distressing that the soul of this brave, wise, and good man would end in Hell because of his lack of faith." For in this period Christian theology did not allow non-Christians to reach Paradise. So Giannotto begins to plead with his friend to accept baptism, for "as he himself could see, the Christian faith was always growing and spreading, while Judaism was growing ever smaller."

In our day, this kind of badgering would almost certainly have ended the friendship (surely few faults are less attractive than the smugness of the cultural imperialist), but Abraham, who was learned in his ancestral religion, displays extraordinary patience with his well-meaning, if obtuse, friend, even finding his arguments "entertaining." At long last Abraham weakens a little, but, first, he says, "I want to visit Rome to have a look at the man you call 'the Vicar of God on Earth.' I wish to study his style of life as well as that of his brother cardinals." Hearing this, Giannotto is cast down, knowing that "I have wasted my time. . . . For if he visits the Roman court and sees the foul and sordid lives of the clergy, not only will he not change from Jew to Christian, but if he had already become a Christian, he would doubtless go back to being a Jew!"

Abraham, as the teller of the tale informs us, is "a most per-

ceptive man" and missed nothing on his Roman holiday. As he "carefully observed the behavior of the pope, the cardinals, and the other prelates and courtiers," he took note that "from highest to lowest, they all without shame were steeped in lechery, not only the natural variety but also sodomy, and without the least embarrassment or remorse—so much so that the influence of whores and rent boys was of no small importance if one should wish to obtain a great favor there." Moreover, Abraham notes that all the clergy are "great gluttons and drunks . . . money-grubbers . . . as likely to buy and sell human (even Christian) blood as to sell sacred objects or offices . . . and that in these commercial exchanges there was more traffic and more brokers involved than there were cloth merchants—or merchants of any kind—in all of Paris," bustling Paris then serving, along with Florence, as one of the two great hubs of emerging European capitalism.

On Abraham's return to Paris, his Christian friend asks him with trepidation what he thought of the Roman court. Abraham spares Giannotto no detail, sharing his assessment that these clergy "are trying with all the talent and skill at their disposal to destroy the Christian religion and to drive it from the face of the earth." But since they have not succeeded, but rather since Christianity "continues to spread and grow ever brighter and more radiant, I am of the opinion that it must have the Holy Spirit as its foundation and mainstay." In conclusion, Abraham asks to be baptized forthwith and the two friends set off for the Cathedral of Notre Dame.

Between 1353, when the *Decameron* was published, and 1511, the papal court did not improve. In the latter year, a little-known Augustinian monk and small-town German professor would visit Rome and find it as corrupt as did our fictional Abraham sixteen decades earlier. The friar, a less traveled and far less worldly soul than the Parisian merchant, seems to have experienced his own conversion, though not exactly to the Catholicism of the pope and the cardinals. The monk's name was Martin Luther.

The striking change in tone and sensibility between the *Comedy* and the *Decameron*, the two monumental masterpieces of early Italian literature, suggests a disruption in Italian life. As the

Irish-English Catholic-Marxist critic Terry Eagleton has cannily observed, "transformation in our language games generally reflects an upheaval in material forms of life." In this case, the upheaval is not hard to find; indeed it is presented to us by Boccaccio at the very start of the *Decameron*. The most noble figures of the High Middle Ages—Francis of Assisi, Thomas Aquinas, Dante Alighieri, Giotto di Bondone—had all lived and died between the late twelfth and the early fourteenth centuries. And in 1347 a terrible plague struck Europe, hitting Florence full force in late spring of 1348. Soon enough, there would be no going back to the supernal gentleness of Francis, the light-filled philosophical explorations of Aquinas, the grave vision of Dante, or the sweet playfulness of Giotto. Even the human compassion and fellow feeling that Boccaccio lauds in the very first sentence of his masterpiece, quoted at the outset of this section, will be cast aside.

"In the face of this pestilence no human precaution or remedy was of any avail," writes Boccaccio. "Its first symptoms in both men and women were swellings in groin or armpit," which soon would grow to the size of an egg or apple, then spread throughout the body, turning black or sometimes livid. "Few of the sick recovered, and almost all died after the third day. . . . Not only did talking to or keeping company with the sick induce infection and the death that spread everywhere, but also touching the clothes of the sick or touching anything that had come in contact with them or been used by them seemed to communicate the disease."

Since there was as yet no accurate medical theory to explain communicable disease, people devised their own solutions. "There were those who thought that abstemious living and the avoidance of any extravagance" might do the trick. "They shut themselves up in houses where there were no sick people" and even "refused to speak to outsiders or listen to any news of the sick and the dead who lay outside. . . . Others thought otherwise: they believed that drinking to excess, enjoying themselves, singing their hearts out and living it up, sating all their appetites, and making light of anything that happened was the best medicine." People abandoned their holdings; houses became common property, and "reverence for law, whether divine or human . . . virtually disappeared," since the ministers of religion and the magistrates of secular law were all

dying off, just like everyone else. There was plenty of alternative medicine on offer, as many thought that smelling flowers or consuming herbs might keep one safe.

As the effects of the plague increased, "one citizen avoided another, almost no one took care of his neighbor, relatives seldom if ever visited one another . . . brother deserted brother, uncle forsook nephew, sister left brother, and very often wife abandoned husband, and—even worse, almost unbelievable—fathers and mothers stopped caring for their children as if they were not their own." Servants were in short supply, to such an extent that "when a woman fell ill, no matter how elegant or beautiful or refined she might have been, she did not mind employing a manservant (whether young or old), and she had no scruple whatsoever about revealing any part of her body to him." This practice, speculates Boccaccio, was one "cause of a certain continued lapse in the chastity of those women who survived."

Many of the poor and those without servants "ended their lives in the public streets" or were found dead in their homes "thanks to the stench of their rotting bodies." Corpses would be left abandoned in the night on their own doorsteps, to be collected in daylight by gravediggers of the lowest class and thrown unceremoniously into a huge trench. As the corpses piled up, churchyards filled to capacity, the few remaining priests became negligent in their duties, and finally funerals were discontinued altogether, events having reached such a pass that "the dead were treated as we might treat a dead goat." In the end, "more than one hundred thousand human beings are believed to have perished for certain within the walls of Florence—whereas before the plague struck, no one would even have estimated that the city contained so many inhabitants."

In the midst of the plague, the seven noble ladies and three noble gentlemen of Boccaccio's masterwork set out from the city, along with their servants, to entertain one another with their tales, while living decorously and discreetly in the countryside. They are representatives of those who think moderate living may save them. But we are never told how many of these storytellers survive the plague.

The pandemic, usually called the bubonic plague—after the buboes (or swelling lymph nodes) that were its most obvious

symptom—killed off about half of Europe's population, worldwide possibly as many as a hundred million. It would not be called the Black Death for many centuries. Its origins lie in China, from which it was carried by black rats into Europe in the wake of medieval Europe's immensely expanded trade with Asia. The effects on Europe were not uniform: southern Europe—particularly Spain, southern France, and Italy—may have lost as much as 80 percent of its population, whereas in much of northern Europe the loss may have been as low as 20 percent, in parts of Scandinavia even lower, though the numbers were seldom uniform across large areas. Paris, Europe's largest city, lost half its population, London a similar percentage.

At any rate, the change in culture—from buoyant and optimistic to grasping and cynical—affected the south far more than the north. The great Ingmar Bergman film about the social consequences of the plague, *The Seventh Seal,* would be far more accurate historically if he had set it in Italy, rather than in Sweden. The frightening religious image of the "Dance of Death" was much more prevalent in the south than in the north; and the flagellants, the bands of men who whipped themselves publicly in reparation for the human sins that they believed had brought on the plague, were a marked feature in southern towns and in German ones, but were almost entirely unknown as far north as Scandinavia.

Wherever the plague struck, waves of accusation and intolerance seemed to strike in its wake. Sinners were responsible, or heretics, or foreigners, or beggars, or lepers—whoever was Other. None suffered more from these waves than communities of Jews. In early 1349, the Jews of Strasbourg were slaughtered, later that year all the Jews of Mainz and Cologne. By 1351, more than two hundred Jewish towns and urban neighborhoods across Europe had been obliterated.

Given the considerable regional differences in the rates of death and in the consequent cultural effects, it is not so surprising that Abraham, a cosmopolitan character of Boccaccio's imagination, is far less scandalized by the open graft and cynical laxity of the papal court than would be a provincial German professor, who, nearly two centuries later, would have been much less influenced by the devastations of the plague. But the *Decameron* surely serves

as a bellwether of late medieval disenchantment and presages future disjunctions within a Europe that will only grow more regionally diverse from this time forward.

The long cultural lassitude that affected Western Europe after the fall of Rome in the late fifth century AD stretched through the so-called Dark Ages and was alleviated only toward the end of the eleventh century by a rising merchant class, greater wealth, the growth of cities, a new confidence, more leisure, and an expanding interest in education and the arts. This blossoming—often referred to as the twelfth-century renaissance—propelled Europe forward for two and a half centuries, fostering continuing cultural (and even scientific) experimentation and excitement that looked unstoppable.* In important ways, however, this great movement was halted in its tracks in the mid-fourteenth century by the advent of an infection that appeared to be of cosmic proportions.

1381–1451: LUTHERANS LONG BEFORE LUTHER

Perhaps someday someone will write a history of rhyme and its impact.

In ancient times, rhyme was generally eschewed as childish babble, silly stuff lacking the dignity that was so precious to the ancients. For this reason none of the classical writers and orators of the Western tradition (or of any other tradition, so far as I can judge) made use of rhyme. The sole exception was the Greek mathematician Pythagoras, who was something of a wing nut anyway and who told his wide-eyed followers that word combinations that rhymed contained hidden spiritual meanings. In the early fifth century of the Christian era, Augustine of Hippo did occasionally play with rhyme, especially in his sermons, for the sake of giving his African congregation an easily remembered phrase, such as *bona dona* (good gifts). One might almost wonder if his method is the prototype for the rhyming of African American preachers like Jesse Jackson. In the late sixth century, we find a few examples of what may be intentional slant rhyme in the slick hymns of that urbane Italo-Gallo-Germanic courtier Venantius Fortunatus.

* This cultural movement is the subject of Volume V of the Hinges of History, *Mysteries of the Middle Ages.*

In the eleventh century, we find the Old French poets, the authors of *The Song of Roland* and other stirring *chansons de geste,* who employ rhyme as a matter of course, as do the jingly Latin writers of Germany in such twelfth-century collections as the *Carmina Burana.* In the thirteenth century, in the jolly, singsong Latin hymns of such writers as Thomas Aquinas (who was no doubt taking a day off from weightier pursuits), rhyming took a definite place in church ceremony. Thence it traveled easily to all the emerging European vernaculars, useful in giving shape to both song and spoken poetry. Medieval playfulness had won a permanent victory over classical dignity.

But we should never minimize the importance of rhyme as a mnemonic device, especially useful to both street monger and preacher (or, in more modern times, to politicians) who want their spoken message to stick permanently in the minds of their listeners. And it was in this guise that a single rhyme brought about a late-fourteenth-century rebellion that would reverberate through all of subsequent European history.

When Adam dalf and Eve span,
Who was thanne a gentilman?

This was the question John Ball put to his many audiences. Ball was an English priest, and his question was posed perfectly in the English of his day. "Dalf" is the original past tense of the verb "delve" (or dig); "span" is the original past tense of the verb "spin." So, when Adam and Eve, expelled from the Garden of Eden, were the only humans on earth, toiling away at their various tasks, who stood on the sidelines at leisure? Why, no one. In the original order of the fallen world, decreed by God himself, there were only laborers, who toiled at all the necessary obligations imposed on human beings. There was then no leisured class, no gentlefolk whose privilege it was to observe the laborers and idly profit from their ditch digging and cloth spinning and all the rest of the work that was their lot in life.

The only conclusion to be drawn was that the nobility, those who lived off the honest sweat of others, were not only unnecessary but a thwarting of the will of the Almighty, an undoing of God's

own plan. To an English peasant of 1381, this struck home, an amazing, unforgettable, unassailable idea. If it weren't for the backdrop of Judeo-Christian theological belief, the reasoning might have come straight out of Karl Marx: the members of the leisured class were no better than leeches, sucking the blood of decent working men and women!

Contemporary chronicles, written by clerics, who were employed by nobles and bishops, are all against Ball, so much so that it is impossible to separate fact from fiction in their accounts. Ball, they say, was a "hedge priest," a self-ordained preacher without parish or other normal clerical post. He wandered from town to town, barefoot and stirring up trouble. He preached not in churches but in the open on village greens. He had been excommunicated for his opinions, and the English had all been forbidden to hear him preach—forbidden by competent ecclesiastical authority. But still the ignorant and unlettered came to learn what they might from "the mad priest of Kent," as the French chronicler Froissart contemptuously called him.

However despicable and unwelcome Ball may have appeared to his betters, to the peasant farmers—the so-called villeins or serfs in bondage to their local lord, who had the right to extract unpaid service—he was a truth teller; and the few sentences of Ball's that have survived only confirm his powerful—and long-echoing— eloquence: "From the beginning *all men were created equal* [emphasis mine] by nature, and . . . servitude had been introduced by the unjust and evil oppression of men, against the will of God, who, if it had pleased him to create serfs, surely in the beginning of the world would have appointed who should be a serf and who a lord."

As the national economies of Europe had experienced considerable growth, the gulf between the world of peasants and servants and the world of lords and bishops grew immense. In many places, peasants toiled incessantly, starved in lean times, died young, and saw many of their children die, as they had always done. They had few pleasures, fewer recreations. The lords and ladies, however, and their clerical equals had managed to make for themselves a new world of pleasure. When Boccaccio's ten privileged storytellers reach their destination in the countryside, they find the grounds "abundant in different kinds of shrubs and trees, rich in green fo-

liage. On the summit of a hill was a great country house, built around
a fine and large inner courtyard and containing loggias, halls, and
bedrooms, all of them perfectly proportioned and marvelously dec-
orated with depictions of gay scenes. Surrounding the house were
glorious meadows and gardens and wells of fresh water and cellars
stocked with precious wines, more suited to wine-bibbers than to
well-behaved, respectable young ladies. And the party discovered,
to no little delight, that the place had been cleaned from top to
bottom, all the beds made, fresh and seasonal flowers everywhere,
and the floors strewn with rushes." Though hardworking serfs and
servants are scarcely alluded to in such airy descriptions, their solid,
loyal, essential presence undergirds everything.

　　Whether or not, as the chroniclers report, John Ball encouraged
the peasants—at a great assembly at Blackheath, near Greenwich—to
assassinate all the chief lords and kill all their lawyers,✝ vast throngs
of rebels entered the city of London, including an army from Kent
led by Wat Tyler (whose name is permanently affixed to this insur-
rection, known as Wat Tyler's Rebellion) and an army from Essex
led by the priest Jack Straw. They commandeered the Tower and
beheaded Simon of Sudbury, the antipathetic archbishop of Can-
terbury, whose name was associated with an unjust poll tax leveled
against the peasants. They beheaded several other Canterbury cler-
ics and even executed Richard of Wallingford, uncle to King Rich-
ard II, who was then a boy of fourteen and easily led by his elders.

　　When the rebels insisted on meeting with Richard, he agreed
and met with them at Mile End, where he
promised to address their grievances. This
was a ruse, however. The very next day,
Wat Tyler would be knifed to death by the
Lord Mayor of London, with assistance
from one of the king's knights, in Rich-
ard's presence. Once the armies, charmed
by the boy king, had disbanded, Richard
went back on his word, Jack Straw was
beheaded, and John Ball was hanged and,
while still alive, drawn (that is, cut down,
castrated and disemboweled, his organs
burned while he watched), decapitated,

✝ This exhortation sounds
false to me, part of the general
disdainful mischaracterizations
of the peasantry by the
educated classes. It is at
one with the conspiratorial
exhortation of Dick the
Butcher in Shakespeare's
Henry VI, Part 2—"The first
thing we do, let's kill all
the lawyers!"—also used to
demonstrate the supposed
villainy of the villeins. But
then, Shakespeare was hardly a
fan of peasant uprisings.

and quartered, his quarters and severed head sent for display to five
strongholds of rebellion as reminders of the fate that awaited rebels.
When a respectful deputation of peasants later begged the king to
fulfill his promises, Richard would dismiss them with the words
"Villeins ye are still and villeins ye shall remain."

Behind this rebellion and others like it in continental Europe,
especially in France, lay a great economic shift that had occurred
as a result of the Black Death. Because there were far fewer people,
there was no longer any reason for serfdom. Without artificial legal
constraints, anyone could make a good living, because there were
so many jobs to be done and so few to do them. So the lords of
the English manors had got Richard's grandfather and predeces-
sor, Edward III, to proclaim the Statute of Labourers, according to
which landowners could summon as many laborers as they needed
and pay them no better wages than what they'd received before the
plague. Despite my earlier reference to Karl Marx, a better way to
understand the peasant unrest of this period may be to think of it
in terms of our so-called free-market economy. What the peasants
wanted was a market in which they could get whatever price a cus-
tomer was willing to pay, so long as each provider of labor could be
free and unconstrained in striking his bargain. Though the peasants
lost this battle, there could no longer be any doubt that they would
eventually win the war.

We know the punishment given John Ball was one reserved
for high treason, not heresy. Convicted heretics were not hanged,
drawn, and quartered but burned to death. The rebellion initiated
by the preaching of Ball would, nonetheless, result eventually in not
a few convictions for heresy and subsequent incinerations. Three
especially should be considered.

Behind Ball stands what many of his well-placed contemporaries
took to be a larger conspiracy, that of the Lollards, who probably
got their name from their supposedly sloppy, uneducated speech.
(They were thought to mutter or mumble "lull-lull" or "loll-loll,"
as if their tongues were slow.) For slow-witted, slow-speaking dull-
ards, however, their ideas were many and keen. Churchmen, they
thought, should be poor like Christ and prohibited from accruing
personal wealth. Wealthy church properties should be taxed. The
endless hubbub about the nature of Christ's presence in the ele-

ments of the Eucharist was excessive: no one really knew whether it was symbolic or real, and, if real, in what way. Far too much was made of images and relics in churches, which hardly deserved the reverence accorded them. Let's stop paying clergy for prayers for the dead, which benefit only the rich. All the dead, as well as all the living, should be prayed for equally. Church ceremony should be simplified and the focus put on reading the Scriptures, which need to be translated into local languages, so that everyone may understand them. There is nothing special about ordained priests; every Christian is a priest. Priests have no special power to forgive sins and should not be expected to be celibate. Nonetheless, official churchmen should not concern themselves with secular matters, which are none of their business. War is wrong, as is capital punishment and the taking of oaths.

There were probably additional tenets held by various groups of Lollards. Soon enough, they had to meet in secret, and it becomes harder to track their beliefs. That John Ball was a Lollard seems indisputable; so was Sir John Oldcastle, boon companion of Prince Hal (one day to reign as King Henry V) and model for Shakespeare's Falstaff. At times, Chaucer has been labeled a Lollard and certainly seems, in *The Canterbury Tales,* to express Lollard-like sympathies. To combat Lollardy, Henry IV, Henry V's father and Richard II's successor, had, as early as 1401, issued *De Heretico Comburendo* (On the Burning of Heretics), which prohibited both the translating of the Bible into English and the owning of such a Bible and made provision for the burning of heretics in England.

The probable founder of Lollardy was John Wyclif, Oxford don and by traditional acclamation "the Morning Star of the Reformation"—nearly a century and a half before Luther. Besides the convictions of Lollardy outlined above, Wyclif attacked the claims of the papacy as unfounded, reestablished the Scriptures as Christianity's authoritative norm, translated much of the New Testament into splendid vernacular English (a translation that continued to be imitated by others even as late as the King James Version of 1611), and taught—if in a simpler, more primitive form—what would become Luther's central doctrine of justification by faith, rather than by works. Though he died in his bed in 1384, he was convicted of heresy by a church council in 1428. His remains were

dug up at the command of Pope Martin V, burned, and cast into the River Swift. Despite this posthumous animosity, Wyclif was much loved in his lifetime and known by his many friends and admirers as "the wisest and most blessed of all men." Like Luther, Wyclif was very much an Augustinian Platonist, so much so that he was dubbed "John of Augustine" by his students. In advance of his time in so many ways, he also despised Aristotle.

Wyclif's most famous disciple was Jan Hus, the Czech priest and reformer who to this day is held in special reverence by the Czech nation. He advocated theological and structural reforms similar to those of Wyclif—though it would be difficult to find anything he had to say that would be unacceptable today to a moderate Roman Catholic—and was burned at the stake for his honesty and candor. His martyrdom took place not in his native Bohemia but in 1415 in the Alps at the ecumenical Council of Constance, whither Hus had journeyed to debate his proposals at the invitation of the Holy Roman Emperor Sigismund, who had assured him of safe passage. He was condemned by a consensus of the bishops in attendance. He said he would die "with gladness" "in the truth of the Gospel." As the flames licked higher, poor Hus, naked except for a high paper hat inscribed with the single word *haeresiarcha* (heresiarch), is reported to have called out that "in a hundred years, God will raise up a man whose calls for reform cannot be suppressed." One hundred and two years later, Martin Luther will—or so it is recounted—nail his Ninety-Five Theses to the door of the Wittenberg church on October 31, now remembered as Reformation Sunday.

The most notorious heresy conviction in this period was that of Joan of Arc, an illiterate French peasant who was burned at the stake in 1431, at the probable age of nineteen, for having dared to attempt the military task of reuniting France and expelling its English occupiers. The church court that condemned her as a witch was an irregular one, convened by the sniveling bishop of Beauvais, an English partisan, who had not the ecclesiastical jurisdiction to try her case. Joan, a genuine mystic and visionary, would never have fallen into English hands if her sovereign, Charles VII, had had the courage to pursue the daring military strategies she urged on him. Everything in the extensive contemporary records under-

scores both her genius and her unadulterated honesty. The record of her trial reads at times like the gospel accounts of the trial of Jesus before Pilate. She was, perhaps somewhat too enthusiastically, awarded the title "the first Protestant" by George Bernard Shaw. However challenging she may have appeared to the official church in her insistence on the truth of her personal inspiration over any supposed norms of Catholic orthodoxy, she was later than both Wyclif and Hus.✝

These ecclesiastical inquiries into heresy—or inquisitions as they were called—could clearly end in dire consequences for the accused. Nonetheless, we should bear in mind that, bloody-minded and misguided as they were and, like so many public trials even to our own day, easily influenced by emotional and political pressures, they were fairly infrequent in the Middle Ages. The gruesome terrors of the rack and other forms of torture belong more properly to the period of the Renaissance and Reformation than to the medieval period to which they are so often referred. More than this, we should recall that in times past even the most reasonable and pacific of men imagined that heresy—that is, diversity of religious opinion—could not be tolerated if a society was to remain whole. As late as the enlightened eighteenth century, we find Samuel Johnson, that most considered of Englishmen, rendering this shocking judgment:

"They set out for Harwich in the stage-coach . . . as planned," writes Christopher Hibbert in his biography. "Johnson, in high good humor, fell in conversation with a fat, talkative, elderly gentlewoman. . . . In the afternoon, the old lady began to talk violently against the Roman Catholics and of the horrors of the Inquisition. To the utter astonishment of everyone present, except Boswell who knew by now that he would talk on any side of a question, Johnson defended the Inquisition warmly, maintaining that a false doctrine should be checked on its first appearance, that the civil power should unite with the church in punishing those who dared to attack the established religion, that none but such as these had ever been punished by the Inquisition."

✝ More than four and a half centuries after her martyrdom at the hands of churchmen, Joan was canonized by the pope and named a patron of France.

1452: THE THIRD GREAT
COMMUNICATIONS REVOLUTION

The first communications revolution was precipitated by the invention of writing in Mesopotamia a little more than five millennia ago.✝ To begin with, the invention seemed of use only to ancient accountants, those who counted up the sheep in the sheepfold and the wares in the warehouse. Soon enough, its manipulators discovered that it could also be useful for recording more complex human events (history) and even for making more permanent records of the tales they told one another (literature). But because writing soon required the mastery of thousands of separate symbols, its use was confined to those who had the leisure to master such a complicated system. Literacy came to serve as a new means of political control.

The second communications revolution took place a little to the west of Mesopotamia in the Levant, where someone—perhaps a little before the era of Moses, about midway through the second millennium BC—devised the first alphabet, based on Egyptian hieroglyphs but using only twenty-odd symbols to represent not words but sounds. This was an astounding simplification, enabling almost anyone, even a slave, to become a reader. Direct descendants of that first alphabet remain with us to this day as written Aramaic, Hebrew, and Arabic. Centuries later, the Greeks would make an alphabet in imitation of the Semites (though with innovative symbols added for vowel sounds, which are largely absent from the Semitic alphabets); last of all, the Romans would make an alphabet of their own, based on the Greek. The book you are reading was composed in this Roman alphabet.

The third communications revolution was a rather drawn-out affair. It involved several inventions: paper, movable type, and the printing press.✱ In the

✝ See Volume II of the Hinges of History, *The Gifts of the Jews,* Chapter I. Quite recent and isolated finds—a few undecipherable hieroglyphs on tiny bone tags—at Abydos in Egypt may indicate that the Egyptians invented writing at almost the same time as the Mesopotamian Sumerians. But it would appear from the fragmentary evidence that the Sumerians disseminated their invention more quickly and used it far more extensively than did the Egyptians of this period.

✱ The economist W. Brian Arthur argues in *The Nature of Technology: What It Is and*

early fifteenth century all these things came to Europe from East Asia, where the Chinese and the Koreans had been using them for hundreds of years. But movable type—manufactured symbols, such as the letters of the alphabet, that could be locked in a frame, inked, and impressed onto paper by a mechanical press—proved far more useful to alphabetical Europeans than the invention had ever been to Asians, who needed to draw on thousands of separate pictographic symbols in order to create a text, since their written languages, like those of Mesopotamia, had never known an alphabet.✦

Johannes Gutenberg, the German who introduced printing to the West, was a jeweler and goldsmith who knew how to fashion metals into shapes. He realized he would need to use extremely hard material if he was to set up an assembly that could repeatedly stamp letters onto paper (thwack, thwack!) without the letters breaking up. He was the first to make durable alphabetical typefaces out of lead and similar metals. (In the East, far less durable forms, fashioned from ceramic, wood, and sometimes bronze, had been employed.) For his press, he used a slightly altered winepress.

A little before 1440, Gutenberg produced his first printed pages, and by about 1452 he was printing his first Bible. It was a large Latin Bible, using the Vulgate, the traditional translation made by Saint Jerome in the late fourth and early fifth centuries from the original Hebrew

How It Evolves that new technologies are seldom, if ever, accidents but normally emerge as novel combinations of already existing technologies, brought together by human beings who are searching for means to ends they have already identified.

✦ Though Korean, like several other Eastern languages, would eventually adopt an alphabet, the Chinese languages would never do so. It is enlightening, however, to list, as Eduardo Galeano, that great list maker, has done, the principal inventions that have come to the West from China: "Silk began there, five thousand years ago. Before anyone else the Chinese discovered, named, and cultivated tea. They were the first to mine salt from below ground and the first to use gas and oil in their stoves and lamps. They made lightweight iron plows and machines for planting, threshing, and harvesting two thousand years before the English mechanized their agriculture. They invented the compass eleven hundred years before Europe's ships began to use them. A thousand years before the Germans, they discovered that water-driven mills could power their iron and steel foundries. Nineteen hundred years ago, they invented paper. They printed books six centuries before Gutenberg, and two centuries before him they used mobile type in their printing presses. Twelve hundred years ago, they invented gunpowder, and a

and Greek texts. It is thought that 180 copies were printed, 135 on paper and 45 on vellum. Two colors of ink were used, black and red, and spaces were left for illuminations (in the medieval manner) to be added later by hand. In most copies the sheets were divided into two bound volumes. Fewer than fifty copies of this first Bible have survived, most of them now quite incomplete.

What was most astounding about Gutenberg's project—which he called *Das Werk der Bücher,* The Work of the Books—was the number of Bibles produced in his first print run. For in this period the catalogues of all the great university libraries of Europe barely contained, on average, more than one hundred separate book titles apiece. In the future made possible by Gutenberg, books of all kinds would be everywhere in multiple copies, and soon enough everyone would be reading, comparing, checking, communicating.

But it inevitably takes a while for human beings to absorb the changes that each new invention will work in our lives. We are certainly not so good at predicting what these changes will be. This is because, as one observer has remarked, "real innovation in technology involves a leap ahead, anticipating needs that no one really knew they had."✝ When, for instance, motion pictures were invented at the end of the nineteenth century, most audiences and most entrepreneurs thought they would be extensions of theater. The great French stage actress Sarah Bernhardt, already in her mid-sixties, enthusiastically repeated her most praised performances for the movie camera. "This," she exulted, "is my one chance at immortality!"

What we see today is an aging woman, putting on weight, gesticulating silently and wildly, overacting in parts written for much younger actresses. Whatever Bernhardt's talents, they are hidden from the camera. She should have

century later the cannon. Nine hundred years ago, they made silk-weaving machines with bobbins worked by pedals, which the Italians copied after a two-century delay. They also invented the rudder, the spinning wheel, acupuncture, porcelain, soccer, playing cards, the magic lantern, fireworks, the pinwheel, paper money, the mechanical clock, the seismograph, lacquer, phosphorescent paint, the fishing reel, the suspension bridge, the wheelbarrow, the umbrella, the fan, the stirrup, the horseshoe, the key, the toothbrush, and other things hardly worth mentioning."

✝ The speaker is David B. Yoffie of the Harvard Business School, commenting on the role of Steve Jobs in computer technology.

had a look at what her fellow Frenchmen, the brothers Lumière, were doing with their new movic camera, making their unflamboyant but exceedingly observant and natural documentaries, such as *Workers Leaving the Lumière Factory,* which gives us a much better idea of the capabilities and limitations of the new medium in its astonishing realism. Alternatively, she could have consulted another of her countrymen, Georges Méliès, the original Cinemagician, who in such beguiling and awesome spectacles as *A Trip to the Moon* was the first to experiment with film's fantastic capacity for trick photography. What film has never been especially good at, however, is extending the experience of live theater.

The first printed book was a Bible, impressed in a language intelligible only to educated Europeans. To those few who took note of what Gutenberg was up to, his must have seemed a commendably pious effort, a more efficient way of doing what had always been done by scribes in monastic scriptoriums—and nothing more.

How wrong they would have been.

I

NEW WORLDS
FOR OLD

INNOVATION ON SEA AND LAND

———————— ❖ ————————

There is something in the wind.
The Comedy of Errors

Winter completes an age
With its thorough levelling;
Heaven's tourbillions of rage
Abolish the watchman's tower
And delete the cedar grove.
As winter completes an age,
The eyes huddle like cattle, doubt
Seeps into the pores and power
Ebbs from the heavy signet ring;
The prophet's lantern is out
And gone the boundary stone,
Cold the heart and cold the stove,
Ice condenses on the bone:
Winter completes an age.

Thus the perspicacious W. H. Auden in *For the Time Being*. Like seasons, ages are seldom so precise as to end abruptly, while allowing another age to commence. Few events of European history have been as final as the Black Death in bringing to an end one age (which we might call the Innocently Playful Medieval) and bringing into view another (which we might call the Colder Late Medieval–Early Renaissance). But even at this interstice, old forms and old mental states hang on, while new forms and new mental states peek uncertainly into view. Locality often determines how boldly or timidly the new will come to supplant the old; and localities can find their integrity, even their ancient right to existence, open to question. ("This village has always been crown territory." "But which crown, England's or France's?" "Which religion,

Christian or Muslim?" "Oh, and where, pray, is the boundary stone, the definitive separation between Us and Them?")

At such a crossroads, it is difficult if not impossible to see much farther than one's nose: the watchman's tower is down and the prophet's lantern out. Those who occupy traditional seats of power—those who use signet rings—may begin to find their perches less stable and secure, more open to question. The ordinary bloke, the commoner attempting to make his way in the world, is all too likely to experience a new if vague sense of unease, of doubt seeping into his pores like unhealthy air. It is not a time of dancing and embracing but of stepping back and taking stock. Yet life goes on: men travel and make deals, as they have always done; monarchs make decisions, as they have always done, with far-reaching and often unpredictable consequences.

1492: COLUMBUS DISCOVERS AMERICA

One such man was Christopher Columbus, born of undistinguished forebears near Genoa, long a shadowy petitioner at various European courts, now arrived at Córdoba to the new headquarters of Spanish royalty, the Alcázar, former stronghold of Muhammad XII, whom Spaniards called Boabdil; and two such monarchs were their Catholic Majesties Ferdinand and Isabella of Spain. The year was a fateful one, 1492. To it, historians, looking backwards, have assigned the final expiration of the Middle Ages and the (as yet unheralded) birth of a new age.

Many Americans will recall having suffered through a school pageant or two meant to dramatize the monumental encounter between the Genoese ship captain and the Spanish royal couple. And since such dramatizations invariably contain almost as much misinformation as they do historical fact, it is worth revisiting the great moment with a colder eye.

The ship captain was probably born in 1451 at or very near Genoa, the son of a weaver who also sold cheeses on the streets of Genoa, then of Savona, his son helping out at both locations ("Parmigiano! Mozzarella! Gorgonzola!!"). The boy would have been called Christoffa Corombo in his native Ligurian, later Cristóbal Colón by Spaniards. Since documents of any importance were writ-

ten in Latin, his Latinized name, Christophorus Columbus, which appears in his own hand as well as in other records of the period, was easily Englished as Christopher Columbus. Though there have been numerous attempts to render Columbus as Jewish, or even Muslim, and to trace his origins to a European country other than Italy, there is no evidence to support such theories, but there is good evidence to support his birth as an Italian Catholic.

Genoa and Savona, ports on the Italian Riviera north of Corsica, offered adventurous boys many opportunities for seafaring apprenticeships. Columbus claimed to have first ventured to sea at the age of ten, and there is little reason to doubt him; surely by his late teens he was almost an old salt, and by his early twenties he had already docked as far away as the west coast of Africa, Chios in the Greek Aegean, Bristol on Britain's west coast, Galway at the edge of the Atlantic, and probably Iceland. He also began to act as agent for a consortium of Genoese merchants, who traded far and wide. One of his voyages took him to Lisbon, where a brother, Bartolomeo, worked as a cartographer. In their collaboration we may glimpse the origin of Columbus's great endeavor.

Thanks to the enormous expansion in world trade that had been booming for more than two centuries, Europeans of means had come to take for granted certain substances that did not originate in Europe, especially the spices, opiates, and silks of faraway Asia. No one (who was anyone) could any longer imagine doing without these things. But the fall of Greek Constantinople to the Ottoman Turks in 1453 had created a profound and permanent alteration in international affairs. It was of course still possible to extract the expected goodies from the Far East, but getting them past the Turks required both more cunning and more gold—and sometimes more blood—than had been previously required, considerably raising the price of the beloved commodities by the time they came to market. (Imagine if Americans could no longer afford chocolate, salt, or cocaine, or if most of the Wal-Marts closed down.) If Europeans could not dislodge the Turks—which they could not—what were they to do? At times, it seemed as if all the best practical minds of Europe were engaged in figuring out how to solve the problem. But think as much as they might, no one could come up with a solution. Except Columbus.

What he suggested made little sense. He proposed to sail around the world, heading west into the Ocean Sea (as it was then called) till he hit the Island of Cipangu (Japan, as identified in the writings of Marco Polo) or perhaps, if he was especially lucky, the fabulous coast of Cathay (China) itself. Maps of the period, inaccurate about many things, nonetheless show both the principal island of Japan (misshapen and lacking most of its fellow islands) and the coast of a strangely squeezed China. There are even attempts to sketch in the archipelagos of Malaysia and Indonesia.

The diameter of the spherical Earth had been calculated accurately by the Greek Eratosthenes in the second century BC, and his calculation was still widely known in the time of Columbus. Though no European foresaw what lay in wait for Columbus, since all thought mistakenly that the Ocean Sea, empty of land, was much larger than it was, almost all who could read and had looked into the subject understood that Columbus was seriously underestimating the overall size of the Earth.+

Columbus, basing his calculations on inaccurate assumptions, theorized that the east coast of Asia could be reached by a European ship within a few weeks of its leaving port. The actual circumference of the Earth is about 40,000 kilometers, whereas Columbus assumed it to be closer to 25,000 kilometers. Compounding his mistake was his misreading—in a Latin translation—of a renowned ninth-century Persian astronomer, Ahmad ibn Muhammad ibn Kathir al-Farghani, known to the West as Alfraganus. The Persian's correct measurements were given in Arabic miles, which Columbus assumed to be the same as Roman miles. In actuality, Roman miles are about 25 percent shorter than Arabic ones. Had the Ocean not held the Americas and the vast sea been empty of land between Europe and Asia, Columbus and his crew, heading west, would have perished in the deep and never been heard from again. This had indeed been the fate of several earlier (and well-known) attempts.

Columbus's good luck lay not in his

+ No one who knew anything thought the Earth was flat. This was an anti-Catholic fable created by a nineteenth-century Frenchman named Jean Antoine Letronne and disseminated widely to English speakers by Washington Irving in his unreliable biography of Columbus.

miserably wrongheaded calculations about distance but in his accurate knowledge of the North Atlantic trade winds, which flow in a great clockwise circle. How he came by this information we can't be sure. It may have been the result of his own observations on his previous voyages, only some of which we know about. In any case, it was information not widely understood at the time, even if in our own day it is common knowledge to transatlantic airline passengers. As a result of his awareness of the trade-winds pattern, he was able to keep them at his back, plotting a southerly outgoing course and a northerly homecoming one, both of which enabled him to travel much more quickly than others had been able to do. In this way, Columbus and his crew were saved from contrary winds, becalmings, and death by dehydration on the high seas.

Columbus was a man of high color—reddish hair and ruddy cheeks enclosing a long, handsome face, surmounting a towering, tautly muscular body—and of highly colored personality. People seem either to have been instantly attracted to him or to have taken an instant dislike. He gestured grandly and spoke engagingly and loudly with the confidence of the true aristocrat, which he was not but was determined to become. He always presented himself as a nobleman, alluding vaguely to his familial line and crest, the son certainly not of Italy but of Genoa, *la Superba* (the Proud One), city of cities, link between Europe and the great globe. Despite his poor resources, he managed to dress well, cutting a fine figure at the European courts he visited. No doubt his admission to the presence of several monarchs in succession was made possible by the convincing show he made. His fair coloring and cool eye (gray or green in different reports) bespoke his northern European genetic origins and assured his welcome by monarchs who were all engaged in marriage games to render their legitimate stock more blond and blue-eyed.

But after he had made his impressive presentation, his proposal would be turned over to the scholars of the court, the people who had read all the books Columbus cited and many more, which he had failed to mention. Inevitably, the scholars would return to their monarch with the same conclusion: Columbus was a crackpot, not an investment opportunity. But, as we know only too well

from recent dramas in our financial sector, sooner or later someone somewhere will make the investment. In the event, that someone was Isabella la Católica, reigning Queen of Spain.

Before this, Columbus had conducted a long dalliance with King John II of Portugal, whom he nearly succeeded in convincing. He sought out financial power brokers in both Genoa and Venice but came up short. He sent his brother Bartolomeo to Henry VII of England with the astounding proposal. Henry, father to Henry VIII and founder of the Tudor dynasty, whose claim to the throne was quite shaky, said he would think about it. He thought and thought but had nothing more to say (at least not till it was too late). Meanwhile, Columbus found himself at the Spanish court, spending nearly six seemingly sterile years in the attempt to lure the monarchs into financing his scheme.

Ferdinand and Isabella were not naïfs. Hereditary monarchs and crafty sovereigns, they had created Spain by the ploy of their marriage, uniting Ferdinand's Aragon with Isabella's much larger Castile and then pushing the Iberian Peninsula's one remaining Islamic kingdom into the sea. This last they had accomplished only in March 1492 after years of war and had come to occupy the Alcázar but minutes (as it were) before Columbus appeared once more to present his final and most eloquent plea. Political to their fingertips, the Catholic Monarchs allowed not a whisper of disagreement to squeeze between them. Their motto, *"Tanto monta, monta tanto,"* means something like "Each is the same as the other." So don't try any special pleading with one of us.

Columbus's task was therefore a tricky one, but it seems from the scanty evidence that it was the queen, a woman of exquisite composure and silky speech, whose blue eyes and long gold tresses betrayed her high Castilian and Lancastrian origins, who was especially receptive to Columbus's charm. Though the dark, jowly Ferdinand, whose stubbly beard was incapable of a close shave, would one day boast that he was "the principal cause why those islands were discovered," it was Isabella who actually found the way forward for Spain to finance Columbus's expedition. Columbus had already raised about half the needed cash from his Genoese contacts; and Spain, at the end of a long and draining military campaign, was out of cash. So Isabella donated her jewels (or at least

some of them), knowing full well that her act of public generosity would necessarily drive all the nobles of Castile (and perhaps even of Aragon and of Ferdinand's other territories)* to follow suit in their effort to show themselves at least as generous.

The year 1492 was a busy one for the Catholic Monarchs. Besides their conquest of the Moorish Kingdom of Granada, they had begun to take considerable interest in the religious observances of their subjects. Like Doctor Johnson in the stagecoach, they felt that false doctrines should be checked and that those who dared espouse such doctrines should be punished by the civil power in union with the church of the realm. Venturing a bit further than Johnson might have done, they issued—within days of their having situated themselves in the Alhambra—the Alhambra Decree, expelling all unconverted Jews from Spain.

As we have already seen in the case of the Black Death, communities of Jews made convenient scapegoats in difficult times. But by this point, Jews had lived among European Christians for the better part of a millennium and a half—often uneasily, sometimes (as in papal Rome) appreciated for their special skills, sometimes targeted for elimination. In general, insofar as Christians thought about them at all, Jews tended to be considered flawed or partial Christians, believers in the Old Testament but not the New, people who—inexplicably—failed to see that Jesus was the fulfillment of all their prophecies. They were not universally hated, as were the Muslims (called Moors or, more ominously, Saracens), those who had cooked up a new religion—really, a heresy—and stolen the Holy Places from their rightful owners, the Christians. The fast friendship Boccaccio describes between the two Parisian merchants, one Christian, the other Jewish, is a bit harder to imagine occurring between a Christian and a Muslim (at least in a Christian country).

Selectively admired or merely tolerated, Jews were an expected part of the European social scene. The expulsion from Spain, however, was not their first. On several prior occasions, Jews had been ordered to move en masse from a European country. In 1182 the teenage King

* Valencia, Naples, and Sicily.

Philip II Augustus of France, whose treasury was empty, had seized all Jewish property and forgiven all debts owed to Jews, provided only the debtors pay to the king 20 percent of what they owed. (Sixteen years later, Philip, feeling the adverse effects on French commerce of the departure of the Jews, would allow them to return.) In 1290, Edward I banished all Jews from his kingdom of England, a ban that remained in effect into the 1600s. In 1306, King Philip IV the Fair (who was not) expelled the Jews of France once again. Though readmitted in 1315, they were expelled once more in 1322, readmitted in 1359, and re-expelled in 1394. If the Spanish expulsion seems particularly harsh on account of the huge numbers involved and the efficiency with which results were pursued, it only signaled more execrable banishments to come: by the end of the Second World War, Ireland would stand out as the only European nation that had never expelled (and/or attempted to eliminate) its Jews nor subjected them to pogroms nor confined them to ghettos.

Parenthetically, we must lay at Spain's door what was almost certainly the earliest of these European persecutions (and a characteristically Spanish one): the offer, laid out by the primatial archbishop of Toledo in 694, that all Spanish Jews choose between baptism and perpetual enslavement. Nor should we forget that in 1391 the newly crowned Spanish king, Henry III, encouraged the massacres of Jews in Seville, Córdoba, Toledo, and other cities of his realm.

Spanish Jews were given exactly four months from the date of the Alhambra Decree to clear out of the extensive realms of the Catholic Monarchs, not an easy feat for most to perform. Moreover, though departing Jews were graciously allowed to take their belongings with them, they were not permitted to take any "gold or silver or minted money." (Remember: the Monarchs were experiencing an extreme cash flow crisis.) The punishment for failing to depart (or convert) was death. The punishment for Christians who attempted to hide Jews was confiscation of all property and cancellation of all hereditary privileges. So it is hardly surprising that not a few Jews publicly converted to Christianity and were baptized. These conversos, as they were called, elicited suspicion from their Christian neighbors. Were their conversions sincere or merely convenient? As many were subsequently discovered to have continued their practice of Jewish religious customs, Spaniards found themselves devising

bizarre tests of Christian orthodoxy, such as forcing suspects to eat pork.✶ (If you refused or gagged, you must be an insincere convert. Converts from Islam would soon be subjected to the same test—which did have a certain twisted logic behind it: prized Spanish ham, *jamón ibérico de bellota,* from well-bred pigs fed on the acorns of ancient oaks is the best in the world.)

The decree did not, however, produce the first conversos. Thanks to the efforts of Toledo's archbishop nearly eight hundred years earlier, there was an ancient tradition of Jewish conversos within Spanish society. More than this, the pogroms of 1341, centered on Seville, had greatly expanded the class of converted Jews, many of whom had subsequently achieved high status in southern Spanish society. Two of these conversos, the bankers Luis de Santangel and Gabriel Sánchez, would be numbered among the financiers of Columbus.

Many unconverted Sephardim (as the Jews of the Iberian Peninsula were called, in contrast to the Ashkenazim, the Jews of France, Germany, and eastern Europe) found refuge in the Islamic countries of North Africa and the Ottoman Empire and were able to remain there and even to thrive.✴ The establishment of the State of Israel, however, on land that had previously been controlled by Muslims, as well as the grave diminishment of its prior inhabitants, has in our time provoked Muslim rage and a hostility toward Jews that had never before been characteristic of the relationship between the two communities of faith. Indeed, in the centuries

✶ Insincere Jewish converts were labeled Marranos. Discovering and ejecting them from society became a Spanish obsession. An American friend recalls that when he applied to become a Jesuit in 1959, he had to sign a statement attesting that he had no Jewish blood. (My friend, as it turned out, did have a Jewish grandfather, though he did not know this at the time, and therefore responded falsely.) He was accepted into the order and began his training but left to pursue a secular career five years later.

The Jesuits were founded by Ignatius Loyola, a Spanish nobleman, toward the middle of the sixteenth century. When, or if, the question about Jewish blood was removed from their application I have not been able to ascertain to my satisfaction. But I would guess it was removed on or about December 16, 1968, which is when the Alhambra Decree was at last revoked! In late 2012 the Spanish government began to offer repatriation to descendants of expelled Jews, but not to the descendants of expelled Muslims.

✴ Others fled to England (despite the royal ban), the Netherlands, Eastern Europe, and especially tolerant Italy. Still others, probably more than half of all Spanish Jews, migrated to Portugal, which would soon prove an unstable refuge.

during which Muslim rulers had held sway over the Iberian Penin-
sula, Jews could breathe much more freely there than they could in
most Christian countries. They, like Christians living under Mus-
lim rule, had to pay a special tax, but for these designated "Peoples
of the Book" there was no specifically religious persecution.

The expulsion of unconverted Jews from Spanish territory was,
however, but one prong of a campaign of increasingly cruel exac-
tions on the part of the Catholic Monarchs. Though the terms of
the treaty that followed their successful war against the Kingdom
of Granada guaranteed religious freedom to their Muslim subjects,
the Monarchs soon discarded that provision and began to hound
unconverted Muslims, as well as those (Moriscos or little Moors)
who only outwardly accepted Christianity, in a fashion similar to
their persecution of Jews, if somewhat less vigorously. The margin-
ally greater toleration of Muslims lay in the fact that they were even
more intricately threaded through Spanish, and especially through
Aragonian, society (though certainly not through other European
societies) than were Jews, many Muslims even gaining positions of
trust at the courts of various Spanish noble families, who valued
their contributions and would not cooperate willingly in their per-
secution or banishment.

As early as 1478 the Monarchs had set up a new institution to
ensure unity of faith throughout their realms. Even today, its name,
the Spanish Inquisition, is capable of sending a shiver through many
a breast. In recent decades, scholars have revised their historical
judgments, now informing us that this Inquisition wasn't as bad as
its reputation. But it was a grim business for anyone who incurred
its interest. And despite the inspired humor of the famous Monty
Python sketches, featuring madcap English comedians galumphing
into view in the getup of Roman cardinals and shouting "Nobody
expects the Spanish Inquisition!" there was nothing bumbling,
antic, or remotely silly about the men who staffed this merciless
ecclesiastical tribunal.

Throughout the Middle Ages there had been inquisitions,
arranged by the papacy in concert with local bishops. These had
had, however, only a very occasional impact on medieval life, func-
tioning locally, operating seldom and with some highly specified
object, that is, the rooting out of a particular *Christian* heresy in

a particular place. The most important inquisitions of the Middle Ages were directed against the Albigensians, who held an extreme Platonic conviction that God's world was entirely spiritual and that all matter was evil, having been created by Satan. It is impossible to determine now how many Albigensians there were, centered primarily in the regions of Languedoc in France, the Rhine Valley, and (perhaps) Verona in Italy, but the extreme unattractiveness of their doctrine would seem necessarily to have limited their numbers. The popes, who directed inquiries into heresy from afar, were normally more interested in convincing the heretics of the error of their ways than in burning them alive. Only unrepentant holdouts were put to the torch.

The burning of Jan Hus at the Council of Constance stands as a sinister exception to the normal course of events and was enabled because the Council was in the hands of the voting bishops rather than of a pope, who would almost certainly have proved more irenic. There were then three popes striding about in different jurisdictions, each demanding universal obedience, and the Council's main job was to put an end to this embarrassing state of affairs. Hus dared to question the claim of the conciliar fathers that they held their authority over the universal church "immediately from Christ," which questioning the fathers could not abide, especially as they were themselves a tad uncertain about who in fact *did* hold such power. We should also not underestimate the impact that nationalism was already beginning to exert on the bishops (as on everyone else). Hus's Czech movement was seen by many as an illegal nationalistic challenge to imperial German sovereignty. Many of the bishops were either German or at least in sympathy with the jurisdictional claims of the Holy Roman Emperor.

The *Spanish* Inquisition—that is, an inquiry answerable to the Spanish Monarchs, rather than to Rome—was an innovation and a devolution from *relatively* humane papal standards. The scariest thing about it was its omnicompetence, the broadness of its mandate, its freedom to look into anything and anyone for any reason. The Monarchs had been encouraged to set up their own national inquiry into heresy among their subjects by Isabella's personal confessor, Tomás de Torquemada, whose name is a stain on their reign despite the famous description of him by his contemporary Sebas-

tián de Olmedo as "the hammer of heretics, the light of Spain, the savior of his country, the honor of his order" (the Dominicans, in case you were wondering).

Torquemada, a heavyset, brutal-looking man with an anxious brow, beady eyes, and a long, thick, bent nose, became an essential figure in the Monarchs' self-conscious *Reconquista,* the reconquest of Spain, culturally reclaiming it from its centuries of Muslim rule during which Muslims, Jews, and Christians had lived side by side in a fondly remembered *convivencia* and had even collaborated with one another in preserving and translating seminally important religious and philosophical texts. Torquemada, hostile to any text from which he thought he could sniff a whiff of heresy, enthusiastically promoted the burning of Hebrew and Arabic books. But what he became most famous for was his enthusiastic burning of human beings, probably close to two thousand individuals in the course of his fifteen-year tenure (1483–1498) as Spain's Grand Inquisitor.

Besides the public burnings, carried out with great solemnity and grand panoply as *autos de fe* (acts of faith),✝ the numbers of those he ordered tortured were, according to even *The Catholic Encyclopedia,* "vast" and "on an unprecedented scale."✚ "Exceptionally intolerant even for his times," the entry continues, he established an exceedingly efficient "spiritual police system" that would continue to terrorize Spain for centuries, to be abolished only in 1834. Its official work was to investigate heresy among Christians, but it marched far beyond that mandate,

✝ The phrase *auto de fe* is Spanish; *auto-da-fé,* the more usual phrase in English, is Portuguese.

✚ The torturers employed a considerable variety of devices. According to the incomplete list of Eduardo Galeano, these included "the barbed collar; the hanging cage; the iron gag that stifled unwanted screams; the saw that cut you slowly in two; the finger-stretching tourniquet; the head-flattening tourniquet; the bone-breaking pendulum; the seat of pins; the long needle that perforated the devil's moles; the iron claw that shredded flesh; the pincer and tongs heated to fiery red; the sarcophagus lined with sharp nails; the iron bed that extended until arms and legs got pulled out of their sockets; the whip with a nail or knife at the tip; the barrel filled with shit; the shackles, the stocks, the block, the pillory, the gaff; the ball that swelled and tore the mouths of heretics, the anuses of homosexuals, and the vaginas of Satan's lovers; the pincer that ground up the tits of witches and adulterers; the fire on the feet; among other weapons of virtue." But some of these tortures, especially the sexual ones, may owe more to Victorian fantasy than to historical accuracy.

investigating and punishing a wide variety of "spiritual offenders," from so-called "crypto-Jews" to supposed witches to those accused of such sexual crimes as sodomy and bestiality. Even Spain's most outsized (and orthodox) Catholic saints—Ignatius Loyola, Teresa of Ávila, and John of the Cross—would in the next century fall under suspicion and be shadowed for a time by the Spanish Inquisition, Loyola even cast into prison as a possible heretic on two separate occasions, experiences that convinced him to quit Spain altogether.

In the atmosphere of fear and hysteria that Torquemada encouraged, he himself could have been tried as a crypto-Jew. (Given how thoroughly Jews were threaded through Spanish society, this accusation could probably have been leveled against a great many Spaniards.) There were at least two Jewish conversos in his family line, one of them a grandmother. But Torquemada quickly achieved such control over Spanish society that no one would have dared question his antecedents for fear of attracting his attention. So hated did he become that he had to travel surrounded by fifty mounted guards and an additional 250 armed men.✱

It would be dismayingly reductive, however, if we were to attribute Torquemada's success only to the craven fear he struck in the hearts of men and women. As Fyodor Dostoevsky would so awesomely dramatize the reasoning of Torquemada and his ilk in "The Grand Inquisitor," the great story-within-a-story to be found in *The Brothers Karamazov,* the inquisitor's insistence on shared universal belief expresses a yearning that may also be found in the human heart—a desire "to be united unequivocally in a communal and harmonious ant heap." This "need for universal unity of mankind" against dissenters certainly appears and reappears throughout history, and its impact on human affairs, as in Dostoevsky's vivid accounting, should never be underestimated.

But besides this profound reality of hidden motivation—this infernal, usually unspoken quest for universality of

✱ Humor can occasionally give us as just a perspective on such characters as do more stern-faced assessments. The Jewish comedian Mel Brooks played Torquemada in the film *History of the World: Part I,* in which he is introduced by another inquisitor with a New York accent: "Torquemada—do not implore him for compassion. Torquemada—do not beg him for forgiveness. Torquemada—do not ask him for mercy. Let's face it, you can't Torquemada [tawk 'im outa] anything!"

belief—it must be said that many participants in witch hunts are simply disgruntled, jealous partisans in search of retribution against their betters. This is the motivation that Arthur Miller would bring to the fore in *The Crucible,* his remarkable play about the American witch trials of seventeenth-century Salem—which is also a play about Miller's judgment on the tawdry machinations of the House Un-American Activities Committee during the McCarthy era.

Sensing the dark underside of the enthusiastic persecution of "heretics," successive popes tried in vain to rein in the excesses of the Spanish Inquisition. According to a bull of Pope Sixtus IV, "many true and faithful Christians, because of the testimony of enemies, rivals, slaves, and other low people, and—still less appropriate— without tests of any kind, have been locked up in state prisons, tortured, and condemned as if they were relapsed heretics, deprived of their goods and properties, and turned over to the secular arm to be executed, at great danger to their souls, giving a pernicious example and causing scandal to many."

Despite this nice rhetorical flourish, Sixtus quickly backed off his resolve to inhibit Torquemada's incursions once the pope found himself opposed by King Ferdinand, who was solidly in the rabid Dominican's corner. Sixtus was one of a series of popes in this period who could have stepped right out of the pages of the *Decameron*. A lover of art, music, and literature, he built the Sistine Chapel (which is named for him), founded its famous choir, established the Vatican Archives, greatly enlarged the Vatican Library, and opened it to scholars. But he also made six of his feckless young nephews into cardinals, blocked all church reform, and was drawn into the huge Pazzi conspiracy, which resulted in the murder of Giuliano de' Medici, the wounding of his brother Lorenzo, and a scandalous war between Rome and Florence. (See page 75.) He then got Venice to attack Ferrara, switched sides, imposed papal penalties on Venice, and emptied the papal treasury, after which he sold indulgences and curial offices in order to refill his empty coffers.

His successor, who took the inappropriate name of Innocent VIII, was just a little worse. It was he who conferred upon Ferdinand and Isabella the title *los Reyes católicos.* He ordered a bloodthirsty inquisitorial witch hunt throughout Germany. He fathered several bastards, made his thirteen-year-old grandson a cardinal,

created new church offices just so he could auction them off to the highest bidders, and interfered disastrously in international affairs, alienating kings unnecessarily and leaving the much-reduced Papal States in anarchy by the close of his reign. On his deathbed in the summer of 1492, in a last tremor of self-knowledge, he begged the cardinal electors to choose a successor who would be an improvement on him.

Thanks to a spectacular series of bribes and promises of future rewards by the winning candidate, the cardinals chose the Catholic Monarchs' fellow Spaniard Rodrigo de Borja y Borja, the worst pope in history, father of several children (born both before and after his election to the papacy), including dear Lucrezia of the poisoned ring and Cesare Borgia (as the family name was Italianized), the model for Machiavelli's prince. That the thrice-married and much-bedded Lucrezia actually poisoned the food of husbands and others she wished to be rid of, or that she slept with her father and her brother and had children by them, cannot now be proven conclusively. That the Borgias were vicious and implacable and threw howlingly good parties is indisputable.

Rodrigo took the papal name, forever infamous, of Alexander VI. His election on August 11, 1492, came but a week and a day after Columbus's departure from the coast of Spain in three ships—the caravels *Niña* and *Pinta* and the larger carrack *Santa María*—headed for the unknown. We shall have reason to return to Rodrigo-Alexander. But for now let's follow Columbus.

After departing Spain's Atlantic coast, Columbus's little fleet made for harbor in the Canary Islands, a volcanic archipelago off the northwest coast of Africa. There, at the Castilian port of San Sebastián on the island of Gomera, the crews restocked and made repairs, finally setting off for God Knows Where on September 6, just as the great volcano of Tenerife erupted behind them, seeming to offer a portent, whether of good fortune or ill no one could be certain.

It is instructive to consider for a moment these islands from which Columbus left "the known world," that is, the world known to Europeans. The islands had been familiar to the imperial

Romans, who called one of the larger ones *Insula Canaria,* Dog-
gie Island, perhaps an allusion to large dogs, perhaps an allusion
to the sea dogs, or seals, with which the second-largest island, still
called Gran Canaria, was once well supplied. The seals were long
ago hunted to extinction, a foreshadowing of the fate that lay in
wait for the islands' human inhabitants. The indigenous popula-
tions, Neolithic in their technology but culturally varied from one
island to another, were collectively called Guanches by the Europe-
ans, who subdued them slowly but inexorably, the Castilians gain-
ing complete control only three years after Columbus sailed. For a
long time, other European powers contested Spain's overlordship,
especially the seafaring nations of Portugal, Holland, and England,
which fought bloody battles on the islands, drawing the natives
into their wars. The Spaniards imposed single-crop cultivation on
the Canaries, which became a chief European source of cane sugar
and, later, of wine. In the sixteenth century enormous houses and
churches would be built, expressions of the Canaries' explosive
prosperity, as the islands came to serve as a first stop on the trade
route to the Americas.

What became of the original inhabitants? They no longer exist
as identifiable groups. Slaughtered, indentured, exiled, or enslaved,
they can be traced in the genes of a fraction of today's Canary
Islanders. But only occasionally does one now pass a person whose
appearance corresponds to the medieval descriptions of the native
population of fair-haired, heavy-browed, thick-bodied, copper-
colored Cro-Magnons. The beautiful blond women of Tenerife,
largest of the islands, who were once the subject of exclamations by
medieval sailors, are no more. Did they ever exist, or were they sim-
ply creatures of an overheated Spanish imagination? We can never
know, because the cultures, religions, worldviews, and indeed even
the identities of the Guanches were almost completely erased. I,
looking around on the island I inhabit, Manhattan, never see a face
or body that could be representative of the people who once hunted
here, whose very name is now uncertain.

The connection between the fate of the Guanches and the fate
of the natives of the lands that Columbus and his successors were
about to discover is not accidental but profound. It speaks to the
assumptions of Europeans in 1492 about the nature of humanity,

about the God they claimed to serve, and about the limitations on activities that this God could be said to approve.

On October 12, 1492, as all Americans know, land was sighted from the deck of the *Pinta* by a sailor named Rodrigo de Triana. The time was 2 a.m. The sighting came not a moment too soon for Columbus. They had sailed for five weeks and were beginning the second day of their sixth week. The crew, among whom served a sprinkling of convicts with little to lose, were growing nervous about the unlikelihood of their return if their outward voyage should continue to drag on. Columbus, though a charismatic leader, could not have commanded their compliance much longer. The land was an island in what is now the Bahamas. Though the captain christened it San Salvador, we are no longer certain which island it was.

As the ships approached the island in the light of dawn,

> they presently saw naked people, and the Admiral went ashore in the armed ship's boat with the royal standard displayed. So did the captains of *Pinta* and *Niña* . . . in their boats, with the banners of the Expedition, on which were depicted a green cross with an F [for Ferdinand] on one arm and a Y [for Ysabella] on the other, and over each his or her crown. And, all having rendered thanks to Our Lord kneeling on the ground, embracing it with tears of joy for the immeasurable mercy of having reached it, the Admiral arose and gave this island the name San Salvador. Thereupon he summoned to him the two captains, Rodrigo de Escobedo secretary of the armada and Rodrigo Sánchez of Segovia, and all others who came ashore, as witnesses [to the claim he was about to make]; and in the presence of many natives of that land assembled together, took possession of that island in the name of the Catholic Sovereigns with appropriate words and ceremony. And all this is set forth at large in the testimonies there set down in writing. Forthwith the Christians hailed him as Admiral and Viceroy [the titles promised him by the Sovereigns, should he reach the Indies] and swore to obey him as one who represented Their Highnesses, with as much joy and pleasure as if the victory had been all theirs, all begging his pardon for the injuries [that is, the mutinous grumbling that had preceded the sighting

of land] through fear and inconstancy they had done him. Many Indians having come together for that ceremony and rejoicing, the Admiral, seeing that they were a gentle and peaceful people and of great simplicity, gave them some little red caps and glass beads which they hung around their necks, and other things of slight worth, which they all valued at the highest price.[*]

Poor naked people. "Discovered" after thousands of years of living in their island home, they were about to be eliminated. The Tainos and other native peoples whom Columbus encountered on this first voyage, as well as the additional peoples he met on his three subsequent voyages, were all grouped together in the Admiral's mind as "*los indios*," the Indians, people of "the Indies," the all-purpose word that Europeans sometimes employed to refer to various nations of South and East Asia. Despite subsequent evidence to the contrary, Columbus could never—except for a few moments of exceptional clarity—admit that he had failed to sail as far as the Orient. He even ordered that any sailor who said otherwise be given one hundred lashes, be assessed a considerable fine, and have his tongue cut out. Unwilling to be hailed the discoverer of a new land, he failed in the end to see it named for him. It would be named—by the German cartographer Martin Waldseemüller fifteen years after Columbus's first voyage, when European exploration of the Americas was in full swing—for Columbus's exploring rival and fellow Italian Amerigo Vespucci.

Felipe Fernández-Armesto points out the peculiarity of Columbus's mention of the people's nakedness long before he describes their land ("well watered and wooded with an abundance of fruit," which Fernández-Armesto labels a promoter's description). The nakedness of the people puts them in a category: "A late fifteenth-century reader would have understood that Columbus was confronting 'natural men,' not the citizens of a civil society possessed of legitimate polit-

[*] This passage, intended to serve as a direct quotation from Columbus (who wrote of himself in the third person), is taken from Samuel Eliot Morison's biography of Columbus. Columbus's original log is lost, so Morison "fit together" two surviving passages, one from a partial transcript of the log by Bartolomé de las Casas, the other from the biography of Columbus by his son Ferdinand, who also had before him a copy of the then-extant log.

ical institutions of their own. The registering of this perception thus
prepared the way for the next step, the ritual appropriation of sov-
ereignty to the Castilian monarchs, with a royal banner streaming
and a scribe to record the act of possession." Lucky naked people:
they are now Spanish subjects.

"Clothes," continues Fernández-Armesto, "were the standard
by which a people's level of civilization was judged in medieval
Latin Christendom. It became an almost frantic preoccupation of
Spanish governors early in the history of the New World to per-
suade the natives to don European dress, just as Spaniards at home
had been to much trouble and expense to persuade conquered
Moors to 'dress like Christians' and had troubled deeply over the
nakedness of the aboriginal Canary Islanders." These Caribbean
natives "presented, because of their innocence, a unique oppor-
tunity for spreading the Gospel; because of their primitivism, an
unequalled chance to confer on them the presumable benefits of
Latin civilization; and because of their defencelessness, an irresist-
ible object of exploitation."

Perhaps half the natives of the Americas would fall to European
diseases against which they had no resistance. Most of those who
remained standing would be mutilated for imaginary offenses (such
as failing to hand over gold, for which both hands were severed and
the offender was left to bleed to death), or shot dead in skirmishes
with Spaniards (or with subsequent waves of European conquerors),
or worked to death in mines established to yield fantastic quanti-
ties of precious metals, or otherwise enslaved on their own soils or,
occasionally, sold in Europe. The wide-open spaces of the Americas
were not found as uninhabited lands; they were made so. All in
all, it was an easy conquest. Naked people with bows and arrows
were no match for armored men with firepower. It is difficult to
disagree with the conclusion of Eduardo Galeano that "Renaissance
Europeans ventured across the ocean and buried their teeth in the
throats of the Indian civilizations."

Within fifteen years of Columbus's first voyage, the Spaniards
who continued to cross the Atlantic in search of new lands to subdue
had worked out to their own satisfaction a little ritual for assuag-
ing whatever dim objections their strangled consciences might have
voiced about these adventures in exploitation. As they reached a

58 NEW WORLDS FOR OLD

new shore, the sailors would plant the standards of the Catholic Monarchs, now Ferdinand and Juana la Loca (Joan the Mad),* the daughter who on the death of Isabella in 1504 had succeeded her mother; and accompanied by a Spanish notary, the leader of the expedition would read the following notice to the curious natives, whether naked or clothed, who invariably ventured forth from under the canopy of trees:

* Juana, a fluent linguist and graceful athlete, much loved and well tended by her mother, became after Isabella's death a political chess piece in the twitching fingers of her father, who married her to Philip the Handsome, Archduke of Burgundy and son of the Holy Roman Emperor Maximilian I. Juana was crazy about Philip, who was indeed very handsome, but he, after a hot romance with the pouty teenage Juana, embarked upon the common practice among his peers of bedding all the beautiful ladies-in-waiting. Juana responded with fury, punishing the ladies severely and replacing them with ugly ones. In one case, she had an inamorata's lustrous locks sheared off and left them on Philip's pillow. After Philip removed himself to his native Flanders, Juana became progressively unhinged, screaming for hours one night at her castle gate in the freezing cold. Philip's unexpected death by typhus (or, some said, by poison supplied by his father-in-law, who had come to find him too threatening a rival) seems to have rendered Juana

In the stead of the King, Don Fernando, and of Dona Juana, his daughter, Queen of Castile and León, subduers of the barbarous nations, we their servants do notify and make known to you, as best we can, that the Lord our God, Living and Eternal, created the Heaven and the Earth, and one man and one woman, of whom you and we, and all the men of the world, were and are all descendants, and all those who come after us.

Of all these nations God our Lord gave charge to one man, called Saint Peter, that he should be lord and superior of all the men in the world, that all should obey him, and that he should be the head of the whole human race, wherever men should live, and under whatever law, sect, or belief they should be; and he gave him the world for his kingdom and jurisdiction.

Wherefore, as best we can, we ask and require that you consider what we have said to you, and that you take the time that shall be necessary to understand and deliberate upon it, and that you acknowledge the Church as the Ruler and Superior of the whole world.

But if you do not do this, and maliciously make delay in it, I certify to you

that, with the help of God, we shall powerfully enter into your country, and shall make war against you in all ways and manners that we can, and shall subject you to the yoke and obedience of the Church and of their Highnesses; we shall take you, and your wives, and your children, and shall make slaves of them, and as such shall sell and dispose of them as their Highnesses may command; and we shall take away your goods, and shall do you all the mischief and damage that we can, as to vassals who do not obey, and refuse to receive their lord, and resist and contradict him: and we protest that the deaths and losses which shall accrue from this are your fault, and not that of their Highnesses, nor ours, nor of these cavaliers who accompany us.

Variations on the standard text were often introduced into this bizarre ceremony, but these tended only to elaborate on the centrality of the church and the role of the pope ("that you acknowledge the Church as the Ruler and Superior of the whole world and the high priest called Pope," to whom God had given "the world for his kingdom and jurisdiction" and the right "to judge and govern all Christians, Moors, Jews, Gentiles, and all other sects").

The claims made for church and pope, which will necessarily strike the modern reader as absurd, were in fact part and parcel of an extreme monarchical papalism that had blossomed into a dramatically evil flower in the course of the Middle Ages. Once viewed simply as an office of service to others, the office of bishop—and especially bishop of Rome—was gradually attracting to itself all the worst trappings of absolute monarchy. In the sixth century, Pope Gregory the Great had rejected the title of "universal pope," asserting that the only title he

permanently unstable. She kept Philip's corpse beside her long beyond what was customary, perhaps even for months. Queen in name only, she spent the last three and a half decades of her long life in a locked, windowless room at the order of her young son, who would reign as the Holy Roman Emperor Charles V and whom we shall meet as a leading figure in the coming drama of Reformation. The shocking ill use of Juana at the hands of father, husband, and son may supply us with some reason to modify the contemporary diagnosis of madness. Despite her later confinement, Juana lived for a time at the center of European events, giving birth to a second emperor and to four queens. One of her younger sisters was the ill-used Catherine of Aragon, queen (for a time) of England.

wanted was "servant of the servants of God." But a famous forgery, called the Donation of Constantine, in which the fourth-century Roman emperor Constantine was shown to have handed over his supposedly universal power to the pope, was the shaky basis for all this papal trumpery.

Not everyone believed in the theory built so airily on the false Donation. Indeed, it may be that no one really believed in it except for a few benighted Roman clerics. Certainly, power players like Ferdinand paid it no heed, unless it served their purposes rhetorically, as in the text above. But what were illiterate natives half a world away from Europe to make of it? Or to make of the supposed rights of the Spanish monarchs, who had been assigned their lordship by the pope?* The native peoples had never even heard of such roles; they knew nothing of the histories and cultures of Europe, Africa, or Asia. They knew nothing even of the existence of these vast other worlds. And in any case, *El Requerimiento,* as it was called, was usually read to them without translation in Castilian, which none of them understood. What was important to the Spaniards was that all legal requirements had now been fulfilled for the utter usurpation of native rights. To imagine the encounter, full of faux dignity on the part of the Spaniards and of complete incomprehension on the part of the natives, is (once more) to summon up a scene of seeming comedy worthy of Monty Python. But there was nothing funny about what followed.

The simple natives, naked or half dressed in their unseemly costumes, could not possibly harbor "societies" in

* In 1493, Alexander VI, the Borgia pope, solemnly affixed a line of global longitude between Spanish and Portuguese zones of exploration and conquest, the Spanish to have whatever "new" lands lay west of the line, the Portuguese whatever lay east. A year later, the line had to be modified somewhat because the original was too obviously drawn in Spain's favor. It is to this demarcation that we may attribute the Portuguese overlay of the culture of Brazil (whose territory lies to the east of the line), as well as the lasting Portuguese influence on parts of Africa, whereas almost all of the rest of the Americas south of the Rio Grande owe their cultural overlay to Spain.

Many were the gifts from Alexander to the Spanish Monarchs. Perhaps as important as the line of longitude was the perpetual gift of the so-called Royal Third by which the Spanish kings were awarded two-ninths of all papal tithes to assist them in their wars against the Moors.

the European sense, complete with monarchies and other politi-
cal structures, great buildings, ecclesial structures, and elaborated
philosophies and theologies. They were obviously in need of these;
and the Catholic Monarchs and their collaborators would hap-
pily supply them. Had the natives exhibited more complex social
structures—as would be expected of, say, the Chinese, about whose
exemplary society the Europeans knew from the writings of Marco
Polo—Columbus and those who followed him would have been
persuaded to follow a different approach. Columbus had with him
letters from the Monarchs to the Great Khan, who was thought
to rule the Chinese, though the last of the Mongolian khans had
vanished from China more than a century before Columbus's voy-
age. These letters presumed to express friendship for the Khan, his
name cringingly Latinized as *Magnus Canus* (Big Old Guy—almost
Big Dog), and stated that the Monarchs had heard of his admiration
for their great realm, though no Chinese emperor had ever heard of
little Spain or its presumptuous kings.✦ No European would have
been so stupid as to imagine that China, so awesomely described
by Polo, could be conquered by European firepower, its inhabitants
forcibly converted and enslaved. China
would be approached only with the most
delicate diplomacy.

Naked natives were another matter,
however. The Tainos, whom Colum-
bus encountered throughout his island
landfalls—in the Bahamas, Hispaniola
(today divided between the Dominican
Republic and Haiti), Cuba, and Puerto
Rico—are now nowhere to be found as a
distinct group. Their genes may be traced
in some present-day inhabitants of mixed
blood, but their only certain legacy is
in the evocative words they left behind:
*canoe, hammock, tobacco, potato, barbecue,
hurricane.* Otherwise, they continue to
live and move in the recorded impres-
sions of Columbus himself:

✦ Columbus also had a letter
from the Monarchs to Prester
John, a legendary version
of John the Apostle, the
supposedly undying Christian
ruler of some African or Asian
country. (Europeans were
unsure of its whereabouts,
though certain of its
existence.) And Columbus had
on board an Arabic speaker,
because it was thought that
with knowledge of Arabic
one could communicate in
any Oriental tongue. Though
no one thought it necessary
to learn the languages of
the unimpressive American
natives, everyone was eager
to address possible foreign
potentates properly.

> They traded with us and gave us everything they had, with good will. They took great delight in pleasing us. They are very gentle and without knowledge of what is evil: nor do they murder or steal. Your Highnesses may believe that in all the world there can be no better people. They love their neighbors as themselves, and they have the sweetest talk in the world, and are gentle and always laughing.

We cannot simply take such words at face value. We must always recall that Columbus and those who followed in his wake were entrepreneurs, selling themselves and their enterprises and manipulating their audiences for preconceived objectives. What Columbus is selling here is the Myth of Eden. All right, he hadn't yet quite reached Japan or China and all the fabulous riches of the East. Forget that inconsequential business and look here: he had come upon Adam and Eve before the Fall. His audience is first of all the sovereigns, then all of literate Europe, which would soon be lapping up Latin versions of his letters.

But we can surely take at face value the descriptions of the rape of native societies by Spanish adventurers, as recounted by the Dominican priest Bartolomé de Las Casas:

> [The Spaniards] made bets as to who would slit a man in two, or cut off his head at one blow; or they opened up his bowels. They tore the babes from their mothers' breasts by their feet and dashed their heads against the rocks. . . . They spitted the bodies of other babes, together with their mothers, and all who were before them, on their swords . . . and by thirteens, in honor and reverence for our Redeemer and the twelve Apostles, they put wood underneath and, with fire, they burned the Indians alive.

Las Casas, who had been an admiring boy standing on the quay at Seville when Columbus returned in triumph from his first voyage, eventually sailed with the Admiral, even becoming a landowner in Hispaniola. But, as the cruel despotism of his fellow Spaniards gradually impressed itself upon him, he turned against the whole system of oppression and became a champion of the Indians. The descriptions he has left us in his *History of the Indies* are as chilling today as

they were when they were first published four and a half centuries ago. Las Casas describes Indian men being forcibly separated from their women so that they could be sent off to mine for gold and silver, while their wives were forced to till the soil without them. Reunited briefly after months of separation, they were "so exhausted and depressed on both sides that . . . they ceased to procreate." As for the few children brought to birth, their mothers, "overworked and famished, had no milk to nurse them, and for this reason, while I was in Cuba, seven thousand children died in three months." In desperation, mothers and fathers drowned their babies, and there were even instances of large-scale mass suicides, adults drowning their children, they themselves jumping off cliffs or eating poisonous plants. "And in a short time, this land, which was so great, so powerful and fertile, was depopulated. . . . My eyes have seen these acts so foreign to human nature, and now I tremble as I write."

The historic encounter between the natives of the Americas and the societies of Europe may be said to be complex, not all of it to be summed up in the few paragraphs I have written. Certainly, the richer and more structured societies the Spaniards would encounter among the Aztecs, the Inca, and the Maya (and their criminal despoliation) require a more extensive treatment than is possible here.* But in all instances, whoever the tribes, whoever the Europeans, whatever the excuse, the cumulative result is depressingly similar: a genocide as extensive and as cruel as any in history.✣

* One might have expected that the Spaniards, encountering complex Indian cultures, would have approached them more or less as they had intended to approach the Chinese. But the superiority of European firepower easily persuaded the Spaniards that conquest, not diplomacy, was the obvious route to take. Moreover, the discovery of garish rituals of human sacrifice at the heart of these cultures meant that the Spaniards could easily convince themselves that their conquests were wars against anti-human evil. Once again, the Europeans were on God's side.

✣ A case can be made for the American seizure of the Philippine archipelago at the end of the nineteenth century as being one of the outermost waves of "European" conquest of "American" natives. The Americans certainly imagined themselves as bringing European civilization to benighted savages. The American president William McKinley, who initially thought the Philippines were Caribbean islands, proclaimed (according to one report) that there was nothing to be done but to "take them all, and to educate the Filipinos, and uplift and Christianize them." The Filipinos had been evangelized by the Spanish in the sixteenth century and had a system of

Columbus, as Fernández-Armesto points out, "was predis-
posed to success, unresponsive to setbacks and blind to any obsta-
cle, of however incontestably material a nature, that might lie in
his path. He had a deep conviction of self-righteousness and the
unlimited capacity for self-deception that usually accompanies that
quality. He was intensely religious, and his religion was strongly
providential"—that is, providential in regard to himself and his
enterprise, though utterly lacking in regard to anyone who was not
his patron or similarly on his side. He was, as Fernández-Armesto
observes, "made of the quintessence of wishful thinking," a travel-
ing salesman, full of empty charm. He was, in short, very nearly our
contemporary, a completely self-made man, the first to claim our
attention across the centuries.

It is impossible to imagine Columbus, as he was, existing before
the disaster of the Black Death, which emptied so much of Europe
and opened land ownership and other enterprises for the first time
to men of no provenance. If that field across the way belonged
to my now dead neighbor and his dead family, and there are no
enforceable claims upon it, what is to prevent me from claiming it?
If the town's chief business (say, shoemaking or distribution of farm
products), which kept us all employed and a few of us in riches, is
now in idleness because of so many deaths, what is to prevent me
from starting it up again and claiming ownership? Of course, I must
carefully cloak my desires and my plan in the raiments of piety: I
want only what God himself wants. To be quite successful, I must
actually believe that this is so.

It is a shock for the historian, contemplating this overnight trans-
formation of medieval sensibility (in which virtually everything and
everyone had a place and stayed there) into the more upwardly mobile,
if slimier, sensibility of the characters in a David Mamet drama. Fran-
cis of Assisi, meet Bernie Madoff.

If I intend to make my fortune as
an exploiter of one kind or another—an
exploiter of something beyond myself,
since I know that in myself I have noth-
ing, not family or holdings or even
knowledge—I must find something or
someone *appropriate* to exploit, that is,

universal free public education
from 1863, a year when such a
system was still lacking in the
United States. More than one
million Filipinos, however,
many of them civilians, would
be killed in the course of the
American occupation.

something or someone virtually begging to be ripped off. And at this point we hear, almost for the first time in Western history, the sounds of racism. The ancient Greeks had been racist, believing themselves to be *hoi aristoi,* the best, and all others to be seriously deficient, barbarians of one sort or another. But the Greek attitude never found a foothold in Catholic Europe; and the Christian Middle Ages, intolerant about religion, were full of cultural, rather than racial, chauvinism. Those who persecuted Jews and, more occasionally, Muslims within their midst were not racists, for they found their old antagonists quite acceptable the moment they converted to Christianity. Medieval people may have been anti-Judaic; they were not anti-Semitic. (Anti-Semitism would require the aura of specious scientific proof, something that lay in the future.)

But it is in this period that the African slave trade begins to get under way and that several varieties of humans—Canary Islanders, black Africans, the Irish tribes "beyond the Pale" of English colonization, and the native tribes of the Americas—begin to be dehumanized, casually considered subhuman, fit only for manual labor or worse. It is also in this period that we first hear mention of Jewish "blood"—at least in Spain, which serves as a harbinger of attitudes that will eventually infect all of Europe. And it is in the Spain of this period that the phrase *sangre azul* (blue blood) begins to be bandied about—in reference to those whose lightness of skin allows the blueness of their veins (particularly on the backs of their hands or the undersides of their arms) to be displayed for all to acknowledge.

The science of the Greeks had been largely lost in the early medieval centuries, the centuries of barbarian invasions of the old Roman Empire, of wholesale destruction of books, and of near-universal loss of literacy. By the time of Roger Bacon in the thirteenth century, science had been reborn but was still in its second infancy: it had a long way to go. The discovery of America served as a goad to the energetic expansion of science. All maps had to be redrawn; and all geography had to be reconceived and rewritten. Inevitably, new questions arose in cosmology: if we had been so wrong about the continents of our own planet, what might we have wrong about the rest of the universe?

Are all human beings descended from Adam and Eve or is there

some other explanation for the immense diversity of peoples? Are these natives on the far side of the globe really human? Could God have intended them to be saved by the blood of Christ when, at least before the arrival of Europeans bearing Christianity, all their dead, never having heard the gospel, had gone to Hell? What does this say about God? Or what criticism might it imply about our theological presuppositions? In light of these things, what theological revisions might be necessary? Could these natives be surviving instances of Edenic beings? Or are they rather subhumans, such as the monsters mentioned in the *Odyssey* (for instance, cannibals, Lotus-eaters, and Cyclopes) and in the book of Genesis (for instance, the Nephilim, who were believed to be the offspring of giant demons and earthly women)? But if these creatures are truly human, what does it mean to be human?

These may not have been questions posed by Columbus's sailors, but such questions as these threw intellectual Europe into a wild tizzy of speculation and revisionism—a confusion as unending as ours would be if extraterrestrials were to land among us. This New World awakened a European drama of ceaseless questioning, a questioning that, like the spirits released by Pandora, could never again be contained.

"New World" also entered common speech, serving as an everyday reference to novelty, excitement, even unthinkably exquisite experience. Toward the end of the sixteenth century, in his Elegie XIX, the Jacobean poet John Donne undresses his mistress, removing each of her articles of clothing till she is completely naked:

> *Licence my roaving hands, and let them go,*
> *Before, behind, between, above, below.*
> *O my America! My new-found-land,*
> *My kingdome, safeliest when with one man man'd,*
> *My Myne of precious stones, My Emperie,*
> *How blest am I in this discovering thee!*

It is most unlikely that Donne ever read Las Casas. As he entered his beloved's "Myne of precious stones," he was not thinking of Tainos being worked to death in Spanish mines. He was, however, thinking about what all those naked natives had given him (and his age) license to think about:

Full nakedness! All joyes are due to thee,
As souls unbodied, bodies uncloth'd must be,
*To taste whole joyes.**

His mind was filled with marvels, whether related by deceptive travelers or imagined—just as Thomas More had imagined the island of Utopia, just as William Shakespeare would imagine the island of Prospero in *The Tempest,* just as generations of science fiction writers would eventually imagine fantastic voyages to "other worlds." In Europe, at a safe distance from the horrors being perpetrated on the natives, America commonly served as a prelapsarian Eden, sometimes even as an Eden of a particularly lubricious sort, seldom if ever as the Hell it became for so many.

1345–1498: HUMANISTS RAMPANT

In early April of the same year that Columbus discovered the New World, an itinerant Greek scholar returned to Florence to the fabulous court of Lorenzo de' Medici—Lorenzo *il Magnifico,* as everyone called him—with a weighty cache of precious Greek manuscripts. The riches the scholar—Ianos Lascaris (also known as Giovanni Rhyndacenus)—meant to lay at the feet of his patron did not represent the start of the Renaissance, which had broken through Italian soil almost simultaneously with the Black Death. Rather, Lascaris's great gift was a sure sign that the Renaissance was now close to blooming in all its racy perfection.

It should never be forgotten that, despite its eventual influence across Europe, the Renaissance (as we call it, following the historic French influence on English letters), *il Rinascimento* (as it was called in Florence), the great Rebirth, was, to begin with, an entirely homegrown northern Italian phenomenon.

Francesco Petrarca, known to the English-speaking world as Petrarch, is credited with being the first figure of the Renaissance. Son of a banished White

* This assertion is an arresting twist on Platonic philosophy, which looks forward to the human soul's achievement of true bliss by casting off its earthly body in death. In the same way, claims Donne, the human body (which Plato despised) finds its true bliss by casting off all its clothing. To those who catch Donne's reference, this may be judged a humorous conceit.

Guelph—the same party Dante had once taken a prominent part in—Petrarch grew up, not in his ancestral Florence, but in the south of France at papal Avignon, a very Italian town. By the time he was sixteen, however, Petrarch was studying law at Bologna at the insistence of his father, who was concerned about his son's peculiar intellectual interests and wanted to make sure the boy would eventually be able to earn a living. Long before he was packed off to Bologna, Petrarch was collecting (and reading appreciatively) the works of Cicero, consummate orator and philosopher of ancient Rome, and of Virgil, greatest of all Latin poets. Petrarch's other early literary hero was the late Latin rhetorician and theologian Augustine of Hippo, a Christian bishop and a man solidly on Plato's team (as we saw in the Prologue). Old Petrarch, alarmed at his son's bizarre interests, even burned some of the boy's precious books but at length, like the good Italian *papà* he was, threw up his hands and relented.

What Petrarch discovered in his reading was an ancient literary and philosophical tradition that, though once vigorous, had been rent and left in tatters by subsequent ages. These ages—from the death of Augustine, the last great Latinist, in the early fifth century, to the time of Petrarch—the young man labeled "the Dark Ages," a label that would stick. Now in the mid-fourteenth century, thought Petrarch, the time had come to renew the once vibrant tradition, so full of exploratory jaunts, surprising divagations, and delicious subtleties.

On the one hand, there were the dreary methods of the schools and universities, which, in part because of a lack of books, relied on much memorization. Even at so august an institution as the University of Bologna, Europe's oldest institution of higher learning, chartered in the mid-twelfth century, the amount of rote learning was enough to crush the spirit of the keenest student. And the content of what had to be memorized was even worse: proofs of this and that, set in the unalterable form of thesis statement, list of authorities backing the thesis, objections to the thesis (in the form of straw men, easily vanquished), proof demonstration relying on Aristotelian logic, and wham! that was the end of that subject, whether science, law, or philosophy.✝

✝ The author acknowledges that, as a philosophy student at a Catholic seminary in the early 1960s, he was forced to swallow scholastic philosophy by means of this antiquated, enervating method and, therefore, knows far more about it than he might wish.

On the other hand, classical writers such as Cicero, Virgil, and even Augustine offered not numbing rote but pleasure—the pleasure of minds exploring, embracing, revising, and even loving ideas for their own sake. Thus did the first shoot of the Renaissance poke its way through the seemingly inhospitable ground of the mid-fourteenth century, the same period as that of Petrarch's friend Boccaccio and of the leveling horrors of the Black Death. But while Boccaccio looked back on Dante with supreme admiration, Petrarch did no such thing. Dante, in Petrarch's estimation, belonged to the insufferable Dark Ages, just another whimpering breast-beater caught in a trap of his own phantasmagoric fears.

In Petrarch's mistaken demotion of Dante we may easily read an instance of Harold Bloom's theory of the "anxiety of influence," an example of the pattern by which a new age so often sneers at even the most timeless influences of the age that went before. Petrarch was indeed a very limited man, only somewhat talented and somewhat learned. He was a somewhat good, if somewhat boring, poet and a somewhat good scholar, though he never set himself the task of learning the language of the ancient Greeks—in the catalogue of whose authors he would have discovered the ultimate sources of the Latin writers he so admired. For Petrarch, his Latin-speaking ancestors from the Italian peninsula supplied all needed inspiration. He collected books—in his day an unusual activity and probably the contribution we have the most to thank him for. In 1345 he even discovered a previously unknown collection of Cicero's letters, *Ad Atticum*.

The collection of books—crumbling old manuscripts, many with titles and contents long lost to scholarship, many in languages other than Latin, in Greek especially, but also in Hebrew, Arabic, and what was then called Chaldean (Aramaic)—was the great enterprise on which the Renaissance was built. Or rather, it was the satiating *pleasure* that Petrarch and, after him, so many others derived from their collections, from their loving attention to the great writers of the past, to the thoughts and feelings of the classical authors of the Golden and Silver Ages, and from their resolve to bring about a splendid new age in imitation of what once had been.

This pleasure—in collecting, understanding, savoring, imitating (and even surpassing)—becomes the essential hallmark of the

Renaissance and its rich abundance of activities. Combined with what we may call the "new realism" (or the "new detachment" or even the "new selfishness") consequent upon the Black Death, this new sense of pleasure will make for a new age. Men like Petrarch came to be called humanists, that is, people interested in human subjects rather than in the divine or theological subjects that had so enticed the previous age. This did not mean that they were irreligious or antireligious. (Petrarch himself was a Catholic priest, though openly in love with a married woman, Laura, about whom he wrote obsessively.) It did mean that, like the ancient authors, their chief interest was in the lives and fates of human beings, not in the unknowable life of God, certainly not in the highly artificial philosophical and theological structure called scholasticism, supposedly inspired by Aristotelian logic, which had come to dominate university instruction throughout Europe. For those who had suffered in adolescence under the oppressive, unpalatable dominion of the scholastics, the activities encouraged by the Renaissance seemed welcome as a scented spring after a long, lugubrious winter.

These humanists might better be called philologists. Though these scholars spoke, to begin with, a simplified, late-medieval Latin, their intensive and extensive reading enabled them to create new dictionaries, new grammars, and new manuals in the art of rhetoric, modeled especially on the Latin and Greek classics. Appreciation of ancient Greek, knowledge of which had very nearly died out in Western Europe, was markedly reinvigorated by the flight of Greek scholars from the Byzantine Empire, now overwhelmed by the Turks. Many, probably most, of these scholars came to Italy, where they felt exceedingly comfortable and were received with high enthusiasm.

One of the Greeks was Ianos Lascaris, who found in Lorenzo the Magnificent the patron whom many an intellectual in need could only dream of attracting. Lorenzo, scion of the Medici banking family, whose tremendous lending institution dominated not only its hometown of Florence but much of capitalist Europe, was a supremely gracious if hard-driving athlete of immense appetite and, it must be admitted, impeccably good taste. The only thing he seemed to lack was physical beauty—he had a large, skewed nose and bumpy brows, if a face pulsing with life and vigor—but he cer-

tainly appreciated beauty beyond himself, especially in music, the plastic arts, literature, and young women. His poems, at least in the opinion of this reader, were a lot better than those of Petrarch, who wrote mostly in bland, imitative Latin. Lorenzo fashioned lapidary verses in the simple, open Tuscan of his time, yet tacking close to the immaculately chosen subjects of Horace and the invigoratingly lyrical dash of Catullus:

> *Quanto sia vana ogni speranza nostra,*
> *Quanto fallace ciaschedun disegno,*
> *Quanto sia il mondo d'ignoranza pregno,*
> *La maestra del tutto, Morte, il mostra.*

> *How vain is every hope, each breath.*
> *How false is every single plan.*
> *How full of ignorance is man*
> *Against the monstrous mistress, Death.*

So begins one of Lorenzo's sonnets. But often, such meditation only impels him to urge his reader to take whatever pleasure the moment may offer, as in the opening verse of his "Triumph of Bacchus and Ariadne," written for a public pageant of the same title:

> *Quant'è bella giovinezza*
> *Che si fugge tuttavia!*
> *Chi vuol esser lieto, sia:*
> *Di doman non c'è certezza.*

> *How very beautiful is youth*
> *That slips our grasp and flies away!*
> *So if you like, be merry, gay:*
> *Uncertainty's tomorrow's only truth.*✝

These lines, repeated throughout the poem, gain force with each restatement. And though this sentiment had never dis-

✝ The English translations, which are mine, are necessarily inadequate. Robert Frost once defined poetry as what is lost in translation. Without being quite so absolute, I confess that the natural rhythm and expansiveness of Italian have no easy English equivalents. Rather, the natural terseness of English militates against its usefulness in word-for-word translation of Italian. Nor is there any way to successfully imitate feminine rhyme scheme (in which stress is laid on the penultimate, rather than on the last, syllable in each line). So read the Italian, if you can make any sense of it at all.

appeared entirely from European literature, it had hardly been heard
with such intensity since pagan Horace in the first century BC had
raised the famous cry *"Carpe diem, quam minimum credula postero!"*
(Seize the day, trust little in tomorrow!) Though the humanists
were Christians, their adherence to their religion—certainly by the
end of the fifteenth century—was often more formal than deeply
felt.

Lorenzo himself loved nothing so much as a good party. "The
early years" of his inheritance, writes Christopher Hibbert,

> were notable in Florence for a succession of entertainments:
> pageants, tournaments, masques, spectacles and parades; musical
> festivals, revels, dances and amusements of every kind. For gen-
> erations, indeed, Florence had been famous all over Europe for
> such festivities. No city had more spectacular nor more numerous
> entertainments. . . . There were carnivals, horse races and foot-
> ball games, dances in the Mercato Vecchio [Old Market], mock
> battles in the Piazza Santa Croce and water displays beneath the
> bridges of the [River] Arno. Sometimes the Piazza della Signoria
> would be turned into a circus or hunting-field; wild animals
> would be let loose; boars would be goaded by lances; and the
> Commune's lions would be brought out of their cage behind the
> Palazzo and incited—rarely successfully—to set upon dogs. On
> one occasion at least these escapades got out of hand: three men
> were killed by a rampaging buffalo, and afterwards a mare was
> set loose among stallions, a sight which one citizen thought the
> "most marvelous entertainment for girls to behold," but which
> in the opinion of another, more respectable diarist, "much dis-
> pleased decent and well-behaved people."

Into all such displays there entered processions of gaily clad gen-
tlefolk, knights and their ladies, "heralds, standard-bearers, fifers,
trumpeters," pages, and men-at-arms, all magnificently decked out
in colorful costumes, none more resplendent than Lorenzo himself,
who at the citywide celebration of his engagement to the Roman
heiress Clarice Orsini wore "a cape of white silk, bordered in scar-
let, under a velvet surcoat, and a silk scarf embroidered with roses,
some withered, others blooming [to symbolize the sorrows and

joys of life], and emblazoned with the spirited motto, worked in pearls: LE TEMPS REVIENT.* There were pearls also in his black velvet cap as well as rubies and a big diamond framed by a plume of gold thread. His white charger, which was draped in red and white pearl-encrusted velvet, was a gift from the King of Naples"—and on runs the account, describing the armor Lorenzo wore in the jousting and the prize he won, "a helmet inlaid with silver and surmounted by a figure of Mars."

The openhanded Medici knew how to enjoy their good fortune and to include as many of their fellow citizens as possible in their celebrations. The Medici, as well as their (often envious) imitators among the other wealthy families of Italy, became patrons of the arts to a degree so lavish that we may say unreservedly that no one had ever seen their like before nor have we seen it since. The young Michelangelo sat at Lorenzo's table and slept in his bed, treated by Lorenzo as a boon companion and by others as a young god. But many artists were similarly entertained, and Lorenzo's court shone with such attendants as the brothers Pollaiuolo, Andrea del Verrocchio, Leonardo da Vinci, Sandro Botticelli, and Domenico Ghirlandaio. Not a few of these also attended sessions of Lorenzo's Platonic Academy, where they found themselves locked in intense conversation with the famous humanistic scholars of the day, men such as Marsilio Ficino, Agnolo Poliziano, and the great and good Giovanni Pico della Mirandola. All were welcome to peruse the vast collection of books in the eponymously named Laurentian Library.

The high spirits of Renaissance Italy spilled over into other European lands, though the waves set off by so much gaiety sometimes landed elsewhere with a shock and might even be received with contempt. The Renaissance, as it appeared elsewhere, could at times look and sound quite different from its lively Italian manifestation. And though the humanists of Italy were generous in sharing their artistic and intellectual riches with other Europeans, they were quite certain that the great classical tradition was a uniquely Italian treasure and that Italians had nothing to learn from anyone else (except—when they remembered—from the Greeks, of course).

* In French "the time returns," meaning the Great Time.

This attitude militated against the dissemination through Italy of the art of printing, where it was for years considered something concocted "among the Barbarians in some German city." Duke Federigo of Urbino, an important collector, dismissed the invention out of hand, admitting that he "would have been ashamed to own a printed book." No printing press was set up at Florence till Bernardo Cennini established one at last in 1477, a full quarter century after its invention in Germany.

So the multiplication of copies of individual books in Italy continued to depend for decades on the ancient traditions of the scriptorium. But it was at such scriptoria as Lorenzo's that many scribes were employed for the sake of making many copies of many manuscripts, so that these might be distributed widely. (Even in their self-imposed cultural isolation, the Italians remained generous.) And it is thanks to these last scriptoria of Europe that you, dear Reader, can today read the book in your hands (or on your screen) so easily.

The thing that most put off the Italians from adopting printing was the monstrous appearance of the Gothic letters employed by German printers. Thick, heavy, overweight, very nearly sludgy, unattractive to the modern eye, these letters (whether in movable type or in earlier manuscript examples) reminded Italians of everything they disliked about the Barbarians.✝ (*Madre di Dio,* those letters looked like overweight people with inert bowels!) Instead, the Italians invented calligraphy, beautiful—and eminently readable—script. From this calligraphy, lean and swift, balanced and shapely, full of sweeping slides and lovely loops—rather than the stolid shapes of Gothic—were born the typefaces we still use today, roman, italic, and their derivatives.

Lascaris was only one of several agents Lorenzo employed to scour libraries far and wide for forgotten treasures, many of which would be copied in multiples by Lorenzo's scribes. Lascaris returned to Florence with more than two hundred separate manuscripts from the impoverished libraries of formerly Byzantine lands (soon to be known as the Middle East). But the lavish reception he had imagined for himself and his extraordinary num-

✝ See Volume I of the Hinges of History, *How the Irish Saved Civilization,* Chapter I, for the original confrontation of taste between Italians and Germans in the early fifth century.

ber of finds was not to be, for Lorenzo was dead—at forty-three a victim perhaps of his own lifestyle, more likely a casualty of the immense forces that had been ranged against him for years.

Fourteen years before Lascaris's return to Florence, Lorenzo and his beloved younger brother Giuliano had been attacked while at mass in Florence's grand Cathedral of Saint Mary of the Flower. Both were knifed, but whereas lightning-quick Lorenzo had escaped death with a minor wound to his neck, Giuliano was cut down viciously. The anti-Medici conspirators were a rival family, the Pazzi, who had been urged to these assassinations by none other than Sixtus IV, the reigning pope, who had had quite enough of the Medici. They'd refused to loan him everything he wanted for his campaigns to refashion the power dynamics of northern Italy to his advantage (and to the concomitant disadvantage of Florence and the Medici). The pope was particularly outraged at the effrontery of Lorenzo's careful diplomacy in several northern cities, all in the service of preserving a league that would keep the peace—not one of Sixtus's goals. Though Lorenzo was in fact an indifferent banker, whose enormous fortune had been amassed in the time of his grandfather, Cosimo, and his father, Piero the Gouty, he was a skilled peacemaker and a gracious and warmhearted diplomat who found welcome practically everywhere.

But Lorenzo, though the central citizen of Florence, was not its ruler. The sovereignty of Florence, as of many other Italian city-states, lay in the hands of a corporation, a board of elected citizens. As in the ancient Greek city-states, the Italians never went so far as to extend anything approaching universal suffrage. Their republican governments were oligarchies, formed by the leading citizens, who offered wider suffrage to adult males of some financial consequence at those crucial moments when broader participation was required to ensure that the ordinary citizenry would support a special undertaking, such as going to war.

But given the Medicis' power and prominence within Florence, Lorenzo was able (and virtually expected) to act as dictator in moments of crisis. In the words of the Florentine historian Francesco Guicciardini, "He had a reputation such as probably no private citizen has ever enjoyed from the fall of Rome to our own day." And "if Florence was to have a tyrant, she could never have

found a better or more delightful one."✝ We should not, however, underestimate the negative long-term effect on the individual of having the game without the name—of always bearing the responsibility of the role without being able to assume the title—or the personal consequences of finding oneself the pope's implacable enemy (to such a degree that he is willing to have you bumped off while attending mass), or the political consequences of watching while this evil man attempts to align all Italy against you and your city. For a time, Lorenzo was even excommunicated, as was his entire family, and all Florence placed under interdict.✢ The bishops allied with Florence responded in turn by excommunicating the pope. The consequent dustup would be pacified only by the death of Sixtus and the election of a pontiff even more worldly, if more conciliatory. But by then Lorenzo's health had suffered.

✝ Guicciardini is considered the father of modern history because of his use of official documents. He was, however, only nine when Lorenzo died.

✢ Interdict was, in effect, the excommunication of everyone living in a particular city or country. Strictly speaking, it meant that all religious services were forbidden and no sacraments could be conferred. The consequence of this was that children could die without baptism and end up, therefore, in Hell, at least according to conservative theologians; and a similar fate awaited anyone who died without priestly absolution. But the interdict had been overused by the papacy, and so was no longer experienced as the extreme punishment it once had been. Often enough, local bishops and priests simply ignored it and continued their ministries.

One further actor must be brought onto the great open stage that was Florence: the Dominican friar Girolamo Savonarola. Born at Ferrara in 1452, grandson of a quack doctor who recommended imbibing large quantities of alcohol to ensure longevity and who saw to Savonarola's education, such as it was, Savonarola was one of the ugliest men ever to gain such an impassioned following and to reach such heights of fame. He was known to sleep on a comfortless straw mattress over a wooden board. He made it a practice not to speak to women, except to upbraid them, though it was rumored that in youth his suit had been firmly rejected by a young woman he had fallen in love with. (He himself insisted that he had always intended to serve God alone and not to marry.) Ghostly pale, consumptive-looking in the extreme thinness that could be discerned beneath his white habit and black cloak and hood,

Savonarola was further distinguished by an enormous hooked nose set between hollow cheeks, a tightly pursed but smiling mouth, and twitching, green irises that resembled the merciless orbs of a bird of prey.

The friar first came to Florence in Lent of 1481 as a guest preacher at the Church of San Lorenzo. He was not well received. His voice was harsh, his gestures abrupt and graceless. But he practiced and improved. By 1491 his devoted congregation had grown so large that his sermons had to be delivered in the Cathedral, where Savonarola revealed to the assembled Florentines that, after much fasting and prayer, he had been granted the gift of foreknowledge by God. "It is not I who preach," the friar shouted to the surprised crowd, "but God who speaks through me!"

What sort of future did Savonarola foresee? One of great calamity and divine punishment for the church, for Italy, and especially for Florence, unless Christians returned to their former simplicity.* They must forget about the classical authors of Greece and Rome, who were all at this very moment burning in Hell. They must renounce all the terrible pleasures—gaming, festivals, fashionable clothes—that were destroying their souls. They must get rid of all this new art, the cleverly made, lasciviously conceived paintings that made even "the Virgin Mary look like a harlot." It was especially important to bring an end to prostitution—ladies of the evening ("pieces of meat with eyes," Savonarola called them) must be whipped till they reformed—and all sodomites must shortly be burned alive. God would see to it that Lorenzo de' Medici would die soon, as would the pope and the king of Naples, after which the entire political process must be transformed and brought under his rule. Florence needed a new constitution, one that did away with the

* Predicting divine vengeance for sin is a standard refrain of reproachful types, as is confirming that a current calamity has been imposed by God in response to sin—a favorite ploy of the American preacher Pat Robertson, who explained (along with Jerry Falwell) that the 9/11 attack had been meted out by God because Americans were allowing abortions to be performed and homosexuality to thrive. More recently, Robertson was able to enlighten us on the parlous state of the people of Haiti, who are being punished because they made a pact with Satan two centuries ago. God's vengeance, in the estimation of such personalities, is remarkably lacking in discrimination, since those being punished so often have had little or nothing to do with the supposed crime.

current tyranny and replaced it with . . . with . . . Here Savonarola grew vague. It was clear that God wanted to replace Lorenzo with something new. But with what, exactly?

One by one, the great humanists caved. Pico della Mirandola, Poliziano, Botticelli, perhaps Michelangelo spoke of Savonarola with respect, even with awe. When Savonarola's name was advanced to be Prior of San Marco, a friary funded with Medici money, Lorenzo made no objection. After all, Lorenzo encouraged variety everywhere and was never one to interfere unnecessarily. We can almost see him shrugging his muscular shoulders in the very Italian gesture of "Live and let live." As he lay dying, Lorenzo even asked to see the fiery friar. Though no one knows exactly what was said in this final meeting, we may well imagine that Savonarola heard Lorenzo's confession, gave him absolution, and applied the anointing chrism of the church's last rites to Lorenzo's dying body. The tradition that holds that the friar cursed Lorenzo is certainly mistaken. At the least, Savonarola blessed the dying man and left him consoled.

Once Lorenzo was gone, however, the friar's preaching became ever more intense and admonitory. He pointed to the sky, where he claimed to see the Sword of the Lord hanging over the city. "Repent, O Florence, while there is still time!" intoned the preacher, sounding ever more like Isaiah. (Indeed, it seems fairly obvious that he was imitating language to be found in Isaiah 21 and elsewhere in the Hebrew Prophets.) "The Lord has placed me here: 'I have put you here as a watchman in the center of Italy that you may hear my words and announce them to the people.' " Foreign enemies were about to cross the Alps, like "barbers armed with gigantic razors," and they would fall upon the people. Then would the Turks turn Christian.

Prophets are exciting people, natural celebrities. Here was a man who could never have cut a figure or raised a response at one of Florence's storied celebrations; rather, one who had refashioned himself as Isaiah to Florence's Jerusalem and Italy's Judea. And his predictions were all coming true! Lorenzo was dead, so were the pope and the king of Naples! French armies were crossing the Alps, soon to subject Italy—and especially recalcitrant Florence—to ghastly penalties. Soon, too, no doubt, the Turks would submit themselves to baptism, as the whole world is remade by God.

To prepare for these events the Florentines altered their constitution, creating a virtual theocracy with Savonarola in charge. Clutching a crucifix high above his head, Savonarola pressed on, as his fellow Blackfriars swarmed about the city's streets: the people must now fast continually; they must denude their churches of all unnecessary ornament—gold plate, silver cups, precious candelabra, jewel-encrusted sacred objects, beautifully illuminated books—all of which must be set afire or melted down, for these were nothing more than diabolic temptations to vanity. Opposite the Palazzo della Signoria in the very center of Florence an enormous scaffold was erected and upon it people placed their collections of fine clothing and the beautiful adornments that had once made Florence famous. Atop this mountain of finery, the citizens piled profane books they had but lately treasured, as well as any drawings or paintings that could possibly lead a viewer to impure thoughts. Even famous artists, such as Botticelli, were seen to sacrifice their pictures to the pile. As the great mound was set afire—the original "Bonfire of the Vanities"—a children's choir sang, trumpets were blown, and bells were sounded.

Children were mustered, and not only for singing: the friars organized what Savonarola called "Blessed Bands" of such children, their hair trimmed short, who went throughout the city collecting donations for the poor and seeking out whatever vanities had eluded the flames. These children were instructed to root out all remaining vice, which included informing on anyone caught gambling, behaving unsuitably, wearing an ostentatious costume, or harboring some undivulged treasure. The Blessed Bands were especially encouraged to inform on family members.

What are we to make of this volte-face on the part of the previously partying people of Florence? Why did they submit themselves to Savonarola and to such a revolution in their way of life? For simple people, there was undoubtedly the prophetic dimension: what he predicted came true! (Well, yes, though predicting the deaths of dying people is not so amazing, nor is predicting an invasion when the threat is already at your door. Now, the conversion of the Turks—I guess if he'd got that one right, he'd be worth a second look.)

Beyond finding an explanation for the celebrity awarded Sa-

vonarola by simple souls, it must be said that we are presented here with a conundrum: the enthusiasm of the cultivated and the learned—the most cultivated and learned (and, till now, the most joyful) people in all of Europe—for an unpleasant, unsympathetic, unbelievable windbag. Why did they not resent their Garden of Love being invaded by these "Priests in black gowns . . . walking their rounds,/And binding with briars [their] joys and desires," as William Blake would one day express it? Is this just an instance of the lemming rule, of crowds following crowds? If everyone's going over the cliff, I might as well go with them?

No doubt Lorenzo's calling Savonarola to his deathbed helped precipitate the transformation. If Lorenzo il Magnifico himself submitted to the friar, who am I to hold out? The age-old reliance of Italians—as well as not a few other nations—on charismatic leaders (now Lorenzo, now Savonarola) may also have figured in the equation. But beyond these partial explanations there lies the Christian faith of Italy, where—even today after centuries of secularism—supposed unbelievers generally call a priest to their deathbeds and arrange for a church funeral. This is, to some extent, an aspect of Italian canniness—of the impulse to place bets on both horses. As one exceedingly agnostic Italian friend said to me recently when he refused to cross the path of a black cat, "Better to be cautious." And I'm sure the same man, when his time comes, will welcome a priest to his deathbed. Better to be cautious.

But it is also possible at this point in our consideration to part the curtains of cynicism and to look out the window in the morning light: to admit that, for all his admiration of Horace and Catullus, for all his lifelong meditations on Plato, Lorenzo was a Christian, at least of a kind, and a Christian who believed deeply enough that he did not wish to enter into Eternity without having properly closed his life on this earth. Certainly, he was the son of an intelligent but deeply pious woman;✝

✝ "Lucrezia Tornabuoni was a remarkable woman, charming and spirited, profoundly religious and highly accomplished. . . . She was a poet of more than moderate ability. Since her interests were largely theological, most of her poems were hymns or translations into verse of Holy Writ. But they displayed a depth of feeling as well as a literary quality rarely to be found in such compositions. . . . Both her husband and her children, as well as her father-in-law, all seem to have adored her." From Christopher Hibbert, *The House of Medici*.

and in our deaths we must in some manner recapitulate, even re-integrate, our lives by returning to the scenes of our earliest days. He could not have foreseen that his private deathbed conversation would help to usher in the Age of Savonarola.

The age did not, in any case, last long. Savonarola proved far less talented at politics than at preaching. He quickly lost the confidence of the invading French, antagonized the new Borgia pope (a serious mistake), and sent Florentines out to die in skirmishes for which they were ill prepared. Finally, Pope Alexander excommunicated the obstreperous, interfering cleric and threatened to put the Florentines under interdict once more if they did not give him up. Savonarola continued defiantly to preach in the Cathedral but to dwindling audiences. The Roman Church, he now claimed, had become a satanic institution, a whore promoting whoredom and all manner of vice.

Florentines had other matters on their minds: meager harvests; hungry, even starving people haunting the city's streets; plague breaking out. At last, the oligarchs acted: Savonarola was arrested and paraded through the streets while citizens lined the route to jeer at him. He was horribly tortured, confessed to everything he was asked to confess to, retracted his confession when he was removed from the *strappado*,* was tortured again, convicted of heresy and schism, and finally burned at the stake, the very end he had wished upon all sodomites lurking in Florence's midst. The date was May 23, 1498, just seven years after the man had preached his first sermon in the Cathedral.

France, a kingdom for untold centuries, exhibited a stability that was denied the independent city-states of Italy. The Italian communes, by their very nature, were more subject to the fickleness of crowds, otherwise known as voters, than were political entities that traced their legitimacy to a long tradition of sacred kingship. As nationality continued to grow in importance, a nation with a king found expansion easier and more natural. The league of city-states that Lorenzo tried to hold together in northern Italy (or any similar alliance) would

* A method of torture whereby the victim's hands are tied behind his back, after which his arms are lifted behind him by rope and pulleys and he hangs suspended in midair. The procedure causes terrible pain, normally dislocating both arms.

always suffer from a weakness of unity not so characteristic of a country with an anointed king (or an empire with a Holy Roman Emperor). As nationalistic consciousness waxed ever stronger in Europe, Italy would continue to find itself at a disadvantage.

More than this, religion was primed to stoke new political conflicts everywhere. Would our Christianity be like that of Lorenzo or of Savonarola? Like that of Columbus or of Las Casas? Would we be humanists or firebrands? Imperialists or peacemakers? Tyrants or republicans? (There were no democrats, as yet.) Dictators or colleagues? Torturers or nurturers? Would we build pyres or throw parties? Would we read books and view pictures or poke our noses into other people's affairs and tell them how to live? Would we be relaxed* or reformed? And if reformed, what sort of reformers would we make?

The stage was now set for two kinds of expansiveness: the expansiveness of humanism, issuing in the easeful gorgeousness of the Renaissance, and the expansiveness of the Reformation, which would seek moral improvement both personal and institutional, as well as the abandonment of error. Neither Tomás de Torquemada nor Girolamo Savonarola could be strictly called Reformation figures; but both were reformers of the strictest sort, Counter-Reformation figures of Catholic Europe long before the Counter-Reformation, or even the Reformation itself, had properly got under way. Their ghostly presences will necessarily haunt some of the pages to come.

* Jacqueline Kennedy Onassis, a friend and publishing colleague, once described her family's religious outlook by saying "We're relaxed Catholics," this in the midst of a public denunciation that I, as Doubleday's director of religious publishing, had received from Cardinal John O'Connor, then archbishop of New York, because he disapproved of a book I had published. Her description was a play on words, the condemnatory phrase "lax Catholic" being well known to anyone brought up Catholic in the years prior to the partial relaxation of oppressive norms by the Second Vatican Council. I confess I find her description, offered as a sign of solidarity with me in my conflict with the archbishop, appealing.

II

THE INVENTION
OF HUMAN BEAUTY

AND THE END OF MEDIEVAL PIETY

Beauty itself doth of itself persuade
The eyes of men without an orator.

The Rape of Lucrece

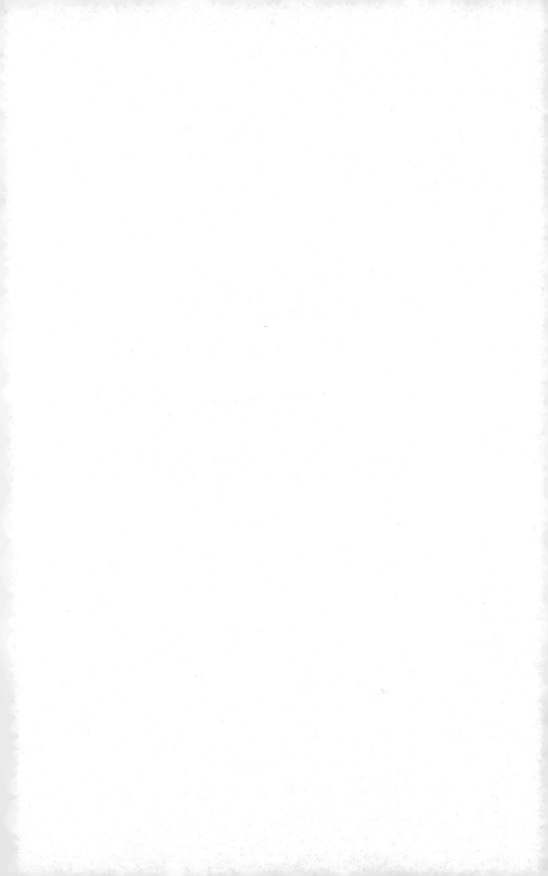

Before the sobrieties of saints and the rigidities of reformers begin to consume all our attention, let us immerse ourselves once more in some of the unique pleasures bestowed on us all by those generous party givers, the Renaissance artists whose lavishness amazes still—even if we come to discern within their celebrations a singular seriousness of purpose and an unparalleled (and occasionally unpardonable) sense of self. There being no way, however, in a book of this size to do even rudimentary justice to Renaissance art, we shall have to content ourselves with a kind of morning bus tour, pointing out only a few of the more obvious delights in which this sensationally sensuous territory abounds.

1445?–1564: FULL NAKEDNESS!

The final collapse of the Greco-Roman world in the West entailed the loss of many things, among them statuary—or, more precisely, the classical tradition of sculpture. The freestanding figures, life-size and larger, that punctuated the public spaces of antiquity were sculpted no more; and gradually the ones that remained standing were lost beneath the waves of change and the rubble of decline. For one thing, Christian palates found nudity unacceptable (unless you were discreetly depicting Adam and Eve before the Fall), and so many of the subjects of ancient sculpture were nude. Worse still, so many of the nudes were pagan gods and goddesses, for whom there was no longer much call. And the idea of putting divinity and nudity together was downright scandalous. Yahweh, the God of the Jews who had become the God of Christians, was never described south of his waist. Whatever was there, no one had

ever seen it. But more to the point (as it were), coupling divinity and nudity necessarily implied a sort of Holy Eroticism, an idea that could only make medieval standard-setters squirm. Whatever examples of Greco-Roman sculpture were not smashed or melted down mostly ended up buried or drowned, awaiting rediscovery in a more appreciative age.

The *David* of Donatello [Plate 1] must, therefore, have come as a great shock to viewers in Quattrocento Florence. This was not Donatello's first *David*. An earlier one, sculpted perhaps as early as 1408, when Donatello had barely reached his twenties, and intended as a decoration for the Cathedral's buttresses, is more in keeping with the artistic conventions of its time, well clothed in cloak and leather jerkin, if displaying a handsome right leg rising next to the severed head of the giant Goliath. But even in this earlier *David*, Donatello is an innovator, for David had all through the medieval centuries been portrayed as a bearded king of venerable years, playing his psalms on his plangent harp. This first *David* of Donatello is a sturdy boy, the sweet curls of his exquisitely shaped head bound by a viny chaplet, his wide-eyed face expressing the *pathos* and *pietas* of his young years. Though this youth would soon enough become the standard depiction of the biblical David, in the first decade of the Quattrocento (or 1400s) he was a startling departure.

But this figure was as nothing compared to Donatello's second *David*, who stands free, never intended to be incorporated into niche, wall, or buttress as mere architectural adornment, as had been all the statues of the previous Middle Ages. He is intended—indeed, he demands—to be looked at solo, without reference to anything else. Struck in bronze, he is a boy, standing (as would a boy of the time) but two and a half inches higher than five feet. And he is brazen in more ways than one.

We don't know what classical models Donatello may have used. Surely, he couldn't have come up with this shameless child without having encountered some Greek-like sculptures, or parts of sculptures, or cartoons of sculptures in forms now lost to us. We are at a total loss to explain how Donatello could have conceived such a statue—such a Presence—because nothing still extant from his time gives us the least hint. In the words of Kenneth Clark, "How pleasure in the human body once more became a permissible sub-

ject of art is the unexplained miracle of the Italian Renaissance. We may catch sight of it in the Gothic painting of the early fifteenth century, revealed in the turn of a wrist and forearm or the inclination of a neck; but there is nothing to prepare us for the beautiful nakedness of Donatello's *David*."

Even more shocking, this David is no mere copy of a Greek original. Though it refers to the long-lost tradition of classical sculpture in its life-size boldness, its stand-alone uniqueness, its utter nudity, and its many anatomical perfections, it uses all these things—in fact, plays with them—by way of allusion, as if the sculptor were telling us, "Yes, yes, I know all about the great Greco-Roman tradition and I treasure it, but I wish to give you something New."

Which he has. Unlike the chunky, chesty gods and athletes immortalized by the Greeks, with their perfect limbs and blank faces, their absolution from all normal human trials, and their unwillingness to take the least notice of us, their spectators, this child is not quite so absolved or abstracted. He seems rather pleased with himself as his left foot toys with the decapitated giant's beard. What, for Heaven's sake, is that serpentine thing slithering its way up David's right leg and almost reaching his joining thighs? Why, it's the tickling wing of Goliath's helmet. How extraordinary, what can it be meant to mean? And the pose: almost Greek but more insouciant, more provocative, more (dare one say?) sexually inviting. The nearly thrust-out pelvis, the narrow, girlish breasts, the slightly exaggerated but gracefully balanced sway of the figure, the left hand on the hip virtually summoning us to take a walk around and examine the swelling buttocks—dear God, what a breathtaking display!

I am trying here not only to give voice to reactions of our contemporaries but to imagine the reactions in Donatello's own day, when no one had ever seen anything remotely like this statue. Since we now have no record of any reaction whatever, we can only speculate. Are there no records because people didn't trust themselves to say anything publicly? Was everything done sub rosa and behind the scenes, the statue banished to some private garden where it would not disturb the public? (We do know that whatever the original, and undoubtedly public, purpose of this commission, the figure ended up in the private courtyard of the Palazzo Medici.)

I imagine an Italianate version of the reaction of Dorothy Helms, wife of the self-proclaimed "redneck" Senator Jesse Helms, as she inspected for the first time the homoerotic photography of Robert Mapplethorpe: "Lawd, Jesse, Ah'm not believin' what Ah'm seein'!" Subsequently, Senator Helms did everything he could to blacken Mapplethorpe's reputation and destroy any American gallery, museum, or government body that would sponsor his work. (Of course, Helms succeeded only in helping to ensure Mapplethorpe's enduring reputation.)

We don't even know when this second *David* was made. It might have been in the 1420s or '30s or, most likely, '40s, by which time Donatello would have reached his fifties. In the late 1970s, one art historian, H. W. Janson, at last uncovered a clue that the statue itself had concealed all along but that no one had previously decoded. Goliath's highly unusual winged helmet had always been a stumper. Janson realized that the winged helmet was an emblem of the Viscontis, dukes of Milan, Florence's mortal enemy. Thus was David, intended by Donatello to represent little Florence, able to slay even monstrous Milan. But this David with his pornographically high boots, his belaureled, pretend-butch huntsman's hat, and his narcissistic visage is most unlikely to have appealed to aggressive Florentines as their military symbol. Even to the artistically dim, he must have looked too much like the toyboy of an aging artist. This was a kid who may have conquered Donatello but was hardly up to the task of conquering Florence's enemies. So he ended up closeted in a private garden, rather than displayed as a public statement. "With Donatello," remarks John M. Hunisak of this image, "we discover the first modern instance of the fusion of art and autobiography."

Donatello has provided us with other expressions of autobiography, none more poignant than his *Mary Magdalene* [Plate 2], carved in wood for Florence's famous Baptistry. Here, toward the end of his life, Donatello gives us a figure as far removed from the teasing provocation of the *David* as can be imagined: Magdalene, the penitent prostitute, as a desert figure like John the Baptist, clothed in rough animal skin, her old, emaciated limbs the opposite of the *David*'s self-satisfied plumpness (or the plumpness of virtually any other Renaissance figure). Her face speaks only of regret. One could misinterpret this depiction by suggesting that, in Donatello's

eyes, boys are for pleasure, women for pain and suffering, but I doubt Donatello would have had any difficulty imagining himself as a woman. Here is a figure that, unlike the *David*, might have been carved at almost any time in the Middle Ages. It leads us to contemplate faith and repentance, not Neoplatonic perfection. Like Lorenzo the Magnificent's deathbed confession, it is an echo of an earlier time.

But to place Donatello's scandalous *David* more securely in its historical context, we have only to ask ourselves: who was the next artist to sculpt a David and what did it look like? It took thirty years or more before another artist dared try his hand. The supremely competent Verrocchio, once the student of Donatello, cast his *David* [Plate 3] in 1476 or so. The result imitates Donatello, if in a wishy-washy way. Verrocchio imagined a young David, as had Donatello, who had succeeded in wiping away the former depiction of David as an aged musician. Like the earlier *David*, this one is cast in bronze, but at scarcely more than four feet it is somewhat shorter than life-size. And there is almost nothing in Verrocchio's version to provoke the viewer's lust. Here is a genial, skinny young fellow, a little bland, only the flowery nipples of his breastplate hinting at anything remotely unusual. Like Donatello's *Magdalene,* this *David* would have been at home in an earlier age—as a figure in a Gothic niche.

But does the faint suggestion of a smile remind you of anyone? Perhaps of the *Mona Lisa*? At the time Verrocchio cast his *David,* the young Leonardo da Vinci was his apprentice and may even have served as a model for Verrocchio's *David*—which may cast some light on what the statue does *not* say. For in 1476, the same year Verrocchio was casting this piece, complaints were twice put before the magistracy of Florence that Leonardo and other young artists were engaging in sodomy with (it would seem) a willing seventeen-year-old named Jacopo Saltarelli.

These incidents occurred two decades before Savonarola's attempts to rid Florence of its sodomites by burning them all alive. What the anonymous accusers may have meant by sodomy and what the magistrates may have taken them to mean may remain a

trifle unclear—and, in any case, it appears that the accusations were never proved. But we may note that, not only was there a marked tendency among Florentine artists and other humanists to engage in homosexual (as well as heterosexual) relations; they found their high-minded justification for these practices in the works and lives of the most admired Greek and Roman poets, artists, and philosophers. Though there was not a whisper of justification for such activities in Judeo-Christian sources (in which only the sternest condemnations could be found), there were many laudatory references to homosexual love in Greek art and literature and (more occasionally) in Roman poetry.

It is likely that the sodomy charge had some basis in reality. Leonardo never married and is known to have cohabited with a succession of young men. Some of his drawings and paintings would certainly indicate that he had an intense interest in beautiful male bodies. At the same time, there is no definitive proof, and there are even contrary indications—evidence that Leonardo may have been celibate, if not for his entire life, at least in his later years. I would speculate that the public accusations were sufficiently unsettling to Leonardo that they may have pushed him into a lifetime of concealment—his whereabouts in the years immediately following the accusations are unknown, but if he remained in Florence he was probably hiding out with the Medici—and that they even impelled Verrocchio, then at work on his *David,* to similar concealment, which is why this *David* is so sweetly bland. At the same time, nothing of Verrocchio's ever created a scandal: he was a consummate professional who always satisfied his customers—which is why his extant works never rise to the level of Donatello's or Leonardo's. In the end, we are left with irreducible mystery.

Leonardo himself would have approved our tact, our unwillingness to reach beyond the evidence. He had an instinctive dislike of precipitate generalization. "Abbreviations," he wrote in one of his famous notebooks, elaborate but unrevealing of his personal life, "do harm to knowledge and to love, seeing that the love of anything is the offspring of this knowledge, the love being the more fervent in proportion as the knowledge is more certain. . . . It is true that impatience, the mother of stupidity, praises brevity, as if

such persons had not life long enough to serve them to acquire a complete knowledge of one single subject."

Well, though he might have admired our tact, I have to admit that he would most certainly not have approved our morning bus tour of Renaissance art. This is the authentic voice of Leonardo: considered, exploring all angles, willing to wait as long as need be for knowledge, inspiration, insight, enlightenment. So willing was he to wait till a given task could be undertaken properly that his life was punctuated by partial, unfinished, and collaborative works.

The first of these should be accounted a painting once ascribed wholly to Verrocchio but later understood to be partly the work of Leonardo, a *Baptism of Christ* [Plate 4], dating to 1472, four years prior to the accusations, when Leonardo was just turning twenty. The angel on the far left is Leonardo's—and how angelic and mysterious is this curly-haired visitor in contrast to Verrocchio's pug-faced, earthbound child. The main action of Jesus and John the Baptist, surmounted by trinitarian symbols, is conventional and unremarkable. But the background, by Leonardo, speaks to us of mystery, surprise, delight, as does the landscape that, more than thirty years later, will frame Mona Lisa. As Yeats would describe such vistas:

> *Quattrocento put in paint*
> *On backgrounds for a God or Saint*
> *Gardens where a soul's at ease;*
> *Where everything that meets the eye,*
> *Flowers and grass and cloudless sky,*
> *Resemble forms that are or seem*
> *When sleepers wake and yet still dream,*
> *And when it's vanished still declare,*
> *With only bed and bedstead there,*
> *That heavens had opened.*

After this collaboration with his assistant, Verrocchio gave up painting altogether, devoting himself wholly to sculpture and goldsmithery. No more dreamscapes for him.

Despite Verrocchio's ceding the field to Leonardo, the younger

man's first solo outing, *The Annunciation* [Plate 5] of the same year
(or perhaps the following), is endearingly tentative. The perspective
is carried out as if taken directly from a student manual—the vanish-
ing point in the exact middle of the horizon and just two-thirds up
from the bottom of the picture. There is something wrong with the
positioning of the awkwardly elephantine lectern, the feet of which
sit closer to the viewer than the Virgin's right hand could possibly
do, though both furniture feet and human hand all appear intended
to occupy nearly the same plane. Leonardo was left-handed; and, as
I know from personal experience, it takes left handers a bit longer
to get such things right.

But for me the great charm of the conception lies in Mary's
attitude. Though she has yet to learn just who this deeply bowing
visitor may be, she is slightly annoyed at being interrupted in her
reading and, determined not to lose her place, has put the index
finger of her right hand on the passage she was reading. Her
raised left hand politely salutes the angel, another of Leonardo's
curly-haired marvels, but her right hand announces her hope that,
whatever her winged visitor may have to say, he will keep it brief.

Of Leonardo's own mother we know almost nothing, save that
her name was Caterina and that she was a peasant girl who had an
affair with a local notary named Piero, a man who had a "Ser" (Sir)
in front of his name. She bore Leonardo out of wedlock; and though
Caterina and Piero, being of different classes, never married, Piero
acknowledged his son and maintained a relationship with him, later
bringing him from their outlying village of Vinci to Florence and
apprenticing him to Verrocchio, the best artist he could find. We
have documentation indicating that in her later years Caterina lived
with her son after he had moved to Milan and that she died there
in his house. So Leonardo seems to have had a decent relationship
with each of his parents, however brief their mutual relationship
may have been; and I would guess that the quiet self-possession of
Mary, herself a peasant girl, in the face of an angel invading her
privacy is a hidden homage by Leonardo to the independent spirit
of his own dear mother.

I would even take this unprovable speculation a bit further
and wonder if Mary's face—in its uncompromisingly realistic
stare—may be a somewhat idealized version of Caterina's. She

doesn't look much like Leonardo's many other Marys, for whom he no doubt used local models. But her face, though unsmiling, does rather closely resemble the face of Verrocchio's *David*.

At any rate, Leonardo's interest in faces never lessens. One of his earliest completely self-assured works, *The Virgin of the Rocks* [Plate 6] of 1482–83, is a triumph of faces. Mary kneels before her infant son, her right hand encouraging the infant Baptist-to-be in his worship of his cousin Jesus, who raises his right hand in priestly blessing. The fourth figure, another curly-haired angel, is the most unearthly of all. But all four are profoundly, mysteriously otherworldly; their beautifully modeled light-dark faces speak of inner spiritual life, of individual selves connected to an unseen reality immensely larger than anything our eyes can see. And their pageant-like interactions are exquisitely framed by the mysterious but earthy rock formations that surround them. The figures are enclosed in an invisible triangle, which works in tension with the invisible column in which the Christ Child sits, formed by the pointing right hand of the angel and the protective yet demonstrative left hand of the Virgin. Her encouraging right hand and the shielding sweep of her cape protect not only the Baby Baptist but us, the human race—*exules filii Evae*, the banished children of Eve—whose representative he is meant to be.

"The design," as Clark remarks of a much later painting of Leonardo's,[*] "has the exhilarating quality of an elaborate fugue: like a masterpiece of Bach it is inexhaustible. We are always discovering new felicities of movement and harmony, growing more and more intricate, yet subordinate to the whole; and, as with Bach, this is not only an intellectual performance; it is charged with human feeling."

Leonardo's interest in faces can take a comic turn, as in his sketch of a comely but diffident youth being inspected by a grotesque old man. The youth is almost certainly Giacomo Salai,[†] who, though in Leonardo's own words was a "thief, liar, pigheaded glutton," boarded with Leonardo and was, despite his social faults, protected by the artist for years

[*] The unfinished *Virgin and Child and St. Anne* of perhaps 1510, which hangs in the Louvre.

[†] His full name was Gian Giacomo Caprotti da Oreno. His nickname, Il Salaino or Little Unclean One (that is, the Devil), was shortened to Salai.

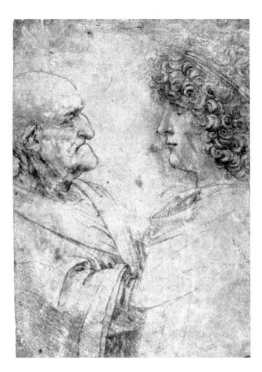

and even mentioned in his will. No one knows who the old uncle may be.

Both comedy, of a prickly kind, and mysterious beauty are to be found in the faces of those gathered for *The Last Supper,* one of Leonardo's three most famous images. But this image, or what survives of it, must be accounted one of Leonardo's great failures. It is still evident that Leonardo intended to bring a fresh sensibility to this scene. Whereas earlier artists had sought to portray the moment at which the central Christ figure institutes the Eucharist of bread and wine ("This is my Body"; "This is my Blood"), Leonardo meant to portray the moment at which Jesus predicts that "One of you will betray me" and the ensuing buzz of speculative interaction among the twelve apostles. ("Is it me?" "Is it him?") But the wall on which Leonardo painted—in the refectory of the Dominican friary of Santa Maria delle Grazie in Milan—was damp. Moreover, Leonardo failed to employ standard fresco technique to fix the image to the wall.[*] Rather, he worked on the project off and on for most of a year, 1497, and

[*] Fresco technique is described in *Mysteries of the Middle Ages,* page 248.

used a medium that contained oil and varnish. It was perhaps an experiment on his part. But even in his lifetime the painting began to disappear. By the mid-sixteenth century, the great Renaissance art critic Giorgio Vasari visited the friary and wrote that "there is nothing visible but a muddle of blots." What we see today is the result of multiple "restorations," seven or more, carried out by a variety of artists of varying skill, vision, and style over several centuries. It is scarcely possible to speak now of *Leonardo's Last Supper,* but perhaps some may find a sort of defense in Leonardo's most famous quotation: *"L'arte non è mai finita, solo abbandonata"* (Art is never finished, only abandoned).

As famous as this abused image is the *Mona Lisa.* Though her fate has been less terrible, she has hardly survived unscathed. To protect the painting from its millions of admirers, the countless tourists who flock to see it every year, the Louvre has elected to place it high on a wall, framed within a bizarre structure that almost gives the impression that the painting is submerged. Here is Vasari's description of his unmediated encounter with the *Mona Lisa:*

> The eyes had that lustre and watery sheen which is always seen in real life, and around them were those touches of red and lashes which cannot be represented without the greatest subtlety. . . . The nose, with its beautiful nostrils, rosy and tender, seemed to be alive. The opening of the mouth, united by the red of the lips to the flesh tones of the face, seemed not to be colored but to be living flesh.

Alas, as one strains to see the painting today, there is little color, and much of the subtlety has been erased, washed away by the underwater effect and perhaps by time as well. In the words of Kenneth Clark, who was able to view the painting up close and out of its frame in the early twentieth century:

> She is beautiful enough even now . . . Anyone who has had the privilege of seeing the Mona Lisa taken down, out of the deep well in which she hangs, and carried to the light will remember the wonderful transformation that takes place. The presence that rises before one, so much larger and more majestical than one

had imagined, is no longer a diver in deep seas. In the sunshine
something of the warm life which Vasari admired comes back
to her, and tinges her cheeks and lips, and we can understand
how he saw her as being primarily a masterpiece of naturalism.
He was thinking of that miraculous subtlety of modeling, that
imperceptible melting of tone into tone, plane into plane, which
hardly any other painter has achieved without littleness or loss of
texture. The surface has the delicacy of a new-laid egg and yet
it is alive.

And something of Leonardo's own self shines through so many
of his portraits. This woman, this Mona Lisa, is also in some sense
Leonardo. One of the miracles of his art is how deeply personal it
is, how revealing of the artist who did not revel in self-revelation.
Which is why we, after gazing at a succession of the artist's depic-
tions of faces, can spot Leonardo as the model for Verrocchio, as
well as the inner self of Mona Lisa. Of the actual, exterior Leo-
nardo, we have but one probable self-portrait—in red chalk—and,

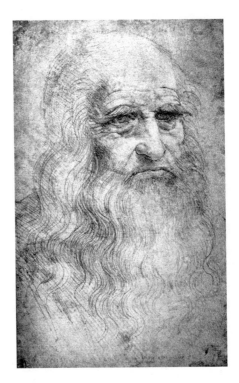

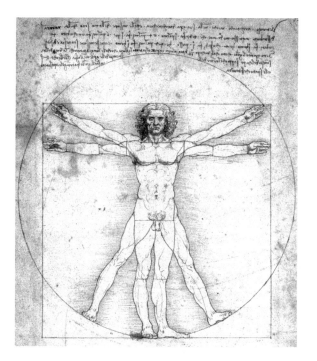

like his notebooks, it reveals little, except that Leonardo, then but sixty, thought of himself as much older than he was.

We may find much more of Leonardo in his *Vitruvian Man*. This icon of the Renaissance has become in our time an icon for any number of things. One catches sight of reproductions of it at the offices of both medical doctors and homeopaths, on T-shirts and tattoos, NASA spacesuits, denominations of the euro, and computer operating systems. People who consider themselves humanists of one variety or another often employ it as a favorite symbol. I once taught at a "Center for Humanistic Studies" that used the *Vitruvian Man* as its logo. Throughout the Americas and Europe perhaps only troops of fundamentalist Christians would find it inappropriate to their organizational purposes.

The image is called "Vitruvian" because it refers to the ancient Roman engineer Vitruvius of the first century BC who in his treatise on architecture showed how the ideal human (male) figure was constructed from a series of proportional measures and that these proportions could be projected beyond the body itself and used to create pleasing proportions in architecture. It was Vitruvius who

came up with the idea of encompassing the male figure in a circle (with the central point his navel) and in a square. "The length of the foot," wrote Vitruvius, "is one sixth of the height of the body; of the forearm, one fourth; and the breadth of the breast is also one fourth. The other members, too, have their own symmetrical proportions, and it was by employing them that the famous painters and sculptors of antiquity attained to great and endless renown. Similarly, in the members of a temple there ought to be the greatest harmony in the symmetrical relations of the different parts to the general magnitude of the whole."

Whether such a system is truly workable I am not equipped to say. In our time, which is postclassical, postromantic, and postmodern, we are more likely to emphasize the subtle and even the grotesque variations from one human body to another rather than a system of ideal proportions. But there is no denying the powerful attractions of a vision that makes man the measure of all things and even his architecture an expression of his humanity—a world made (or remade) to a human scale.

Earlier attempts to interpret Vitruvius's writings—and earlier artists' sketches of the *Vitruvian Man*—had been failures. Leonardo, who had had little formal education, had taught himself Latin. He was the first to read Vitruvius's Latin carefully enough to realize that all previous attempts at interpretation had misunderstood Vitruvius to mean that the circle and the square should have the same center, the human navel. By adjusting the position of the square, Leonardo succeeded in rendering the first correct reading of Vitruvius since antiquity. In this way, Leonardo made Vitruvian ideas of human anatomy and architecture accessible to the artists and architects of the Renaissance. Without this correction of Leonardo's it is hard to imagine how the architectural works of Michelangelo, Bernini, Palladio, and even Christopher Wren could have come to be.

Leonardo was the ultimate Renaissance man. Painter, sculptor (of lost works), engineer (who sketched out workable inventions such as the helicopter, the tank, the calculator, and many smaller laborsaving devices that were manufactured in his own time), scientist (incisive student of optics, the first to offer a theory of plate tectonics), anatomist, military strategist, theoretician of architecture, peace-loving ambassador, vegetarian, a man who bought

caged birds in order to free them, he died in 1519 in the arms, it was said, of his student and passionate protector, Francis I, king of France.

"In the normal course of human events," wrote Vasari, "many men and women are born with remarkable talents; but occasionally, in a way that transcends nature, a single person is marvelously endowed by Heaven with beauty, grace, and talent in such abundance that he leaves other men far behind, all his actions seem inspired and indeed everything he does clearly comes from God rather than from human skill. Everyone acknowledged that this was true of Leonardo da Vinci, an artist of outstanding physical beauty, who displayed infinite grace in everything that he did and who cultivated his genius so brilliantly that all problems he studied he solved with ease."

To pursue Leonardo's other interests would take us several books. We have, in all truth, barely touched on his importance as an artist. I can only regret the many omissions forced on us here and say that we will have one additional chance to bow our heads in Leonardo's direction—as we have a closer look at some Renaissance approaches to female anatomy.

There is probably no Renaissance artist more associated with the female form than Botticelli, whose celebrations of women's bodies—at least in the early stages of his artistic journey—are second to none. Like every other artist, Botticelli did not emerge without precedent: there were indeed several earlier masters who influenced him. Of these we shall fleetingly consider two: Masaccio (born in 1401) and Piero della Francesca (born perhaps as early as 1415).

Masaccio's baptismal name was Tommaso, a name easily shortened to "maso," very close to "masso," Italian for bulk (or mass). The added "-accio" serves to further deprecate the person so designated. A good translation of "Masaccio" would be "Fatso," which pretty much describes the one likeness we have of him as a broad-faced, brooding onlooker, framed by a dark doorway, in his own fresco sequence on the life of Saint Peter in the Brancacci Chapel of Florence's Church of Santa Maria del Carmine.

The wide panel in which Masaccio's likeness is to be found
[Plate 7] depicts a medieval legend that Saint Peter, before traveling
to Rome and martyrdom, endeared himself to Theophilus, Roman
prefect of Antioch, by raising the prefect's son from the dead. By
means of this miracle all Antioch received the gospel, the grateful
Theophilus providing a church furnished with an appropriate bish-
op's throne, where Peter could sit while expounding the new faith.
(In the classical world teachers and others in authority sat rather
than stood when they spoke to an audience; and Peter did sojourn
in Antioch and make converts there. But the larger legend—of the
miracle, the role of a bishop, and the building of a church—though
it tells us a great deal about Renaissance Catholicism's myth of itself,
has no historical validity. In the time of Jesus's apostle Peter, there
were no bishops and no church buildings. These would be later
developments. And the miracle itself is an ahistorical fantasy.)

The panel very nearly returns us to the time—a century
earlier—of the great Giotto, whose vibrant sense of color, rounded
volumes of figures, and close human interactions on a single plane
are clearly the models that light Masaccio's imagination. At the
same time, there are no undraped nudes in Giotto's work, not even
one so obviously prepubescent as Theophilus's son.

So let us turn to Masaccio's extraordinary adult nudes, to be
found in the same chapel. Masaccio worked on this sequence with
an older master, Masolino, and, for the sake of comparison, it is
worth our taking a look first at Masolino's *Adam and Eve* [Plate 8],
who seem to have been prepackaged to receive a PG–13 rating. They
have no more human reality than Barbie dolls, their genitals might
as well have been designed for assembly-line reproduction—and
what are those slight protrusions on Eve's chest supposed to be?
Surely, not breasts? Okay, the proportions of the figures are fairly
accurate and, uh, standard, but their bodies have none of the tactil-
ity of real flesh.

Next panel [Plate 9]: *Adam and Eve*—painted by Masaccio—as
they are thrown out of Eden. (Masaccio seems to have been, too.)
The figures are less standard, even less accurate, than Masolino's:
Adam's arms are far too short, his right calf is impossibly bowlegged;
Eve's arms are of unequal length and she is dumpier than in Maso-
lino's version, with a fat back and hefty haunches and an awfully

thick right ankle. But they are alive, believable, fleshy!—and being pushed forward into all the horror of real life. Adam's stomach, sucked in and emphasizing his vulnerable ribs, displays the tension of inconsolable grief; Eve's hands, placed to shield her *belles choses* (and copied by Masaccio from the teasing poses of ancient Venuses), have been transformed into demonstrations of irremediable shame. Her breast, peeking out above her wrist, is a real breast; and Adam's genitals are downright funky—not smoothly attractive, not ready for the style section of the Sunday newspaper, just their grotty selves. Never before had such nudes been seen or even thought of. How far they are from the ideal figures of the ancients, as well as from the self-censoring expressions of so many Christian centuries.

You could say that Masaccio was inspired by the terrible event of the Expulsion from the Garden, which gives his depiction more drama and more forward force than was possible for Masolino, stuck with portraying the perfection and utter tranquility of the Garden itself. You could say that—but it doesn't fully explain Masaccio's embrace of these raggedy-limned but fully human bodies.

Masaccio never finished his work in the chapel; it would be completed many years later by Filippino Lippi in accordance with illustrative instructions Masaccio left behind. Masaccio died at Rome three years after abandoning work on his frescoes and just short of his twenty-seventh birthday. According to gossip of the time, he was poisoned by a rival painter. Some, probably much, of his work was subsequently destroyed.

The second influence on Botticelli that we must have a quick, morning-bus-tour glance at is Piero della Francesca. Piero, deserving of far more attention than we shall have space to devote to him, was an outsider in Florence, having been born in Borgo Sansepolcro (the Village of the Holy Sepulcher) at the opposite end of Tuscany in the vicinity of Arezzo. His extra-Florentine roots did not assist his fame: in his own time and for centuries thereafter, his works were treasured by local inhabitants in the towns where they were displayed, not becoming universally known much before their championing by the English critic Walter Pater in the nineteenth century. But unlike poor Masaccio's, Piero's was a long life: he died in his mid-seventies, though he seems to have stopped painting as much as twenty years before his death because, in all likelihood, he was

going blind. In contrast to Masaccio's sparse surviving output, works by Piero may be found throughout Tuscany, in Venice, Rimini, Urbino, Perugia, Milan, and even Rome (a nearly destroyed fragment of fresco) and hang today as far afield as Berlin, Lisbon, New York, Boston, Williamstown (Massachusetts), and especially London, where the English have been conducting a long-standing love affair with this artist's work. Squadrons of British tourists may often be encountered throughout northern Italy in their sensible walking shoes, hard on the "Piero della Francesca Trail."

This national fascination with Piero actually saved a painting of his from destruction. In a collection of travel essays published in 1925, Aldous Huxley had called Piero's *Resurrection* [Plate 10], the fresco that decorates the Museo Civico of Sansepolcro, "the greatest picture in the world." In the last days of World War II, as British soldiers began shelling Nazi-occupied Sansepolcro with the intention of reducing it to rubble, their captain, Antony Clarke, was trying to recall where he had heard the name "Sansepolcro" before. Suddenly, he remembered reading Huxley's description—of a fresco Clarke had never seen in a Tuscan village he had never visited—and he called off the shelling. Soon thereafter, the Brits received a message informing them that the Germans had already retreated from the neighborhood, so continued shelling was unnecessary. Thanks to Captain Clarke's tenacious memory and discerning sensibility (and to Huxley's extravagant praise), both the village and the fresco survived the war.

Is Piero's *Resurrection* the greatest picture in the world? Whether it is or not, it is surely a prime example of Piero's treatment of human figures, which pop out from their two-dimensionality almost as if they were exceedingly subtle holograms. Even in their unruffled dignity and stillness—what Huxley terms Piero's "passion for solidity"—they are hologram-like. Few poses in all of art are more definite, more authoritative, than the planting of Christ's left foot at the edge of the sarcophagus (or *san sepolcro*), silent medium between Heaven and earth, life and death. The strapping Roman soldier in brown is Piero himself, and his head resting against the shaft of Christ's banner (a Guelph* banner, what else?) indicates the sleeper's

* The Guelphs were the party of Dante—and of all the good people of Florence. See *Mysteries of the Middle Ages*, pages 276–77.

own silent hope of resurrection. For Huxley, the scene incarnates all the most noble qualities of the best ancient and the best Renaissance art. "A natural, spontaneous and unpretentious grandeur—this is the leading quality of all Piero's work. He is majestic without being at all strained, theatrical or hysterical—as Handel is majestic, not as Wagner." His risen Christ is not the usual portrayal, but in Huxley's view "more like a Plutarchian hero than the Christ of conventional religion. The body is perfectly developed, like that of a Greek athlete. . . . It is the resurrection of the classical ideal, incredibly much grander and more beautiful than the classical reality, from the tomb where it had lain so many hundred years."

The other image of Piero's that I would have us examine points in its singularity of subject to the singularity of Piero's imagination: *La Madonna del Parto* [Plate 11], the Madonna of Childbirth, the only treatment of this subject in the history of art. Piero has surrounded his main figure, a patently pregnant Mary, with twin angels engaged in a ritualized drama of presentation. What they are presenting to us is a woman of severe dignity who is nonetheless about to deliver a child. The Italian *parto* can mean either labor or delivery. If Mary is in labor, she is not at this moment experiencing a severe contraction. On the other hand, in classical theology, she did not actually experience labor, since medieval theologians reasoned that a child passing through the birth canal would rupture her hymen, rendering the Ever-Virgin no longer virginal.✝ Thus, they imagined, the infant Jesus appeared in her arms, having passed miraculously through the wall of her womb without the usual labor necessary to birth. If such speculation seems rather silly to our contemporary ears, it was something Catholic orthodoxy once took with high seriousness (and still does, at least among its more unhinged partisans).

So what is Piero depicting here? I'd say we are looking at Jesus's mother experiencing the first stirrings of his birth—which permits the artist to stay clear of the knottier aspects of the ascendant theology. He doesn't need to allude to what happened next—though in his way he does prompt the viewer to specu-

✝ These are complications that never occurred to Matthew and Luke, the narrators of these events in the gospels. For a complete treatment of the function of virginity in the gospel narratives, I commend to the reader the extraordinary *God and Sex: What the Bible Really Says* by the exquisitely precise American scripture scholar Michael Coogan.

late on that next stage of *il parto*. In the midst of such quiet dignity, is the woman about to fall to the ground screaming in pain? But theology aside, there is once again Piero's uncanny ability to render aloof figures with an "unpretentious grandeur" that leaves us in awe.

Piero's uncommon sense of spatial depth emerged not only in painting but in architecture. His two Latin treatises, *De Prospectiva Pingendi* (On Perspective in Painting) and *De Corporibus Regularibus* (On the Rules for Bodily Masses), were among the most influential scientific and theoretical writings of his time. The panel in Urbino's National Gallery labeled *Ideal City,* though not painted by Piero, is a vivid demonstration of his architectural ideas.

Both Masaccio's sense of the flesh and Piero's respect for the architectural impact of the individual figure will find new life in the supremely lovely work of Botticelli, who also comes as close as any great painter ever did to the gorgeously pretty. What a celebration of bodiliness is the smashing, jaw-droppingly beautiful *Primavera* (Springtime) [Plate 12], a complex image that, like Leonardo's much simpler *Vitruvian Man,* seems to sum up and ritualize an entire current of human experience.

In a densely, darkly imagined orange grove, its ripe fruit ready to hand, its wildflowers springing to abundant life beneath our feet, there emerges a procession of renowned figures: Venus, goddess of Love, commanding her central place, blindfolded Cupid above her head (for attraction is always blind in the sense of irrational and unprovoked), aiming his arrows everywhere. The male figures—Mercury to our left, winged Zephyr to our right—serve as framing devices to the central tableau of women. The Three Graces, those ancient bestowers of beauty, charm, and the enjoyment of life, in arabesques of elegance dance their eternal dance. From the union of stinging but unavoidable Zephyr, the west wind of March, and the bedazzled goddess Flora,✚ already in his blue embrace, there issues Primavera, already standing, or, more accurately, floating from her mother's embrace

✚ This figure is originally called Chloris. She becomes the goddess Flora upon congress with Zephyr. Her feast of May 1 was observed with wild delight by the ancient Romans. The *Ludi Florales* (or Floral Sports) were actually celebrated from April 28 to May 2 and were conducted, in the dry description of *The Oxford Companion to Classical Literature,* "without much restraint." This background was known to Botticelli.

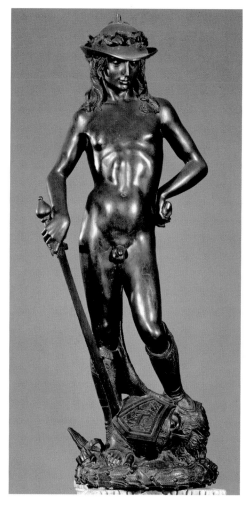

1. Donatello, *David*, 1440s

2. Donatello, *Mary Magdalene*, c. 1457

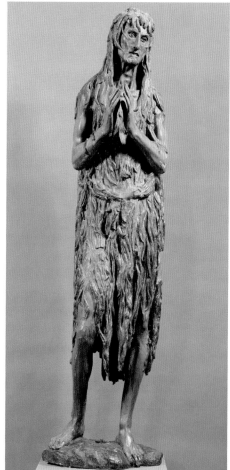

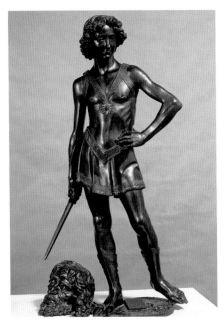

3. Verrocchio, *David*, c. 1476

4. Verrocchio, *Baptism of Christ*, 1472

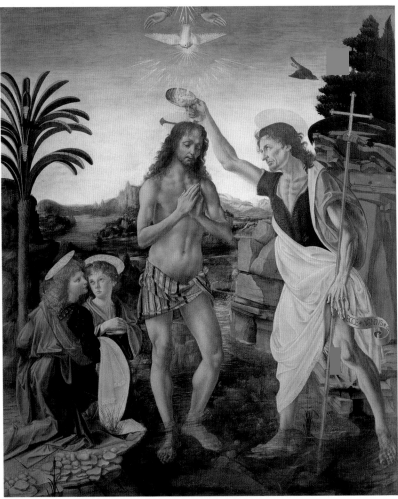

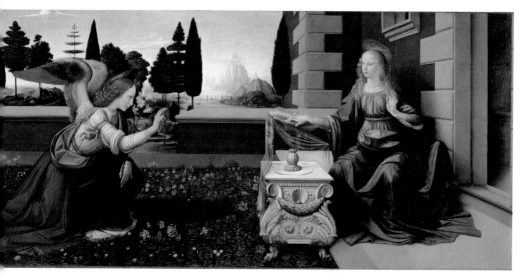

5. Leonardo, *The Annunciation*, c. 1472

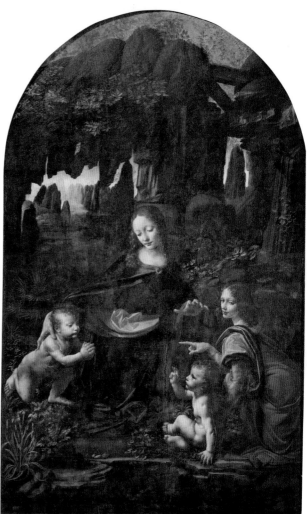

6. Leonardo, *The Virgin of the Rocks*, 1482–83

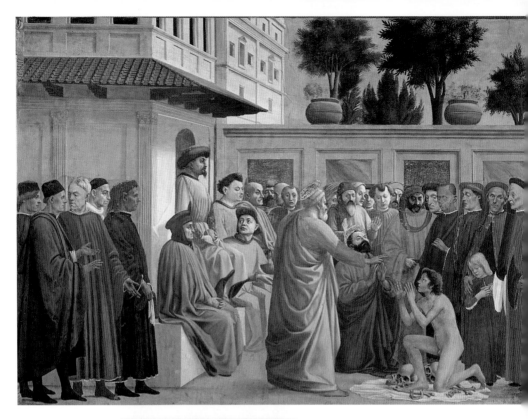

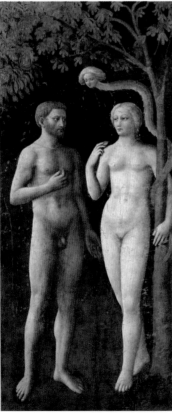

8. Masolino, *Adam and Eve*,
c. 1424–25

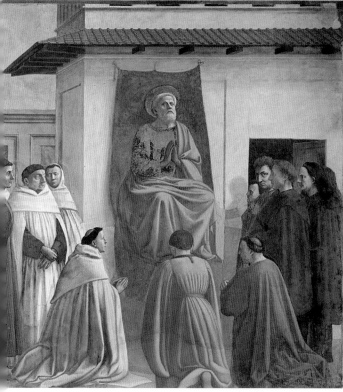

7. Masaccio, *Raising of the Son of Theophilus and Saint Peter on His Throne*, 1425

9. Masaccio, *Adam and Eve*, c. 1425

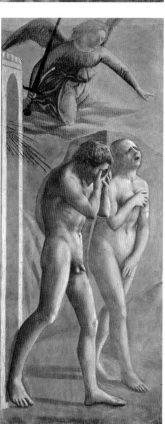

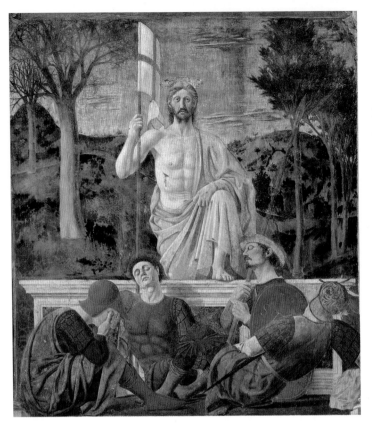

10. Piero della
Francesca,
Resurrection, 1458

11. Piero della
Francesca,
*La Madonna del
Parto*, c. 1465

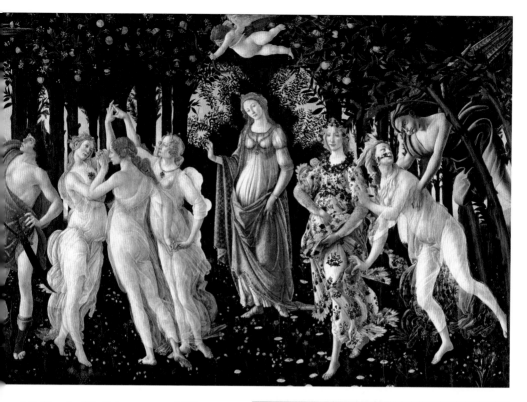

12. Botticelli, *Primavera*, c. 1482

13. Botticelli, *Athena and the Centaur*, c. 1482

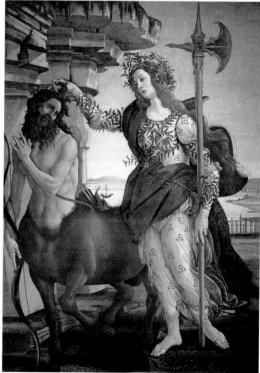

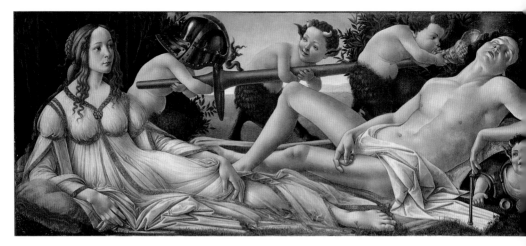

14. Botticelli, *Venus and Mars*, c. 1483

15. Botticelli, *The Birth of Venus*, c. 1485–87

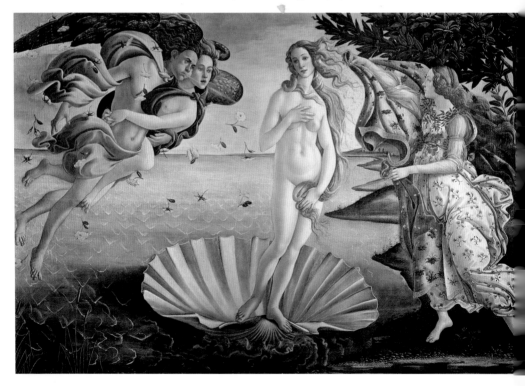

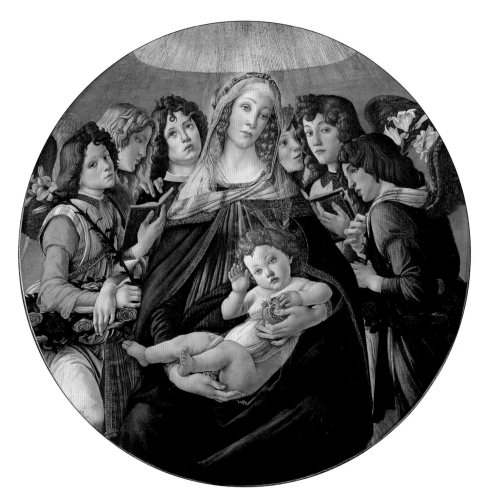

16. Botticelli, *Madonna of the Pomegranate*, 1487

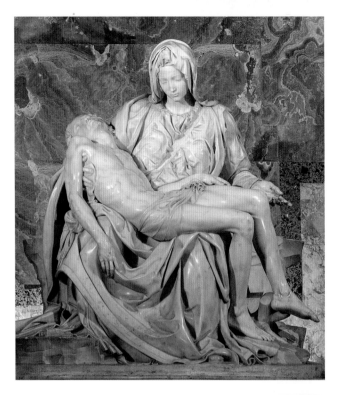

17. Michelangelo, *Pietà*, 1498–99

18. Michelangelo, *David*, 1504

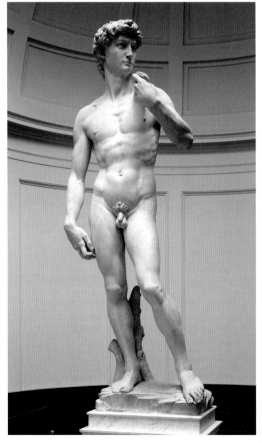

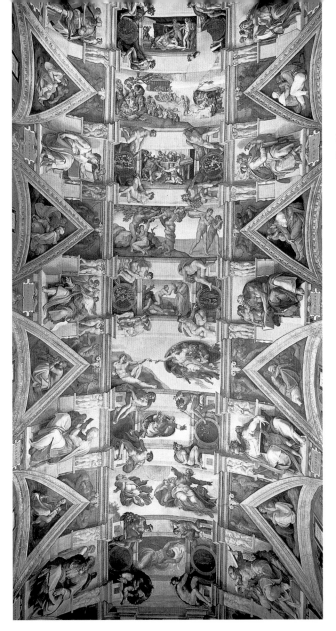

19. Michelangelo, Sistine
Chapel ceiling, 1508–12

20. Michelangelo, *The Creation
of Adam* from the Sistine
Chapel ceiling, 1508–12

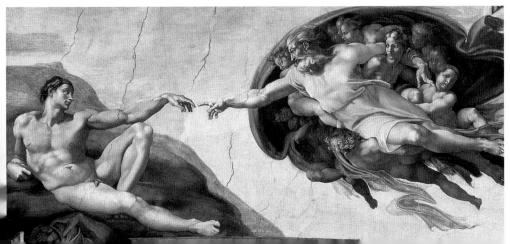

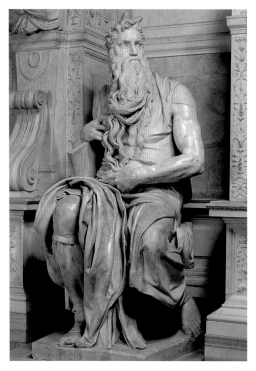

21. Michelangelo, *Moses*, c. 1513–15

22. Michelangelo,
The Last Judgment,
1537–41

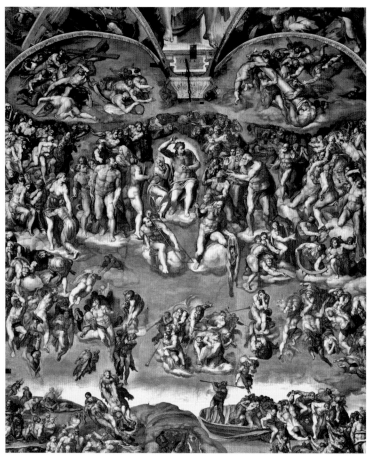

23. Caravaggio, *Sick Bacchus*, 1593–94

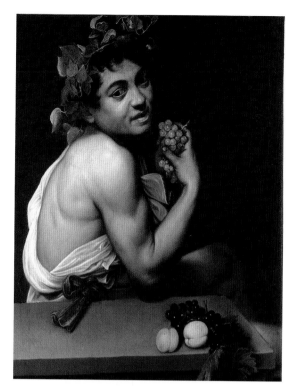

24. Caravaggio, *Basket of Fruit*, 1599

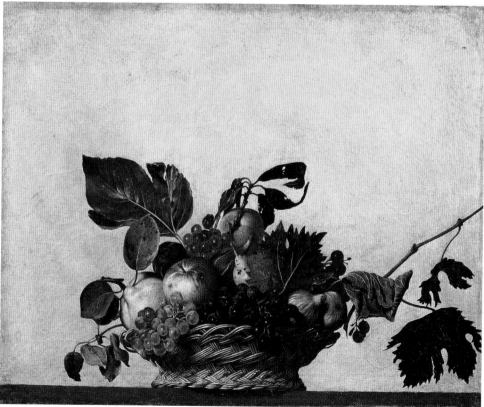

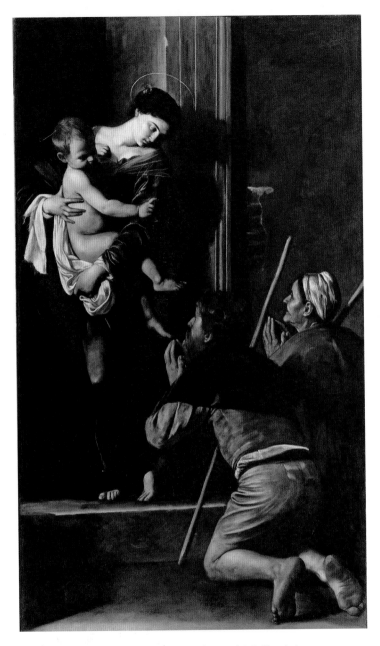

25. Caravaggio, *Madonna dei Pellegrini*
(Our Lady of the Pilgrims), 1604–06

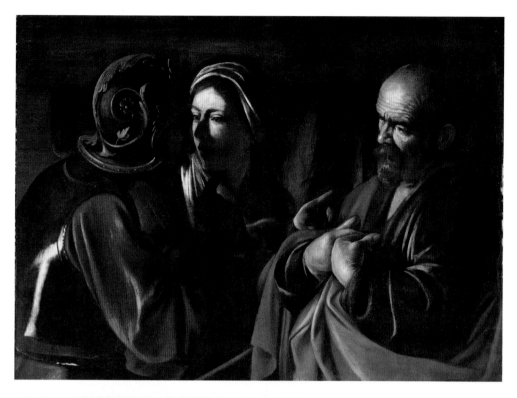

26. Caravaggio, *The Denial of Saint Peter*, c. 1610

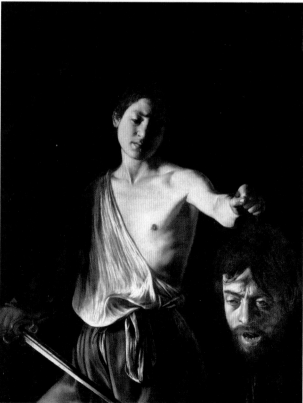

27. Caravaggio, *David with the Head of Goliath*, c. 1610

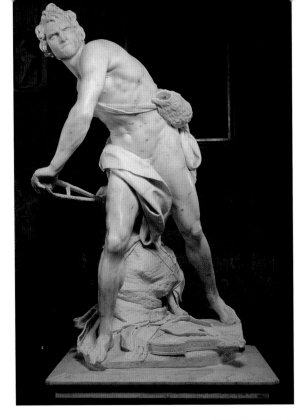

28. Bernini, *David*, 1623–24

29. Bernini, *Saint Teresa in Ecstasy*, 1647–52

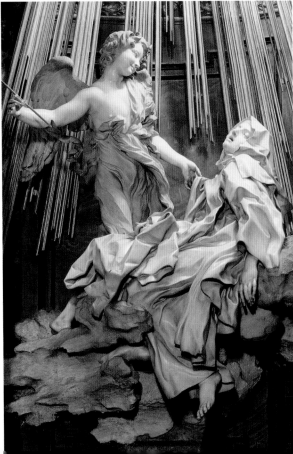

toward the middle of the orange grove, Primavera crowned, neck-laced, cinctured, and dressed in every conceivable flower (more than five hundred plant species have been identified in this panel) and scattering large blooms of white, pink, and deep rose from the ample lap folds of her diaphanous dress. What an assembly greets us here!

These words are a defensible description of what we see. But the ultimate meaning of the allegory and especially its judgment on the human enterprise have been hotly debated for centuries, not surprising for a picture as suggestive as this one. Rather than pursue each of the vagaries of possible interpretation, I shall keep to the main road. And to do so, we shall need to invoke Plato, or rather Plato as seen through the eyes of his Christian interpreters—for Plato himself, who wished to banish all the witchery of poetry, art, and music from his ideal Republic, would never have countenanced such an extravagant display as Botticelli offers us here.

In the course of the Christian centuries, and especially in the time of Lorenzo's Platonic Academy, many of Plato's central asser-tions had been softened, almost without anyone noticing. One could now think human flesh a fine thing—the creation, after all, of God himself—rather than simply a rotting appendage to one's immortal soul. Beyond this, the dark, fated, gloomy world of the Greeks (on full display in their tragic dramas, which end always in ruin, catastrophe, and abomination) had been lightened by the Gospel of Jesus (the Word of God made flesh), in which our end was to be found in eternal light and love, which is why Dante's great poem on the meaning of the human enterprise was entitled not *Tragedy* but *Comedy*—a viewpoint that would have made no sense to the ancients. Christian readers of Plato, such as Lorenzo and his philosophical and artistic friends, had of course made connections of their own between the myths of the ancients and the stories of Christianity—to such an extent that the two sets of literature and legend were now woven together in a sort of confluent whole that neither the ancients nor the Christians of the first centuries, who looked upon the pagans merely as poten-tial converts, could ever have imagined.

How far we have come from more primitive Christian approaches to the

* Dante called his poem *Commedia*. "La Divina" was added later.

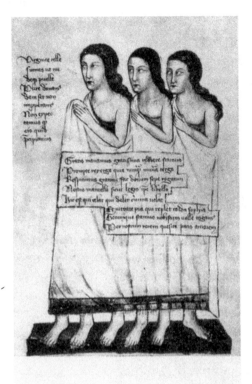

body. To review this progress visually we have only to glance at a twelfth-century depiction of the *Three Graces* in an Austrian manuscript. Poor, shapeless ladies, hovering behind their blanket, their unattractive feet splayed out before us, their barely functional legs just visible through their very necessary covering. Please, ladies, whatever you do, don't drop that blanket.

But back to Botticelli. Venus, the central figure, is no longer just the ancient goddess of Love; she is now *Humanitas,* humanness, humanity itself, her dress the expression of Botticelli's own time (as all instances of humanity must be set in a particular time), her face observant, thoughtful, expectant, haloed by the arbored arch of Nature. Here is humanity at its best, embodiment of the ideal. This sense of ideality, this enfleshed symbolic presence, has been made possible by the combination of an ancient sense of symbolism, to be found especially in the writings of Plato, and of a more hopeful, optimistic outlook on the world than the ancients could ever have achieved. What humanity is observing is the repeatable drama

of Nature, seen under the aspect of *its* ideal, springtime. Symbolic ideals are shown in the manner of the ancient Greeks, pretty much absolved of clothing or adorned with the kind of clothing that makes the figures almost nuder than if they were merely nude. And these barely but beautifully draped figures are not only female: they are voluptuously female, females such as any male, however windy, would wish to impregnate, Zephyr's intended target winking alluringly through Flora's transparencies.

So why then is Mercury, the quick god with wings on his feet who delivers messages, turned away from all this sensuous fecundity? He's using his caduceus, his famous serpent-entwined herald's staff, to dispel rain clouds. More than this, it appears that he is summoning our eyes to something beyond. Indeed, the panel's figures have been staged in such a way that our eyes are naturally drawn from right to left: from Zephyr's importunate entrance to each of the six female figures to Mercury and past him to something outside the panel altogether.

Horizontal panels such as this were normally created to hang above daybeds in elegant palaces—and Italian daybeds were not intended just for napping. *Primavera* was hung in a house of the Medici, and we have good reason to believe that to Mercury's right there hung a smaller panel by Botticelli: *Athena and the Centaur* [Plate 13], in which Athena, the reasonable goddess of wisdom, tames a hairy centaur, the very figure of human animality, by pulling his hair. Athena's beautiful, vine-encircled breasts, at least as prominent as her serious expression, seem almost to offer a possible escape from the picture's main message, which is that human reason and wisdom should tame human bestiality. Shall we, relaxing on our daybed, be moved to imitate Zephyr and the breezy ladies who celebrate springtime? Or shall we contemplate more soberly the triumph of wisdom over our animal nature? Hmm.

It seems clear that Botticelli himself was conflicted as to which resolution the siesta-takers should favor. At this point in his life, Athena is something less than his central ideal. Marginalized in a small panel beyond the fecund grove, she can hardly compete with the luscious *Ludi Florales*. But there is in Botticelli an ambivalence that twinkles at us through the translucencies.

It appears in another guise in another daybed panel, the post-

coital *Venus and Mars* [Plate 14], in which Mars, utterly spent, snores openmouthed, while Venus, neither satisfied nor disgusted, simply wonders: What was *that* about? Her expression is a masterpiece of ambiguity, as she contemplates him, their future, her future. Was Mars just too frenzied to undress her properly? Is this wham–bam, followed by insensate snoring, what life will be like? The little imps playing with Mars's weapons of war seem to undercut whatever residual dignity might have accrued to him. Though one imp blows a conch shell straight into the war god's ear, we know that not even the shrill sound of that horn can waken him.

There is at least one more daybed panel, *The Birth of Venus* [Plate 15], Botticelli's most famous painting, and in this one there is no ambiguity at all. Rather, *The Birth of Venus* seems so straightforward in its intention and so complete in its execution that it scarcely calls for commentary. Long ago I had a rather batty classics professor who always referred to this picture as *Venus on the Half Shell,* as if that were its actual title. It might as well be. The psychological connection between sex and food has never been more blatant. Venus is being served to us by chef Botticelli as the most exquisite morsel of his imagination. The face of Venus draws us. Neither as ambiguous as Venus contemplating the sleeping Mars nor as thoughtful as Venus observing the riot of Springtime, this Venus is at most calmly pensive, nearly smiling, and as sweetly content as any newborn.

Botticelli would use his sensational model for this *Venus* in other pictures as well, most notably in his *Madonna of the Pomegranate* [Plate 16]. But here Venus-Madonna seems not at all content. If the infant Jesus looks dazed, his mother looks downright depressed. No doubt the task awaiting them—redeeming the human race—would be enough to give anyone pause; and the succulent pomegranate, which was then believed to be the fruit with which the serpent tempted Eve and she Adam, surely served as a reminder of what lay before them. After this, Botticelli would give us but one more female nude, as the severe symbol of Truth in his strange and elegant *Calumny.* After *Venus on the Half Shell,* all of Botticelli's surviving pictures are religious, many of them complexly allegorical, all (except for *Calumny*'s Truth) featuring elaborately clothed females.

What happened to Botticelli's imagination? What became of his elegantly beautiful female nudes? Why did he excise them from

his later work? It may be that only one word is needed by way of explanation: Savonarola. The crabbed Dominican friar changed Botticelli's life and art as radically as any external force could possibly do, remaking Botticelli into a pious avoider of what he had formerly experienced as intense physical realities.

But there is also a more complicated possibility. Botticelli, so obviously heterosexual, never married. In fact, he claimed the very idea of marriage gave him nightmares. (In this he seems to have been at one with his Venus contemplating the snoring Mars.) But there was a rumor circulating in his lifetime that he was madly in love with Simonetta Vespucci, the honey-haired, creamy-fleshed model for *The Birth of Venus*. By the time Botticelli painted her as the *Madonna of the Pomegranate,* she was long since dead. Botticelli, who outlived Simonetta by thirty-four years, certainly never forgot her, for he asked to be buried at her feet. And there to this day his body lies at the foot of Simonetta's grave in Florence's Ognissanti, the Church of All Saints.

If any Renaissance artist—or, for that matter, any artist in history—is worthy of being approached on one's knees, that artist is Michelangelo, *il Divino,* as he was hailed in his lifetime. He was born at Caprese, near Arezzo, in Tuscany; his parents were Florentines, and to Florence they returned within months of his birth. During his early childhood, however, his mother died, after which he was fostered out to the family of a stonecutter who lived in Settignano, a village with dramatic views, set on a hillside just northeast of Florence; and there he came in contact with the medium that would bring him such fame: marble. "If there is any good in me," claimed Michelangelo to his biographer Vasari, "it is because I was born in the subtle atmosphere of your country of Arezzo. Along with the milk of my nurse I received the knack of handling chisel and hammer, with which I make my figures."

Whether those claims are true, romanticized, or a biographer's inflation, the words sound very much like Michelangelo, a man capable of humility and arrogance in the same sentence. He cared not a whit for riches, nor even for food or clothing. Throughout his long life of eighty-nine years he remained lean and muscular, silently

despising those who were otherwise. He often slept in his clothes, not even bothering to remove his boots, and he never bathed. He cared only for the perfection of his art. He believed that every block of marble already contained a perfect form within it and that it was the task of the sculptor to free that form by chipping away all excess. To fall short of releasing such perfection was a moral as well as an artistic failure. He was often as dissatisfied with himself as he could be with others. An unsmiling loner, he hardly encouraged apprentices to attach themselves to him. Another early biographer, Paolo Giovio, wrote that "his nature was so rough and uncouth that his domestic habits were incredibly squalid and deprived posterity of any pupils who might have followed him."

In many ways he was the opposite of Leonardo, the only other Renaissance artist who can approach him for greatness. Whereas Leonardo loved the natural world with the eye of a draftsman and the mind of a scientist, Michelangelo, Platonist to his core, saw little value in nature as such or even in the flesh as it actually is. The ideal form: that was what he wanted. Because of this, he looked down on painters as piddling draftsmen: they were as nothing compared to sculptors, who could release forms of such dynamic power as to remake mere nature and overwhelm the viewer completely.

At thirteen, Michelangelo was apprenticed to the Florentine painter Domenico Ghirlandaio.✝ By the age of fourteen, the boy was already being paid a salary by Ghirlandaio, a most unusual development. In the same year, Lorenzo de' Medici called Michelangelo to be part of his court, to roam through his gardens, and to behold—and to touch—his precious collection of classical statuary, then under the supervision of old Bertoldo di Giovanni, who had long ago been a student of Donatello's. Michelangelo, teaching himself by trial and error—copying earlier works, especially paintings by Masaccio, experimenting with the fash-

✝ "Ghirlandaio," a nickname meaning "Garland-maker," refers to the fact that this artist started out as a designer of garland-shaped necklaces for his goldsmith father. The graceful necklaces were much treasured by the jewelry-loving women of Florence, but Ghirlandaio also went on to become an important painter, though his work shows little influence on the work of Michelangelo. Nonetheless, artistic-intellectual Florence comprised a tight social circle: for example, one of Ghirlandaio's earliest panels, the *Madonna of Mercy*, decorates the wall above the sepulcher of Simonetta Vespucci.

ioning of clay figures—soon felt himself ready to sculpt. By the age of fifteen or sixteen he had already produced two extraordinary bas-reliefs, the *Madonna of the Steps* and the *Battle of the Centaurs,* completely different from each other and so assured that the viewer finds he can credit the artist's youth only by an almost painful contortion of faith. The young loner had also had a savage fistfight with another teenage *artista,* leaving Michelangelo with a squished nose for the rest of his life.

In the same period, the boy also carved in wood a slender and utterly nude Christ, nailed to his cross, a figure we may or may not still possess. This crucifixion was made as a gift to a local pastor who had allowed Michelangelo "a room to work in and bodies to study." The bodies were, of course, corpses entrusted to the church for burial. Michelangelo was most grateful for the opportunity that the priest gave him to make this secretive study of anatomy—not an easy thing to pull off in those days—"for he could imagine nothing which would give him more pleasure" than to study these bodies.

The study certainly paid off. By his early twenties, Michelangelo was sculpting some of his most startlingly accomplished works, including a plumply muscular and inebriated Bacchus, god of wine and dark dreams, uncertain of his footing and trailed by a small but scary faun. The faun, smiling his creepy smile and sucking on bunches of grapes, clutches the lion skin that Bacchus holds indifferently in his left hand. The lion skin, symbolic of death and opposed to the life-giving power of the grapes, elegantly underlines Michelangelo's meaning: self-indulgence in life leads to death.

Had Michelangelo been spending too much of his time amid corpses? Apparently not. His next work displays a grasp of human anatomy seldom if ever surpassed in the history of art: a *Pietà* [Plate 17], his first but hardly his last interpretation of the subject. The Italian word has many grades of meaning: pity, compassion, mercy, piety, devotion. Capitalized, however, it refers to a scene not found in the gospels but considered by medieval piety to be appropriate to the biography of Jesus: after the dead Jesus was taken down from the cross and before he was entombed by Joseph of Arimathea, it was imagined that his body would have been laid in the arms of his mother, Mary, who had followed him to his crucifixion (at least as reported in John's Gospel). This unlikely scene is made even more

unlikely by the difficulty of setting a grown man's body in the lap of his (presumably) smaller and weaker mother. The medieval attempts at illustration are invariably awkward and unconvincing.

Michelangelo's solution is extraordinarily clever, to such an extent that viewers are seldom aware of the visual trickery. Jesus is slightly smaller than his mother, but her draperies and her wide-kneed position successfully mask that reality. Moreover, the body of Jesus, slouching loose-limbed in an intensely realistic imitation of death, serves—along with Mary's pose and her ample skirts—to attract our attention and to further mask the difference in the respective weights of the two figures. Perhaps even more important, the anatomy of Jesus is so exquisitely detailed as to demand soon enough almost our whole attention. But if that attention should stray, it will inevitably stray to Mary's once-nurturing breasts, emphasized by the cross-band that slices through them and by the gathered cloth, and to Mary's ever youthful but spiritual face, just bending forward over the body, resigned but—mysteriously enough—not inconsolable. She knows what has happened and why this was necessary.

Michelangelo was twenty-three when he finished this *Pietà*. His contempt for human self-indulgence and his sense of the need for human suffering will only grow as he ages. But it is worthy of note that this most loyal Platonist of all Renaissance artists, loving the reality of symbols, eschewing the follies of the flesh, is also an intensely loyal Christian, whose reverence for the episodes of the gospels and whose belief in the reality of the Redemption can be second to none. It is also worthy of note that Michelangelo's piety takes at times an almost northern European turn. Before his *Pietà,* this grouping had been found almost exclusively north of the Alps, where it was called *das Vesperbild* (the Evening Image). As the respected contemporary critic Lutz Heusinger, professor of art history at Marburg, the original German Lutheran university, has written: "North of the Alps . . . the portrayal of pain had always been connected with the idea of redemption." If Michelangelo's Tuscan Platonism gives his *Pietà* a sinuosity that would be impossible for any German artist of this period, we should still bear in mind that Michelangelo's mind and heart were open to very non-Italian and, from a strictly Roman Catholic viewpoint, dubiously orthodox Christian influences.

In the summer of 1501, Florence, after a long period of political chaos, was declared a republic once more, and friends of Michelangelo entered the government. Little more than a week after the declaration, Michelangelo was commissioned by Arte della Lana, the powerful wool guild, to sculpt a new *David* [Plate 18] that was to symbolize resurgent Florence. The result would be the most famous of all Davids, a historic symbol not only of Florence but of the human spirit. Michelangelo had spent his time well in the gardens of Lorenzo il Magnifico, where he seems to have learned all the secrets of the ancient Greek sculptors, none more valuable than their appreciation for what Italians came to call *il contraposto* (the opposition or antithesis), the art of sculpting a human body so that one half of it stands in opposition to the other half.

The earliest sculpture of every culture is symmetrical. On my desk, for instance, sits an ancient Canaanite fertility goddess—only her head is missing. But from her necklace a vertical line can be drawn reaching down the middle of her body, from her clavicle to the soles of her feet. On either side of this line her body appears in perfect symmetry, left shoulder mirrored by right shoulder, left breast by right breast, left hip by right hip, left leg by right leg, left foot by right foot. The only movement is in her forearms and her hands, her left hand pointing to her vulva, her right hand offering her left breast. This movement is an innovation, setting off this figure from the oldest prehistoric fertility figures, such as the Venus of Willendorf, which were rigidly symmetrical in all aspects.

The Greeks realized that such poses could quickly become static and boring and that the way to stir the viewer's interest was to take even further such minimal movement as can be found in my Canaanite goddess and, in effect, force the sculpted body into a swivel, so that it will appear almost living. Thus, Michelangelo's *David* stands in the Greek manner with his weight on his right foot, his whole right side at rest, even the right side of his face very nearly tranquil. But his left side is already moving forward, his left foot having taken its first step, his left buttock tensed, his left elbow jutting, his left hand (for like Leonardo, Michelangelo was left-handed) grasping the slingshot that will bring down the giant Goliath, the left side of his face resolute, ready, almost angry, even the curls of the left side of his head more tousled than those of his right.

Though the pubic hair and the dropped testicles alert us to the fact that David is no child, the oversized hands and feet (features the Greeks would have shunned as inelegant) remind us that this boy is still growing and possibly a little awkward. The breastbone pushing through his chest (another non-Greek feature) even elicits our tenderness for this boy-man. Though completely nude, this is no Donatellesque toyboy. Rather, to use an expression found in many languages, he's got balls:* this is a serious, even a grim figure, shown to us in his last moment before the decisive battle, when all is at stake.

A committee of citizens (including Leonardo) decided that the extraordinary work must be exhibited in Florence's central square in front of il Palazzo Vecchio, the town hall. "It was," remarks Heusinger, "the first time since antiquity that a large statue of a nude was to be exhibited in a public space." Though local newsstands today sell postcards displaying, among other views of the statue, a close-up of David's genitals, this is just an example of contemporary embarrassment before herculean greatness: there is nothing sexually suggestive about this *David*. Michelangelo would have pulled down the newsstands in short order.

What could an artist be expected to accomplish as an encore to a feat of such consummate grace? Why, the Sistine Chapel ceiling, of course.

When, at the command of the newly elected Pope Julius II, Michelangelo came to Rome in 1505, he was just turning thirty. He brought with him not only his own colossal talent but the entire Italian Renaissance, which till then had been almost wholly confined to Tuscany, largely to Tuscany's capital. Julius, a titanic figure possessed of a will to match Michelangelo's in strength, wished to build a tomb for his own eventual interment, and this the pope envisioned as an enormous freestanding monument with forty-five life-sized statues, to be constructed in a manner so grand that its like had not been seen since the burials of great men in ancient times. Michelangelo, the pope thought, was the obvious fellow for the job.

As the young artist settled into his work, the pope—at twice Michelangelo's age—began to have trouble finding the right venue for his elaborate funerary erection. Meanwhile, he decreed, Michelangelo could

* *È uno coi coglioni* in Italian.

keep busy by helping with plans for the new Saint Peter's Basilica. Michelangelo, failing to obtain an audience with the pope to discuss these matters—and even barred by an officious little footman from entering the pope's chambers—fled Rome. Soon enough, the artist found himself confined to Bologna and forced to work on most unwelcome tasks. Back in Rome by 1508, he was still prevented from working further on Julius's tomb. Rather, the mercurial Julius decreed, Michelangelo could occupy himself by painting the ceiling of the Sistine Chapel.

In order to perform this feat, Michelangelo, who, as we know, despised painting, had to learn the elaborate art of frescoing, something he'd never done before—but, as we also know, Michelangelo was an incredibly quick study. Now, as Michelangelo grudgingly accepted the limits placed upon him by the pope and began to plot a complex scheme for the ceiling, Julius II "allowed himself to be carried away by Michelangelo's creative violence and the two inspired each other in turn with always grander designs," to quote Heusinger.

The result was the most splendid work of this reluctant artist's amazing career, a progressive set of illustrations of salvation history that to this day fills every viewer with an awe that overwhelms whatever historical or theological preconception one may bring to the chapel, drowning any and every objection you may wish to pose between yourself and this ceiling and finally exalting you mercilessly in its very nearly blinding illumination. As Yeats would put it:

Michael Angelo left a proof
On the Sistine Chapel roof,
Where but half-awakened Adam
Can disturb globe-trotting Madam
Till her bowels are in heat,
Proof that there's a purpose set
Before the secret working mind:
Profane perfection of mankind.

It may be profane in the sense of its pagan roots in art history, but it is also deeply religious, profoundly rooted in the

artist's—certainly not the warrior-pope's—biblical faith. While Michelangelo remained for four years wedded to the pope's ceiling and his own elaborate plan for it, the equally busy pope—in silver armor—was leading papal armies through northern Italy, forming a holy league with Venice and Spain, then with England and Switzerland, driving the French from Italy, and adding Parma, Piacenza, and Reggio Emilia to the Papal States.

Michelangelo, meanwhile, was gradually being crippled in the execution of this commission, as he lay on his scaffold straining himself unnaturally toward the ceiling, ending up with a goiter in his throat and most of his muscles and joints pushed out of shape. As he put it in one of his many excellent poems:

> La barba al cielo, e la memoria sento
> in sullo scrigno, e 'l petto fo d'arpia,
> e 'l pennel sopra 'l viso tuttavia
> mel fa, gocciando, un ricco pavimento.

> My beard toward Heaven, I feel the back of my brain
> Upon my neck. I grow the breast of a Harpy:
> My brush, above my face continually,
> Makes it a splendid floor by dripping down.

> . . .

> Dinanzi mi s'allunga la corteccia,
> e per piegarsi adietro si ragroppa . . .

> In front of me my skin is being stretched
> While it folds up behind and forms a knot . . .

Michelangelo had also to endure the curiosity of various papal insiders, as well as rival artists who, at work on other papal commissions, would inevitably attempt to steal a look at what he was up to. Raphael, in particular, was an annoyance. Eight years Michelangelo's junior, he recognized the older artist's enormous talent, but, a gifted imitator, he even tried to be appointed by Julius as Michelangelo's replacement, once he had had a peek at the "new and marvelous style" in which Michelangelo was proceeding. Had

his vile little conspiracy succeeded, we could have had a ceiling
that gradually devolved from Michelangelo's noble conceptions
to a sweetly sentimental soup. Easy, untrustworthy Raphael, bon
vivant, lover of many women, professional charmer, often painted
in a mawkish style that he knew would be popular. Cute children
and lovely women, whether the Virgin Mary or one of his current
mistresses, tended to be his favored subjects. Essentially, he went
Botticelli one better, though he lacked Botticelli's underlying seri-
ousness and owned no trace of Michelangelo's unbending nobility.
His late-night carousing shortened his life considerably: he died
while still in his thirties. Let us memorialize him here with his
sketch of *Leda and the Swan,* which he made in imitation of a lost
work by Leonardo. (More of Raphael's work may be found in the
Portfolio of Egos, which follows.)

Once Julius was able to absorb what Michelangelo was about, it
is hard to imagine his ever switching artists. Rather, the old pope
found himself ever more attached to this artist of his ceiling: he

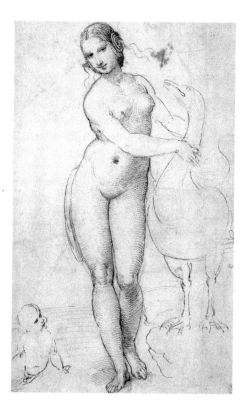

"loved him utterly," wrote Ascanio Condivi in Michelangelo's own lifetime, "and was more caring and jealous for him than for anyone else whom he had around him." And Michelangelo returned the sentiment, despite the shocking candor with which he often addressed God's Vicar. When Julius ordered him to enrich his Old Testament figures by adding some gold leaf to their draperies, Michelangelo refused outright, saying, "My Lord, they were all poor men."

The vaulted ceiling on which Michelangelo lavished such love that he became utterly loved by such a pontiff, a man exceedingly brusque and egotistical even for a pope, cannot be adequately described here, for indeed it cannot be adequately described anywhere. It contains, by my count, seventy-five principal images—both full-fledged scenes and dramatic single figures, such as a succession of Hebrew prophets and classical sibyls—each one set off by itself and framed by some architectural or trompe l'oeil effect. Kings of Israel, as well as figures from secular history, such as Alexander the Great, put in an appearance. David slays Goliath once more, as Judith decapitates Holofernes. Moreover, there are scores of cherubs and youthful nudes that serve as additional framing devices to the principal scenes and figures. And all is in aid of the central panels: the cosmic God of the Jews creating the universe and its first human beings, the Temptation in the Garden, the Expulsion, and the salvific story of Noah and the Flood.

There are whole books devoted to unpacking this ceiling, and this book cannot be one of them. Rather, we print here a photograph of the ceiling [Plate 19] and a close-up of one of the scenes—the most famous image of all: *The Creation of Adam* [Plate 20]. But to understand the "proof" that Michelangelo left for us one must, like the "globe-trotting Madam" of Yeats's poem, behold the thing in itself, not merely in reproduction. Go early in the day, taking the first bus from Saint Peter's Square at 8:30 a.m., when most tourists are still eating their breakfasts. And when the bus drops you at the Vatican Museum, do not linger over any of the astonishing riches to be seen along the way. Go straight to the Sistine Chapel. If possible, lie down on the floor. And look.

And as you look, the ceiling will greet you, welcome you, and take you in. As Elaine Scarry has described the confrontation with a

supreme masterpiece: "Not Homer alone but Plato, Aquinas, Plotinus, Pseudo-Dionysius, Dante, and many others repeatedly describe beauty as a 'greeting.' At the moment one comes into the presence of something beautiful, it greets you. It lifts away from the neutral background as though coming forward to welcome you—as though the object were designed to 'fit' your perception. . . . It is as though the welcoming thing has entered into, and consented to, your being in its midst. Your arrival seems contractual, not just something you want, but something the world you are now joining wants."

I promise you, you will feel you have come home.

When Julius died in 1513, his tomb remained unfinished. Though he had always been generous in his payments to Michelangelo (as to his many other artists)—in the process making Michelangelo a rich man—the pope probably never amassed the extraordinary sums necessary for his tomb, at least as originally planned, modern dictators never quite being able to pull off the depredations that ancient ones could manage. Julius, putting the brakes on his personal monument while sending Michelangelo off in other directions, forced the great sculptor to become both a great painter and a great architect. Michelangelo's best-known achievement in architecture is of course the dome of Saint Peter's, but there are numerous others.

Michelangelo very much wanted to construct an elaborate tomb for Julius, but both Julius's occasionally straitened circumstances and, after his death, the parsimony of his heirs made that impossible. Today, his much-reduced monument stands in a side aisle of the otherwise modest Church of San Pietro in Vincoli (Saint Peter in Chains), its paltry size a commentary on the priorities of a formerly impoverished family—the della Rovere—made rich and powerful by their famous relative's pontificate. But central to the monument is the statue of *Moses* [Plate 21], which Michelangelo considered his most lifelike creation. It is certainly a great work, as appropriate a tribute to the barely contained violence of Julius's tremendous ego as to the austerely dominating will of Michelangelo. (Each man was, in his way, a kind of Moses.) The figure's horns, a usual feature of Moses in Christian art because of a (probably) inaccurate trans-

lation of the Torah's Hebrew into Latin, seem appropriate to this muscular middle-aged man, no longer a forward-moving, athletic aspirant like the *David,* but a singular, seated, unbendable authority.

Sadly, Michelangelo's personal authority, however impressive, was no match for the authority of popes. Of the eight popes who succeeded Julius II in Michelangelo's lifetime, most were enthusiastic patrons of the arts, but they lived in different times, and far more complicated political pressures than Julius had known forced them to look upon Michelangelo with caution and even, as time went on, with suspicion.

It was, of course, Julius, always in need of funds to implement his large ideas, who struck the match that lit the fires that would encircle these later popes. To finance the building of the grand new Basilica of Saint Peter's, which would just have to be the most astounding building in all of Christendom, Julius arranged for a sale of indulgences. At the time, it seemed not at all a momentous move, almost routine, but it would serve to spark the Protestant Reformation and to help trigger, subsequently, a Catholic Counter-Reformation, the movements that will occupy us for the remainder of this book. The end result would entail the permanent fracture of Christendom.

Clement VII, a Medici bastard and the third pope after Julius II, would commission Michelangelo to paint a vast mural on the wall above the Sistine Chapel's main altar. His successor, Paul III, would reign as Michelangelo completed the commission, a seven-year project. This mural, known today as *The Last Judgment* [Plate 22], was given by Michelangelo a much more positive title, *The Resurrection.*

At its dramatic center, a muscular Christ, accompanied by the Virgin Mary, raises his right arm in a gesture of repudiation. It appears that he is assigning some to Heaven, others to Hell, a depiction of the scene of final judgment related in Matthew 25. But there is mass confusion, especially among the figures on either side of Christ and his mother. There are actually four tiers of clustered nudes: the ones on the lowest level are either in Hell or on the nearby shore of the River Styx, waiting to be ferried to Hell by an exceedingly horrific Charon. Even at this lowest level, however, there are skeletons rising from their graves, yet to be clothed

in flesh—and who knows where they will end up? On the second tier—of nudes floating on clouds—some seem about to sink below, while others appear destined to float higher. Next comes the tier with Christ, Mary, and large clusters of nudes who seem mostly uncertain as to where they will end up. The highest tier, whose floaters mostly embrace instruments of torture, are already safely Heaven-bound: the instruments they hold—a cross, a crown of thorns, a pillar—are the instruments of Christ's own passion and possibly theirs. These are the martyrs.

Except for those already arrived in Hell and perhaps those few in the second tier who seem to have already despaired, Michelangelo appears to hold out the hope that many will reach Heaven. Why then is one's initial impression that of sheer confusion or even despair? Surely, because this is part of the artist's conception—to confuse viewers initially and foist a question on them: Will I make it or not? This is meant to be—finally—a hopeful scene, but offering hope only after one has made a personal examination of one's own conscience and resolved henceforward to live a better life.

The moral was insufficient for Pope Paul III. He was shocked by so much nudity, as were many in his court—or at least they claimed to be—and the pope, egged on by his master of ceremonies, Biagio da Cesena, began objecting to the nudes long before Michelangelo was finished. To Michelangelo the nudity was unremarkable, even required: "Naked came I out of my mother's womb," insists the Book of Job, "and naked shall I return thither." By 1541 when the mural was completed, it was clear that one of the nudes in Hell, the one sprouting donkey's ears and encircled by a snake that was biting off his genitals, looked remarkably like the master of ceremonies. Biagio objected vigorously to Paul, insisting that the painting belonged in a tavern. The pope, unwilling to confront the artist, shrugged his shoulders and explained to Biagio that popes have no jurisdiction over Hell.

Papal Rome was at last singing a new and more solemn tune. Luther's Reformation and its consequences had fragmented Europe politically as well as religiously, and, like Humpty Dumpty, the continent would never be put back together again. The Catholic Church's own instrument of Reformation, the Council of Trent, was intermittently wending its tortuous way. Everyone now knew

that public scandal would only hurt the Catholic Church further. Nudes were scandalous; in fact, they were pagan, not Christian, no matter what Michelangelo might have to say about their honesty, beauty, reality, or symbolic worth.

Walter Pater would describe the aging Michelangelo thus: "The world had changed around him. The 'new catholicism' had taken the place of the Renaissance. The spirit of the Roman Church had changed: in the vast world's cathedral which his skill had helped to raise for it, it looked stronger than ever. . . . The opposition of the Reformation to art has been often enlarged upon; far greater was that of the Catholic revival. But in thus fixing itself in a frozen orthodoxy, the Roman Church had passed beyond him, and he was a stranger to it."

Once Michelangelo was dead and could no longer wither others in confrontation, a subsequent pope—the exceedingly antipathetic Paul IV—hired Daniele da Volterra, one of Michelangelo's old assistants, to paint *perizome* (loincloths) over all the visible genitals and backsides in the mural. This assistant also scraped and repainted whole figures that were judged too sexually suggestive. He never finished his work; most of it, though not all, has recently been removed.

Pants painters and pants sculptors were suddenly everywhere, concealing at the direction of the frozenly orthodox what had formerly been open to the light of day. Even a late marble sculpture of Michelangelo's, one of his best, a nude Christ bearing his cross, a beautiful figure with a beautiful face, had to be assigned its (metal) drapery. Fig leaves became omnipresent. It is a shameful human dynamic that so often in history reformation should precipitate, and then codify, hypocrisy.

1565–1680: CHARRING THE WOOD

In the straitened new atmosphere of Reformation and Counter-Reformation, it is not surprising that art took a nosedive. What follows Michelangelo is a long procession of imitators. If they're not imitating Michelangelo (who was not really imitable), they're imitating Raphael to even worse effect. They are called the Mannerists, and we will pass over them in silence.

At last we come to Caravaggio, who's the real deal. Though Caravaggio certainly would have his own imitators, he himself imitated no one. His real name was Michelangelo Merisi, a Lombardian who hailed from Caravaggio, near Milan. Quite early he set himself a course in very nearly direct opposition to his great namesake. He rejected the idea that art should be elevated in subject or ennobling of purpose. According to one of his critical contemporaries, Caravaggio "knew no master other than the model." And his model could be anyone, the odder, the more begrimed, the funkier the better. He was a realist, indeed a superrealist, in an age of idealists.

When he paints Bacchus, god of wine, his god has nothing godlike about him [Plate 23]. In fact, he's a sick kid. Sick Caravaggio was himself the model for this picture, observing his own image in a mirror, for at the time he could not afford to employ a model.

When he paints a basket of fruit—the first artist to paint a still-life since ancient times—that's what it is: a basket of fruit [Plate 24], extraordinarily real in every respect, so real it almost seems about to pop out of its frame and hit us in the face. Why had still-life subjects dropped out of art? Because they weren't considered sufficiently significant. Symbolism? Drama? Yes, there are symbolism and drama, if you consider that in this deceptively simple image Caravaggio shows us green leaves and brown, healthy fruit and spotted. Think whatever you like, Caravaggio would have said, it's just a basket of fruit.

Even Caravaggio's pictures of traditional religious subjects, painted as commissions for the usual cast of cardinals, titled patrons, and wealthy merchants, were shocking in their sheer nitty-grittiness. His *Madonna dei Pellegrini* (Our Lady of the Pilgrims) [Plate 25] provoked enormous consternation when it was first displayed in the Roman Church of Sant'Agostino, where it may nonetheless still be seen. Who is the utterly ordinary-looking woman holding a child who might be seen in any backstreet of the city? Why, she actually seems weighed down by him. Is her forehead glowing, or is she sweating? What poor hovel is it that she is emerging from? Why is there so much darkness, such obscurity? And those unthinkable peasants on their knees! Without boots! And with their dirty legs and filthy feet!

The first audiences to view this picture were scandalized by its lack of reverence and propriety. Caravaggio would no doubt have answered as did Michelangelo to Pope Julius, "But they are all poor people." Nor was Caravaggio lacking in religious conviction. Among his very last paintings is *The Denial of Saint Peter* [Plate 26], in which Peter, achingly frightened, abjectly ashamed, denies that he knows Jesus on the night of his arrest. It is the very picture of the sinner in horror at himself as he commits his sin. It is, by far, the most effective (and affecting) image ever made of this scene, though one might say upon examination that it could very nearly have been painted by Rembrandt, a spiritual son of Caravaggio.

We have seen in the course of our bus tour several Davids. Caravaggio was also drawn to the subject of the young David, but whereas our other artists tended to imagine themselves (more or less) as David himself, Caravaggio at the end of his brief life imagines himself as the beaten Goliath, his head already severed from his body. The face of Goliath, modeled on the artist's own, is now a ravaged face, disfigured in one of his many knife fights [Plate 27]. This was a man who knew the depths of his own darkness, who saw himself (though he would never have admitted it) as God's own charcoal. In the words of Francis Thompson, another boozing, brawling street person of a later century:

Ah! Must—
Designer infinite!—
Ah! Must Thou char the wood ere Thou canst limn with it?

And yet Caravaggio was also a man capable of great enjoyment. He seems to have loved his models, all of them, men and women, the seductive and the desiccated, the beautiful and the ugly, the impish and the broken. Kenneth Clark is right to compare him to D. H. Lawrence in his "thoroughgoing sensuality," which "has about it a kind of animal grandeur" and "that conquest of [sexual] shame which D. H. Lawrence attempted in prose."

He died in a hospice in Port'Ercole, Tuscany, after losing all his belongings, including his paintings, in a travel mix-up during which the boat to Rome took off without him. His desperation at his loss impelled him to run frantically up the beach after the

boat in the full glare of the summer sun, after which he collapsed. He died of fever a few days later, weeks short of his thirty-ninth birthday.

Let us conclude with the ever resourceful Gian Lorenzo Bernini, a man on top of the world, almost the exact opposite of poor, doomed Caravaggio, though Caravaggio was indeed one of his inspirations. Born in Naples to a Neapolitan mother, Bernini was sired by a Mannerist sculptor from Florence. The family soon moved to Rome, where the boy was sculpting prodigiously by the time he was eight. Bernini, a daily mass-goer and frequent communicant, ended each day in prayer at Rome's new Jesuit church and was a vocal advocate for the hard-edged *Spiritual Exercises* of Ignatius Loyola. He was in every respect a fervent Counter-Reformation Catholic. He was also a highly competitive, high-pressured, vindictive son of a bitch, who could never bear to lose any match or contest. His *David* [Plate 28] is depicted not before or after the contest with Goliath, as had been all other youthful Davids, but on the very edge of his success. All of Bernini's own pumping aggression has gone into this sculpture, in which there is no coy hint of lissome weakness, only floods of testosterone and an overwhelming will to win. David's face is a not very concealed idealization of Bernini's own.

Ruthless with rivals and demanding every compliance from his many mistresses, the sculptor once ordered a servant to cut up the face of one of those mistresses—a woman who was the wife of his assistant—when Bernini discovered her two-timing him with Bernini's own brother, whose ribs the artist broke with a crowbar. How he squared these activities with his evening prayers we don't know.

But there is no taking away from Bernini the imprint he left on the city of Rome, an imprint greater than that of any other single artist. To him belongs the still-breathtaking Piazza Navona with its three soaring fountains. To him we must credit Saint Peter's Square, the most extraordinary public space in the world, and the Scala Regia, the grand stairway that leads to the Vatican Palace. To him we must assign much of the interior of Saint Peter's: the sheltering

baldacchino with its unique, oscillating columns that surround the papal altar, the enormous, floating Chair of Saint Peter in the apse, and the luminous window with its depiction of the Holy Spirit as a dove entering its sanctuary.

Bernini's talent was as theatrical as it was sculptural. His combinations of paint, glass, sculpture, architecture, and light were principally intended as dramatic stage sets for the public performance of religious belief and theological assertion. Perhaps his most successful continuing performance may be found in the Cornaro Chapel of the Roman Church of Santa Maria della Vittoria, where we encounter the great female saint of the Counter-Reformation, Teresa of Ávila, wounded by the spear of love administered by an angel [Plate 29]. The scene is based on Teresa's own description of her experience:

> I saw in his hand a long spear of gold, and at the iron's point there seemed to be a little fire. He appeared to me to be thrusting it at times into my heart, and to pierce my very entrails; when he drew it out, he seemed to draw them out also, and to leave me all on fire with a great love of God. The pain was so great, that it made me moan; and yet so surpassing was the sweetness of this excessive pain, that I could not wish to be rid of it. The soul is satisfied now with nothing less than God. The pain is not bodily, but spiritual; though the body has its share in it. It is a caressing of love so sweet which now takes place between the soul and God, that I pray God of His goodness to make him experience it who may think that I am lying.

Though we would normally think such language metaphorical, Teresa seems bent on having us take her literally. But by turning his sculpture of her experience into an elaborately staged spectacle, Bernini may be showing the viewer more than he intended. The longer we contemplate Teresa and the clever appurtenances devised by Bernini to frame the scene, the more likely we are to note the magician's sleight of hand in the construction, and the more the spectacle seems not so much divinely inspired as earthbound. As one worldly Roman lady was heard to remark when *Saint Teresa in Ecstasy* was first unveiled, raising an eyebrow as she made her comment: "If that's spiritual ecstasy, I've experienced it."

DATES OF THE ARTISTS WHOSE WORK IS
DISCUSSED IN CHAPTER II

Several artists are known—in an affectionate Italian custom—by their first name only or by their nickname (in which case their legal name follows in parentheses).

Masolino da Panicale (Tommaso di Cristoforo Fini) c. 1383–c.1447

Donatello (Donato di Niccolò di Betto Bardi) c. 1386–1466

Masaccio (Tommaso di ser Giovanni di Simone) 1401–1428

Piero della Francesca c. 1415–1492

Andrea del Verrocchio c. 1435–1488

Botticelli✝ (Alessandro di Mariano di Vanni Filipepi) c. 1445–1510

Ghirlandaio (Domenico di Tommaso di Currado di

 Doffo Bigordi) 1449–1494

Leonardo di ser Piero da Vinci✤ 1452–1519

Filippino Lippi c. 1457–1504

Michelangelo di Lodovico Buonarroti Simoni 1475–1564

Raphael (Raffaello Sanzio da Urbino) 1483–1520

Caravaggio (Michelangelo Merisi) 1571–1610

Gian Lorenzo Bernini 1598–1680

✝ "Botticelli" means "Little Barrels," rather an odd nickname. The artist's older brother was first nicknamed "Botticello" (Little Barrel). Why the name subsequently accrued to the artist and why it turned plural, no one knows, but—at least in his self-portrait—he does not appear to have been either barrel-shaped or little.

✤ As with so many of the names from this period, Leonardo's "di ser Piero da Vinci" is not a genuine surname, merely a designation, indicating "(son) of Sir Piero from Vinci."

III

NEW THOUGHTS
FOR NEW WORLDS
DEVIANT MONKS

———— ❖ ————

You two are book-men.
Love's Labour's Lost

1500–1517: ERASMUS AND LUTHER

Erasmus of Rotterdam—for so he called himself, even though he spent but the first few years of his life in (or near) that city—was the poor bastard son of a Dutch priest. A narrative—somewhat confusing, in all likelihood deliberately so—of his early years is contained in his *Compendium Vitae* (Summary of My Life). It seems that when he was still in his teens both his parents died of plague, after which he was sent by his legal guardians, who wished to discharge their responsibilities as expeditiously as was seemly, to a tuition-free boarding school run by the Brethren of the Common Life. The Brethren had begun as a lay association of similarly minded men who endeavored to follow the example of Jesus by living as simply and prayerfully as possible. Erasmus soon enough found himself forced to take monastic vows in the convent of the Augustinian canons at Steyn near Gouda, so that he might continue to be fed and housed once his school years were over and the small inheritance left by his father had dwindled to nothing—thanks, according to Erasmus, to the guardians' mismanagement. By the time Columbus set sail, Erasmus had been ordained a priest. It was, in one respect, an unequal exchange: Erasmus had received no inner call to be a cleric and had to spend much of the rest of his life putting distance between himself and his official vocation.

His encounter with the Brethren, however, gave him solid building blocks on which to construct a career. At their school—of which Erasmus has little good to say—the boy had been turned to the pleasures of the intellect, especially to the spirit of Italian humanism and Renaissance textual scholarship, which were slowly

gaining adherents in northern Europe. Moreover, the Brethren were devoted to a book—possibly, after the Bible, the most influential book in all of Western history—by one of their predecessors, *The Imitation of Christ,* the masterwork of Thomas à Kempis, written a century earlier, which pointed the reader toward constant meditation on the events in the life of Jesus as depicted in the gospels. The practical purpose of this meditation was to implement the advice and imitate the example of Jesus in one's own life, insofar as that was possible. This evangelical* bias—that is, this predisposition for interpreting all matters through the perspective of Jesus and the challenge of the gospels—remained with Erasmus for the rest of his life. Humanistic learning in original languages and enthusiasm for ancient texts and their interpretation were combined in Erasmus with his profound reverence for the received words of Jesus.

For more than a thousand years, the only Bible known to Christians in the West was the translation called the Vulgate (page 33). Over time, despite the fact that Jerome may have had to rely in some instances on inferior Hebrew manuscripts, the Vulgate accrued virtually infallible status in the monolingual Western Church, whose intellectual resources had been so diminished.

The Vulgate was not infallible but, like any large translation ever made, contained both obvious mistakes and passages and phrases the accuracy of which was arguable. By Erasmus's day, however, the ability to read Greek and even Hebrew (both of which had been virtually unknown to Christian scholars of the West in the Middle Ages) was becoming more usual, at least among the learned. And this development, supported by the spreading use of the printing press, enabled Erasmus to carve out an original career: he became the first writer to live by his writing. He was indeed the inventor of the bestseller.

His first book, *Adagia* (Adages), was a collection of Latin sayings and phrases, which Erasmus had culled from antiq-

* In the United States in our day, the word "evangelical" has come to be associated almost solely with fundamentalist (and similarly unbending) Christians. But its original meaning is "of the Gospel." Our word "gospel" is an early English contraction for "good spell," "spell" then meaning "tidings" or "news." This English word "gospel" is intended as a translation of the Greek *euaggelion* and the Latin *evangelium,* both meaning "good news" and referring to the four narratives of the New Testament, the earliest of which, Mark's, is actually labeled "the good news of Jesus Christ."

uity, some attributable,* others copied by Erasmus from classical monuments, still others as anonymous as the most ancient of ancient writings. The *Adagia* could hardly have been simpler in concept and execution, but it caught something of the mood of the time—a popular quest for ancient roots—and was an enormous success in its first edition as well as in its several subsequent editions, each edition expanded and containing ever more notes and diverting mini-essays by Erasmus. Thanks to this collection, modern European languages contain translated variants of many of the simple sayings originally collected by Erasmus, such as *"Festina lente"* ("Make haste slowly"). Such seemingly timeless bons mots as "to call a spade a spade," "a cough for a fart," "crocodile tears," "the bowels of the earth," "to look a gift horse in the mouth," "In the land of the blind the one-eyed man is king," "There's many a slip 'twixt the cup and the lip," "Leave no stone unturned," "Fields are green far away," and thousands more may be traced ultimately to the *Adagia*.

Erasmus's second book was entitled *Enchiridion Militis Christiani* (Handbook for a Christian Knight), and with it the author took his first uncertain step into the fray of controversy. He himself tells us how he came to write it, driven out of Paris, where he was then studying, to the castle of Tournehem on account of a recurrence of plague. At the castle resided a knight, a friend of Erasmus, whose wife was "of a deeply religious turn of mind, while he himself was no man's enemy but his own—a spendthrift plunged in fornication and adultery, but in other respects a pleasant companion in every way." The pious wife entreated Erasmus to "write something that might get a little religion into the man," for she was "fearfully concerned about her husband's salvation." Erasmus goes on to boast—modestly—that he was chosen for this unenviable task because the man to be addressed had "the greatest contempt for all theologians, except for me."

The burden of Erasmus's argument in the *Enchiridion* is that Christianity comes in two versions: formalistic Christianity, concerned only with physical rituals and outward show, and a Christianity of the spirit that takes seriously the words and spirit of Jesus but is unconcerned with

* Many of Erasmus's favorite sayings were taken from Lucian, a Greek satirist of the second century AD, whose copious writings and hilarious skepticism would continue to inspire Erasmus's work. Luther would find the atheistic Lucian repellant.

what Erasmus calls "silly little ceremonies." "What is the use of being sprinkled with a few drops of holy water as long as you do not wipe clean the inner defilement of the soul? You venerate the saints, and you take pleasure in touching their relics. . . . Would you like to win the favor of Peter and Paul? Imitate the faith of the one and the charity of the other, and you will accomplish more than if you were to dash off to Rome ten times." Unfortunately, claims Erasmus, "most Christians are superstitious rather than faithful, and except for the name of Christ differ hardly at all from superstitious pagans." The sole escape route from this pagan impasse of holy water, relics, and pilgrimages is what Erasmus calls *philosophia Christi* (the philosophy of Christ), anchored in "the Gospel teaching."

The argument, as presented by Erasmus, is dotted with learned Platonic references, all pointing out that the only purpose of visible things is to lead us to the Invisible; and it is full as well of Thomas à Kempis's constant emphasis on a life uncluttered, poor, and centered on the example of Jesus. Erasmus's unique combination of humanism and Christ-centeredness has a stoic, even a grimly serious northern European flavor. It is hard to imagine any Italian, except perhaps Michelangelo, making a similar argument and bringing together such seemingly disparate elements as an unyielding Platonism and an equally unyielding evangelical piety.

No one knows if Erasmus won over his friend the knight, though I doubt it. Pleasant companions steeped in fornication are seldom amenable to such reasoning, posed, it must be said, in so monkish a manner. I imagine the knight continued as he was, attracted to religion as outward show and pursuing his pleasures with knightly vigor. But the book was so original in its literate and clever criticism of religious formalism that it fairly tore through the Europe of its day. Written in 1501 and published a few years later, it would by century's end boast more than seventy Latin editions and countless translations into every major European language.

With his newfound celebrity, Erasmus discovered that he was increasingly able to live apart from the monastic community to which he was formally vowed. In his first years as a monk, he had fallen passionately in love with another young monk. Once that relationship had come to nothing, Erasmus kept himself free of

erotic entanglements for the rest of his life.[*] But he also came to loathe the shut-up atmosphere of convents, and gradually he found himself in contact with humanistic churchmen throughout Europe who were so entertained by his books that they were happy to dispense him from monastic obligations, especially *stabilitas*—the obligation to remain in one place and not flit about. Erasmus would be a traveler and guest for the rest of his life, never residing for long in one place, seldom serving even a short term at a university (though offered many such positions), but often the recipient of the genial private hospitality of his fellow humanists in various parts of Europe.

One of his favorite jaunts was to cross the Channel to visit his dear English friends, especially the lawyer Sir Thomas More, who would soon become the young King Henry VIII's confidant and high official. Sir Thomas was personally more austere than Erasmus. He had in his youth considered a monastic vocation and continued to practice monastic-style mortifications (much fasting, a hair-shirt worn in secret beneath his handsome street clothes) throughout his life. But More was never dreary: we have abundant attestation to the merriness of his populous household, to his own playfulness and wit, and to his personal generosity. However hard he may have been on himself, he was the ideal host.

Erasmus was most appreciative. So much so that he wrote an original book-length composition in tribute to More. It was entitled *Moriae Encomium* (In Praise of Folly) and, like his earlier publications, it was wildly successful. The text is a soliloquy by Folly herself, explaining her thoughts on various subjects. The reasoning is cockeyed but convincing. Like a puffed-up politician or public personality of our own day (say, Glenn Beck, Charlie Sheen, Donald Trump),

[*] Publicly, at least, Erasmus condemned homosexual relations, taking the same Aristotelian line as the church: it was obvious that the penis–vagina instrumentality of the human body indicated that the Creator had intended sex for procreation. Anything else— sex for any other reason— was therefore a violation of the Creator's wishes and a grievous sin. But it is impossible to know whether Erasmus actually subscribed to this view or was just keeping himself out of unnecessary trouble with theological authorities. Sex, as may be seen by its absence from his treatise to his friend the philandering knight, was not one of Erasmus's subjects.

Folly takes herself quite seriously. She introduces her attendants: Drunkenness, Ignorance, Self-Love, Flattery, Wantonness, et al. She insists that all great endeavors—war, civil society, the church and its theology—depend upon her, and that all important people—lawyers, professors, scientists, kings, popes—are her followers. At the end of her discourse, she finds herself incapable of making the customary rhetorical summary of her remarks because she has already forgotten what she was saying. The format enabled Erasmus to satirize everything and everyone in the world of his time while escaping the condemnations that would have been hurled at him had he tackled his subjects straight on. Even the newly crowned pontiff, Pope Leo X, was amused.

Moriae, the genitive form of the Latin word for "folly," is also a tongue-in-cheek nod to More himself, since the book's title could be translated *In Praise of More.* For a reader today, the title pretty much sets the tone of the tome: it is full of donnish jokes, learned if mildly humorous asides meant to be caught and appreciated only by insiders, other humanists. But by this point the fashion for humanism was sweeping Europe, giving Erasmus an audience so sizable as to be the envy of all.

Following quickly on the *Encomium* came the anonymous distribution of a brief dialogue entitled *Julius Exclusus e Coelis* (Julius Excluded from Heaven) in commemoration, as it were, of the death of Pope Julius II, Michelangelo's great patron and Leo X's immediate predecessor. Julius arrives at the Pearly Gates in full armor and is stopped by good, honest Saint Peter, who has no intention of letting this smug monster into Heaven. Julius fulminates in the excessive manner that always got him what he wanted on earth. He even declares Peter excommunicate, but to no avail. In life, says Peter, Julius failed to perform his one real duty—"to preach Christ to others." He can go to Hell.

This dialogue traveled up and down Europe at warp speed, causing repeated outbreaks of laughter everywhere at the expense of the Holy See. Erasmus never admitted to being its author, though he never actually denied authorship, either. He had become the Jon Stewart of his day.

Erasmus was now in a position to offer his most consequential— and least humorous—work. About the middle of the second decade

of the sixteenth century, there appeared an Erasmian text that would become the essential catalyst of the Reformation. It was initially entitled *Novum Instrumentum Omne* (The Whole of the New Instrument), an attempt no doubt to camouflage its contents; in later editions it would receive the plainer, more revealing title of *Novum Testamentum Omne* (The Whole of the New Testament). In its most complete editions it offered three texts in parallel columns: the New Testament in the traditional Latin Vulgate of Jerome; the New Testament in a better Latin version as translated by Erasmus; and the original Greek text of the New Testament, supplied so that those who knew enough Greek could check that Erasmus's Latin was indeed an improvement on Jerome's. "It is only fair," boasted Erasmus, proud of his gracefully classical Latin style, "that Paul should address the Romans in somewhat better Latin." The Greek text became the *textus receptus,* the standard scholarly text for generations to come.[*]

It is astonishing to realize that till this publication saw the light almost no one in Western Europe had read through the original Greek of the New Testament for close to twelve centuries. The Greek East, of course, had always depended on its Greek manuscripts of the New Testament. (Erasmus created his Greek text by pasting together different portions of the best manuscripts he could find, "collating," as he called it blandly, "a large number of ancient manuscripts.") But this publication marked the first time the Greek text had been set in type anywhere in the world.

It also marked the first time anyone had seen fit to issue a completely revised Latin translation. It made possible all the vernacular translations that would soon flood Europe, eventually putting this more accurately Latinized New Testa-

[*] Another Greek New Testament was printed a year or two earlier than Erasmus's version. It was to be part of a much larger Spanish project, the *Complutensian Polyglot,* which would include the entire Greek Bible, the Vulgate, the original Hebrew of the Old Testament, and an ancient Aramaic rabbinical commentary. Its New Testament had to await the editing and printing of the much larger Old Testament before it could be distributed. Meanwhile, Erasmus got wind of the Spanish project and won from pope and emperor an exclusive four-year license, thus ensuring that his own multilingual work, rather than the *Complutensian Polyglot,* would become the European standard. He understood instinctively what has since become conventional publishing wisdom: if there are to be two books on the same subject, be sure to get yours out there first.

ment within the grasp not only of those who could read Latin but of anyone who could read the printed words of his own language. And as the cheap and novel products issuing from more and more printing presses encouraged more and more people to learn to read, the potential audience for Erasmus's great work was growing phenomenally. Though, as yet, probably few more than 10 percent of Western Europeans could read fluently in any language, many, listening to the new texts read to them, must have made a silent resolution to master the alphabet. "Literacy now!" could almost have been the slogan of the age.

How different the passionless, calculating, urbane, friend-making Erasmus from his younger contemporary and fellow Augustinian, the impassioned, impulsive loner and small-town professor, Martin Luther. Though their names would be forever linked by their northern European origins, by their common devotion to the New Testament, by their desire to put its text into as many hands as possible, and by the controversies each would engender as a result of his prayerful meditations on this text, their temperaments could hardly have driven them further apart.

Luther first came to public notice as an innovative lecturer on the Bible at a tiny new university in the little Saxon town of Wittenberg. Like the vast majority of university teachers throughout Europe, he was in orders, in his case as an Augustinian monk of an especially severe convent, called the Black Cloister. Unlike Erasmus, who had sought the cloister only to avoid hunger and homelessness, Luther's motivation was highly subjective, even neurotic. On his way to becoming a lawyer in accordance with the wishes of his upwardly mobile father, a prosperous businessman engaged in copper mining and smelting, young Martin found himself on horseback in a darkening countryside near his university* as a thunderstorm was unleashed. A bolt of lightning, striking beside him, terrified the rider (and, I should imagine,

* As an undergraduate he studied at Erfurt (which he would later describe as a "beerhouse and whorehouse," i.e., a typical German university of the time). His doctorate in theology, however, would be bestowed by Wittenberg when he was twenty-six.

his horse), convincing Luther that the next strike was meant for him, and he cried out to the patroness of miners, *"Hilf du, Heilige Anna!"* ("Help thou, Saint Anne!"), promising *"Ich will ein Mönch werden!"* ("I will become a monk!") The scene, recalled by Luther many years later, evokes the fast-receding piety of the Middle Ages, in which external events were often read simply as signs from God (or, more darkly, from Satan), and even seems to belong more properly as a fictional episode in a timeless collection of German fairy tales.

Such a scene cannot be imagined of our placid Dutch humanist, who would surely have calculated the probability of his escape from electrocution with more dispassion and perhaps comforted himself with an adage from Horace or from one of the Greek dramatists. And yet, the parallels between Erasmus and Luther remain striking: like the Dutchman, the German was schooled by the Brethren of the Common Life (later offering no bouquets to their educational practices, which he compared to going to Hell) and came under the influence of Thomas à Kempis's revered *Imitation of Christ.* Like Erasmus, Luther was unhappy in the cloister—but unlike Erasmus, it is a bit difficult to imagine what mode of life would have made Luther happy.

As it was, the young Augustinian devoted himself to much fasting, self-flagellation, long and stressful hours spent on his knees in prayer, anxious pilgrimage, and frequent, interminable confession of his supposed sins, imposing on his confessor for up to six hours at a single session. "If anyone," he would recall later, "could have gained Heaven as a monk, then I would indeed have done so." But, looking back, he was to remember this period as a desert of despair: "I lost touch with Christ the Savior and Comforter, and made him the jailer and hangman of my poor soul."

Luther's much-put-upon confessor and monastic superior, Johann von Staupitz, tried to jolly him out of his obsessions, telling the young man that he seemed to turn every fart into a sin, then, in a continuing attempt to free him from his ever deeper slough of introspection, ordering him to take up theological studies in preparation for a career as a university lecturer, hoping that such an occupation would return the young monk to a healthier frame of mind.

Luther was hardly unique, except perhaps in the abysmal depth and unrelieved constancy of his melancholy. Manuals for masters of novices and for other superiors charged with the care of new monks have always been full of warnings on the dangers to young inmates of scrupulosity of conscience and obsession with personal sin, so easy to cultivate in the hothouse atmosphere of a religious house. Those who indulge themselves in unrelenting breast-beating are recognized as drags on communal spirit and on their own mental health and are even labeled informally as "scrupes" or awarded some similarly unflattering cognomen in an attempt to zap them out of their lethargic self-presentation. In ordering his charge to concentrate on something other than himself and his supposed sinfulness, Staupitz was just going by the book.

Luther's plunge into biblical studies—he never did anything by half measures—became the all-pervading occupation of his life. The worried monk's central psychological problem was that he could never make himself believe that he was forgiven by God. No matter what he did or tried to do, no matter how much he abased himself, he could always detect the perverse pride of the unregenerate sinner beneath all his attempts at self-justification. The answer was to give up on self-justification, and he found the answer to his paralyzing dilemma in Paul's most elaborate and considered piece of prose, the Letter to the Romans—written to the community of Roman Christians, whom Paul had never met. Whereas all of Paul's other surviving letters are addressed to Gentile communities (or individuals) that he had personally converted, this one, the longest of Paul's letters, is addressed to a community founded by others, which Paul would meet only in his last days, while awaiting his own execution.

Paul's other letters have as their subjects problems current in the lives of those addressed. "Romans," as it is called in church circles, is more general, more theoretical, more essay-like, as befits a letter to strangers. It is also the author's last general statement of his central theological preoccupations, full of memorable, emotion-filled passages: "If God be for us, who can be against us? . . . For I am persuaded, that neither death, nor life, nor angels, nor principalities, nor powers, nor things present, nor things to come, nor height, nor depth, nor any other creature, shall be able to separate us from

the love of God, which is in Christ Jesus our Lord" (Romans 8:31, 38–39).✝

Though Luther found ultimate relief for the dilemma of his conscience in Romans, Paul is addressing there a quite different dilemma, one that had occupied the writer in one way or another throughout his ministry: the claim that the ethical norms of pharisaical (later, rabbinical) Judaism justify those who keep them. Jesus himself had made light of such justification in the course of his own ministry and had often dismissed it outright,✤ as in this passage from Luke:

> And [Jesus] spake this parable unto certain which trusted in themselves that they were righteous, and despised others: Two men went up into the [Jerusalem] temple to pray; the one a Pharisee, and the other a publican [tax collector for Rome, a profession despised by Jews]. The Pharisee stood and prayed thus with himself: "God, I thank thee, that I am not as other men are, extortioners, unjust, adulterers, or even this publican. I fast twice in the week, I give tithes of all that I possess." And the publican, standing afar off, would not lift up so much as his eyes unto heaven, but smote upon his breast, saying, "God be merciful to me a sinner." I tell you, this man went down to his house justified rather than the other: for every one that exalteth himself shall be abased; and he that humbleth himself shall be exalted (Luke 18:10–14).

Here, as in many other passages in the gospels, Jesus condemns self-righteousness as a form of self-delusion and praises honesty and humility, which lead to true justification before God. Indeed, Jesus throughout his ministry shows himself extraordinarily sympathetic to the trials and sorrows of ordi-

✝ In this volume, I normally use the King James Version (with modernized punctuation and spelling) when quoting from the Bible, because it seems especially appropriate for tasting the flavor of the period. Here, however, and in subsequent quotations from Romans, I employ the Anchor Bible translation by Joseph A. Fitzmyer, because of the clarity of its contemporary English.

✤ I do not mean to pass judgment on the sufficiency of the ethical norms of ancient Judaism, which does so repeatedly on its own, as in Isaiah 64:6, which condemns "our upright deeds" as no better than "used tampons." (Some of the best lines in the Hebrew Bible never quite make it into the translations.)

nary people, condemnatory only of the smugly religious and the uncaring rich of his time and place. Because his time and place were first-century Jewish Palestine under Roman occupation, there is no way of knowing for sure whether Jesus would be similarly condemning of smugly religious pagans (or of smug Christians, devotees of a religion that did not yet exist). It is difficult even to know if such a category could be made to refer to the religions that encircled the territory known to Jesus, or if he was dealing only with what he saw as a specifically Jewish syndrome. (There can be no doubt that he would have found the uncaring rich of any time and culture appropriate objects for condemnation.)

In Romans, Paul certainly seems to be building to some extent on Jesus's bias against pharisaical Judaism, but he also moves that sentiment in the direction of a more detailed analysis, one that involves not just dramatis personae like the Pharisee and the publican but that places Jesus himself at the center of the argument. "All" of us, whether Pharisee or publican, says Paul, "have sinned and fall short of the glory of God; yet all are justified freely by his grace through the redemption that comes in Christ Jesus. Through his blood God has presented him as a means of expiating sin for all who have faith. . . . For we maintain that a human being is justified by faith apart from deeds prescribed by the law" (Romans 3:23–25, 28).

Jesus in the course of his earthly life could hardly have been expected to speak of universal expiation through the shedding of his own blood. But he does refer to something quite like that on "the night before he died for us" (in the words of the Eucharistic rite): "And he took the cup, and gave thanks, and gave it to them, saying, 'Drink ye all of it; for this is my blood of the new testament, which is shed for many for the remission [forgiveness] of sins' " (Matthew 26:27–28).

Paul pushes these propositions still further, coming so close to Luther's obsessions that the young monk could have felt that Romans was written especially for him:

> Now we know that the law [of the Jews, especially the Ten Commandments] is spiritual, whereas I am of flesh, sold in bondage to sin. I do not understand what I do. For I do not do what I want to; and what I detest, that I do. Yet if I do what I do not

want, I agree that the law is good. But as it is, it is no longer I who do it, but sin that dwells in me. I know that no good dwells in me, that is, in my flesh. I can desire what is good, but I cannot carry it out. For I do not do the good I desire, but instead the evil I do not desire. Yet if I do what I do not want, it is no longer I who do it, but sin that dwells in me. So I discover this principle at work: when I want to do right, evil is ready at hand. For in my inmost self I delight in God's law; but I see another law in my members battling against the law that my mind acknowledges and making me captive to the law of sin that is in my members. Wretch that I am, who will rescue me from this doomed body? Thanks be to God—(it is done) through Jesus Christ our Lord! So then I myself in my mind am a slave to God's law, but in my flesh to the law of sin (Romans 7:14–25).

However much such passages may have clicked with Luther, assuring him that Paul had foreseen his dilemma and had the perfect resolution, I doubt Paul was imagining anyone remotely similar to a fussily scrupulous monk. "The law of sin that is in my members"—Paul repeats "my members" at least five times—would have been far more appropriately applied to a Roman paterfamilias, the kind of male who saw himself as free to do whatever he liked to almost anyone, someone closer in presumptuousness to, say, an Arab tyrant, an American movie star, a macho Italian prime minister, or a sensual Frenchman in charge of the IMF.

Nevertheless, Luther fashions the argument of Paul's letter into the foundation of his own theological vision: "We realize that all things work together for the good of those who love God, for those who are called according to his purpose. Those whom he foreknew, he also predestined to be conformed to the image of his Son [Jesus] that he might be the firstborn among many brothers.* Those whom he predestined, he also called; those whom he called, he also justified; and those whom he justified, he also glorified" (8:28–30).

By the time Paul wrote these words to the Roman community, probably in

* The New Revised Standard Version (NRSV), a gender-inclusive translation, renders this phrase as "the firstborn within a large family," certainly a defensible translation. The Greek word for brother, *adelphos*, meaning "from the same womb," has a ready feminine form, *adelphe*.

the late 50s of the first century AD, there are unlikely to have been many Jewish Christians among them, even though Jews would have been the original founders of the Christian Church in Rome. We know that in the 40s the emperor Claudius had expelled the Jews from the city and that they had only recently been returning in significant numbers. Paul, however, finds it necessary to make reference to his own people in his usual lamenting way: "My sorrow is great and the anguish in my heart is unrelenting. For I could even wish to be accursed and cut off from Christ for the sake of my brothers, my kinsmen by descent. They are Israelites, and to them belong the sonship, the glory, the covenant, the giving of the law, the cult, and the promises; to them belong the patriarchs, and from them by natural descent comes the Messiah, who is God over all, blest forever! Amen" (9:2–5).✝

✝ *Pace* Fitzmyer, I doubt this is an assertion of Jesus's divinity. A more likely translation might be "the Messiah. God who is over all be blessed forever. Amen," a very Jewish conclusion. The translation challenge lies in the lack of punctuation in ancient manuscripts.

✤ Paul's first scriptural quotation here is from Isaiah 28:16, the second from Joel 3:5, in both of which "the Lord" referred to is—in the Hebrew original, which Paul would have known—"YHWH," the God of the Jews. These glancing references *could* suggest that, at least toward the end of his life, Paul may have seen Jesus as, in some sense, God—a development I found no evidence for when considering Paul's earlier letters in Volume III of the Hinges of History, *Desire of the Everlasting Hills*, Chapter III.

But the Jews have in the main rejected Jesus. This, too, Paul speculates, is part of God's plan, so as to make room for the Gentiles "until the full number . . . comes in," after which "all Israel shall be saved" (11:25–26). This hope, thrown in between more richly rhetorical passages, is not given much logical ballast; it is merely asserted. What occupies Paul more generally is the persistent restatement of his central theme: "If you profess with your lips that 'Jesus is Lord,' and believe in your heart that God has raised him from the dead, you will be saved. Such faith of the heart leads to uprightness; such profession of the lips to salvation. For Scripture says, '*No one who believes in him shall be put to shame.*' No distinction is made between Jew and Greek: the same Lord is Lord of all, bestowing his riches on all who call upon him. '*For everyone who calls upon the name of the Lord shall be saved*' " (10:9–13).✤

There are certainly passages in the Scriptures that would take us in another direction altogether. Paul and Luther have, in effect, bracketed the whole of the Hebrew Bible, labeled by Christians "the Old Testament." Yes, in their view that library of witness is—in some sense—the Word of God, but now (since the sacrifice of Jesus) its words can be properly interpreted only in the light of the words of the New Testament.

But just a minute! Cannot even some of Jesus's words, as recorded by the evangelists, the writers of the four gospels, be set at variance with Paul's argument? Is not the Good Samaritan—in Luke's Gospel Jesus's great (if fictional) figure of authentic kindness—a *Samaritan,* that is, a despised heretic and no believer in Jesus? Is he not meant to be seen as saved by his acts of kindness to the anonymous victim of a mugging, whom more respectable types refuse to assist?

And, even more pointedly, what of all those who at the Last Judgment in Matthew's Gospel are welcomed into Heaven not because of their faith, but because of their deeds? Do they not even confess to Christ that they were unaware of his presence in their lives? Could they not be unbelieving Jews or Hindus or (my God!) atheists?

> When the Son of man [Jesus] shall come in his glory [at the end of time], and all the holy angels with him, then shall he sit upon the throne of his glory. And before him shall be gathered all nations; and he shall separate them one from another, as a shepherd divideth his sheep from the goats. And he shall set the sheep on his right hand, but the goats on his left. Then shall the King [Jesus] say unto them on his right hand, "Come, ye blessed of my Father, inherit the kingdom prepared for you from the foundation of the world. For I was an hungred, and ye gave me meat, I was thirsty, and ye gave me drink, I was a stranger and ye took me in, naked and ye clothed me, I was sick and ye visited me, I was in prison and ye came unto me." Then shall the righteous answer him, saying, "Lord, when saw we thee an hungred, and fed thee? Or thirsty, and gave thee drink? When saw we thee a stranger, and took thee in? Or naked, and clothed thee? Or when saw we thee sick, or in prison, and came unto thee?"

And the King shall answer and say unto them, "Verily I say unto you, inasmuch as ye have done it unto one of the least of these my brothers, ye have done it unto me" (Matthew 25:31–40).

What I mean to point out by citing critical biblical passages that seem to argue against the Pauline/Lutheran stance of justification by faith alone is that the Bible is indeed a complicated business, not in any sense a single book dropped by God into the laps of the faithful for their simple instruction and edification, but an elaborate double library of many separate volumes (most in Hebrew with a little Aramaic mixed in and containing a separate bookcase or two in Greek), the oldest stories originating in a dimly appreciated, preliterate Mesopotamian society, the whole production the result of more than a thousand years (perhaps, if we go back to earliest sources, more than two thousand years) of storytelling, transmission, addition, and revision, written, rewritten, edited, and compiled by more hands and hearts—and in more places and evolving cultures—than we will ever be able to identify; and all this adding to the unadulterated mystery even of the most recent volumes, dating to about the end of the first century AD.[*]

Here, in the second decade of the sixteenth century, as Luther lectures to his university students on the text of Romans, we are looking at an early moment in something almost analogous to the Big Bang. Thanks to the scholarship and entrepreneurial labors of Erasmus, the original Greek text of the New Testament is on the verge of becoming widely available once more. It will, together with a growing continent-wide hunger for pristine literary texts of all kinds and—most unexpectedly—the spark of Luther's immensely subjective reading of the Bible, induce a societal explosion of, well, biblical proportions.

[*] The mysteries of the Bible can only be nodded to here. *The Gifts of the Jews* and *Desire of the Everlasting Hills* examine its texts (and the unity of its two compilations) in some depth.

Luther's personal approach to the Bible could scarcely have been further from the careful, text-reverencing approach of Erasmus, whose notes to his edition of the New Testament are marvels of dispassionate consideration of style and content, still useful (and even revela-

tory) to a contemporary biblical scholar. In Luther's exposition the contemporary scholar will find only Luther, not especially interested in history or the evolution of cultures and ideas, in search of the Word of God only to quiet the quaking in his breast.

At the same time, we should not imagine that Luther's psychological theology came to him full blown. Though it is easy enough now to read his earliest notes on Romans and see where he is headed, it would take the prompting of an unusually shameless and aggressive display of ecclesiastical corruption to provoke Luther into the public challenge that would make his a household name throughout Germany and, soon thereafter, throughout Europe. That irruption would ever after be called the Indulgences Controversy.

Albrecht of Brandenburg was a bishop in need of money, lots of it and as soon as possible. He was a pluralist, which may sound like a good thing but wasn't. In recent times, the word is sometimes drafted to mean a philosopher holding more than one ultimate principle; in Luther's time it meant only someone holding more than one bishopric.* Albrecht held two and a half: in 1512 he was named archbishop of Magdeburg and administrator of the monastic town of Halberstadt and from 1513 he was also archbishop of the much grander city of Mainz. The archbishop of Mainz was one of the seven electors of the Holy Roman Emperor and therefore one of the most powerful men in Germany. Albrecht could not at first exercise his episcopal offices because he was still in his early twenties, and the church's canon law required an acting bishop to be at least thirty. Pope Leo X, himself only thirty-seven at his election (having been created cardinal at the tender age of thirteen, though not ordained priest till after his election), found that he and Albrecht had so much in common that he graciously dispensed with the canon that blocked Albrecht's path. What the pope and the archbishop especially had in common was their need for vast sums of money, Albrecht because he was in serious debt to the Augsburg banking house of the Fugger family, Leo because he was extraor-

* Or other highly lucrative ecclesiastical benefice. It did not refer to an overburdened priest attempting to serve two or more poor parishes.

dinarily overextended. He loved the many beautiful and expensive purchases that he made continually and unhesitatingly; he had wars to conduct; he was, in addition to his duties as pope, ruler in all but name of his beloved Florence (and the second legitimate son of Lorenzo il Magnifico); and he was building the new Saint Peter's Basilica, for Heaven's sake.

Why, you may ask, would anyone want to be archbishop of two separate sees more than 250 miles apart? Awfully burdensome, no? No, since one of the few distinct obligations would be to collect the revenues due by law to the archbishop of each city. It was in anticipation of such income that the famous Fuggers had extended their loans in the first place.

Pope Leo meant to raise the new Saint Peter's without making any contribution from his own purse, which he reserved for more personal satisfactions. To pull this off, the obvious papal route would be a spectacular secret deal. Leo was good at doing deals: after all, important bishoprics (and not a few unimportant ones) were always for sale. This was how Albrecht, the baby bishop, had won Mainz: the Fuggers had put up the capital that Albrecht had turned over to the pope in exchange for his appointment. Such quid pro quo, called simony,* was the oil that lubricated the greasy world of ecclesiastical appointments.

To lubricate all necessary wheels, Albrecht entered into an agreement with the pope and the Fuggers: the bankers would finance the continued building of Saint Peter's; Leo would renew the practice, initiated by his predecessor Julius, of selling indulgences to fund the building of the papal basilica; Albrecht would allow a band of salesmen to enter his dioceses to sell the indulgences to the faithful; and the proceeds would be split fifty-fifty between the pope and the Fugger family.

* Simony was named for Simon Magus, a sorcerer who makes an appearance in Chapter 8 of the Acts of the Apostles, asking to buy from the apostles the power to bestow the Holy Spirit, in later centuries imagined to be a specific capability of a bishop.

We who in the recent past have been victimized by a great conspiracy of bankers may be tempted to regard the Fuggers as the underlying villains in this deal. But the astonishing self-regard and almost cosmic gluttony of the reverend churchmen—neither of whom had so much as a dash of genuine spirituality in

his makeup—can hardly be minimized. Both supposed "successors to the apostles" were worldly epicureans, devoted to their own pleasures. Albrecht was a Hohenzollern, amorous and overweight. His influential family, from whom would spring the kings of Prussia, was using his appointments to block the ambitions of a rival clan, led by Frederick the Wise, also an imperial elector. Saxony was divided between the two families. Leo's family, the Medici, iconic bankers of Europe, would in this period lose their precedence to the fabulous Fuggers. Leo himself, dying unexpectedly of malaria in late 1521, would leave empty the papal treasury, which had been overflowing at the time of his election, and leave his successors struggling under considerable debt.

To understand what an indulgence is, one must visit the funhouse of medieval theology. The first Christians seem to have expected the end of the world (and the Second Coming of Christ in judgment) to occur in their own lifetimes or soon thereafter. As the interim between the two advents of Christ began to stretch into centuries, prophets would rise in most eras to announce that the End Time was just around the corner. Then, after nothing happened, the prophets would fall and be forgotten. Most Christians turned their attention from the possible end of the world and toward the mystery of death. If Christ is unlikely to return in my lifetime, what can I expect after death? What can my friends and family expect? What can I do for those who have gone before me, those who "sleep in Jesus," as Paul put it in his letter to the Thessalonians?

I can pray for them, of course. More than that, because the church is a Communion of Saints, of those on earth and of those who have gone before, I can surely pray—that is, speak in supplication—to those who have already reached God and ask them to pray for me and for others who may need their prayers. But what can I do for a loved one—a friend, a parent, a spouse, a child—who I know made a mess of things on this earth, who stole money, betrayed another, committed murder, told monstrous lies, or failed to fulfill profound obligations to others? In brief, what can I do for friends, acquaintances, and relations who failed at some point in the course of their earthly existence in their duty to love God and neighbor—which category probably includes most people?

If they failed spectacularly, they are already in Hell and there is

nothing that can be done for them. Spectacular failure—in medieval Christian terms—was not a matter of doing great evil (say, genocide or serial murder or robbing widows or oppressing orphans) but of failing to repent for what one had done. Even the most grievous sin could be forgiven if one were to repent sincerely, for God is merciful. Hell was reserved for those who failed to repent, who by clinging to their sin had made themselves permanently unworthy of God's presence. This was why sudden death was so feared: it did not give you time to put your spiritual house in order. You might have meant to repent but hadn't quite got round to it. Too bad. Down you go. All the way.

Thanks be to God, the mysterious Communion of Saints that we (or at least all the baptized) are part of has a very earthly component, the visible, audible church, which guides us along the paths of our lives, enabling us to sort out our sins, make repentance, and at the last return to God. In its manuals for priestly confessors, the church enumerates the sins we must all confess, listing these in order of seriousness from the least (venial) to the most serious (mortal), to those so grave as to entail formal excommunication from the Communion of Saints and, therefore, requiring special dispensation, such as a writ of forgiveness issued by a bishop or pope.

One of the big questions in all this is: Who gives forgiveness? The only obvious answer is God or, if you like, God in Christ. On what basis does God, the Supreme Being who created all things and keeps them in existence, forgive? The basis is the blood of Christ, the Incarnate Word who by his suffering and death redeems mankind, who buys back human beings from their just perdition, which their sins should by rights make inevitable. This salvation was first foretold (ever so dimly) by God in the Garden of Eden just before the first man and the first woman were sent off into permanent exile (Genesis 3:15). Then, in the course of the Old Testament it was foretold ever more explicitly, especially in the words of the latter prophets, whose books Christians moved (from their original position after the Torah in the Hebrew Bible) so that they would serve as introduction to the four gospels of the New Testament.

But God uses ordinary men for his purposes. One of the clearest uses may be seen in his deployment of the clergy to guide and instruct other Christians, who are mostly ignorant and illiterate.

Priests and their bishops are there to lead the rank and file in the fulfillment of their Christian duties, to remind them of their sins, and to guide them to repentance.

Okay, but, keeping in mind how dull-witted most of these people are, let us, the clergy, lead them not just by example and exhortation but by law and order, prescription and proscription, regulation and exclusion, condescension and condemnation. Ordinary Christians must be kept in line for their own good and for the good of society as a whole.

It is easy to see how, as literacy increased by leaps and bounds and as the petty chieftains of Europe gradually grew into powerful princes of grand ambition, the time-honored legitimacy of pastors leading their human flocks and of bishops interfering in the political sphere might be called into question, especially as so many members of the higher clergy were seen not as holy exemplars but as grasping hypocrites, looking to take personal advantage of the whole complicated system they themselves had created.

Erasmus and other humanists had already made "silly little ceremonies" the objects of their derision. No arena of church life was more open to criticism and satire than the scam of indulgences. However sincere the original idea may have been, indulgences seem to have been designed as virtually irresistible temptations for corrupt churchmen. The original idea was that you or I, because we had been saved by the blood of Jesus and were members of the Communion of Saints, could call upon the merits he had piled up for us in the course of our redemption and apply them to ourselves and to others.

Huh?

This is where most reasonable people may begin to lose the thread of ecclesiastical reasoning. The merits of Christ—and of his saints (those already with him in Heaven)—came to be seen by higher churchmen as a sort of bank account of infinite worth that could be called upon as needed. The church—that is, higher churchmen—could set the rules for writing checks against this account. According to these rules, the faithful could borrow from the merits of Christ and assign them to the needy, either to themselves or to others, especially to their deceased loved ones. Thus, the kissing of a certain bone from a dead martyr's hand, penitential pilgrimage to a particular shrine, an assigned set of prayers, an assigned

number of masses (endowed by the pious faithful and whispered by a priest at a designated altar), a good work (such as volunteering at a hospice), even a financial contribution to the building of a small chapel or a great basilica, could shorten or even eliminate the temporal suffering due to sin.

Let's say you have repented your sin, whatever it was, and can rely on the merits of Christ for your salvation. That doesn't mean that God is going to let you completely off the hook now, does it? Let's say you murdered a particularly annoying relative. You confessed your sin to a priest and were assigned a significant penance. All well and good, but you still must suffer for that sin, if not in this world, then in the next. You won't go to Hell, though you may end up spending a very long time in Purgatory (exactly like Hell, except that you finally get out). But an indulgence can lessen your sentence. And a plenary indulgence means that all the temporal punishment due to your sin is erased. So if you have won a plenary indulgence (or someone else has won it on your behalf) and if you die right at that moment, without the opportunity to commit additional sins, you will go straight to Heaven.

It is not only rather easy, it is even tempting, to knock over this elaborately rationalized house of cards. Several aspects of it—such as the dominance of clergy over the lives of other Christians, the necessity for a sacrament of Penance, and the existence of a place called Purgatory*—were not, in any genuine sense, part of the faith of the earliest Christians and took centuries for bishops and theologians to construct and justify. These constructions became ever more elaborate in the course of the Middle Ages; by the time of Luther what we might call "justification by rationalization alone" had become so much a part of the clerical mindset that many would no longer have noticed how much invention and even fantasy was going into these constructions.

* The early Christians thought of all the members of the church together as a "holy priesthood" (1 Peter 2:5 and 9); private confession was invented in Ireland about the seventh century AD (see *How the Irish Saved Civilization*, pp. 176ff.); the word "sacrament" originally referred to a pagan Roman legal or military obligation. Augustine of Hippo in the early fifth century referred to the faithful dead as passing through a purgatorial fire, but Purgatory as a place like Heaven or Hell would take centuries more to be fully imagined.

In spring 1517, bands of indulgences salesmen arrived in Hohenzollern Saxony. They were selling plenary indulgences in return for monetary "donations." They stayed through summer. They walked (or rode)✝ everywhere, preaching in cathedrals, churches, and public squares. Wherever they went (and there were few places too small for their attentions), they were received as celebrities, stirring up interest and enthusiasm. They offered an excellent return on investment: salvation for gold, just an insignificant bit of gold. Whether or not the words are accurate, news of their rhyming pitch resounded through the land:

> *When the coin in the coffer rings,*
> *The soul from Purgatory springs!*

Some, it seems, believed that a little gold could even release a damned soul from Hell itself. "Even if you have ravished the Virgin Mary, an indulgence will free you from punishment!" is one of the promises the gossips claimed had been made. Whatever was said—and we have no recordings to consult—it is only too likely that the peddlers, Dominican friars all, were no more scrupulous in their pitches than Columbus in his descriptions of the North Atlantic route. The object of a successful salesman is to clinch the sale.

We do have drafts of their sermons, probably penned by their leader, Johann Tetzel, and, while they do not engage in the basest claims, they are models of how to stir a crowd by pity and fear:

> You priest, you nobleman, you merchant, you woman, you virgin, you matron, you youth, you elder, go into your church (which, as I have said, is now Saint Peter's) and visit the hallowed cross that has been set up for you, that incessantly calls you. . . . Remember that you are in such stormy peril on the raging sea of this world that you do not know if you can reach the Harbor of Salvation. . . . You should know: whoever has confessed and is contrite and *puts alms into the box, as his confessor counsels him* [emphasis mine], will have all his sins forgiven. . . .

✝ Friars, supposedly paupers, were enjoined by canon law to walk, never ride, but any bishop could dispense them from this rule for a supposedly greater good.

So why are you standing about idly? Run, all of you, for the salvation of your souls. Be quick and concerned about redemption as about the temporal goods you doggedly pursue day till night. "Seek ye the Lord while he may be found . . . while he is near"; work, as John says, "while it is day," for "the night cometh when no man can work."

Do you not hear the voices of your dead parents and others, screaming and crying: " 'Have pity on me, have pity on me . . . for the hand of God hath touched me'? We are suffering severe punishments and pain, from which you could rescue us *with a few alms* [emphasis mine], if only you would." Open your ears, because the father is calling to the son and the mother to the daughter.

One of the most revealing sentences is the opening invocation, addressing priests, nobles, merchants, and their wives—in other words the people with some money. Little time would be wasted on farmers, serfs, the poor. We're really interested only in those who have gold to part with. The salvation of the penniless is none of our business.

Wittenberg, located in the part of Saxony ruled by Frederick the Wise, lay just outside the commission of Tetzel and his fellow friars. Frederick had one of the largest collections of holy relics in Europe. He was not about to allow their power and importance to be leeched away by a new papal indulgence. And, anyway, cooperation with Albrecht (who also had a large collection)* was unthinkable. But Tetzel set himself up across the border in nearby Jüterbog whither Wittenbergers were lured to hear the famous friar preach. They returned to Wittenberg with their purchased certificates, granting full remission of sins, which some of them brought to Doctor Luther in confession. Luther was deeply troubled by what they showed him and horrified by the promises they claimed had been made to them. He felt compelled to act.

What he did not do, despite the

* Albrecht's collection included such items as some of the mud God had used to fashion Adam, branches of the Burning Bush from which God had spoken to Moses, the finger with which the apostle Thomas had traced the scar in the side of the risen Jesus, and, most precious of all, several vials of the Virgin Mary's breast milk. Frederick's collection included similar items.

strength of the legend, was to nail ninety-five theses to Witten-
berg's church door in an act of public rebellion. It is important to
realize that Brother Martin was at this time a faithful Augustinian
monk, a small-town professor who taught theology at his little, new
university. He would later express regret that, as he came to public
notice, he was still a convinced papist. If we know he had a some-
what rocky spiritual life, the world knew nothing of him; and what
he knew of himself hardly suggested the revolutionary fame that
would soon accrue to him. Martin framed his displeasure, not in a
public act of any kind, but in a diplomatically phrased and private
letter to Archbishop Albrecht.

Luther, aware of the enormous social distance between himself
and the princely archbishop, begins humbly, calling himself "*fex
hominum*" (a shit among men),✝ who nonetheless dares to address
his august archbishop on account of the gravity of the occasion.
Indulgences, he argues, cannot bring a human soul to salvation
or holiness; and Christ never commanded anyone to preach such
things, only to preach his gospel, which is being submerged and
lost beneath the vulgar clatter of this hawking of indulgences. It is
a simple but pure and powerful argument that any saint would have
taken seriously.

Along with his letter, Luther included a list of thesis statements.
These were not fully reasoned arguments, nor were they meant
to be; they were just sentences intended
to spark a formal academic argument or
disputation. Such statements are still used
in our day to announce a public debate,
usually following the word "Resolved."
Sending off such thesis statements was
not an unusual action at the time. Many
writers and university lecturers availed
themselves of the format. Erasmus used
it, as would Galileo. The thesis statement
was simply the announced proposition
that would then have to be defended or
opposed by reasoned argument in the
course of a scheduled academic defense.✱

✝ *Fex* (or *faex*), the plural
of which is *feces* (or *faeces*),
can mean dregs or refuse,
but here there is no doubt
about Luther's meaning.
Whether writing in Latin or
German, he seldom missed
an opportunity for a little
bathroom humor.

✱ If a particular thesis came
subsequently to be accepted
by a majority of academics,
it could end up as part of the
curriculum, to be taught by
lecturers and memorized by
students. See page 68.

Ninety-five such thesis statements may have seemed a bit much, but then Luther was an overreacher, not a man easily confined to conventional limits.

The first thesis statement smartly sets the stage for all that will follow: "Our Lord and Master Jesus Christ, when he said 'Poenitentiam agite,'* willed that the whole life of believers should be repentance." The second thesis statement calls into question the need for the church's sacramental confession, asserting that Jesus cannot have meant to impose such a thing when he spoke the words quoted in the first thesis. As always, Brother Martin is not far from his own experience, whether as confessant or confessor. The fourth thesis statement continues in this personal vein: "The penalty [of sin], therefore, continues so long as hatred of self continues; for this is true inward repentance, and continues till our entrance into the Kingdom of Heaven." Self-hatred, though hardly smiled upon in our current how-to books on self-esteem, was part and parcel of an exemplary Christian life from the time of Jesus till well past the time of Luther. But Luther's early emphasis here on the primacy of self-hatred surely speaks of his own inner turmoil.

By the fifth thesis statement the pope is cited with the claim that he "does not intend to remit, and cannot remit any penalties other than those which he has imposed either by his own authority or by that of the canons [of church law]." Thereafter, the pope is cited more than thirty times, in some instances to delightfully humorous effect. (At the time of composing these thesis statements, Luther was reading *Julius Exclusus,* which can only have cheered him on.) "Christians are to be taught that the pope, in granting pardons, needs, and therefore desires, their devout prayer for him more than the money they bring" (Thesis 48). "Christians are to be taught that if the pope knew the exactions of the pardon-preachers, he would rather that Saint Peter's church should burn to ashes than that it should be built up with the skin, flesh, and bones of his sheep" (50). So the pardon-preachers have begun to

* These are the words of Jerome's Latin translation. Literally, they should be translated as "Do penance." The actual Greek of the New Testament—*Metanoeite*—means literally "Change your mind" (or, more loosely, "Change your heart, opinion, or attitude"). It is less prescriptive and surely has nothing to do with the sacrament of Penance. See *Desire of the Everlasting Hills,* pages 69ff.

reach out even to those with little or no gold to spare (not unlike the greedy American bankers who, in our day, have made fortunes by luring those with insufficient resources into taking on subprime mortgage loans). "Christians are to be taught that it would be the pope's wish, as it is his duty, to give of his own money to very many of those from whom certain hawkers of pardons cajole money, even though the church of Saint Peter might have to be sold" (51). Oh, yeah.

Luther goes on—in the form of thesis statements, no less—to report some of the questions he has heard people raise: "This unbridled preaching of pardons makes it no easy matter, even for learned men [like Luther], to rescue the reverence due to the pope from slander, or even from the shrewd questionings of the laity. To wit: 'Why does not the pope empty purgatory, for the sake of holy love and of the dire need of the souls that are there, if he redeems an infinite number of souls for the sake of miserable money with which to build a church?' " (81, 82). These questions, supposedly framed by others, occupy eight theses, ending with "Since the pope, by his pardons, seeks the salvation of souls rather than money, why does he suspend the indulgences and pardons granted heretofore, since these have equal efficacy?" (89).

The questions, couched in innocent language, are actually clever and sophisticated. And, for the most part, they are unanswerable. Luther may not have nailed his theses to the church door, but he has nailed the papal scam for what it was. "The true treasure of the Church," as he states in Thesis 62, "is the most holy Gospel," in keeping with which "Christians are to be taught that he who sees a man in need, and passes him by, and gives [his money] for pardons, purchases not the indulgences of the pope, but the indignation of God" (45). But perhaps the most unanswerable is Thesis 86, also couched as a "shrewd" question from "the laity": "Why does not the pope, whose wealth is today greater than that of the richest Crassus,✝ build just this one church of Saint Peter with his own money, rather than with the money of poor believers?"

The piquancy, the verve, of these "theses" is enough, even today, to stimulate a reader's thinking or even to shock

✝ Crassus was a legendary Roman profiteer of the first century BC who, like our vulture capitalists, made his fortune on the misfortunes of others.

one into wakefulness. Though Luther would continue to write reams and reams of books and broadsides throughout his life, some exceedingly eloquent and few dull, he seldom if ever improved on the lively asperity of the Ninety-Five Theses; and so it is not surprising that this list of statements, tucked in with his humble letter to the archbishop, should continue to stand as his most famous work.

> *Good ol' Marty Luther, oh good ol' Marty Luther*
> *Played in the Reformation Band.*
> *His Five-and-Ninety Theses*
> *Just tore the pope to pieces.*
> *We think the Reformation's gra-n-d!*

So sing children at Lutheran summer camps in the United States (or so they did before a new fashion of interconfessional ecumenism embarrassed their counselors).

The Theses send out a spirit that is catching: here is a bandwagon, the reader may be prompted to declare, that I'd like to jump on. Of course, if they'd remained in their envelope or been deep-sixed in the archiepiscopal archives, no one would ever have heard of them. Somebody (a disgruntled secretary perhaps) had them printed; and then the distribution began! For the network of printing presses had now become what the Internet is for us: an unstoppable, nearly instant, and universal marketplace of communication. Within a month, all of Germany had read the Theses or heard them read publicly; by year's end, all of Europe—in Luther's original Latin or in the many vernacular translations made with amazing alacrity. There were as yet no copyright laws, so no one asked Luther's permission to print his Latin text or to make and publish translations.

The Theses appeared so fresh, so bold that no one could remain neutral: you loved them or you hated them. In Germany, at least, where there was much muttering against the anti-German policies of the papal establishment (which collected fees and taxes and gave back little or nothing), most people delighted in the Theses' vigor and passion but even more in their clarity and appositeness. All of Germany's resentments, and no doubt even some points no one had

thought to raise before, had at last been given clarion expression. The sale of indulgences plunged throughout the German lands, as people roared with laughter and the name "Luther" became a household word. No wonder the Theses are remembered as having been nailed to the door of Wittenberg's collegiate church.

IV

REFORMATION!

LUTHER STEPS FORWARD

———— ❖ ————

Though justice be thy plea, consider this,
That in the course of justice, none of us
Should see salvation: we do pray for mercy,
And that same prayer doth teach us all to render
The deeds of mercy.

The Merchant of Venice

Much of what happened next was fairly predictable. Though the Theses were the work of an exceedingly pious monk who had no thought, at this point, of preaching open rebellion against the papal establishment, the pope and his supporters—that is, the personnel and machinery of the entire Roman Catholic Church—reacted much like a unified, living body gathering its strength to expel an aggressive infection. The intellectual assault represented by the Theses was simply too explicit, too extensive, and too memorably articulated to be ignored. This pushed far beyond the in-jokes and allusive indirection of Erasmus's satires. One didn't just raise an ironic eyebrow and titter politely behind one's hand. One was forced to take a stand, *stare aut pro aut contra,* to come out for or against.

It is tempting, as we look backward to a past that will soon be half a millennium gone, to caricature its principal players: Erasmus, the realistic, immensely learned critic, can so easily be turned into Erasmus the self-protective cynic; Luther, the scrupulously sensitive, wounded intellectual, can be neatly forced to play the fulminating, hysterical extremist, very nearly the psychotic. The latter is the picture that the famous psychologist Erik Erikson painted of his subject in *Young Man Luther,* invoking twentieth-century clinical clichés—Luther's supposed fear and hatred of his father, his pathologically induced constipation—that have no convincing basis in the historical record. Luther obviously loved his father, a demanding man, no different from other responsible fathers of his time and place, all of whom—as well as mothers and teachers—thought it imperative to beat children into obedience and conformity. Luther

did experience constipation, but most notably in the period in which he was forced into hiding and could not exercise. Luther's supposed obsession with feces, as illustrated by his conversation, was no different from that of northern European contemporaries. The refined Thomas More's talk and writing were hardly less full of what an analyst of our time might deem "excessive anality."

Yes, Luther was a dramatically sensitive human being of a type we have all met. Despite his immersion in the forms and spirit of medieval monasticism—and specifically in the pessimistic severities of Augustinian spirituality—he never gave off the aura of a medieval saint, united mystically to the Godhead and awesomely in control of the passions of his lower nature. Rather, he confessed his personal flaws, publicly and often. And, despite the quirky, neurotic behavior of the novice Luther, the man wasn't nuts, at least not most of the time.

What is perhaps most refreshing about him is the zinging, often self-deprecating, humor of his growing defiance—what we must retrospectively name his courage, his monumental courage, a demonstration that may be possible only to those who are genuinely humble. As he grew older, he would realistically evaluate his strengths and weaknesses and never overrate his talents. "I am the ripe shit," he confided to dinner guests as he was reaching the old age of sixty and had scarcely two years left to live. "But then the world is a wide asshole, and soon we shall part."

Receptivity to challenge is not a virtue of official Catholicism, then or now. As we watch in mute horror the astounding unresponsiveness of the worldwide Catholic episcopate to the seemingly endless contemporary scandals of pedophile priests, we learn that the episcopal repertoire is generally confined to a sequence that begins in blank denial (What on earth are you talking about?), is followed by gestures of false reform (Here is our extensive program of self-correction),*

* Evidence of false reform is abundant. Most recently, Seán O'Malley, the current cardinal archbishop of Boston, brought in to amend the mistakes of his predecessor Bernard Law, Cardinal Coverup himself, issued a *partial* list of clergy accused of sexual abuse, this nearly ten years after the Boston scandal broke. All of the 132 names on the published list were previously known to the public, though O'Malley managed to declare that he was publishing the list "after serious and thoughtful consideration and prayer." What the cardinal failed to mention was that, in addition to consulting God, he had spent considerable time in conversation with his attorneys.

and ends in the huffy pulling of rank (How dare you!). How much more so was this the expectable pattern in sixteenth-century Europe, which had never experienced a successful challenge to its dominant hierarchy.

What saved Luther and his growing bands of supporters from the fate of the Lollards and the Hussites—that is, from being hunted down and burned at the stake—was the growing power of Europe's secular princes, no longer simply civil servants to ecclesiastical princes. But such protectors would in due course take their own costly exactions. To flee from the arms of the Roman Church to the arms of the territorial nobility would prove to be something of a devil's bargain.

To begin with, however, the German (or Germanic)✝ nobility looked like a good bet to Luther and to many of the religious dissenters who would follow in his wake. The Alps defined a chasm that was at least as cultural as it was geological. When as a young monk Luther made his one trip beyond the Germanic lands—over the Alps into Italy in early 1511,✤ in the very time when Michelangelo was painting the Sistine Chapel ceiling—he was scandalized by what he saw: men pissing shamelessly in public throughout the streets of Rome; priests hurrying through their masses without appropriate reverence and even telling the reverent Brother Martin to hurry up so they could make use of his assigned altar (no doubt to buzz through their endowed masses); bishops and cardinals openly patronizing prostitutes and keeping catamites; general irreverence and a sense that everything and everyone in society was for sale. For the rest of his life, there was no put-down Luther found more cutting than to dismiss a man as "an Italian."

Even today the divide between the customs of northern and southern Europe remains vivid and can lead quickly and easily to either misunderstanding or just an ugly display of national prejudice. This continuing divide lies even at the

✝ The principal tribes of northern Europe—the Franks, the Scandinavians, the Germans, the Swiss, the Dutch, the Flemish, the English—were of Germanic, rather than of Celtic or Greco-Roman, origin.

✤ Luther said he made his Roman visit in 1510, though the best evidence suggests that it was made, by our reckoning, in January 1511, which was then part of 1510, since the new year did not commence till March 25, the feast of the Annunciation (and, therefore, of the supposed conception of Jesus).

heart of Europe's current economic crisis. (Why should prudent Germans and Scandinavians bail out improvident Greeks, Irish,* Portuguese, Spaniards, and—especially—Italians?) In Luther's day, as the universal language of Latin receded and was replaced by national tongues, by a gathering wave of books and broadsides printed in the vernacular, and by more consciously held national identities, the contrast between the solid northern burgher and the slippery southerner seemed evident. Nor was this an age in which tolerance for difference was lauded as a virtue.

In early 1518, Luther published his first work in German, *Sermon on Grace and Indulgence,* which restated arguments central to the Theses. Indulgences, wrote Luther, were for lazy Christians, who should not be buying them with their surplus funds but turning over whatever money they did not need to poor people. In August 1518, Luther published his *Explanations of the Ninety-Five Theses* in Latin. Its purpose was to defend his theological orthodoxy against the accusations, mounting on all sides, that he was a heretic. He sent a copy to the pope, along with a respectful letter of introduction. From now on, Luther's life would be one of heroic hard work—of almost ceaseless writing, in both defense and accusation, and of not a few public appearances in which he would attempt to explain himself to his audiences, some warmly sympathetic, others chillingly condemnatory.

Between 1518 and 1521, Luther made four public appearances in cities beyond Wittenberg—in a time when most people seldom ventured beyond the nearest market town—and published (in addition to the works cited above) eight seminal essays. Indeed, between the Theses of 1517 and his death in early 1546, Luther would write and subsequently publish, on average, a new work every two weeks. In the period of public appearances, and largely as a result of growing opposition, many of his opinions took a more radical turn, after which the course of his intellectual development seemed determined and the historical outcomes irreversible.

In April, Luther set out on foot southeast across Germany for the University of Heidelberg and was received everywhere along his route as a celebrity, greeted enthusiastically even by a local bishop. In his public disputation

* As an extremely British Brit once explained to me, "Ireland is a Mediterranean island lost in the Atlantic."

on Augustinian questions of grace and human nature, he impressed everyone. Martin Bucer, who was in the audience and would become one of his principal intellectual supporters, was fascinated: "[Luther's] sweetness in answering is remarkable, his patience in listening is incomparable . . . his answers, so brief, so wise, and drawn from the Holy Scriptures, easily made all his hearers his admirers." As Richard Marius, one of Luther's more recent and judicious biographers, remarks: "We could wish that Luther had kept that tone throughout his life. He did not."

In August, Luther ventured even farther south to the city of Augsburg, where the German Diet, or quasi-parliament, was convening in the presence of the old emperor Maximilian. Pushing sixty, the emperor was fixated on his own approaching death—he always traveled with his coffin—and much more focused on securing as his successor his eighteen-year-old grandson Charles, son of Philip the Handsome and Juana la Loca, than he was on theological questions. Maximilian would manage to secure Charles's succession by bribing key electors with funds supplied liberally by (who else?) the Fuggers—to the tune of 850,000 gulden in all.

Also present was the papal legate, the Dominican Jacopo di Vio, who called himself Tommaso Cajetan—in tribute to Thomas Aquinas and his own Italian hometown of Gaeta. (In a world where surnames were just coming into vogue and there was no such thing as a defined legal name, many, especially among the intellectuals, took names they felt suited them better than the ones they were born with.) Cardinal Cajetan represented the interests of the pope, who was mainly concerned with preventing the accession of Charles—Francis, the French king, was his preferred candidate—and encouraging a crusade against the Turks. But there was also the bother of that annoying little Augustinian, who had to be put firmly in his place.

Cajetan, whose intellectual contributions are still occasionally praised by right-wing Catholics, was in reality a nap-inducing theologian, more Aristotelian than Aristotle, more Thomistic than Thomas Aquinas; and at Augsburg, where the air was buzzing with intrigue, Cajetan was at any rate wearing his political, not his theological, hat. Luther always looked forward to a debate or at least a lively exchange of views. Cajetan the Italian diplomat simply

expected submission. Only after the principal business of the Diet was concluded and Luther had been kept waiting for six days was he allowed to meet with the cardinal, who offered not a conversation but the opportunity for Luther to recant on his knees. After a few mannerly sentences, the meeting devolved into a shouting match, Luther insisting that the matter of whether the pope had the power to release souls from Purgatory be put before a council of the universal church, Cajetan screaming, *"Gersonista!"* which he thought an unanswerable rebuff. (Jean Gerson, chancellor of the University of Paris in the early fifteenth century and much admired for both his intellectual accomplishments and his genuinely spiritual orientation, was a principal architect of Conciliarism, the theory that only a general council, not the pope, can be said to hold ultimate earthly authority in the church. The theory presaged the eventual development of representative democracy in the Western world.)

At the University of Leipzig, much closer to Wittenberg, a great debate took place in the summer of 1519 between Luther and a wily, practiced public speaker who called himself Johann Eck. Born Johann Maier, he had renamed himself after his native city, today spelled "Egg." (It is easy to make too much of these fashionable name changes: Luther himself had originally given his surname the more homely spelling of "Luder," which can carry such meanings as carrion, cad, and slut.)[*] Eck was a theologian who knew how to win the approval of a German audience with a dazzling display of rapier-sharp invective and an inexhaustible supply of logical objections employed with lightning-quick aggressiveness. The debate, which continued for a week and a half, was thrilling as a top-flight sports tournament to its many spectators. Though Luther was an articulate public speaker and could be cutting both in print and in conversation, he was probably not up to matching the dazzle displayed so effortlessly by his large-lunged opponent. He would ever after refer to Eck as that "glory-hungry little beast."

[*] Nor should one assume that this fashion for name-changing was confined to the period under study. In the late nineteenth century, for instance, Adolf Hitler's father would change the family surname from Schicklgruber to Hitler. The changes seem always to tend in the direction of greater dignity. It is a bit difficult, after all, to imagine *"Heil, Schicklgruber!"* catching on, even among the most devoted fascists.

Did the pope hold some sort of primacy in the church? That was the central question from which all else must flow. To Eck and to the Catholic tradition that he saw himself upholding, the answer was obvious: Jesus himself had established the papal primacy of Peter and his successors, as recorded in Matthew's Gospel (16:18–19) and confirmed by "the fathers"—that is, the principal theologians—throughout church history. Of course, the answer is not really so obvious. The language Jesus uses is metaphorical, far from juridical, and open to a variety of interpretations. Just a few verses later (18:18), he is recorded as saying something virtually identical to a crowd of people identified only as "the disciples." Many perfectly orthodox fathers, especially among the Greeks, as Luther pointed out, never acknowledged that Peter or his successors had primacy. The Greeks, interposed Eck, lost their empire to the Turks as God's punishment for seceding from the Roman communion.

For the audience, made up largely of students and teachers from the University of Leipzig, Eck was the established champion; most were rooting for the home team, not for Luther. In any case Luther's arguments were new to them and required more attention and intellectual discrimination than they were willing to extend. Leipzig was large and venerable; who was this upstart challenger from tiny, new Wittenberg?

By this point in Luther's thinking, the bishop of Rome had no business claiming a distinctive role in the universal church. Such a role belonged only to a genuine consensus of all Christians—and such a consensus could be provided by a representative general council, though even this did not mean that a general council could not err. There was nothing in the Bible to confirm the inerrancy of a general council. Only the Bible itself was inerrant—and only when interpreted by a true Christian.

Gradually, each of Luther's seemingly radical opinions was exposed to view, egged on as he was by Eck, who now accused his opponent of being no better than a Wycliffite or a Hussite, deserving to be burned at the stake. Hus, remarked Luther, had been treated badly by the Council of Constance and perhaps condemned unfairly. Indeed, though having yet to read Hus's principal

works, Luther, despite the gasps of the audience, said stoutly that
he had come to the conclusion that Constance had erred—and this
was one reason he could not claim inerrancy even for a general
council. If only the fathers at Constance had treated Hus with the
fraternal affection he deserved. "I believe that the Bohemians are
men"—something the German audience, victimized in previous
decades by the understandable wrath of the Hussites, was rather
reluctant to acknowledge—"and that they may be attracted by gen-
tle words but that they are only hardened by being called criminal
and by the opprobrious name of heretics."

The idea of treating people with whom one disagrees in a mild
and gracious manner was so alien to the time that it received only
whoops and hollers from the assembled listeners. Eck used a num-
ber of underhanded ploys to best Luther, perhaps the worst being
his pious invocation of the greatest medieval saint, Francis of Assisi,
founder of the Franciscan friars. The miraculous stigmata that
Francis had received in his body were, according to Eck, proof posi-
tive for all to see that God had blessed Francis's perfect obedience
to the pope. In all likelihood, this miracle never occurred.* That
it proves God's approval of papal primacy is surely a large logical
leap, but this sort of crowd-pleasing contortion worked its magic.
Luther's ungenerous reply, suggesting that it might be a better world
if none of the fawning, slimy mendicant orders were to continue
in existence, though not unlike the view that Boccaccio had put
forward more than a century and a half before, brought few to his
side.

Luther was disgusted by the treatment he received at the hands
of Eck and the audience, who cheered Eck, feasted him, and fol-
lowed him through the streets of Leipzig. Luther was aware that,
aside from Eck's extraordinary ability as a speaker, he had trouble
articulating a clear argument of his own. And Luther suspected,
rightly enough, that Eck did not even believe some of the things
he appeared to support so roundly. We know from Eck's corre-
spondence that he had earlier entertained
many of Erasmus's and even Luther's
propositions. But he had turned himself
into a public debater whose object was to

* This is the position of
Donald Spoto, Francis's most
recent and reliable biographer.

vanquish his opponent by dramatic verbal pyrotechnics. The public debater was in devoted service to the secret politician, who had set himself the objective of winning the patronage of the pope and the papal establishment, whither he saw his good fortune lay. Luther's less slick performance was actually motivated by Luther's truthfulness, his profound wish to say only what he believed to be so. Duke George of Leipzig, one of Eck's patrons, was astonished by the open candor exhibited by Luther and his fellow reformers, who tended to reject mere verbal cleverness in their attempt to get at the truth. "They do say what they really mean," remarked Duke George in consternation at such unusual behavior.

For Luther, what had been waged at Leipzig was a pitched battle between Aristotle and Christ. For the schoolmen, the medieval and Renaissance philosophers who depended on the physics and the logic of Aristotle, the world made basic sense and everything in it had a purpose—a cause and an end. In Luther's eyes, such teaching was pagan claptrap. The world made no sense at all, for it was nothing but a repetitive, everlasting cycle of birth and death to no obvious purpose whatever. Real meaning, meaning that we can care about, meaning for *us* comes only through the incarnation of Christ, the God-Man. His life, his hideous suffering, his horrifying death, his resurrection—these give us meaning as nothing else can come close to doing. In the Bible, and especially in the anguish of the Psalms (to which Luther was more attached than he was to the gospels, especially the three synoptic gospels),* Christ speaks to us and we hear his voice, showing us that our experience is his experience and confirming for us the paradox that our seemingly meaningless lives, our secret sufferings—certainly empty of meaning if we remain at the humdrum level of Aristotelian insight—have glorious meaning if taken up into the mystery of Christ.

* Though Luther loved the Psalms, which he took (as did most of the previous Christian tradition) to be the voice of Jesus, he was less attracted to the three synoptic gospels, surely a confused position for one who thought of himself as "evangelical." But as pointed out above, not all of Jesus's sayings in those gospels can be neatly squared with Luther's (or Paul's) "justification by faith." Luther did, however, hold the Fourth Gospel, John's—the least ancient, least historical, and most layered with the theology of the developing church—in high regard.

As 1519 nears its end, we find Luther already in possession of almost all of his signature positions:

- The arguments over Christian history—or rather over the historical development of authentic Christian theology—will never be resolved on historical grounds alone. True doctrine must be grounded in the text of Scripture, which is its only sure foundation.
- We have misunderstood what Scripture means when it speaks of justification. Only God is just; and he is just because he is merciful. Unlike us, God is supremely free; he could have been vindictive and merciless. But he chooses to forgive us our sins; it is he who justifies us. We cannot justify ourselves.
- It is this force of forgiveness that rules the universe, not the blind physical laws of Aristotle. At the heart of the universe is the benignity of God.

In stumbling upon this last insight, the brooding, often morose Luther confided that "I felt myself absolutely reborn, as though I had entered into the open gates of paradise itself."

There are, of course, many subsidiary developments beyond these three, but virtually all additional developments are built upon these central insights. Soon enough, for instance, Luther, provoked by the pope's unyielding high-handedness, will begin to mock him as a diabolical temptation, the Whore of Babylon and/or the Antichrist prophesied in Revelation. On another front, he will elaborate on his theory that the local prince, whoever he may be, acts as the mouthpiece and enforcer of God's will, following occasional Pauline affirmations that appear to point in the same direction. Luther, however, seems normally to find the prince more reliable than any church official. His teaching on predestination—that God has willed from all eternity that some shall be saved, others damned—will wobble back and forth over time. In later life, he will recommend not thinking about the difficult subject at all, if one can banish it from one's mind. But all these positions seem to me to lack the centrality of the first three, especially given the mutability of the subsidiary positions—or at least their evolution—over time.

Even Luther's seemingly strict adherence to the truth of the Bible has its limits. Though no infants are baptized in the course of

the New Testament, Luther will continue to insist on infant baptism throughout his life, as well as on many other traditional beliefs unprovable from Scripture, such as the real presence of Christ in the Eucharist. In a letter of 1528 to two radical pastors, he will indeed demonstrate that he continues to stand up for almost the entirety of Roman Catholic tradition: "We confess that under the papacy much Christian good, indeed all Christian good, is, and so it has come to us. Namely, we confess with the papacy that there is a correct Holy Scripture, a correct baptism, a correct sacrament of the altar, a correct key to the forgiveness of sin, a correct teaching office, a correct catechism, the Lord's Prayer, the Ten Commandments, the articles of faith [of the traditional creeds]." Quite a mouthful from the world's first Protestant.

The best route to understanding Luther's theological positions may lie in appreciating the man's psychology. He was a natural conservative, someone who preferred black-and-white statements to unnecessarily clever and elusive formulations, someone more at home with the literal than the metaphorical, someone who respected tradition and wished only for necessary changes and adjustments.✝ This corner of his psyche he may be said to share with a great many men and women throughout history.

But there is another corner that seems to belong only to the period that begins in his time and continues into ours, for in Luther we sense—for the very first time in biographical history—what may best be called existential terror or what Marius labels Luther's "devouring fear of death." Luther, commenting on the Fifth Psalm, finds the life of the believer filled with "pain, temptation, doubt, and fear." Even for the theologian, the Christian expert, "living, no, on the contrary, dying and being damned makes the theologian—not understanding, reading, or speculating!" The boy who pledged to devote his life out of fear has become a fear-beset adult.

It is not so very surprising that Luther was often misunderstood in his time. He might have been better appreciated in the nineteenth century by Kierkegaard or

✝ My local Lutheran church, whose pastor is a respected figure, well known for both her social activism and her openness to alternative sexual lifestyles, is adorned with a large sign of welcome claiming, "We are completely open—in every way!" Luther might have found such a slogan enraging or hilarious, but his comment would not have been printable in any church bulletin.

Nietzsche or in the twentieth by Sartre or Camus or even perhaps in the twenty-first by an intensely existentialist black-metal band such as Wolves in the Throne Room, who might consider this text of Luther's for their next concert: "We should familiarize ourselves with death during our lifetime, inviting death into our presence when it is still at a distance and not on the move. At the time of dying, however, this is hazardous and useless, for then death looms large of its own accord." See the smoke and gloom, hear the screams and growls; for each of us, claims Luther solemnly, must confront the tragedy of mankind's earthly destiny. Luther never loses completely the fear that he may be damned—though, often enough, his fear of Hell sounds more like the agnostic's fear of slipping into nonexistence than like anything to be found in any tradition of Christian theology.

It strikes me as pleasingly ironic that the defiant language of Luther in his darkest moments can be so reminiscent of the so-called "terrible sonnets" of Gerard Manley Hopkins:

> *No, I'll not, carrion comfort, Despair, not feast on thee;*
> *Not untwist—slack they may be—these last strands of man*
> *In me or, most weary, cry I can no more. I can. . . .*
>
> *O the mind, mind has mountains; cliffs of fall*
> *Frightful, sheer, no-man-fathomed. Hold them cheap*
> *May who ne'er hung there. . . .*
>
> *I wake and feel the fell of dark, not day.*
> *What hours, O what black hours we have spent*
> *This night! What sights you, heart, saw; ways you went!*

Hopkins was a great Victorian poet, and his language is denser than Luther's, which can be prolix. But the two often seem to be speaking about a similar experience, near despair despite a muscular faith. Hopkins was a retiring convert from Anglicanism to Roman Catholicism, homosexual in predisposition and probably bipolar, who spent much of his brief and sickly adult life as a Jesuit priest in an uncomfortable exile in Ireland. On the face of it, he would not seem to have much in common with the far more vigorous Luther, publicly and intellectually engaged with his time and with many of

its principal players. (Indeed, in his greatest poem, "The Wreck of the Deutschland," Hopkins dismisses Luther as "beast of the waste wood"—and we can imagine what Luther would have had to say about Hopkins.) But it may be that the "dark night of the soul" is a phenomenon more common to sensitive Christian believers (or perhaps to sensitive believers of any sort) than has been widely appreciated.

In any case, Satan, the Archdevil and ruler of Hell, looms ever larger in Luther's imagination, his figure encountered everywhere. Luther disparaged the miracles that occurred at Catholic shrines as "works of Satan, permitted by God to tempt your faith." He believed in the power of witches to do grievous harm, opening wounds in the bodies of their victims, causing storms and crop failures and killing livestock. He thought that Satan could appear as a human temptress and, through anal intercourse with a man, conceive a devil child. Though these vivid imaginings sound no more modern than the early Middle Ages, the admonitory figures of Luther's nightmares combine with his profound fears of Hell and nonexistence to fashion a soon-to-be-middle-aged man of restless energy and ceaseless activity.

In the spring of 1520, Luther produced two tracts. The first, *On the Papacy in Rome, Against the Famous Romanist at Leipzig,* is a freewheeling attack on positions proposed by a Leipzig monk who had argued for absolute papal sovereignty over church and state. It is written in German, full of the sort of sarcasm and cutting humor that made it a "must-read" for Luther's growing audience. The second, *Address to the Christian Nobility of the German Nation Concerning the Reform of the Christian Estate,* also in German to render it accessible to even the least literate German prince, is one of the most important statements of the gathering Reformation. In it Luther openly pits the legitimate power of the prince—or secular ruler—against what he claims to be the stolen power assumed by the clergy, especially by the pope and his bishops. For the necessary reformation to take place, the prince must assume his legitimate power over both secular and religious realms. The *Address* represents a giant step toward building the necessary theoretical underpinning for what will soon become the national churches of Protestant Europe.

That many princes (and other secular rulers) were at last grow-

ing powerful enough to defy ecclesiastical prescription and punish-
ment✝ surely made Luther's argument appear more realistic than
it might once have been, but a certain lack of realism is still dis-
cernible in his highly theoretical construct, which lacks any feeling
of intimate acquaintance with persons of power or their accus-
tomed ways of thinking and acting. Indeed, monk Luther knew no
princes. Even his local magnate, the unusually avuncular Frederick
the Wise, who had lent Luther his silent patronage, was a distant
figure, known to Luther through correspondence with one of Fred-
erick's secretaries. The two never met. But black storm clouds were
gathering over Luther's head. He would soon need from the princes
all the help he could get.

Johann Eck was in Rome, where he was helping the chancery
compose *Exsurge Domine,* the historic papal bull that would demand
Luther's recantation under pain of excommunication. The term
"bull" derives from the Latin word *bulla* or seal, suggesting that what
is sealed comes from the hand of the pope himself. The document
begins with a quotation from Psalm 74: "Arise, Lord, and judge the
case before you." It goes on to excoriate Luther, his teachings, and
his followers in no uncertain terms, enumerating forty-one separate
errors that must be summarily rejected. Employing the custom-
ary papal "We," it bemoans the pope's supposedly heroic efforts
to pull the errant monk back from the brink: "Regarding Mar-
tin, dear God, what have We failed to do, what have We avoided,
what paternal love did We not exercise, to call him back from his
errors?" Henceforth, no one under any circumstances may "read,
speak, preach, praise, consider, publish, or defend" any of Luther's
writings. Rather, these are all to be burned publicly by everyone
who does not wish to be burned himself or, in a nice nod to gender
inclusiveness, herself. (Indeed, the thirty-third of Luther's forty-one

heresies is that he doesn't believe that God
wants heretics burned at the stake.) The
bull raises its skirts before Luther's "abu-
sive language"—which "vile poison," we
are told, is "the custom of heretics"—and
condescends as from a great height to
"the German people" for whom "our
predecessors and We Ourselves have

✝ Not many years later,
the English reformer and
translator William Tyndale
would remark that though
the Venetians had been placed
under papal interdict again
and again, they discovered
that "they shat as well as they
ever did."

always had a particular fondness." The bull has Eck's characteristic smugness and sense of superiority stamped all over it.

Erasmus was more than a little worried. He had been writing to Luther, originally in admiration, more recently in words of caution. Once it came to his ears that there was a saying making the rounds that "Erasmus laid the egg that Luther hatched," Erasmus's anxiety was much stoked up. Please, advised Erasmus, write and speak with greater restraint—and whatever you do, leave me out of it. "Otherwise, you will make suspect those who might serve you better, were they not compromised." Why not write something pious and devotional, thus helping to calm things down?

As in most periods of history around the planet, a proclamation or a new law cannot become effective till it is universally proclaimed or distributed. In September, Eck arrived in Germany, attempting to promulgate the bull. But he had to stay out of Frederick the Wise's Saxony, where he knew he would be unwelcome, and not a few other princes refused their cooperation. Even the University of Leipzig, sounding muted notes of German nationalism, refused to be drawn into the distribution. As Eck went on his way, he kept adding the names of additional "heretics" to the bull, wherever he discovered new opponents or was sent additional denunciations by the papal chancery. Luther replied briefly that the bull was the work not of the pope but of Eck himself, who understood Scripture "as well as an ass knows how to play the lyre."

In the first week of October, Luther published in Latin his most incendiary tract, *On the Babylonian Captivity of the Church*. The original Babylonian "captivity" referred to the exile of Judeans in the great Mesopotamian city of Babylon after the conquest of Jerusalem in the early sixth century BC, as recorded in the Second Book of Kings. By the time Revelation, the final book of the Bible, was written at the close of the first century AD, Babylon had become the fabled capital of all evil and a code word for pagan Rome and its power. In the medieval period during which the Francophile popes resided not in Rome but in Avignon, people spoke of "the Babylonian captivity of the papacy." Now, Luther awarded the prize for the epicenter of all evil to the papacy itself, seen as keeping the church in infernal bondage to all forms of perversity and sinfulness.

In the *Babylonica,* Luther came out of the closet, so to speak,

casting aside all Erasmian caution and explicitly reciting his objec-
tions to papal teaching exactly as he saw (and felt) them. The pope
is anti-Christ, his authority illegitimate and his sacramental system a
fraud. "Neither pope nor bishop nor any man has the right to impose
one syllable of law on the Christian man except the Christian give it
his consent." Marriage, though no sacrament, is an ancient human
institution, which the church should not attempt to regulate with its
infinite series of legalisms and the jockeying required by the church's
marriage courts. "Today's Romanists have become salesmen. And
what do they sell? Penises and vaginas." There are, at most, three
sacraments, not seven,* ordained by Scripture: baptism, Eucharist,
and confession (though this third would be gradually downgraded
by Luther to such an extent that it would become at last almost
invisible). The Eucharist (or mass) requires no specially ordained
priest, only the community of believers, to make it happen. Christ
is really present in this sacrament, even though the papal teaching
of transubstantiation is nonsense, since it is based not on Scripture
but on Aristotle, who is also nonsense. Because the Christian always
remains *simul justus et peccator* (both justified and a sinner), the only
sin we need take with ultimate seriousness is unbelief.

Erasmus read the tract in early 1521 and was horrified. What
good could Luther possibly expect to come from such patent intem-
perance? Most upsetting of all, rumors were circulating that Eras-
mus was the secret author of the *Babylonica*. From this time onward,
the tentative alliance between Erasmus and Luther was broken.

Once Luther had got these aggressive arguments off his chest he
seems himself to have realized that he had gone too far in provoca-
tion. His next piece of writing, almost certainly his finest, was *The
Freedom of a Christian,* which he finished in November 1520 and
which makes many of the same arguments as the *Babylonica,* if in
more considered prose and more elevated
style. But there was no denying that
Luther now stood foursquare against the
institution of the papacy and a long line
of papally sponsored theological develop-
ment.

In early December, many German
towns, encouraged by Eck and other

* In fairly late Catholic
tradition seven sacraments are
designated: baptism, Eucharist,
penance (or confession),
confirmation in the faith,
priestly orders, matrimony,
and extreme unction (or final
anointing before death).

Romanists, burned the works of Luther in ominous public cer-
emonies overseen by the shadowy figures of local executioners. On
December 10, the people of Wittenberg made their own bonfire,
throwing books of canon law and anti-Luther tracts into the flames.
Luther, standing amid the revelers, contributed Wittenberg's own
copy of *Exsurge Domine*. Henceforth, as Erasmus had feared, the
battle was joined. There could be no going back.

Frederick the Wise appears in virtually all historical accounts
a paradoxical, even an imperspicuous figure. He died as he lived, a
Catholic, never immoderate yet pious and traditional in his devo-
tions. But he was immovably on the side of fairness and rationality
and against all violence and cruelty. He even disapproved of execu-
tion as a form of punishment: "An easy thing to take a life," he
mused, "but one cannot restore it." In the course of his long reign,
there were no wars within his territories, nor did he ever declare
war against another land. He was in these ways most uncharacter-
istic of his time. He trusted, moreover, in his own deep respon-
sibility to protect those whose lives were lived within his realm,
those formally "under his protection." And he was, if the category
of a slightly later age may be applied to his, a German patriot.
More than any other figure of his time, he was Luther's good
luck.

Frederick not only refused to distribute *Exsurge Domine*; he
actively lobbied for a public hearing for Luther, to be held not in
Rome—whence, he was certain, Luther would never return—but
in Germany, where fairness might be possible. He had cast his elec-
toral vote for the new emperor, the now-twenty-year-old Fleming
Charles, and against the pope's French candidate. He was owed
some consideration.

The next Diet would be held in the spring of 1521 at Worms,
south of Frankfurt, where the gangling young Charles V, who,
thanks to the long tradition of royal inbreeding, had a projecting
lower jaw that made him resemble a somewhat awkward gorilla,
would preside, appearing for the first time to his German subjects.
Though Frederick tried valiantly to rally Charles to Luther's side,
Charles, an outsider with no especially German sympathies and
already making his own private political calculations, knew how
important unity of faith would be to his success as ruler of his vast

and diverse territories, no portion of which loomed larger than the German-speaking lands.

Luther, though sick with anxiety, decided—in the manner of Paul submitting to Caesar—to respond positively to Charles's mandate to appear at Worms. "If Caesar calls me, God calls me," he wrote to Frederick, professing his belief in the God-given role of princes rather than priests. "If violence is used, as well it may be, I commend my cause to God." And though Charles had promised his imperial safe conduct, the fate of Hus in similar circumstances was never far from Luther's consciousness.

On the morn of April 16, after a two-week journey, a trembling Luther, accompanied by a few friends, made his humble entrance into Worms in a borrowed two-wheeled Saxon cart. All along the way, save as he passed through Leipzig, he had been met by large crowds of well-wishers, nowhere more lavishly than at Frankfurt, home of German literacy, already the host to the great annual book fair that continues to this day. At Worms, the infamous monk, now—as was widely known—excommunicated by the pope, was jostled by two thousand supporters, all of whom wished to welcome him and help to escort him to his lodging. Those who did not swarm in the street took up their clamorous positions on the roofs of houses. Luther could hardly have hoped for a heartier welcome.

In the afternoon of the next day, Luther found himself before the emperor and his family, the assembled princes of Germany, the papal nuncios, and assorted courtiers, clerks, and clerics. In the alcove of a window was piled an enormous number of books. Johann von der Ecken, chief official under the archbishop of Trier (and no relation to the Eck at Leipzig), pointed to the pile of books and asked Luther to acknowledge his authorship of them all. We know that, because Luther was almost inhumanly productive, this great pile would have appeared to many less industrious souls as an impossible achievement—short of diabolical assistance. Even Luther seems to have hesitated before claiming them all, so the titles were read aloud, making a long and increasingly incredible list, after which Luther acknowledged authorship.

"Will you then recant?" asked Ecken immediately. Luther, who had vainly hoped to be allowed to argue his case before the court, asked for time to consider his response on account of the momen-

tousness of what he had written about, namely the Word of God. After long moments of silence, the young emperor agreed to a day's consideration, ruffling Ecken's feathers.

Late the next afternoon as the sun was already beginning to sink beneath the horizon, a much larger audience, hoping no doubt for an explosive encounter, filed into a much larger room, which became so crowded that only the emperor himself was provided a chair. The body heat in the room was such that Luther in his woolen monk's habit was sweating profusely. He could not, he told the emperor, simply renounce all his works outright because they were of such differing kinds. Some were so simple and pious that no one could object to them. To renounce such books would be to renounce Christian doctrine, as accepted universally. A second class of books involved denunciations of the immoral lives of so many Romanists—"all this sink of Roman sodomy," as he had termed it elsewhere—and their tyranny over the great and good German people. His audience, by and large, was almost as receptive to this second demur as it was to his first.

In a third class of books he had replied to attacks against him and, he confessed, had not always been mild in his answers. For "we must weigh carefully how wonderful and how awful our Lord is in his secret counsels. We must be sure that those things we do to banish strife . . . do not rather lead to a flood of unbearable evil." Our desire for peace can so easily undo us just as it undid "pharaoh, the king of Babylon, the kings of Israel." So too could even "the government of this young, noble prince Charles—on whom next to God we hope for so much—become sick unto death." Of course, these princes, these "exalted men," need "neither my teaching nor my warning," but "I must not shun the duty I owe my Germany. And so I commit myself to your majesty and to your lordships. I humbly beg you not to condemn me without reason because of the passions of my enemies." Then, to signal that he had nothing further to add, he pronounced his resounding "I have spoken."

He had succeeded in making the speech he was to have been forbidden to make. Ecken, furious, shouted that he had failed to answer the question put to him and was, rather, calling into question "the most sacred orthodox faith" and waiting "in vain, Martin, for a disputation over things that you are obligated to believe with

certain and professing faith." In at least the public stance of men such as Ecken, all theological questions had already been answered. It was time simply to recant "without horns or teeth," ordered the offended Romanist.

"Since then your majesty and your lordships," replied Brother Martin, "desire a simple reply, I will answer 'without horns or teeth.' Unless I am convinced by Scripture and by plain reason (I do not believe in the authority of either popes or councils by themselves, for it is plain that they have often erred and contradicted each other) in those Scriptures that I have presented, for my conscience is captive to the Word of God, I cannot and I will not retract anything, for it is neither safe nor right to go against conscience. God help me. Amen."

A slightly later printed version of Luther's remarks adds the sentence "Here I stand; I can do no other" before "God help me," but the accounts of what Luther said that were taken down as he spoke do not include this sentence. Is this, then, just another mythological addition to the story, like the nailing of the Ninety-Five Theses to Wittenberg's church door? I don't think quite. Surely scribes, hired by the opposing side, can't always be trusted, especially to record every rhetorical flourish. And Luther himself never disowned the additional sentence, which is certainly consistent with the spirit he displayed in his reply.

"Nothing will come of nothing," snapped King Lear at his one loving daughter, as if he had just been reading Aristotle. In logic, as in evolution and in all forms of development, nothing can come of nothing; rather, everything has a precedent: something that went before, something from which the phenomenon under study springs and takes its being. The one exception would seem to be the cosmos itself, which appears, whether in ancient theologies or in modern science, to emerge ex nihilo, from nothing. But everything else known to us has a cause, a trigger, a parent, a thing from which it sprang.

In this series of books, The Hinges of History, we are looking especially at dramas of origination. We are attempting repeatedly to answer the questions: How did x or y get started? How did this

or that valued aspect of our contemporary lives come to be? How far back into the past can we legitimately push its origins? In the previous volume, *Mysteries of the Middle Ages,* we found the earliest evidence for feminism, science, and the plastic arts as we know them in the high Middle Ages—in the twelfth, the thirteenth, and the early fourteenth centuries.

When did ego—the personal "I," the self as we now understand it—come to be? Where do we find its earliest expression? Well, there is certainly ego in the Renaissance artists and, further back, in the self-promotion of a salesman such as Columbus. But nowhere in our earlier history does the force of ego ring so fully and defiantly as in the scene at Worms, where Brother Martin—this "pile of shit," as he so often called himself—dared to say "No" to the assembled forces of early modern Europe, to the entire panoply of church and state, and to cite his own little conscience (surely a negligible phenomenon to the majority of his listeners) as the reason for his absolute, unnuanced, unhedged rebellion. For this reason, though we can certainly name many of his immediate predecessors (and have done so earlier in this book), we must pause before the figure of Martin Luther and acknowledge both his astonishing contemporaneity and our, perhaps somewhat uncomfortable, brotherhood with him.

Thus, it is this scene that is memorialized in the epigraphs at the outset of this book. Appropriately, I believe, Martin Luther's statement about his conscience is followed by the statement of the self-named Martin Luther King Sr. (named "Michael" by his parents), whose admiration for the original bearer of his name was lifelong. For Dr. King senior, the essence of the first Martin Luther was the man's courage; and once he saw "the moral courage to stand up for what he knows is right" exhibited by the Roman Catholic presidential candidate he had no intention of voting for,* King switched his vote (from Nixon to Kennedy) and

* Martin Luther King Jr. had been arrested during a peaceful sit-in and incarcerated by the flagrantly racist state of Georgia. There was understandable anxiety that he might never be seen alive again. Senator Kennedy, beginning his run for the U.S. presidency, intervened publicly on King's behalf, thus casting a spotlight on Georgia and forcing its minions to release their prisoner. At the time, it was a most unlikely move for a prominent white politician to make, especially toward the anti-Catholic South, at least some of whose votes Kennedy would need to win the national election.

his lifelong political allegiance (from Republican to Democratic). King's son, Martin Luther King Jr., would in his brief life prove the most courageous and transformative figure of my generation of Americans, likely even of my generation of human beings.

In the end, the cultural forces that brought about such transformation need not be belittled by evidence that a heightened sense of ego may have led also to a heightened egotism. Egotism, that is, a false or disproportionate value placed on personal, subjective experience and on individual identity, has certainly accompanied the deepening of subjectivity and cheapened it throughout our contemporary world. The current inflation of ego in the self-presentation of so many public figures does not, however, erase the startling moral value of what Luther did, nor can it erase what subsequent men and women of courage have achieved in every hour since then, or what they continue to achieve in our time.

INTERMISSION

IL BUONO, IL BRUTTO, IL CATTIVO

(The Good, the Bad, and the Ugly)

A PORTFOLIO OF EGOS

———————— ❖ ————————

As we, the children of the West, look back across our history, we can only be dismayed by the violent clashes that occurred in the period we are now considering. There is a scholarly theory (as well as a popular variant of it) that monotheism itself is responsible for the violence, because the worship of one God—by Jews from ancient times, by Christians from the time of Constantine forward when they gained political power, and by Muslims almost from their inception—necessarily encourages intolerance of other beliefs.

For Jews, we have only to consult the Bible itself, especially references to the supposed conquest of Canaan: "When the LORD thy God shall bring thee into the land whither thou goest to possess it, and hast cast out many nations before thee, the Hittites, and the Girgashites, and the Amorites, and the Canaanites, and the Perizzites, and the Hivites, and the Jebusites, seven nations greater and mightier than thou: And when the LORD thy God shall deliver them before thee; thou shalt smite them, and utterly destroy them; thou shalt make no covenant with them, nor show mercy unto them." The Book of Deuteronomy goes on to connect all the smiting to the worship of this one God, who finds polytheism in any form both unforgivable and intolerable: "But thus shall ye deal with them; ye shall destroy their altars, and break down their images, and cut down their [sacred] groves, and burn their graven images with fire." Nor are these the Hebrew God's most antihuman instructions, which elsewhere include the slaughter of even the children and the animals of the polytheists.

For Christians, words like "Crusade" and "Inquisition" should induce sufficient historical nightmares; and, if not, slightly longer phrases, such as "the burning of witches" and "the exile and

extermination of Jews," should do the trick. For Muslims, the word "jihad" currently needs no further explanation (even if, in its core meaning, it does not refer to violence).

But it is not as if polytheistic religions can be characterized simply as peace-loving, still less as pacifist. In truth, plenty of human blood has been spilled in the name of virtually every religion and sect on earth; and whether or not more has been spilled on a per capita basis by monotheists than by others is not a matter that can be easily resolved. The question of whether this recurring violence relates more to theological belief or to political gamesmanship or to the ancient human suspicion of the Other complicates analysis still further.

So, having at least given voice to these questions, I leave them to others to settle. I would prefer to tackle the movements and trends that I can trace with some clarity.

One undeniable trend that we see in the history we have surveyed thus far is the new sense of the self that begins to emerge after the catastrophe of the Black Death and that continues to bud—and then to flower in ever more riotous blossoms in the course of the Renaissance.

Christopher Columbus is an extraordinary avatar of the New Man, projecting a new vision of the globe and of himself on the Europe of his time. It is a vision that will have traceable (and sometimes improbable) consequences for centuries to come. And these consequences will be not only far-reaching but profound and permanent, far more profound and permanent than if Columbus had somehow set off major earthquakes or tsunamis or even induced continental shifts. The lives of the inhabitants of the newly discovered islands and continents will be forever changed by his discoveries, as will be the lives of Europeans and finally of all humanity. And as if this were not enough, it may be argued that Columbus himself becomes the first identifiable model of a new mode of conducting one's life and of negotiating society. No longer traversing medieval byways, no longer dependent merely on the structures and rules of a highly stratified society, he invents himself and his project—something we, for better or worse, are all still doing.

It is not as if there had never before been innovators. All the major figures to appear in the earlier volumes of the Hinges of History—Patrick of Ireland, King David, the Hebrew chroniclers and prophets, Jesus, Paul, Socrates, Plato, Hildegard of Bingen, Eleanor of Aquitaine, Francis of Assisi, Giotto, Dante—were innovators. But in Columbus we meet not only innovation but self-invention and self-promotion of an entirely new sort. For better or worse, the *personality* of Columbus is an essential part of his story. This is also true of the stories of Lorenzo, Savonarola, Leonardo, Botticelli, Julius II, Michelangelo, Caravaggio, and Bernini. In these figures, attraction (and repulsion), fascination, and enchantment operate as they have never operated before. Whatever else these characters may have been, in their day they would all have made obvious candidates for cover stories in *People* magazine. Such a journalistic vehicle, utterly dependent on the spell cast by an individual, would not have been able to get enough of them. Indeed, though it is impossible to imagine our contemporary world without such journalistic phenomena as *People,* it is equally impossible to imagine such vehicles in the ancient or medieval worlds.

Those earlier societies lacked the invention of printing, which has surely assisted the exaltation of personality. But it hardly originated it. Personality cults were known in the ancient world, certainly as political phenomena. Think of Alexander the Great and Julius Caesar. But in the early modern period, a veritable culture of personality arises in Europe and the New World. The earliest figures, such as Torquemada, Ferdinand, and Isabella, seem somewhat intermediate characters, not as fully separate from their historical backgrounds, standing somewhere between the milder, more predictable figures of the Middle Ages and the astonishing new pop-up figures of the early modern period, more and more of them popping up from 1492 forward and all cutting spectacular figures in their day.

Nor does this breathtaking ascendancy of personality wane as we approach the Reformation. Was there ever a figure in history more attached to his subjective identity—to his "I"—than Martin Luther? As we approach the many characters in this unfolding drama, we shall find each of the reformers distinct and extraordinarily subjective. Their undying disagreements with one another tend to be the tags by which they are now remembered. In their

own time, however, it was the individual force of each of their overwhelming Selves—the personal impact that each one exerted on his followers—that served as engines for the entire period.

As if to offer a visual confirmation of the assertions above, there is here presented for your enjoyment and edification a portfolio of portraits: Plates 30–53. Though there had been portraits in the classical period—we have a pretty good idea, for instance, of what Socrates, Plato, Alexander, and the Caesars looked like—we have none to speak of from the long Middle Ages. Hildegard's portrait, perhaps even drawn by her, is just the Typical Nun. Similarly, the few appearances of Queen Eleanor in paint are of the Typical Queen. There may be one genuine likeness of Francis of Assisi, a homely little fellow painted by Cimabue; all the other dozens of depictions of Francis are simply the Typical Heroic Male Saint of the period.

But in the Renaissance and later, as Self ascended, so did portraiture, becoming the early modern equivalent of gossip columns and webcam videos. Bizarrely enough, these portraits will be almost the last burst of colorful visual art in this book. The reformers did not look kindly on the plastic arts, and not a few of them rejected all such art as a form of idolatry. (See the quotations from Deuteronomy, above, for their biblical warrant.) Nor would art survive in the Catholic world with the same sublimity and awe, or be cherished as it had formerly been. (See the quotation from Walter Pater on page 122 about reformed Catholicism's incomprehension of the elderly Michelangelo; or see almost any Catholic church decorated after the Reformation, perhaps especially the gold-laden but dead churches of the new Jesuit order.)*

The majority of reformers went even further: they wished to destroy what art there was. They smashed the stained-glass windows; they lopped the heads off the statues; they scraped the paintings off the walls; they heaped the exquisitely wrought illuminated manuscripts on the bonfires. And, portraiture apart, they created only a few images of lasting significance.

* Spectacular exceptions to the dead churches of the Counter-Reformation would include not a few Spanish mission churches in the Americas and, closer to our own time, the French chapels created by Le Corbusier (at Ronchamp) and by Matisse (at Vence). The mission churches are made lively by the pre-Christian sensibility of native American folk religion, the French chapels by post-Christian modernism.

V

PROTESTANT PICTURES

AND OTHER NORTHERN IMAGES

———————— ❖ ————————

Doomsday is near; die all, die merrily.
Henry IV, Part 1

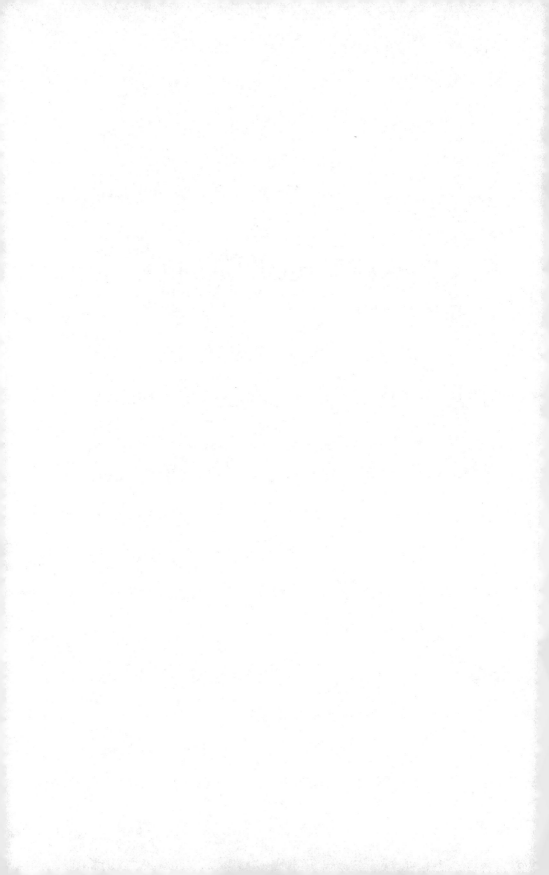

Between Luther's visit to Rome in 1510–11 and 1610, when Galileo in Padua published *Sidereus Nuncius* (*The Starry Messenger*), his challenge to the theory of the geocentric universe, more seeds of change were planted in European soil than in any centenary period before the twentieth century. And even though the permanent effect of the northern (or German) Renaissance on the plastic arts would be fairly slight in comparison with the global remaking of human imagination effected by the Renaissance artists of Italy, it is worth our having a brief look at what the northerners, often prompted by Lutheran courage, accomplished in their smaller sphere of influence.

1498–1528: APOCALYPSE NOW

The strongest and most enduring manifestation of the Northern Renaissance, however, was not really dependent on Luther, for it is to be found in the images of Albrecht Dürer, many of which were known before Luther was even heard of. Despite many volumes of hot air blown by German critics attempting to exalt a passel of their artists, there is no one else like Dürer north of the Alps.✝ He is in some respects the northern equivalent of Leonardo or Michelangelo, except for the fact that he stands alone and none of his Germanic fellows

✝ The German artist most closely associated with Luther was Lucas Cranach: the two were friends, even godfathers to each other's children. A compelling defense of Cranach's artistic excellence, as well as of his undoubted historical role in Luther's Reformation, is provided by Steven Ozment in his *The Serpent and the Lamb: Cranach, Luther and the Making of the Reformation*. I, nonetheless, confess to finding Cranach cloying and second rate.

can cluster about him as do the many lesser lights of Italy about *il Divino* and his near equal.

In the years leading up to 1500, Christian Europe was full of babble about the imminent end of the world. It seemed so obvious: 1500 would be Earth's last year, ushering in all the destructive events of the Apocalypse, as described in *Apokalypsis Joannou,* the Revelation of John the Divine, the Bible's weird last book.[*] The year 1000 had known somewhat similar excitement, though it had been confined to impressionable hysterics in the relatively small circles of those who could then read and count. By 1500, such circles had widened; and, as in our own day, those with the emptiest heads often have the most to squawk about.

Whether Dürer was gullible enough to take their squawking seriously (which I very much doubt), he was enterprising enough to take advantage of the excitement and ride it to fame. He contributed a series of fifteen woodcuts to a printed edition of Revelation. Readers found the large illustrations thrilling, and the illiterate were astonished at the pictures they held in their trembling hands. By 1500, the year of the anticipated apocalypse, Dürer had become famous throughout Germany, the first German artist to attain such renown. Soon enough, his fame, spread far and wide by the medium of printing, would make him the first pan-European artist, his name known to millions.

The woodcuts are wonderful, executed with a masterful sense of overall design, anatomical artfulness, and quirkily personal imagination. The most famous of the fifteen is the woodcut of *The Four Horsemen,* who, though they appear separately in the text of Revelation, are here shown sweeping over the world in concert, urged on by an angel from Heaven, Victory on the far right wielding his unbeatable Parthian bow, accompanied by War with his sword, Famine with his scales, and the pale figure of Death, riding an emaciated nag. In the lower left corner, the loathsome maw of Hell yawns, about to crush a crowned head in its fearsome teeth. The other victims—of lesser station, as their attire reveals—will soon slide toward those jaws of ultimate horror. So no one will escape the final accounting, neither king nor cottier.

[*] For an analysis of the actual meaning of Revelation, as opposed to its many wacky interpretations, see *Desire of the Everlasting Hills,* pages 158ff.

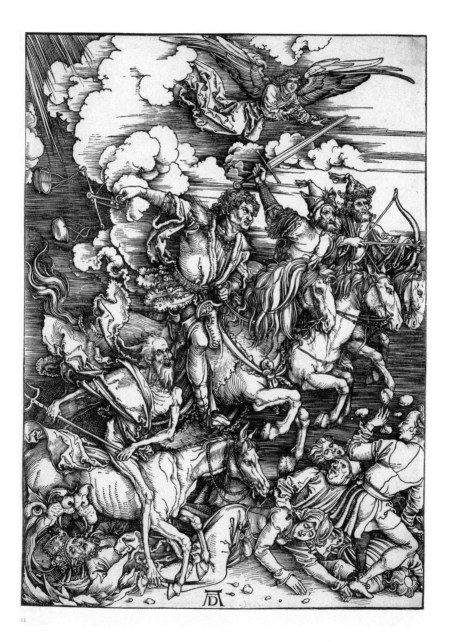

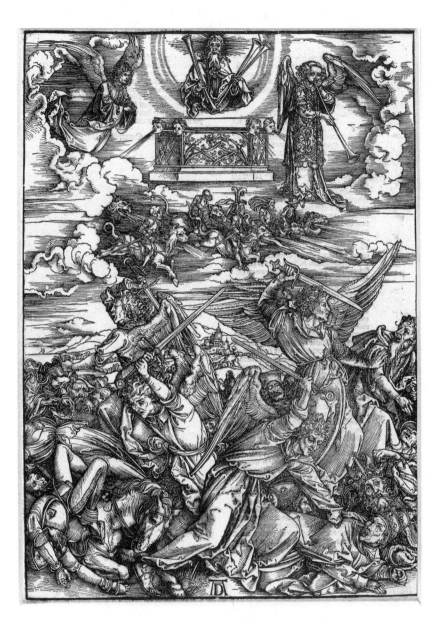

The gruesomeness of apocalyptic retribution, wrought by nightmarish actors of convincing physicality, against identifiable contemporary figures—lords and commons such as anyone might encounter—seized the public and caused viewers to shudder at the horrifyingly thrilling possibility of the End Time. What if this were indeed about to happen? What if Frau Weibsbild down the lane is about to meet her awful last day along with millions of other unregenerate sinners, whilst I perhaps will be lifted up to Heaven with the elect? No creepy horror movie of our own time could have elicited more convincing yelps and yawls.

Another of the woodcuts depicts one of Revelation's more puzzling scenes: "I heard a voice from the four horns⁺ of the golden altar which is before God, saying to the sixth angel which had the trumpet, 'Loose the four angels which are bound in the great river Euphrates.' And the four angels were loosed, which were prepared for an hour and a day and a month and a year, for to slay the third part of men."

The four angels (I'm not sure anyone knows why these four had been previously bound in the Euphrates) are caught in the act of taking their vigorous exactions against one-third of humanity. You'll note that the angel in the foreground is about to whack the pope, who wears his triply tiered papal tiara. Just behind His Holiness is the Holy Roman Emperor on the verge of receiving similar treatment. (The emperor sports the same mitered crown that then-emperor Maximilian I favored.) So, in 1498, almost two decades before Luther's challenge, we have clear evidence that many Germans (and many Europeans beyond the German lands) would have been happy to see the pope lose his head and that virtually as many would have been content to see *der römisch-deutsche Kaiser* follow suit. However we may imagine what passed through the minds of the original viewers of these prints, however much we may attribute to them imaginative projections of their own deepest fears and desires, we can have no doubt that there was considerable public dissatisfaction with rulers, both sacred and profane. No one thought to upbraid Dürer for sending both pope

⁺ The horns of the altar referred to bulges that were part of the construction of ancient Israelite altars. Dürer misunderstands the reference and shows God the Father holding musical horns over the heavenly altar.

and emperor to Hell. At the same time, it should be noted that it is
the pope, not the emperor, who is in the foreground and that just
behind him, indeed hovering at his backside as if in eternal syco-
phancy, is another bishop, wearing his miter of office. So, Dürer's
condemnation of papacy and church is more blatant than his con-
demnation of the civil power.✝

Over the course of the fifteen prints, Dürer exhibits a graceful
ease with the bizarre and unlikely figures that inhabit Revelation.
If he is very good at capturing the heroically muscular action of
the heavenly figures, he may be even better at depicting Gothic
horrors. The nightmarish denizens of Hell have never found an
abler portraitist. And the stark simplicity of black-and-white design
has never found an abler dramatist. The depiction of the "war in
Heaven" between the angelic forces of Saint Michael and the "great
dragon" and *his* angels has an unforgettable visual force. The vigor-
ous heavenly soldiers will win, no doubt. But even Saint Michael's
elongated and thrust weapon draws us visually to the great
dragon—the Devil—and his horrific allies. Behind them the sky is
dark, a series of simple horizontal lines. Below, by contrast, we see
the lightsome and sweetly settled human communities of Earth in
communion with nature, the ships in the harbor giving evidence
of far-flung human communication. And yet, catastrophe is but a
moment away: "Woe to the inhabiters of the Earth and of the sea!
For the Devil is come down unto you [having been expelled from
Heaven], having great wrath, because he knoweth that he hath but
a short time."

The starkness of the black-and-white medium of print only
emphasizes the distance between Italian and northern European
art. Dürer spent several years in Italy, absorbing everything he could
of the Italian masters. His unerring sense of the drama of anatomy, movement, and layout shows what a keen student he was; and the examples of his art that survive from his pre-Italian period can be a trifle poky by comparison. None-theless, there are aspects of Dürer that, like Luther's worst fantasies, derive their power from the nightmares of comfort-

✝ The preference for
condemning church over state
is abundant through much of
Western European literary
history, starting with Dante
and Boccaccio, taking us
through Chaucer, Langland,
and Villon, and ending, if at
all, only toward the late
twentieth century.

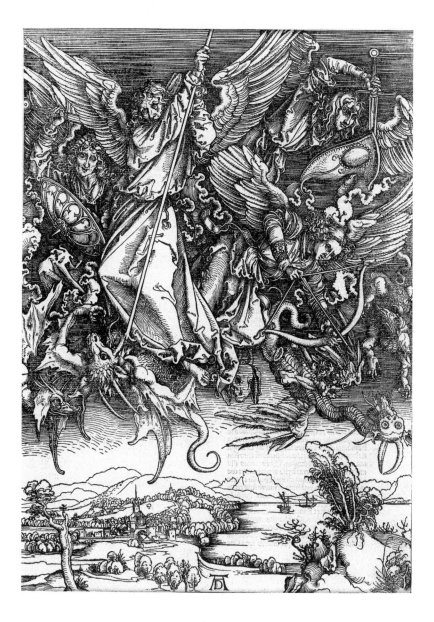

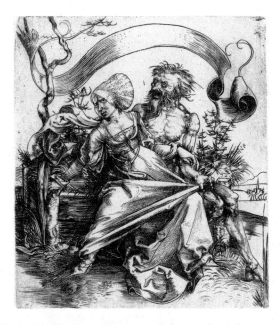

less, endless northern winters and from the gloom of Germanic folktales, haunted by witches and goblins, not from the long, leafy, sun-drenched summers of Greco-Roman civilization, populated by nymphs and fauns.*

Despite all that Dürer learned in his lengthy Italian wanderings, he was never a mere imitator but always rooted in authentic northernness. Soon after his first Italian journey in 1494, he made one of his scariest, least Italian engravings, *Junge Frau, vom Tode bedroht* (*Young Woman Attacked by Death*) or *Der Gewalttätige* (*The Rapist*), in which the rapist Death rips the skirt of a young woman seated on his lap while she struggles to escape. It is a macabre variant on the many sketches of courting couples that were popular at the time—and it is one of the few prints of Dürer that lack his customary AD logo, which, in the absence of copyright laws, provided an assertion of ownership. Leonardo might not have cared for the face of Death, but the Brothers Grimm surely would have.

* This is, of course, classicism much sweetened in the course of the Renaissance by Christian optimism, not the original Greco-Roman fatalism. See pages 105–6.

(Speaking of Leonardo, I am reminded that we stopped in Chapter II at his exceedingly famous image of the *Vitruvian Man*. But Dürer made an image that remains even more omnipresent: the *Praying Hands,* so recognizable that there

is no need to reproduce it here. Two other images drawn by Dürer, however, are perhaps just a tad less well known than the *Vitruvian Man*: the humble *Hare* and the stupendous *Rhinoceros,* an animal never seen by Dürer. He created his attention-grabbing broadsheet using descriptions received by Nuremberg merchants from eyewitnesses in Lisbon harbor, where the first rhino to set hoof on European soil made for excited conversation.)

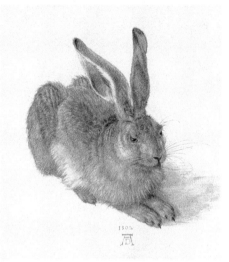

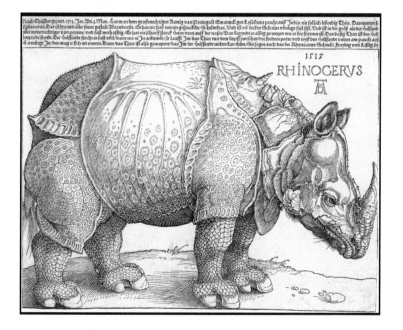

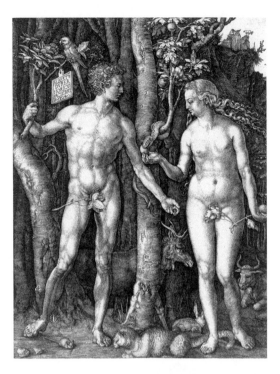

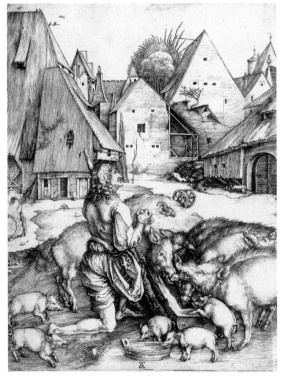

At the same time, it would be caricature to present Dürer as a fear-obsessed northerner, hounded by nightmares. His profound understanding of what the Italians had accomplished issues in some of his most treasured images, such as his engraving *The Fall of Man* (facing page, top), as deft and deep as anything by Michelangelo, especially if one views not just this black-and-white version, but Dürer's exquisitely modeled and delicately colored oils of the same subject, twin panels hanging in the Prado, Madrid, and almost impossible to reprint successfully.

Dürer celebrated not only the ideal human body but every quotidian reality he could capture with his artist's tools. His marvelous picture of the Prodigal Son (Luke 15:11–32), feeding the pigs on his master's farm while kneeling in the muck and praying for a better alternative, contains, by the by, an exactingly detailed picture of an indifferently maintained German farmyard with its multiplicity of barns and dwellings and, beyond these, the roofs and chimneys of a town, including, on the far right, the turrets and steeples of a church, toward which the Prodigal directs his prayer (facing page, bottom).

Similarly, a much later engraving by Dürer (see next page, top) shows a dancing peasant couple in all their glorious ordinariness, the woman with her keys and other symbols of responsibility dangling from her waist, the man ineffectively shod, his left sleeve ripped at the elbow. They are neither ideal nor especially admirable; they may be cunning, but they are not intelligent. They are vulnerable human beings, having fun. Give them a break. Scenes such as this and *The Prodigal Son* open the door to the so-called genre painting of northern Europe, especially to such extraordinary (and extraordinarily sympathetic) artists of ordinary life as Bruegel the Elder and Vermeer.

Occasionally, Dürer tried to crisscross the Italianate with the Germanic—to comic effect. One example is the engraving of *Nemesis,* the Greek goddess of Fate, who had never been depicted by the Greeks or by anyone else (see next page, bottom left). It turns out she looks like a naked middle-aged German frau, whooshing over the South Tyrol on her personal sphere. In her left hand, she holds a bridle and reins, symbolic of her intention to impose discipline. In her right, she offers a Gothic goblet, symbolic of her willingness

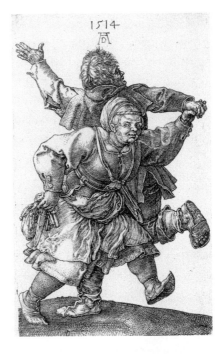

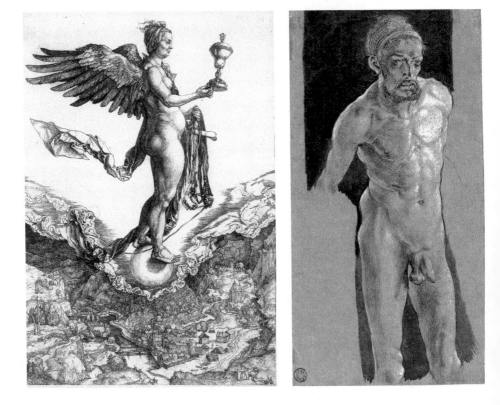

to reward those who submit to her discipline. Beneath the clouds are the beautiful settlements of the Isarco Valley, whose inhabitants speak Italian as well as German. This goddess is not as awful as she might be, but she's no Venus, boys. There seems to be a not-so-hidden commentary here on German women, as contrasted with the genuine goddesses of Italy. Perhaps I read too much into this, but we know that Dürer's arranged marriage was an unhappy one and that he took off for Italy whenever he could get away.

In addition to Dürer's astonishing self-portrait as Christ [second insert, Plate 36], Dürer made almost as many self-portraits as Rembrandt would, none more incredible than the one he made when he was thirteen, surely the earliest worthy self-portrait ever made, before or since. The confidence of this boy was amazing.

Dürer painted himself as a jaunty man-about-town two years before his Christ portrait and as an edgy Christ in his Passion more than two decades later—in 1522, just six years prior to his own death. But perhaps the most unexpected self-portrait is the pen-and-brush image on green grounded paper that Dürer made in 1505 (facing page, bottom right), just three years after his self-portrait as the handsome, curly-haired Christ. Here is surely a revelation: a man from head to knees, watchful, almost anxious, without curls and completely nude, his genitals, as Joseph Leo Koerner has remarked, "the most particularized area of the sketch, displaying an irregularity and profile distinctly their own."* This was a playful man who nonetheless wanted complete honesty, not facile idealization.

In the story of Jesus, Dürer, like Luther, found his way. There is another portrait by Dürer, the simplest of simple charcoals, finished with only a few strokes. It is the *Head of the Dead Christ,* curly-bearded, not curly-haired, garish

* Two schematic anatomy sketches apart, this is the only front-and-center, fig-leaf-less nude in all of Dürer's work. Even his woodcuts of the interiors of bathhouses do not depict complete nudity. The northerners were, at this time, far more modest than the Italians. In time, this would change, very nearly reversing itself over the last century. Today, Italians may appreciate nudity in art, but in swimming pools and on beaches they exhibit far more pudency than the Germanic peoples, who allow and sometimes even prescribe nudity for both sexes in certain public places. The northern European *Lebensreform* ("life reform") and "naturist" movements of the nineteenth and early twentieth centuries, which often enough progressed in tandem with hypernationalism and Nazism in Germany, are largely responsible.

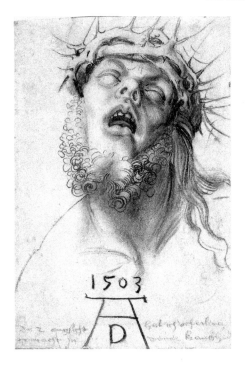

face, undignified, as we all must be in death, and at its base the (proportionately) largest AD monogram in all of Dürer's art. This is not Dürer as Christ but Christ as the ultimate figure Dürer would attach himself to. For Dürer, as for Luther, Jesus, even dead, makes sense of all our lives in a way that no one else can.

Looking at the dead Christ, the viewer may essay a wry smile but will hardly be tempted to laugh. Yet Dürer is fairly bursting with Luther-like humor, bold and hidden, harsh and gentle, and with references to the awful comedy of the human condition. Of his many engravings that feature portraits of his contemporaries, I would leave you with one: Albrecht of Brandenburg, the man who tripped off the Reformation by his involvement in the selling of indulgences throughout Germany (facing page, top). When we met him last (page 147 and following), he was a bishop. By the time Dürer sketched him, he had been made cardinal. How similar is his profile to Dürer's depiction of another religious leader of some historical importance—Caiaphas, the Jewish high priest, as he judges Jesus, the prisoner who stands before him in the gloom of the night (facing page, bottom). For an artist of such consummate attention to detail, can the similarity be just a coincidence?

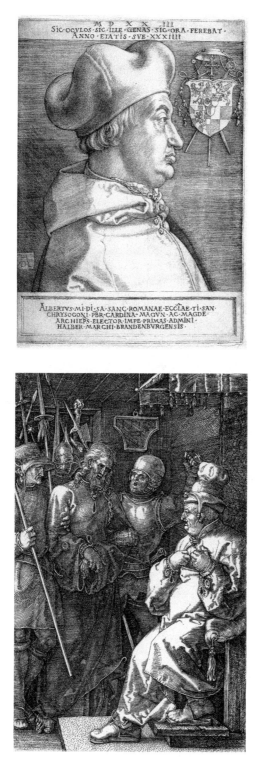

In connecting Dürer to Luther, I have one last, exceedingly northern image to show you, Dürer's *Knight, Death, and the Devil*. No one has explained this mysterious picture—which has often been misinterpreted[*]—more eloquently than the German American theologian Paul Tillich:

> It has rightly been said that Albrecht Dürer's engraving, "Knight, Death, and the Devil," is a classic expression of the spirit of the Lutheran Reformation and—it might be added—of Luther's courage of confidence, of his form of the courage to be. A knight in full armor is riding through a valley, accompanied by the figure of death on one side, the devil on the other. Fearlessly, concentrated, confident he looks ahead. He is alone but not lonely. In his solitude he participates in the power which gives him the courage to affirm himself in spite of the presence of the negativities of existence. His courage is certainly not the courage to be as a part. The Reformation broke away from the semicollectivism of the Middle Ages. Luther's courage of confidence is personal confidence, derived from a person-to-person encounter with God. Neither popes nor councils could give him this confidence. Therefore he had to reject them just because they relied on a doctrine which blocked off the courage of confidence. They sanctioned a system in which the anxiety of death and guilt was never completely conquered. There were many assurances but no certainty, many supports for the courage of confidence but no unquestionable foundation. The collective offered different ways of resisting anxiety but no way in which the individual could take his anxiety upon himself. He was never certain; he could never affirm his being with unconditional confidence. For he never could encounter the unconditional directly with his total being, in an immediate personal relation. There was, except in mysticism, always a mediation through the Church, an indirect and partial meeting between God and the soul. When the Reformation removed the mediation and opened up a direct, total, and personal approach to God, a new nonmystical courage to be was possible. It is manifest in the heroic representatives of fighting Protestantism.

[*] It was even claimed by the National Socialists, that is, the Nazis, as their kind of art.

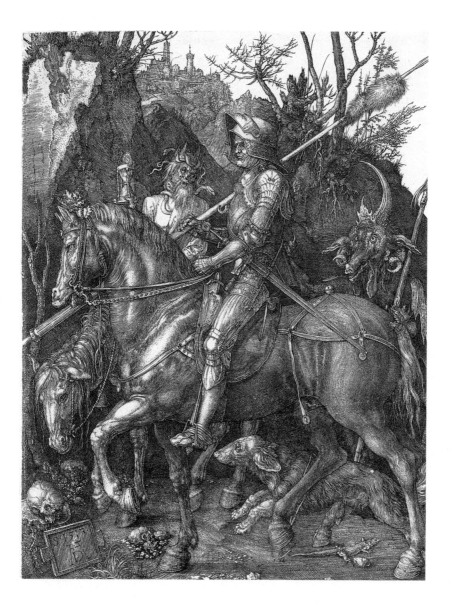

These are extraordinary things to claim for any picture, especially one made in 1513, before Luther had even spoken aloud to the Germans. It is certainly hard cheese for any Roman Catholic or Orthodox Christian to digest, not to speak of any number of contemporary Protestants who have smoothed away the rough bits of classical Protestantism to create a gentler religion more to their liking.

But it speaks to an undeniable vein of northernness. So let us now consider some other northern visions.

1516–1535: UTOPIA NOW AND THEN

The contemplation of a possible apocalypse—and for some temperaments and predispositions, even the *yearning* for such a final and complete catastrophe—arises not so much from the secretly pleasurable anticipation of ultimate destruction as from a previous meditation, growing out of one's own life experience, that reaches the conclusion that human beings are incapable of perfecting society or even of righting its most blatant injustices. So, a plague on all your houses, on all human activity. Nothing and no one will make the Earth a better place. We might as well have done with it. It is just this (as we may call it) anti-utopian, or dystopian, vision that must precede a yearning for apocalypse.

But other less radical, less complete, less final meditations are possible and were broadcast confidently throughout the sixteenth century. There is nothing remotely rational or moderate about apocalyptic thinking, which inevitably attracts fanatics, raving or otherwise. Instead, how about trying the wisdom of gradualism, incrementalism, and rational grappling with human difficulties and challenges? Human beings who are drawn instinctively to moderation rather than to extremes will inevitably find such an approach far more congenial than black-and-white visions of the End of All Things.

It is also true that such an approach was helped along by the Age of Discovery itself. Finding previously unknown peoples, living in societies bizarrely different from anything dreamed of by Europeans, encouraged what we would now call utopian thinking: let's imagine a society different from the ones we are familiar with,

a society that more reasonably answers to human needs and aspirations. The first Renaissance man to do this was an English lawyer and humanist, Thomas More, who was also counselor to his king, Henry VIII, and a man on the rise in London society, one on whom the monarch appeared to bestow extraordinary amounts of trust.

More was the inventor of the word "utopia," which he made up by combining a Greek noun, *topos,* meaning district, and *eu-,* a Greek prefix meaning good—though if one pronounces the first syllable as "*ou-,*" one is using a Greek prefix that negates the noun that follows it. So "utopia" has the double meaning of good place and no place. It is, therefore, an ideal society that does not exist. If this strikes the reader as a trifle pedantic, I would ask you to note that we are now back in the world of the humanists, of playful scholars like More's great friend Erasmus, far from the fight-to-the-death arguments of the Lutherans. More's *Utopia* may indeed be the most blandly boring short book ever written (but one that I have read on your behalf).

There are two exceedingly ancient and famous literary utopias that precede More's, one Jewish, the other Greek, each borne toward us on one of the two great rivers of our Western tradition. The ancient Hebrew depiction of the Garden of Eden in Genesis is a cheerful folk account in few words and with only elementary details sketched in, though the tempting serpent soon brings this prehistoric Mesopotamian utopia to its blank end. Plato's republic, in the book of the same title,* written in the high style of the ancient Greeks, is a detailed and grave, not to say chilling, description of the great philosopher's vision of a perfect society, ruled by specially schooled philosopher-kings who have divided humans into different classes (guardians, soldiers, workers) based on their intelligence. Poetry and music, which can stir the less intelligent to wayward emotion, have been banned altogether.✦

* Our English title, *The Republic,* derives from the Latin translation, *Respublica.* In the Greek original, the title, *Politeia,* would be better translated as *Society* or simply *The State.*

✦ A third model for *Utopia* should be mentioned, Augustine of Hippo's *Civitas Dei* (*City of God*). In this work of the early fifth century, the great African bishop (and Neoplatonist) was much preoccupied with defining the characteristics of the Earthly City, preeminently the Rome of his day, against the characteristics of the Eternal City or Heaven. If not quite a utopian/dystopian work, it is

More certainly had *The Republic* in mind as the literary model for *Utopia*. The great, still open question about More's invention is this: did he intend his utopia as a straightforward description of an imagined ideal or should we take it as a teasing, occasionally ironic presentation, perhaps a kind of satiric commentary on Plato's daydream? Scholars have long disagreed, and continue to do so, over this question. The common reader who makes it through More's arch prose, filled with insider references, is likely to find himself flummoxed by the evasive tone and unlikely to grasp any assured viewpoint. More was not as practiced a writer as his friend Erasmus, though Erasmus's less admirable quirks, particularly the occasional smugness of the prose, can also be found in More's writing and sometimes overwhelm More's exhaustingly cute sentences, alienating all but the most devoted reader.

The work is divided into two parts, Book I being an imaginary dialogue among Peter Giles (the Antwerp printer who would first publish *Utopia*), More, and a fictional Portuguese explorer named Raphael Hythloday, a surname made up of Greek syllables that suggest a "salesman of nonsense," perhaps warning the reader against taking Raphael's coming account too seriously. Alternatively, the explorer's Christian name, Raphael, means "God heals" in Hebrew, which could push one in a more positive direction regarding this character's function. Moreover, it is Hythloday who is given the lion's share of the dialogue—and he soliloquizes in virtually endless sentences, even recounting earlier conversations in which he has taken part, thus presenting the reader with the grating challenge of dialogue within dialogue.

Nonetheless, Book I enables More to set forth a critique of his contemporary Europe, where kings are always starting unnecessary wars that bleed away their people's wealth, as well as their lives. Also pointed out is the then common and cruel practice of executing thieves. But the sources of most theft are poverty and starvation, much of which can be traced

certainly the political critique that over the long course of Western history may have had more influence than any other. In his early twenties and while still a law student, More lectured on *Civitas* at his neighborhood church, Saint Lawrence Jewry. Unfortunately, his lectures are lost and the twelfth-century church itself was destroyed in the Great Fire of 1666 (though rebuilt in neoclassical style to the design of Christopher Wren).

to the practice of enclosure. For up and down the realm of England, wealthy overlords were claiming vast tracts of land previously held in common by local communities for their familial farming plots and for the grazing of their cattle. These tracts were being "enclosed" by the lords—that is, closed off from access to ordinary townspeople by means of stone barriers—for the purpose of grazing sheep. English wool had become highly valued throughout Europe. The lords therefore used new laws asserting their ownership against the immemorial claims and customs of the country people. As in our own world, the rich were becoming ever richer, and the powerful more powerful—through forms of legal fraud—while the increasing numbers of the poor were mired ever more deeply in their propertyless, powerless swamp of despair. As a jingle of the time put it, far more pithily than More's conversationalists can manage:

> *The law locks up the man or woman*
> *Who steals the goose from off the common*
> *But lets the greater felon loose*
> *Who steals the common from off the goose.*

It would seem impossible not to attribute the characters' judgments on the mores of contemporary England to More himself, even though these judgments are articulated primarily by Hythloday. Amidst the complaints, one stands out, especially More-like: our kings will never become the philosopher-kings of Plato's republic. We must settle for something less, something more realistic. And here the gently humorous More speaks in his own persona against Hythloday's vain insistence on an ideal society:

> If you cannot thoroughly eradicate corrupt opinions or cure long-standing evils to your own satisfaction, that is still no reason to abandon the commonwealth, deserting the ship in a storm because you cannot control the winds. You should not din into people's ears odd and peculiar language which you know will have no effect on those who believe otherwise, but rather by indirection you should strive and struggle as hard as you can to handle everything deftly, and if you cannot turn something to good at least make it as little bad as you can. For everything will

not be done well until all men are good, and I do not expect to
see that for quite a few years yet.

Here is the voice of the saintly realist, saintly because he has
in his mind an ideal that he would himself prefer to follow, realist
because he knows he must settle for engaging with real men in the
real world. This is the voice of Thomas More, who had considered
joining the Charterhouse, a London community of ascetic priests
(who, like the teachers of Erasmus and Luther, especially revered
The Imitation of Christ), but who came to believe that God was call-
ing him to a secular vocation. Though he took with him into his
very worldly world many of that community's practices, especially
personal prayer and penance, More did not expect the world to
be a monastery. He knew, rather, that he was in for a wild, even a
frightening, voyage; and he knew very well the dimensions of the
enormous ego of his sovereign, Henry VIII, an ego that continued
to grow to ever more monstrous proportions, just as his body con-
tinued to feed and fatten grotesquely throughout his reign.✝

Part II of More's book is devoted to Hythloday's account of
the large and fabulous island of Utopia, apparently somewhere near
the endless Brazilian coast. Soon enough in Hythloday's narrative,
a numbingly arithmetical view seems to take over: the island has
fifty-four cities, each divided into four equal parts. Each city has
exactly six thousand households, each household numbering between ten and
sixteen adults. These households are grouped together in units of thirty, each
unit electing a keen scholar as magistrate to represent the voters. Every ten of these
magistrates elect a kind of subruler; and all the magistrates together elect a prince,
who reigns for life, unless he is removed because he threatens to turn tyrant.

In order to keep numbers constant and prevent overpopulation, people are
redistributed as necessary. Utopia is a casteless, communist society where no
locks are necessary, since there is no pri-

✝ More, though elaborately respectful, even at times servile, toward his sovereign, was never in the dark about Henry's true character. More than once Sir Thomas predicted that his head might well be removed from his body if Henry had need of it. On hearing that Anne Boleyn, Henry's second queen, was dancing her days away, More prophetically confided to his favorite daughter, Meg: "Alas poor soul, her dances will knock our heads off like footballs; but ere long her head will dance the like dance."

vate property, and where citizens are rotated from one house to another every ten years, thus removing any false desires for ownership. Life in Utopia is rather kibbutz-like: everyone must learn to farm; and everyone must devote at least two years to this endeavor, men and women working side by side. All health care is free; and there is no such thing as unemployment, though six hours of work each day by each adult is enough to keep the economic engine of Utopia running smoothly. Tailors and dressmakers are unknown, as every adult wears the same cloak of undyed wool.

As was the case among sixteenth-century Europeans, Utopia permits conventional slavery both for prisoners of war and for native criminals, though good behavior will lead to their eventual freedom. While enslaved, they are bound by chains of gold. Gold is also used to manufacture chamber pots, thus conditioning everyone to find it repulsive and greatly reducing the temptation to steal. Likewise, jewels are given to children to wear, so that as they grow up they will recognize the frivolous lack of importance of such outward show. Thus, in various ways are Utopians bred to despise wealth as well as what we would call "conspicuous consumption."

Many religions are found among the Utopians, including a kind of monotheism. Even Christianity is beginning to be introduced through limited contact with Europeans. Atheism is permitted, though hardly esteemed; but in general the Utopians are models of religious tolerance. Women seem not quite the equals of men, though it must be admitted that they are given far greater freedom and importance than in any known society of More's time. Women can become priests in the various religions, priests can marry, and divorce is permitted to all, as is euthanasia. But premarital sex is punished by an ensuing lifetime of enforced celibacy. Adulterers are enslaved.

The elderly are the most honored citizens, and age seems in all things to outrank youth. Travel is allowed only by special permit; anyone found violating this rule is at first simply disgraced, but a second infraction brings certain enslavement.

The problem of assessing the author's opinion on all these rules and customs is hardly slight. Does More mean for us to accept Utopia as an unalloyed ideal? Or are we to pick and choose among the various aspects, taking certain innovations to heart while rejecting

others? Or is the whole construct meant to be viewed as an airy philosopher's error that, starting on false premises, builds a society in the sky that could never come to be?

While there cannot be one definitive answer to these questions, we can perhaps approach a tentative solution, given what else we know about More. He will eventually be decapitated on the public scaffold for opposing—or rather for silently refusing to endorse—the marriage of Henry to Anne Boleyn, his second wife, while Henry's first wife, Queen Catherine of Aragon, still lives. For this refusal—courageous or foolhardy, depending on your point of view—More will be canonized in 1935 as a saint by the Roman Catholic Church and memorialized beautifully as "a man for all seasons"+ in his countryman Robert Bolt's famous 1960 play (and 1966 film) of the same name.

Would a Catholic saint have sanctioned divorce, euthanasia, women priests, and communism? I think the answer may be yes. None of these issues had been decided definitively, either by pope or council, in 1516. There was at this time a still-seething controversy over who held ultimate authority within the Catholic Church. (It was to this question that Luther would soon give his novel answer.) But, you may object, the man died asserting that the king had no right to divorce his wife. I think, rather, that the man died asserting that the king had no right to set himself up as "supreme head of the Church in England," as a result of which he was able to grant himself a divorce. In any case, More's martyrdom lay sixteen years in the future, time enough for anyone's theological thinking to evolve.

More stood virtually alone in the Europe of his day in his opinion that women were as educable and capable as men, an opinion that he famously put into practice in his own household. Women priests, especially in non-Christian religions, would hardly have scandalized him. At this time, he may rather have got a giggle out of the discomfort that such an idea would cause more conventionally minded churchmen.

And communism, the unflinching en-

+ The phrase comes from the compliments of a contemporary, Robert Whittington, but may ultimately derive from Erasmus's Latin description of More as a man *omnium horarum* (for all hours). Nor have such compliments been lacking down the centuries, the great Anglican satirist Jonathan Swift, for instance, bluntly naming More "the person of the greatest virtue this kingdom ever produced."

emy of Christianity, the ultimate bugaboo of twentieth-century politics? Surely, More could not have been seriously proposing that! Well, as of the sixteenth century, the only communism ever tried was the communism of monasticism, first exemplified by the primitive Christian Church in Jerusalem, as portrayed in Luke's Acts of the Apostles: "And the multitude of them that believed were of one heart and of one soul: neither said any of them that ought of the things which he possessed was his own; but they had all things common. . . . Neither was there any among them that lacked: for as many as were possessors of lands or houses sold them and brought the prices of the things that were sold, and laid them down at the apostles' feet: and distribution was made unto every man according as he had need" (4:32–35).

I suspect that most, perhaps all, of the philosophical furniture of Utopia found a welcome in More's mind, especially the means by which his imaginary society protected those who would otherwise have been the poor, the dispossessed, the exploited and abused. And he would have welcomed any society that put less store by personal wealth and vanity. The fascistic aspects of Utopia—how many adults are allowed to live in a given household, how many households can make up a given city, the laws against free travel, even the laws against sexual sin—are far less agreeable to us but may have held some virtue for More. This monk manqué had an undeniable fussbudget aspect to him, a monastic preference for extreme orderliness over any hint of chaos—and chaos, filth, and general disorder were surely thought to be the favored modes of the London poor, if we judge by contemporary descriptions. Nor was sexual sin an unfamiliar flourish at the king's sportive court. It is this less sympathetic, even crabbed quality in More that Hilary Mantel brings to the fore in *Wolf Hall*, the first volume of her extraordinary reimagining of the reign of Henry VIII through the eyes of More's great enemy, Thomas Cromwell.

The influence that *Utopia* would have on future literature, as well as on succeeding expressions of political theory and practice, is virtually unequaled in Western history. As early as the 1530s, a Spanish lawyer-bishop, Vasco de Quiroga, established a native society based on *Utopia* in Michoacan, Mexico, positive traces of which remain to this day. In the same century, *Utopia* inspired some

of the more startling pronouncements of Tommaso Campanella, a wonderfully flaky Spanish Dominican whose utopian fantasy, *La città del Sole* (*The City of the Sun*)—in which he advocated community of goods and wives—was published in the early seventeenth century. Maimed and tortured repeatedly by affronted inquisitors, Padre Tommaso managed nonetheless to intervene on Galileo's side and ended his days as the cherished astrological adviser of Pope Urban VIII.

Utopia, for all its stylistic limitations, had an impact on the political theories of the so-called Anabaptists, whom we shall soon meet, on the course of European socialism in its many evolving forms, and surely on the Marxists, even if they would dismiss as unrealistic *Utopia*'s utter lack of theory about how to achieve a workable socialist society. In our time, its impact may be found most signally in its opposites—in imaginative fictions about dystopias, such as Aldous Huxley's *Brave New World* (1932), George Orwell's *1984* (1949), and Margaret Atwood's *The Handmaid's Tale* (1986). To this list I would add Kingsley Amis's *The Alteration* (1976), a shockingly entertaining dystopian treat, long out of print (now republished by NYRB Classics), in which the modern history of Europe is reimagined on the basis of the conceit that Luther, rather than being condemned, was eventually elected pope. The granddaddy of all these negative fictions is probably Voltaire's *Candide,* written in the mid-eighteenth century but still astringently funny. And, of course, we can hardly omit Oscar Wilde's immortal comment: "A map of the world that does not include Utopia is not worth even glancing at."

1522–1611: THE WORD OF GOD GOES FORTH—FIRST IN *HOCHDEUTSCH*, THEN IN SHAKESPEAREAN ENGLISH

We left Luther sweating in the crowded room at Worms, where he had taken his historic stand before the Holy Roman Emperor, the princes of Germany, and their assembled wise men and courtiers. What now?

Had he been left to sort things out for himself, it is unlikely that Luther would have lasted the year. Surely some authority would have

arrested, tried, and executed him. Luther had received a safe-conduct from Charles, which the young emperor meant to honor. But once Luther reached Wittenberg, if he did, all bets would be off as to his continued freedom or even continued existence. Frederick the Wise, therefore, sent Luther word that he should expect to be intercepted soon after leaving Worms in the company of his armed guards and would, in effect, be kidnapped by an unidentified band of horsemen, training their bows on Luther's guards. The interlopers appeared according to plan and took off with Luther, whither no one knew. In all likelihood, Luther himself did not know where he was being taken. The story went round—recounted with varying levels of hysteria—that Luther had been kidnapped by unidentified men and taken to parts unknown. Thereafter, he might as well have dropped off the Earth. No one knew if he was still alive or where he was or under whose constraints, not an uncommon fate for an annoying heretic.

After a lengthy ride, made more arduous by the twists and turns of the "kidnappers," who were determined not to be followed, Luther was brought to his hiding place, an out-of-the-way castle called the Wartburg, high in the forested hills overlooking the town of Eisenach. It was to be his "prison" for several months. While there, Luther was closely confined, since it was essential that he not be seen by casual visitors or passersby. While he grew his hair to eliminate his tonsure and a beard to further disguise himself, the increasingly grumpy guest was often reduced to spending long periods in the small room that had been assigned to him. Thus deprived of exercise, he developed a painful case of constipation, which he wrote about to friends in vivid descriptions. He was given the name Junker George, "Junker" indicating a man of noble rank; his only, and very occasional, conversations were with two of Frederick's trusted friends. His drinking increased as did his waistline. "I sit here idle and drunk all day long," he complained in one letter.

Though Luther never doubted the wisdom of Frederick's precautions, this remarkable level of inactivity might have led to permanent physical and psychological damage—except that Luther soon stumbled upon an all-consuming project: the translation of the whole of the Bible from its original languages into idiomatic

German. Such a project would be exceedingly daunting to almost anyone in any age, but there were excellent reasons in the year 1522 for judging that the task would prove utterly impossible.

For starters, the entire library of scholarly aids available to us was then lacking. Besides the very recent publication of Erasmus's inter-columnar texts of the New Testament, there was no published assis-tance of any kind. There were of course many editions of Jerome's Vulgate in the Latin of the late fourth century AD, but more and more educated readers were coming to doubt its trustworthiness. There were no reliable dictionaries of either ancient Greek, the original language of the New Testament, or Hebrew, the language of almost all of the Old Testament. The science of textual analysis would not get under way much before the nineteenth century, and in any case there was nowhere to be found a reliable collection of ancient manuscripts (certainly not outside the papal library, which was hardly available to Luther).

German was at this time barely a language in the sense that we would today assume. There was high German and low German, and there were a large number of dialects, Saxon, Bavarian, Hano-verian, Swabian, and the Schwyzerdütsch of the Swiss being only the most common. There was no German literary language, no written examples of classic masterpieces that could serve as models of style and substance. German was, like most European vernaculars beyond the Italian models of Dante and Boccaccio, still a language coming into being. Of course, it was spoken everywhere—in one form or another—by ordinary, unliterary folk without shame or inhibition. But writers and professors, lawyers and princes, if they wished their words to be understood clearly and definitively, still spoke and wrote in Latin. Luther had already broken with this con-vention by occasionally publishing in German. But the Bible? Even the innovative Erasmus had published his New Testament in Greek, Jerome's late Latin, and his own more pristine classical Latin, but not in any vernacular. No attempt had been made to translate the Bible into German since a group of unidentified scholars had made a translation into Middle High German in the fourteenth century, a translation of the Vulgate only, certainly not of the Hebrew or the Greek. Like Wyclif's first translation into English in the same period, it follows the Vulgate with a painfully literal awkwardness.

Three months or so into his new project, Martin Luther had finished his historic translation of the New Testament. He had not simply translated the Christian scriptures; he had invented literary German. He did this by peopling the books of the New Testament with ordinary Germans, speaking as colorfully as they did in real life. Such language was hardly unknown to Luther, who enjoyed the frank concreteness of German vocabulary and often availed himself of it in public and private. He had chosen the German that the imperial Saxon court used in official business with its unlettered subjects, which was also the form of German that he and the largest plurality of Germans were familiar with. But he swiftly transformed the rigidities of this official legalese by mixing it with the earthy German of daily intercourse. As he himself tells us, he listened to "the speech of the mother at home, the children in the street, the men and women in the market, the butcher and various tradesmen in their shops." More than this, the translator exhibited a thrillingly expressive ease that harkened back to the traditions of medieval mystics and poets. As would soon become evident in his inspiring hymns, Luther was himself a genuine German poet, even a composer with a natural feeling for the rhythms of speech and the melodies of phrases.

In making his translation accessible to the man and the woman in the street, he translated the coinage of the ancient world into its Germanic equivalents: the *shekel* became the *Silberling,* the Greek *drachma* and the Roman *denarius* became the groschen. He did the same with measures and titles, the Roman centurion turning into a *Hauptmann.* Wherever possible, he employed the alliteratively striking phrases of the common people: *Geld und Gut* (gold and goods), *Land und Leute* (country and countrymen), *Stecken und Stab* (stick and staff), *Dornen und Disteln* (thorns and thistles). Using the German language's tendency to heap words on words in new combinations, he enriched the language with his own evocative new combinations, such as *Gottseligkeit* (God's happiness, or salvation).

Once set in type and printed, the translation was received like rain in a desert. A shocked Johannes Cochlaeus, who had been present at Worms and would remain one of Luther's fiercest and most unyielding opponents, had to admit: "Luther's New Testament was so much multiplied and spread by printers that even tai-

lors and shoemakers, yea, even women and ignorant persons who had accepted this new Lutheran gospel, and could read a little German, studied it with the greatest avidity as the fountain of all truth. Some committed it to memory and carried it about in their bosom. In a few months such people deemed themselves so learned that they were not ashamed to dispute about faith and the Gospel not only with Catholic laymen, but even with priests and monks and doctors of divinity." The condescending Cochlaeus was one doctor of divinity who had no interest in debating theological points with women and other "ignorant persons." The distance between traditional, academic Romanists like Cochlaeus and on-the-ground Germanic evangelists, such as seemed to be sprouting up everywhere, shows itself here as virtually unbridgeable.

A far more considered and balanced assessment of Luther's achievement was made in the nineteenth century by the great Swiss Presbyterian scholar Philip Schaff: "The richest fruit of Luther's leisure in the Wartburg, and the most important and useful work of his whole life, is the translation of the New Testament, by which he brought the teaching and example of Christ and the Apostles to the mind and heart of the Germans in life-like reproduction. It was a republication of the gospel. He made the Bible the people's book in church, school, and house. If he had done nothing else, he would be one of the greatest benefactors of the German-speaking race."

But for all the astonishing literary triumph of Luther's translation, did he go too far in setting these ancient (and quite various) texts in a then-modern German context? Did he on occasion even mistranslate in order to push his own theological agenda? A fair answer to each of these questions must be: "Sometimes, yes."

Each translator (of even far simpler texts than the New Testament) is inevitably faced with the problem that a concept familiar, even taken for granted, in one language is unfamiliar in another. (One of the most compelling educational reasons for studying a language other than one's own is the familiarization it offers with alien ways of thinking and perceiving.) Luther's Germanicization of the New Testament progressed so far that the distance between sixteenth-century Germany and first-century Palestine was all but erased. Let one especially extreme example serve my point.

In Paul's First Letter to the Corinthians, just after his sensa-

tional Hymn to Love (Chapter 13), he devotes a long passage to one of his recurrent headaches: the "speaking in tongues" that had become a feature of some Christian assemblies. "Speaking in tongues" actually meant speaking nonsense, since no one could understand the speaker, but some Christians were certain that their supposedly mystical babbling was a gift of the Spirit. Paul, trying to avoid an outright confrontation with these folk, suggests that there isn't much point to speaking in tongues if no one understands what you're saying: "Therefore if I know not the meaning of the voice, I shall be unto him that speaketh a barbarian, and he that speaketh shall be a barbarian unto me" (1 Cor 14:11). To a Greek speaker like Paul, the meaning of the word "barbarian" was pellucid. Greeks had long ago invented the word because they in their monumental superiority thought that non–Greek speakers spoke nonsensical baby talk ("bar-bar-bar"). Only the commodious Greek language could express all human thought.✝

The Romans, in their turn, thought that all non-Romans— except the Greeks, whom they feared might be their intellectual (though not their administrative) superiors—spoke inferior languages that no Roman (or Greek) needed to know. This is why we know that Jesus and Pontius Pilate spoke Greek together; Pilate, the Roman official, would hardly have bothered to learn Aramaic, let alone Hebrew. To the Romans the ultimate barbarians were the uncivilized Germans, who lived beyond the Rhine and the Danube, hunted like savages, and were always threatening to invade Roman territory.✣

So how does Luther translate "barbarian" into German? Where the word "barbarian" occurs in Paul's letter, Luther supplies in his German translation the word *undeutsch* (not-German)! So the barbarians have become those who are not German. The assumption of the translator is that his audience will perceive anything not-German as inferior, as appositely barbarous. In supplying *undeutsch,* Luther cancels out long swaths of history and leaves in their place only an unwarranted sense of national superiority. Here is a rather determinative clue that the European Reformation does not

✝ In *Sailing the Wine-Dark Sea* (pages 201–2), I point out that this is a form of racism.

✣ For a full account of the Roman attitude toward the Germanic barbarians, see *How the Irish Saved Civilization,* Chapter I.

lie solely in the blindness and blunders of Rome but also in the very large collective ego of the northern Europeans, whose resentment against those who were always assumed to be their cultural superiors is now reaching its boiling point.

Far more serious, however, is Luther's purposive mistranslation of a far more central Pauline text, Romans 3:28, which reads in the King James Version: "Therefore we conclude that a man is justified by faith without the deeds of the law." To the word "faith" Luther attached the word "alone," which does not appear in the text of the Bible, thus changing the meaning of Paul's statement (*allein durch den Glauben,* "alone by faith" in the German word order) for the sake of backing up his own professed faith. But this misstatement also cancels out the entire point of the Letter of James—"by works a man is justified and not by faith only" (James 2:24)—which Luther derided anyway as "an epistle of straw." So, the true Christian can pick and choose among the inspired writings.

Nor did our translator stop there: "If your papist makes much useless fuss about the word '*sola*,' '*allein*,' tell him at once: Doctor Martin Luther will have it so, and says: Papist and donkey are the same thing"—and then goes on at some length, full of insulting invective and embarrassing egotism.

It would take Luther more than a decade to finish his translation of the Old Testament, which would be published in its complete version only in 1534, long after he had returned in safety to Wittenberg. In translating the New Testament, Luther had relied for his Greek text on Erasmus's second edition. For his Hebrew, he was fortunate in having the definitive Masoretic text, which had first been published in Brescia less than three decades before he began his great task. Nonetheless, Luther's most troublesome challenge came in his attempt to translate the linguistic subtleties of the Hebrew prophets and the Book of Job. Luther's Hebrew was several degrees less secure than his Greek, but the truth is that a translator needs a thorough familiarity with—and deep love of—his own language much more than he needs the same for the language he means to translate. And though Luther had a growing group of learned advisers, including several rabbis, to help him through the Hebrew texts, he never stopped amending his translations, correct-

ing misprints, improving phrases, and heightening the melody and even the symmetry of his work.

Despite the ban on Luther's Bible throughout several large German-speaking lands, such as Saxony, Bavaria, and Austria, Hans Lufft, the Wittenberg printer, sold about a hundred thousand copies in the first forty years that the complete text was in circulation. This was a staggering number for a book at this time and suggests that the text was read by millions. The huge number of reprints made by other printers is inestimable. Though this trade in Bibles made fortunes for many, Luther never collected so much as a *Pfennig*, nor did he wish to receive any monetary reimbursement.

William Tyndale, born about 1494, was an ordained priest who had studied at both Oxford and Cambridge, arriving first at Oxford at the age of twelve and earning his master's degree by the age of nineteen or twenty. Contemporary comment on him inevitably stresses his extraordinary skill at languages. He came under the influence of the continental reformers—Luther and those who soon followed Luther—by reading their published works, widely (if surreptitiously) circulated thanks to the new urban phenomenon of printing presses.

He began to translate the New Testament into English, using Erasmus's text. And Tyndale's English was the exquisitely clarified, ringing English of the West Midlands, especially the Malvern Hills, Gloucestershire, the Cotswold scarp, the Vale of Berkeley, and the ancient Forest of Dean, all within tramping distance of musical Wales to the west and the Shakespeare family's Stratford-upon-Avon to the east. In studying Tyndale's choice of words the reader is repeatedly confronted by his elegant simplicity, for, as Proverbs has it, "A word fitly spoken is like apples of gold in pictures of silver." Though the gradual rise in dignity of the vernacular languages and the ever-wider dissemination of printing presses were encouraging more widespread literacy, it was still true that a translator of Tyndale's ambition wrote preeminently not for readers but for hearers of the fitly spoken word.

Tyndale found himself more and more exasperated at the sod-

den ignorance of his fellow priests. An English bishop who surveyed his Gloucester clergy a decade or so after Tyndale's time would find that of 311 churchmen 168 were unable to recite all ten commandments and thirty-one couldn't say for sure whose commandments they were. Forty churchmen were unable to repeat the Lord's Prayer in full in English, nor would they speculate as to who the author of the prayer might be.

In one encounter with a fellow priest, Tyndale kept insisting on the authority of the Bible rather than that of the pope. His frustrated interlocutor exclaimed finally that we'd all be "better without God's law than the pope's!" To this Tyndale replied in the most famous sentence attached to his name: "I defy the pope and all his laws, and if God spare my life, ere many years I will cause a boy that driveth the plough shall know more of the Scriptures than thou dost." Though in its essence this is close to the far more pacific sentiment expressed nearly two centuries earlier by Wyclif about the ability of even simple souls to read the Bible, it also glows with the combativeness that we necessarily associate with the outraged exchanges of the sixteenth century. And this combativeness will continue to power exchanges on both sides of the issues. If you meant to translate the Bible into a vernacular, and especially into English, you could no longer expect to die in your bed.

Tyndale was not in the dark about the danger he was placing himself in. The very existence of an unrepentant and unchastised rebel only encouraged others to rebel. Since never in all of human history have those in power willingly and graciously ceded that power to others, Europe was becoming a powder-keg society, in which new explosions might be expected anywhere, at any time. Eternal vigilance and aggressive response were quickly becoming the order of the day.

In autumn 1523 Tyndale journeyed to London to seek the patronage of its bishop, Cuthbert Tunstall, a learned humanist associated with critics of the church such as Erasmus and Sir Thomas More, then Speaker of the House of Commons. Tyndale met with a cold reception from Tunstall, who was also an intimate of the young king and Lord Keeper of his Privy Seal and who smelled in Tyndale not the playfully ironic detachment of fellow humanists, but the sharp odor of the true zealot. Both More and Tunstall, after

all, were already engaged in providing Henry with verbal weapons in the royal attack against Luther—for which the pope awarded Henry the title "Defender of the Faith," a title still claimed by British monarchs.

Luther had already called Henry "a pig, a dolt, and a liar." Henry had already replied that Luther was "an ape, a drunkard, and a lousy little friar." Gentlemen did not then confine themselves to logical argument. Defenders of the faith felt no constraints upon their pens or their tongues in the face of opposing argument. And as these ever more acrimonious verbal conflagrations were joined, bonfires of Luther's writings, as well as of Wyclif's increasingly archaic translations, were being lit across the land.

Half a year after his unrewarding encounter with Bishop Tunstall, Tyndale sailed for the continent, never to return to his native land. In Wittenberg he may have met with Luther, then settled himself in Cologne, a precarious choice, where he completed his great translation of the New Testament into English. Tyndale's plan was to print a first edition of six thousand copies at Cologne, but he was tipped off in the nick of time that the printer's shop was about to be raided, after which he slipped off to the more staunchly Lutheran precincts of Worms, where in late 1525 the New Testament in modern English was finally printed, bound, and shipped to England, concealed amid cases of grain, fabric, and other dry goods.

Many volumes were confiscated, but in the course of the ensuing years thousands more made their way to the hands of English readers. Henry VIII could not allow such treasonous activities to pass unremarked. Many public burnings were arranged for seized copies of Tyndale's defiant work. Thomas More was set the task of defending the status quo against the revolutionary incursions of this pestiferous translation, "so corrupted and changed," according to More, "from the good and wholesome doctrine of Christ" that it had been deformed into "a clean contrary thing."

What especially irritated More was that by translation alone Tyndale had won the battle of competing theologies. The Greek word *ekklesia,* which was always translated into English as "church," Tyndale translated as "congregation." The Greek word *presbyteros,* always translated as "priest," Tyndale translated as "senior" and in

later editions as "elder." Now, after the long expanse of time that separates us from this controversy, we may say without fear of contradiction that Tyndale was right and More wrong. The ancient church was simply a congregation, not a hierarchy. Each local congregation was likely to have a resident elder, someone who had been witness to the life of Jesus, not in any sense a member of a hieratic order, for which Greek had quite another word (*hieros*).

Many other words that had been assigned theologically technical meanings by the medieval church had only plain, open meanings when read in the original Greek. So the word that had been translated as "penance," suggesting a reference to the church's institution of the Sacrament of Penance, Tyndale translated as "repentance," suggesting not a sacrament but an interior attitude. Similarly, the word normally translated as "confess" Tyndale translated as "acknowledge." For the word usually translated as "grace" (or "*gratia*" in the Latin Vulgate), Tyndale rightly used "favor," at least by implication endangering the hierarchy's cherished doctrine of the Immaculate Conception of Mary, supposedly born "full of grace" (*gratia plena*) and therefore without stain of original sin. Most daringly perhaps, he translated the wonderful Greek word *agape,* not by the then-conventional (and Latinate) English word "charity," but simply as "love."

Tyndale issued a defense (*Answer unto Sir Thomas More*) in response to which the normally considered More published perhaps his least considered work (*Confutation of Tyndale*), describing Tyndale as "discharging a filthy foam of blasphemies out of his brutish beastly mouth." He was, claimed More, the son of Satan. Not that Tyndale was incapable of his own intemperance: in the margins of his translation, he had printed his "pestilent glosses," as Henry termed them, accusing the pope, for instance, of defying scripture by cursing "whom God curseth not" and asserting that "bishops and abbots desire no better tenants" than whores and that the pope would be happy to increase his revenues by levying a tax on the business of prostitution. Many such glosses were unnecessarily combative and sometimes mean-spirited, even when they were not absolutely untruthful.

Doughty Tyndale spent years on the Continent, living hand to mouth and moving from one place to another so as to avoid detection

and capture. As More and his minions (as well as the—somewhat less persevering—agents of the pope) pursued him and diplomatic relations between England and the continental powers were often in flux, no place was safe for long. Despite his fugitive status, Tyndale managed to perfect his knowledge of ancient Hebrew and to translate into English the first fourteen books of the Old Testament from Genesis through Second Chronicles.

At last, in 1535 a fanatical, disreputable Englishman, Henry Phillips, one of those inveterate privateering secret agents who pop up through history, discovered where Tyndale was lodging—in rooms in Antwerp, which had previously provided the translator safe haven. Pretending to befriend Tyndale, Phillips identified him to the Antwerp authorities and collaborated in his capture. Tyndale was cornered in a narrow lane while in conversation with Phillips, who—Judas-style—"pointed with his finger over Tyndale's head" so the arresting officers "might see who to take." Tyndale offered no resistance, and the imperial officers "pitied to see his simplicity."

Imprisoned in the cold, damp dungeon of Vilvoorde Castle, north of Brussels, Tyndale suffered horribly for nearly a year and a half. We have his letter to the prison's governor, begging for warmer clothes and a lamp. "But most of all I beg and beseech your clemency that the commissary will kindly permit me to have my Hebrew bible, grammar, and dictionary, that I may continue with my work. In return I pray every good may come to you, consistent with the salvation of your soul." Tyndale had already completed his translation of the Torah (or Five Books of Moses). Thanks to the "clemency" of the governor, he was able to complete his translations from Joshua through Second Chronicles, an amazing accomplishment. He had fallen in love with the Hebrew language and found many similarities between it and his plainspoken native tongue: "The manner of speaking is both one; so that in a thousand places thou needest not but to translate it into the English, word for word."

In August 1536, Tyndale was found guilty of heresy by a church court, defrocked as a priest, and turned over to the state for burning. One of his two prosecutors, Ruwart Tapper, a theologian at the University of Louvain, remarked: "It doesn't matter whether those we execute are really guilty or not. What matters is that the people

are terrified by our trials." Tyndale may not have been executed till October 6. Out of pity, he was strangled with a chain before his corpse was burned in the prison yard of the castle. His last words were: "Lord, open the King of England's eyes."

The king for whom Tyndale prayed was Henry VIII. After showing initial promise as an artistic intellectual, Henry proved to be one of the worst kings the English have ever had, a Tudor Stalin who sent to the gallows anyone who displeased him, including two of his six wives and many of his most loyal and devoted servants, including, once he had embarked on his endless rounds of marrying, his fast friend Thomas More. As Henry's lord chancellor (1529–1532), More had helped organize the hunt for Tyndale, though by the time Tyndale was executed, More had already lost his head. The older Henry became, the more arbitrary and irrational he grew and the more he was feared by anyone who had to have anything to do with him. This aging, gorging athlete grew so fat that he could be moved only by machinery or the efforts of many muscular attendants. After his death in 1547, his casket is said to have exploded, dripping putrid fat everywhere—as fitting an end as Tyndale's prayerful one.

What Tyndale prayed for was that his king, once his eyes were open, would support the reformation of the English Church. As we all know, Henry did this—sort of. But there was to be no royal enlightenment. His motives were entirely selfish and supremely egotistical. He did not believe in reformation, only in his own superiority.

Henry was succeeded by his three "legitimate" but fruitless children in turn, after which the Tudors were no more. Scotland's James VI, son of the executed Mary Queen of Scots and descendant of Henry's sister Margaret, ascended the English throne in 1603 as James I, the first of the Stuart kings. James, though not as ominous a figure as Henry, was no royal paragon. A crusty, suspicious Scotsman, he wore so many layers of padded clothing (for fear of being surprised and stabbed) that he waddled like a duck. His Scottish experience had left him with a loathing for all things Presbyterian and, especially, Puritan. He was glad to bid farewell to many of these annoyances when the Puritans headed off to North America on a ship called the *Mayflower*. He thought the English parliament, like

anything that smacked of democracy, a nuisance that, unfortunately, "I cannot get rid of." His relationship to the translation of the Bible that bears his name is more tenuous than is usually assumed.

At the beginning of 1604, the first full year of his reign, James assembled a group of churchmen at Hampton Court Palace. During the course of their three-day conference, which proved inconclusive on most matters, a "new translation of the Bible" was proposed. James approved the proposal for such a Bible, dedicated to him as head of the (relatively new) monarchical national church. Surely, he assumed, it would not include Tyndale's "pestilent glosses."

It would not. The marginal notes would be confined to citations of parallel texts and occasional references to unresolved ambiguities in the language of the original. Fifty-four eminent scholars worked on the translation, apportioned among six "companies," each assigned a specific set of biblical books. Though all had been appointed by the monarch to their various academic posts, they were also overseen by bishops with safely predictable theological opinions. *Ekklesia* would be translated as "church," not as "congregation," *episkopos* as "bishop" (really just a shortened Anglo-Saxon rendering of the Greek word), not given its less mysterious municipal meaning of "overseer, inspector, superintendent." *Agape* would be translated not as "love" but as "charity."

Despite these conservative touches, the finished product would not be in any sense a new translation. The instructions provided to the translators specifically pointed them toward consulting existing translations. They consulted even the Douai-Reims, the existing Roman Catholic translation. What emerged at the end of all their work was a translation that was as accurate as they could make it but also fashioned to be spoken "trippingly on the tongue" and received by the ear with "a temperance that may give it smoothness," as Hamlet says in his advice to the players. As a result, countless phrases of the KJV have entwined themselves permanently into our language—from "In the beginning" to "I am Alpha and Omega, the beginning and the end, the first and the last." Numerous longer expressions—such as "The woman whom thou gavest to be with me, she gave me of the tree and I did eat"—scan as smoothly as lines of Shakespeare's iambic pentameter.

The translators worked without recompense from the king or

from anyone else—and they worked so diligently for the eight years of the undertaking that the neglected Lady Margaret, wife of Sir Henry Savile, warden of Merton College and one of the most diligent overseers of the process of translation, was heard to lament, "I would I were a book too."

Though James had virtually nothing to do with the effort, the extravagant dedication to him as "the principal mover and author of this work" seemed almost to place the British monarch but a step lower than God himself, the prime mover and author of all life. The theory of the divine right of kings, then coming to enjoy general acclaim and enthusiastically endorsed by James and many of his fellow princes, has long since lost its allure, even in the royal house of England. Beyond the Isle of Britain, even among disestablished Anglican churches throughout the world, no one today would dream of taking the theory seriously. Nor, for that matter, would any Anglican beyond Britain take seriously the claim of the monarch to be head of the church.

Many perfectly orthodox and serious Christians now resist even the once universal doctrine of scriptural inerrancy, though it is also true that American fundamentalists cling to the KJV to this day, even if their Pilgrim ancestors used the translation only because they had no printing presses for composing more agreeable editions of the Bible. To locate whole societies of those who would kill because of perceived mistranslation (or because of the rending of some equally cherished religious principle), we today would need to journey beyond the borders of the Christian world altogether. And for this we can all whisper *Deo gratias*. Or perhaps less grandly, *hominibus gratias*.

But even after so many centuries of continuing political upheavals around the globe and mind-boggling cultural transformations throughout the Western world, the KJV remains. Indeed, it has more printed copies to its name than any other book ever published—and more than 80 percent of its text must be credited to that inspired and doomed priest, William Tyndale. "Yes verily," as Paul, quoting Psalm 19, reminded the Romans, "their sound went into all the earth, and their words unto the ends of the world."

30. Anonymous, *Manuel Chrysoloras*, 1400
Much cherished by early Florentine humanists, Chrysoloras was a learned Greek and celebrated teacher of his native literature, one of a growing wave of literary men seeking respite in Italy even before the Turkish conquest of Constantinople (see page 41). His widely distributed Latin-Greek grammar would help to make possible the later achievements in biblical translation by Erasmus, Luther, and others. Sporting a long beard in the Greek manner, he stood out among fashionably shaved Italians. Deeply supportive of Christian ecumenical unity, he died en route to the Council of Constance (see pages 30 and 49), where he was to have represented the Greek Orthodox patriarch. His is one of the earliest Western European images clearly drawn from life and intended to be historical rather than merely iconic or archetypal, though the use of his profile (modeled on the tradition of placing rulers' profiles on coins) indicates that we are still a step or two from the easy employment of full-face portraits.

31. Hans Memling, *Portrait of a Young Man*, c. 1472–75
Though we have lost the young man's identity, there can be no doubt that he was noble (note the classical marble columns), wealthy (note the rings and the purple tunic edged in fur), and intended to be serenely detached (note his placid expression and the beautifully arranged countryside). He was also Italian, one of the large number of his fellow Florentines resident in Bruges. Not all elements of the Renaissance flowed from south to north. Italians especially admired the ability of the Dutch to draw with perfect verisimilitude and to introduce peculiar elements of visual charm—in this case, the use of the lower frame of the painting as a seemingly three-dimensional sill on which the sitter's hands rest.

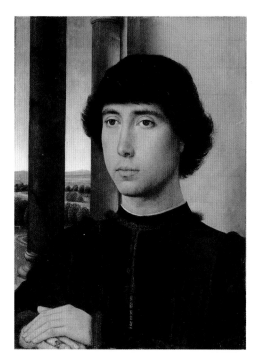

32. Pietro di Spagna (aka Pedro Berruguete), *Federigo da Montefeltro and His Son Guidobaldo*, c. 1476–77

In this funny confusion of the formal and the informal, we are permitted to gaze upon the exceedingly nouveau riche duke of Urbino, supposedly at his ease in his private library, relaxing in full armor, surmounted by the ceremonial mantle of the Aragonian Order of the Ermine and, below his plated knee, the Order of the Garter, conferred upon him by the English king, Edward IV. His ducal hat sits conveniently above his bookshelf, while on the floor, ready to lunge at the viewer, stands the nearly three-dimensional helmet given him by the pope when he was created gonfaloniere of the papal troops. His little son and heir stands stoically at his side, while the duke is absorbed in a gorgeously covered ancient codex, his personal copy of *The Writings of Pope Gregory the Great*. He is, you see, both soldier and scholar, a deeply spiritual as well as an intensely physical fellow. But though Federigo did collect ancient manuscripts, we have no evidence that he read, or *could* read, any of them. We view him in profile, because his right eye was missing, the result of a jousting accident that also notched his nose—though more radically than presented here. The whole conception sprang from the head of the duke himself, who forced it on a compliant artist, one who seems to have been influenced as much by Netherlandish naturalism as by ducal fantasies.

33. Domenico Ghirlandaio, Detail from *The Confirmation of the Franciscan Rule*, 1482–85

In this fresco, still splendidly visible in the Sassetti Chapel of the Church of Santa Trinita in Florence, we find three portraits in which little or no attempt has been made to improve the looks of the men commemorated. They are Lorenzo the Magnificent, young, vigorous, and ugly, flanked by the two rather plain patricians who commissioned the work, Antonio Pucci and Francesco Sassetti. This is Lorenzo soon after the failure of the Pazzi conspiracy (see pages 52–53), exhibiting a winning self-confidence that required no false idealization.

34. Domenico Ghirlandaio, *An Old Man and His Grandson,* c. 1490

Going much further than he had in the previous picture, Ghirlandaio dares to paint one of the ugliest subjects in all of art (at least prior to the work of Lucian Freud), an old man afflicted with the infection of rhinophyma. But the relationship between grandfather and grandson is palpable. What is idealized (in conventional Italian fashion) is the landscape beyond the window, which in this case, however, has been drafted by the artist to serve as the objective correlative to the tender love between the subjects. Though we are unsure of the identities of the figures, we know they are Florentines, and there is even evidence that the old man's visage was copied from his death mask.

35. Giovanni Ambrogio de Predis, *Maximilian I,* 1502

Max was a Hapsburg, and his portrait—though touched up somewhat to improve the shape of his lips and the overhang of his chin—is proof of how urgent it was for dynasts such as himself (or such as the current British royal family) to contract marriages well beyond their gene pool. His marriage to Mary of Burgundy produced his heir, the short-lived Philip the Handsome (see pages 58–59), an infinite improvement in Hapsburg looks, though Philip's heir, Holy Roman Emperor Charles V (see pages 179–80), was at best only a very slight improvement over his grandfather. The emperor is shown in profile, as if on an ancient coin, the hope being that the solemnity of the presentation will soften the egregiousness of the nose, too famous to be remodeled.

36. Albrecht Dürer, *Self-Portrait,* 1500 (LEFT)

Dürer, the great artistic figure of the Northern European Renaissance, was much influenced by Italian models but was hardly their slavish imitator. Rather, offering no compromise to possible Italian disapproval or puzzlement, he enjoyed injecting quirky Germanic elements into his work. Here, he does something no one before him had done—he created history's first stand-alone self-portrait. And what do you know? It's Albrecht as Jesus Christ. Or perhaps Christ as Albrecht. It is, at any rate, the direct ancestor of Rembrandt's self-portraits as well as those of so many other artists. No one has ever conclusively interpreted the curious positioning of Dürer's right hand—actually his left, since this portrait was made before a mirror. Dürer's other hand is not shown because it was the one the artist was using to paint this portrait. Despite the Christ identity and the elaborately coiffed hair, there is no reason to think that this twenty-eight-year-old artist meant to present himself as an unblemished ideal: his eyes are badly misaligned, evidence of Dürer's underlying self-knowledge. (*See also* Dürer's unforgiving nude self-portrait, page 204.)

37. Albrecht Dürer, *Jakob Fugger,* c. 1519 (RIGHT)

Despite his experimental side, Dürer was deft at depicting things (and people) exactly as they were. Here is a man with such a steady, steely gaze, such a firm mouth, and such an unyielding jaw that he could only be . . . the world's most unrelenting banker. Fugger introduced double-entry bookkeeping throughout Europe (after encountering it in Venice); shipped cotton, silks, and spices from their Eastern origins to European markets; and gradually gained a virtual monopoly over the mining of silver and copper. His far-flung European offices kept in touch with one another and with the home office in Augsburg by means of Fugger's newsletter and his exclusive messenger service—business innovations still relied on in our day. Fugger backed the election of Charles V as Holy Roman Emperor and the election of Leo X as pope. Most European monarchs were in his debt. He seems never to have made a mistake. And in his piety he established homes for the elderly poor, called Fuggerei, still in operation.

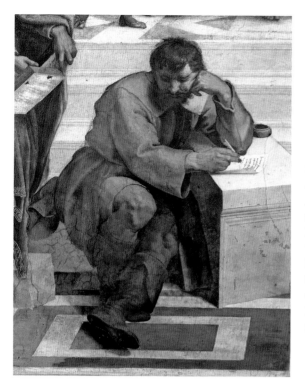

38. Raphael, *Heraclitus,* 1510
This is a detail from Raphael's large mural *The School of Athens,* the artist's dramatically symbolic depiction of the great philosophers of ancient Greece. Heraclitus was known as the "Weeping Philosopher" because of the sadness of his vision of existence. As the model for this figure, Raphael surreptitiously used a fellow contemporary artist, the great Michelangelo. Dejectedly introspective (and not at all sparkly Raphael's type), the figure even wears Michelangelo's smelly old boots—the ones he hardly ever took off. The mural is one of an extraordinary series in the Stanze di Raffaello (Raphael Rooms) within the Vatican Palace.

39. Raphael, *Portrait of Pope Leo X,* 1518
Though Richard Marius calls him "a decent human being," Leo was also a humanistic sensualist who thought of himself as a fortunate temporal ruler rather than as a spiritual leader who had received a divine call. He was completely unprepared to meet the challenge of Luther. Though Raphael has attempted to put some purpose in his expression, the cardinals on either side somewhat undercut a sense of spiritual seriousness. To the pope's right stands his smarmy cousin Giulio, a Medici bastard, who would reign as Pope Clement VII. Far more concerned with European power politics than with theological questions, Giulio-Clement would let the Lutheran challenge and then the matter of Henry VIII's divorce fester unresolved till no resolution was possible. And carrying on in the pleasure-loving pontifical tradition, he left the papacy penniless.

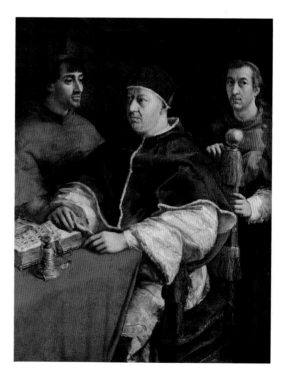

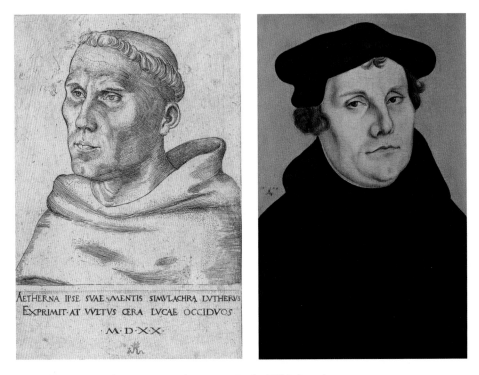

AETHERNA IPSE SVAE MENTIS SIMVLACHRA LVTHERVS
EXPRIMIT AT VVLTVS CERA LVCAE OCCIDVOS
· M · D · X X ·

40. Lucas Cranach, *Martin Luther as a Monk,* 1520 (LEFT)
41. Lucas Cranach, *Portrait of Martin Luther,* 1529 (RIGHT)
Brother Martin was once a bone-thin friar, consistent with his extreme penitential practices. By the time of his marriage in 1529 to Katharina von Bora, however, he had relaxed considerably. Both food and beer were entering his life in ever larger measures. Thereafter, he became even bigger, inspiring the common phrase "as fat as Martin Luther."

FACING PAGE:
42. **Hans Holbein the Younger,** *Portrait of Sir Thomas More,* **1527** (TOP LEFT)
43. **Hans Holbein the Younger,** *Portrait of Erasmus,* **1534** (TOP RIGHT)
44. **After Hans Holbein the Younger,** *Portrait of Henry VIII,* **1536–37** (LOWER LEFT)
45. **Hans Holbein the Younger,** *Anne of Cleves,* **1539** (LOWER RIGHT)
The first three subjects each provided inspiration for more than one picture by Holbein, the German master who became the sixteenth century's most celebrated portrait painter. This portrait of the swaggering Henry is a copy, one of many (commissioned by loyal lords) from the original, which perished in a late-seventeenth-century fire. In actuality, Henry's legs were quite stumpy, and both the width of his shoulders and the prominence of his codpiece have been much enhanced by stuffing. Unfortunately, Holbein outdid himself with Anne of Cleves, giving her a far more winning aspect than she exuded in person. Henry, enamored of this portrait, set in motion the train of events that would bring the German princess to England's shores to become Henry's fourth wife. Seeing Anne in person did nothing for Henry's codpiece, however, to such an extent that he could never bring himself to sleep with her and soon engineered their divorce. But Anne was an agreeable girl who made the best of things: she remained in England in her own castle as the official "sister" of the king and attended all the royal family parties.

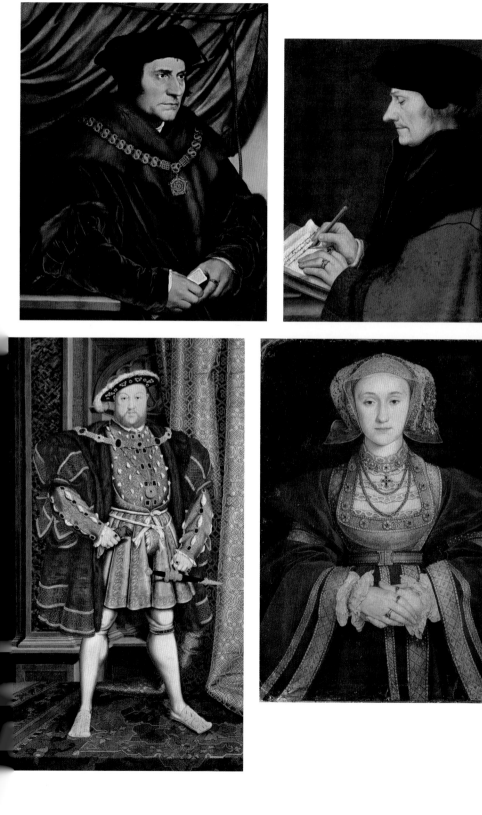

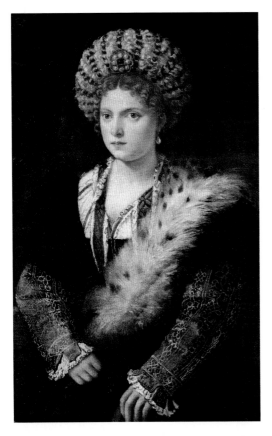

46. Titian, *Portrait of Isabella d'Este,*
1534–36
Isabella, the domineering marquise of
Mantua, considered herself the "First Lady
of the Renaissance." When she was about
sixty, she invited Titian to paint her. She
was not amused at the result and flew into
a rage at Titian (Tiziano Vecellio). So the
artist, bowing to the inevitable, repainted
Isabella's face as it might have looked
when she was twenty. The marquise was
much mollified.

47. Michelangelo, *Portrait of Vittoria*
Colonna, **c. 1540**
Vittoria, the granddaughter of the
ridiculous Federigo da Montefeltro
(Plate 32), was the quintessence of
sixteenth-century cool. Married at
nineteen to a Aragonese prince, whom
she came to love, she mourned his
long absences as he fought the French
in northern Italy; and she arrived at
an almost pacifist position against the
violence of her times. From her idyllic
home on the island of Ischia in the bay
of Naples, she sent forth beautiful *rime*
amorose (love poems) and meditations
deeply critical of European society in
both its political and religious aspects.
Her husband's death from battle wounds,
sixteen years after their wedding, left
her close to suicide; but she rallied,
establishing abiding friendships with some
of the leading cultural leaders of her day,
especially with Michelangelo. She became
more and more part of the growing
Catholic wing that wanted conciliation
with Martin Luther and other reformers.
By the time she died in her late fifties, she
was under suspicion by the forces of the
Counter-Reformation.

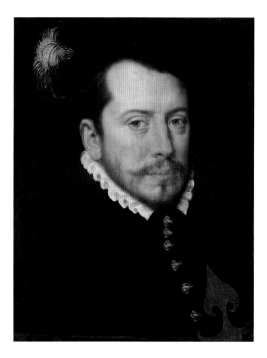

48. Anthonis Mor van Dashorst, *A Spanish Knight,* 1558

I chose this image, though far less well known than the other portraits in this gallery (perhaps because it hangs in Budapest), for its eloquent humanity. In most of the other faces we can read the limits of human character. This one, it seems to me, speaks of moral strength— what one critic has even called "spiritual elegance." We are not certain of the man's identity, though his gold buttons and red fleur-de-lis mark him as a knight of the Order of Saint James. He was probably a well-known courtier, close to the Spanish king, Philip II. The artist has taken the trouble to paint his subject's somewhat sparse moustache and beard hair by hair. In the modeling of the face there is a subtlety that is reminiscent of Titian at his best.

49. Pieter Bruegel the Elder, *The Painter and the Buyer,* c. 1565

This sketch has long been taken as a self-mocking self-portrait of Bruegel himself— the artist tired, dissatisfied perhaps with his work and certainly with the price being offered for it; the silly would-be buyer, beguiled, though nearly blind and already dipping his right hand into his purse to produce his lowball offer. Bruegel's origins are a mystery. He may have come from Antwerp, though from which level of society has long been a matter of controversy. That his subjects were nearly all peasants has led some critics to the shaky conclusion that he was from the peasant class. That he found much comedy, satire, and even surrealism in the interactions of peasant life is undeniable, but that he awarded the peasants as much dignity and humanity as anyone else is just as undebatable. He ended his days in Brussels in his mid-forties, by which time he was, like Vittoria Colonna, feeling political pressure from the forces of Reformation and Counter-Reformation.

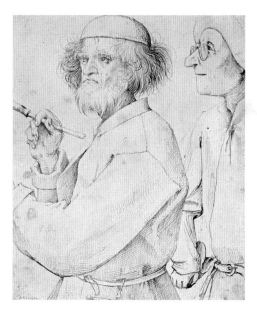

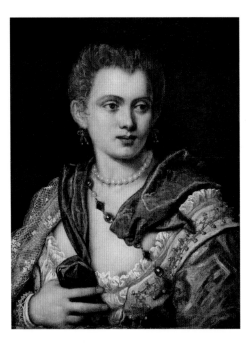

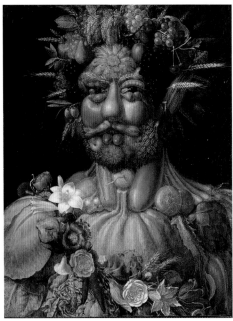

50. Tintoretto (?), *Veronica Franco,* c. 1575
Veronica took up the life of a Venetian courtesan upon walking out on her husband after one year of marriage. Though she faced intense competition (prostitutes made up more than a tenth of Venice's population), she became well known—among visiting foreigners as well as Venetians—for her surpassing charms. She had been educated with her brothers by private tutors and felt at ease discussing philosophy and literature with her well-born customers. Her own poetry was admired for its combination of frankness and discretion. She had many friends, both among her fellow courtesans and among the Venetian literati, and perhaps but one enemy—a dissatisfied customer who wrote anonymously against Veronica as "a cow that could satisfy the entire Ghetto," the neighborhood of Venice's Jews. (Nothing like mixing a little anti-Semitism with your anti-feminism.) Veronica gave as good as she got and rallied other women to her defense. The man was revealed to be a local priest, who was later named bishop of Corfu and eventually died of syphilis. Veronica died in her mid-forties after weeks of fever, leaving a substantial will to provide for her two children as well as for prostitutes wishing to leave their profession.

51. Giuseppe Arcimboldo, *Portrait of Rudolf II,* **1591**
Arcimboldo was a novelty painter whose arresting jumbles of elements in the shapes of men delighted Europe. None of his compositions won greater fame than this portrait of the Holy Roman Emperor Rudolf II, great-great-grandson of Maximilian I. The artist, born in Milan, had spent many years in Vienna, then in Prague after the emperor made it his new capital. Just before Arcimboldo's death, however, he returned to his birthplace and there created his portrait of Rudolf as Vertumnus, Roman god of gardens. Rudolf received the picture in Prague, fell in love with it, and would sit for hours gazing upon his own image disguised as an abundant collection of vegetables, flowers, and fruit.

52. **Sofonisba Anguissola,** *Self-Portrait at Easel,* 1556 (LEFT)
53. **Sofonisba Anguissola,** *Self-Portrait,* 1610 (RIGHT)

Born to a Cremona family of minor nobility, Sofonisba knew from an early age that she must become a painter, even though no one in Italy had ever heard of a woman taking up such a profession. Her doting father sent her to study with a local artist when she was fourteen. She was, however, forbidden by the customs of the times from sketching strange men or studying anatomy by viewing nude male models. So she became a portrait painter, mostly painting the members of her own family, pictures her father would send off here and there to encourage some publicity for his daughter. One of her portraits reached the eighty-two-year-old Michelangelo. His admiration bore fruit in an epistolary friendship and finally a visit by Sofonisba to Rome. Thanks to this association with *il Divino*, the young woman was invited to Madrid as court painter to Philip II. The sojourn in Spain eventuated in the artist's marriage to a Spanish grandee, who would later die in a shipwreck, after which Sofonisba returned to her native Cremona, this time with a new, noble, and very young husband who had captained her ship of return. Eventually, they moved to Palermo, where they had first met and where Sofonisba would die in her early nineties. Her self-portrait at the age of seventy-eight (and another when she was nearly ninety) demonstrates that the artist had none of the scruples about her image that were evidenced by the outraged Isabella d'Este. Sofonisba was content to serve as truth teller.

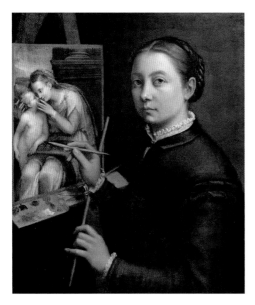

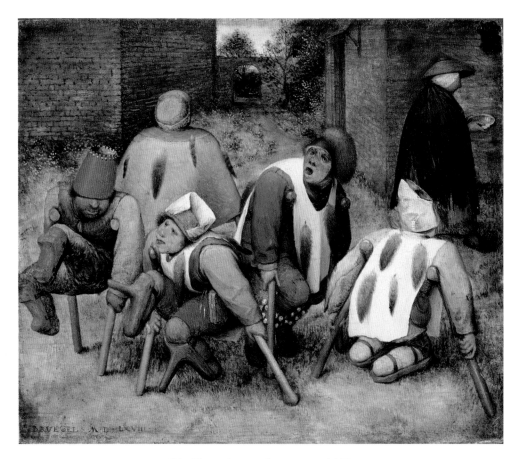

54. Pieter Bruegel, *Beggars*, 1568

55. Pieter Bruegel, *Wedding Dance*, 1566

56. Pieter Bruegel, *The Fall of Icarus*, c. 1558

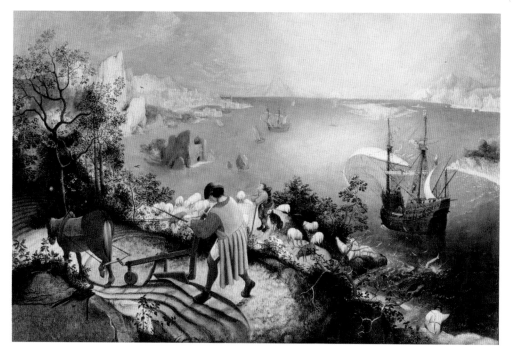

57. Pieter Bruegel, *The Magpie on the Gallows*, 1568

58. Rembrandt, *Self-Portrait*, 1627

59. Rembrandt, *Self-Portrait*, 1634

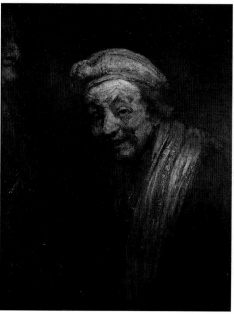

60. Rembrandt, *Self-Portrait*, 1659

61. Rembrandt, *Self-Portrait*, c. 1669

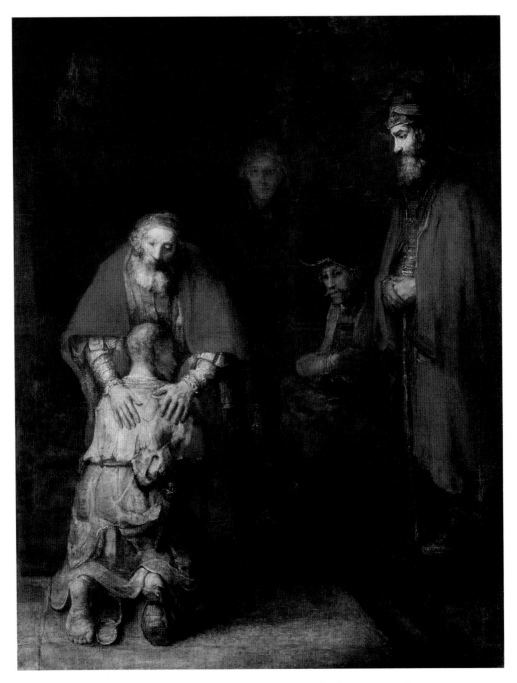

62. Rembrandt, *The Return of the Prodigal Son*, c. 1669

1520s: ENCOUNTERS AND EVASIONS IN PARIS

The University of Paris had been the largest and most prestigious European institution of learning well before the time of Thomas Aquinas in the high Middle Ages,[*] and it continued to draw the keen interest of Christian intellectuals, as well as a large and lively population of international students, who resided and studied at its sixty-odd constituent colleges. One of these colleges, Montaigu (or Montagu or Montaigue, given the lack of standardized spelling at the time), housed in the early sixteenth century any number of soon-to-be-famous religious figures, such as Jean Calvin and Ignatius Loyola, as well as men who would distinguish themselves in other fields, such as the dashing explorer Nicolas Durand de Villegaignon ("half pirate, half scientist," according to one historian). Erasmus had been a student at Montaigu, and one is not surprised to learn that he had not cared for the place. The Scottish reformer John Knox would also spend some time there, as would the great mathematician and physicist Joseph Fourier, discoverer of the greenhouse effect.

Did any of these men know one another? We just don't know. But the encounter I would most like to find a record of was the one that might have transpired between Loyola and François Rabelais, both of whom may have been at the college in the late 1520s. Though we have no record of Rabelais's attendance, his passing description of the place in his great satire *Gargantua* gives us certainty that he knew the college well. He begins mildly by calling Montaigu a *pouillerie*, a louse house, then goes on: "Better treated are galley slaves among the Moors and Tartars, murderers along Death Row, most certainly your domestic dogs, than are the poor devils who must reside in this college! And if I were king of Paris, the devil take me if I did not set the place on fire and roast both the principal and the regents, these men who permit such inhumanity to be practiced before their eyes."

The speaker is Rabelais's character Ponocrates, a typical Renaissance humanist with a spanking new Greek name, a man brimming with openness and fresh theories. He is tutor to the enormous giant Gargantua, who while

[*] See *Mysteries of the Middle Ages,* Chapter III (Paris, University of Heavenly Things).

at Montaigu was first assigned a far more old-fashioned sort of tutor, one Tubal Holofernes, who had Gargantua spend all his time memorizing—first the alphabet, then simple propositions—then reading very old and dusty commentaries. Despite this initial course of study, no correction was made to Gargantua's foul and dismaying personal habits, such as standing on the heights of the Cathédrale de Notre Dame, pulling out his gigantic penis, and urinating on the pious crowds milling below, drowning "two hundred sixty thousand four hundred eighteen, not counting women and children," as Rabelais recounts in the mock-heroic style of an ancient classic.

In the character of Ponocrates, Rabelais is alluding to the prejudice of the humanists against the medieval period that had preceded them. Medieval students, who had no printing presses, were largely confined to memorizing their paucity of revered texts. (Every student seems to have been forced to memorize, for instance, the rather leaden *Sentences* of Peter Lombard, a revered doctrinal standard by a twelfth-century bishop of Paris.) But the new humanists were far more free and wide-ranging in their reading, far more catholic in their literary tastes, and far more refined in their personal habits. They would certainly not urinate on anyone.

And while it is clear that Rabelais loathed the accommodations at Montaigu as distressingly medieval, it is not so clear that he gives unalloyed approval to the humanists. *Au fond,* Rabelais is a skeptic about his own time as well as about times past and a skeptic about all worldviews, whether ancient or up to date. As he claims on the epigraph page of *Gargantua*:

> *Amis lecteurs qui ce livre lisez,*
> *Dépouillez-vous de toute affection,*
> *Et le lisant ne vous scandalisez.*
> *Il ne contient mal ni infection.*
> *Vrai est qu'ici peu de perfection*
> *Vous apprendrez, si non en cas de rire:*
> *Autre argument ne peut mon cœur élire.*
> *Voyant le deuil, qui vous mine et consomme,*
> *Mieux est de rire que de larmes écrire.*
> *Pour ce que rire est le propre de l'homme.*

Dear readers, who this book may read,
Let ev'ry worry slip away.
There's neither scandal here, nor creed,
Nor any illness to allay.
It's true there's no perfection here
For you to note—except for laughs,
Which are my only theme, I fear.
So, noting the gloom each reader mostly quaffs:
It's best of laughter, not of tears, to sing,
For laughter is the proper human thing.

These few lines are full of graceful allusions to then-contemporary matters. The great university, like the cosmopolitan city itself, was electric with contrasting currents of opinion. Erasmus's texts were bestsellers everywhere, familiar even to those who disapproved of them. Luther's views were already well known, as was the dedicated opposition. The old-style scholars were still fighting their rearguard action against the humanists. Everywhere, obedience and conformity battled free thinking and innovation. Scientists were beginning to murmur that the cosmos might be quite different from what everyone had previously supposed. There was almost no intellectual or spiritual proposition that was not up for grabs.

Into such an atmosphere, Rabelais's dismissal of "perfection"—an obsession of both pious churchmen and Neoplatonists in their different ways—in favor of laughter, as the only sure *human* thing, represented for many thoughtful readers a fresh if startling way out of an ever-expanding series of heavy intellectual imponderables. Evelyn Waugh once remarked astutely that no literary form ages as quickly as humor. So it is still surprising to the Rabelaisian reader in our present moment that one continues to find humor in episode after episode, tickling one's sensibility with surprise and delight.

Rabelais was to a large extent *l'homme essentiel de son âge,* the knowing, smiling observer of all the follies of his time, but also a participant in the intellectual and emotional crosscurrents of his moment on this earth. No one knows for sure when he was born, sometime between 1483 and 1494, probably somewhere in the vineyard-rich Loire Valley. His father was a lawyer. Rabelais

would be a priest, leaving one order, the Franciscans, because they disapproved violently of his learning Greek, and joining the more intellectually respectable Benedictines. Like Erasmus, Rabelais did not feel restricted to the cloister: he lived in many parts of France, studying at Paris, where he sired two children, then at Poitiers, then at Montpellier, earning multiple degrees including that of medical doctor, practicing medicine at Lyon, then at Metz, serving in later life as parish priest of several northern French towns, and finally dying at Paris in 1553.

Rabelais's books were condemned more than once by the starchy Sorbonne, leading college of the University of Paris; these condemnations automatically carried the threat of his being burned at the stake as a heretic. One authoritative body or another was forever banning one or all of his titles, and even the national Parlement found time to suspend the sale of his fourth book. Such reverses sent our author into hiding on more than one occasion, as far as French-speaking Metz, which was then not part of French territory but a free imperial city. (In her last days, Queen Marie Antoinette would vainly hope to reach the safety of Metz.) But Rabelais was also fortunate enough to attract the patronage of powerful readers, such as Jean Cardinal du Bellay and the French monarch, Francis I. Du Bellay even managed to obtain a papal dispensation legitimizing Rabelais's beloved children.*

Like Thomas More, Rabelais thought in terms of a utopia, a place that would be better than any society yet known. Rabelais's utopia was a monastery, the Abbey of Thélème, founded by Gargantua. The giant, once he had improved his personal habits and gained sufficient education, turned into a speculative—as well as a practical—philosopher who meditated on the subject of which sort of society would spur men to act honestly and nobly and which sort would push them to baser actions. Gargantua (and Rabelais) believed firmly that the best sort of society was not one centered on "laws, statutes, or rules," but one in which people could live "according to their own free will and pleasure," rising "when they thought good," eating, drinking, working, and sleeping "when they had a mind to it." For these Rabelaisian monks, "*en leur règle n'était que cette*

* One of Rabelais's grandchildren, Jacques Rabelais, would in time become a respected literary historian, specializing in folktales.

clause: FAIS CE QUE VOUDRAS" ("there was but one sentence in their entire rule: DO WHAT YOU LIKE"). Since detailed rules mandating the traditions and styles of monks, friars, and nuns of the various religious orders were taken with high seriousness, Rabelais's single rule-less rule was received by many as insulting levity.

Though much more loosey-goosey than Luther ever thought to be, Rabelais would have made sense to Luther, since the absolute freedom at the heart of Christian life was central to the thought of both men. And though there is no suggestion in the historical record that Rabelais ever considered joining the Lutherans (how or where would he have managed that?), the freedom of his meditations suggests that he knew quite well what Paul and Luther were talking about and was in basic agreement with them. No doubt many of Rabelais's more disapproving readers also saw the connection, which is what impelled them to seek sanctions against him and his outrageous satires.

This doctor-priest-father-comedian who dared lift the curtain of silent censorship to show us the weaknesses of society, education, and religion belongs to that small circle of the greatest European writers, the ones we still read both for pleasure and for wisdom. He's right up there with Dante and Boccaccio before him, with Cervantes and Shakespeare soon after him. Whether he is being merely entertaining ("A mother-in-law dies only when another devil is needed in Hell") or bolstering one's courage on an extreme occasion ("Tell the truth and shame the devil"), he is always surprising, revelatory, and truthful. Not for nothing did Jean-Marie Gustave Le Clézio proclaim him "the greatest writer in the French language."

Rabelais's last will and testament was brief, a satirical version of the typical saint's testament: "I have nothing, I owe a great deal, and the rest I leave to the poor." His last words—the authenticity of which, like his will, is disputed, though not by me—were these: *"Je m'en vais chercher un grand Peut-être. Tirez le rideau; la farce est jouée"* ("I go to seek a great Perhaps. Ring down the curtain; the farce is finished"). Protestant Catholic, humanistic medieval, he was a skeptic to the end, but always a joyful one. Perhaps his most profound advice is to be found in the large block letters he appended to the poetic epigraph with which *Gargantua* begins:

VIVEZ JOYEUX.
LIVE JOYOUSLY.

On reflection, I realize that Rabelais and Loyola could not have met; for if they had, and had Loyola grasped what Rabelais was about, he would have killed the Frenchman. Allow me to explain; but first allow me to defend the appropriateness of Rabelais's appearance in a chapter of "northern images."

France itself is uncomfortable inside the appellation "northern." True, it is named for the Franks, a Germanic tribe once led by Charlemagne, the first Holy Roman Emperor, and the Franks were (and are) at least as German as they are French. The French Normans were of course originally the Northmen or Vikings—and therefore northerners in the extreme. And the Burgundians, once subjects in the ancient kingdom of Burgundy, were descended from an eastern Germanic tribe. But France also contains within its borders the Celtic tribes of ancient Gaul and modern Brittany and even the peculiar Basques of Aquitania. In southern France, one often feels one is among Italians, rather than among Germans or Celts, for the ancient Greco-Roman influence continues to wax strong along the length of France's Mediterranean coast and often much farther inland. Indeed, France, a historic crossroads, harbors and harbored—even prior to its recent acceptance of Africans, Asians, and Eastern Europeans—more ethnic diversity than any other country in Europe. That Rabelais was a northerner is unremarkable; far more important is that his native tongue was French. The language itself, not one's ethnicity, is the great unifier, even if its patois can sometimes seem innumerable. So, France is unique, neither northern nor southern, or rather both northern and southern, European and, to some extent, transnational. The welcome it gave to the Italian Renaissance was warm, celebratory, even—as Rabelais and others prove—original.

So where does Ignatius Loyola fit in? He was a Basque, not a French Basque but a Spanish Basque. We might say that the only reason for including him here is that, like Rabelais, he spent time in Paris at the Collège de Montaigu, becoming eventually a graduate of the University of Paris. He left Spain to study in Paris because in Spain he was repeatedly hounded by the malignant forces of

the Spanish Inquisition. He wanted a degree but feared that if he remained where he was he would earn nothing better than a prison term. But this Parisian student could hardly have been more different from Père Rabelais.

Born to a family of petty chieftains, most likely in the autumn of 1491, he was christened not Ignatius but Inigo, a similar-sounding but different name. The Loyolas were a difficult bunch, well known in their neighborhood for their vanity, pugnacity, and insistence on the perquisites of their position. "The Loyolas," commented one chronicler, "were one of the most disastrous families our country had to endure, one of those Basque families that bore a coat of arms* over its main doorway, the better to justify the misdeeds that were the tissue and pattern of its life."

Inigo's father was typical of his line, avid for status and riches, as were Inigo's six older brothers. His mother, who had also borne three daughters (as well as four other children who perished in infancy), died either giving birth to Inigo or soon thereafter. The child grew up in a seriously macho household, among males for whom sexual conquest was secondary only to physical combat and military glory. Though we have an abundance of Inigo's writings, they all date from later periods. There is good reason to assume that in his early years his literacy was rudimentary and confined to Spanish. There is also reason to suspect that some of the evidence for his youthful misdeeds—multiple and brief sexual relationships with young women of various classes, even the murder of a priest—may have been expunged from the historical record by loyal associates at a later date, once he had attained a reputation not for belligerency but for sanctity. At any rate, long before Inigo was known for his holiness, he was known to be "very careful of his personal appearance, anxious to please the fair sex, daring in affairs of gallantry, punctilious about his honor" and fearing "nothing. Holding cheap his own life and that of others, he was ready for all exploits," according to Paul Dudon, his French biographer. His height, somewhat less than five feet, may also have had some influence on Inigo's outsized aggressiveness.

Inigo's Rubicon was called Pamplona, capital of the tiny kingdom of Navarre and long a source of contention between

* The arms of the Loyolas featured a black cauldron suspended between two wolves against a silver field.

the French monarchy and the "Spanish" Hapsburgs as they vied
for European hegemony. Young Charles, the Hapsburg who was
king of Spain (though himself more a Fleming with French lean-
ings than anything else), had recently been elected Holy Roman
Emperor (see page 179 and following), which was insupportable to
Francis I, the new French king. To have Charles to Francis's south
as king of Spain was bad enough, but to have to endure this boy
king as emperor was just too much. Francis had to push back.

Inigo was then a retainer of the duke of Najera, whose job it
was to defend Pamplona against the French, which in the event
proved an impossible task. As one Spanish contingent after another
opted for surrender against superior French arms, Inigo and some of
his fellow hidalgos fought mindlessly on, unwilling to be thought
chickenhearted, and Inigo eventually became the leader of the
much-reduced Spanish force. A cannonball put an end to his brav-
ery, hitting Loyola in the leg, crushing the shinbones just beneath
the knee and wounding his other leg as well. Two surgeries were
performed, one by Inigo's French captors (who treated Inigo "with
great kindliness and courtesy," as he would later admit), a second
surgery after he had been borne, on a litter and in excruciating
pain, across the countryside and back to the castle of the Loyolas.
For neither operation could anesthesia be administered: it would
not be used effectively till the mid-nineteenth century. According
to the patient, speaking of himself in the third person, "he uttered
no word, nor gave any sign of pain other than clenching his fists."

What a guy. He even insisted on a third surgery to remove an
unsightly bump beneath his knee—a surgery performed against the
advice of his doctors, who warned him the pain would be so great
that the surgery would not be worth it. But Inigo had no intention
of appearing before his fellow courtiers and lady friends with any
but the shapely legs he had formerly sported.

The surgery, however, failed to achieve its goal. During his
months of painful bedridden convalescence, Inigo came to real-
ize that he could never again present himself as the romantic fig-
ure he had previously imagined himself to be. He would limp and
walk with difficulty on unequal legs for the remainder of his life,
nor would he ever again display those legs in fashionable hose and
tight boots. The peacock had lost his plumage—or, to put it in the

jargon of W. W. Meissner, a psychoanalyst, priest, and biographer, this "phallic narcissist" found himself in a "severe regressive crisis" that battered his former self-esteem. Fearful of losing his mind with idleness, the fallen man of action called for romances to read, the only literature he had previously cared for. There were none to be found in the castle, indeed no books of any kind—the Loyolas were not readers—except for two that his pious sister-in-law Magdalena was able to scare up. So Inigo set himself the task of reading Spanish translations of a lengthy *Life of Jesus* by the fourteenth-century monk Ludolph of Saxony, a sort of *summa* of all that was then known about the gospels, and the *Flos Sanctorum (The Best of the Saints),* a traditional collection of saints' biographies. Inigo's reading would show the phallic narcissist a way out of his dilemma: the way of the swashbuckling hidalgo having been taken from him, he would instead follow Christ and become a distinguished saint.

In short order, the suddenly religious young man, still in his twenties, was spending whole nights in prayer, practicing hideously extreme penances, denying himself every pleasure (except the pleasure of his revivified ego), and readying himself for life as "the Pilgrim," which he now called himself. Once he was mobile, the Pilgrim set off on a pilgrimage—to the shrine of Mary, mother of Jesus, at Monserrat in the mountains northwest of Barcelona—but not before committing himself to a vow of chastity, since he was "more afraid of being overcome by the sin of the flesh than by any other burden." Much later in life, he would even cover up a picture of Mary in his prayerbook because the image reminded him too much of his (too-much?) beloved sister-in-law.

Though it was perfectly appropriate for a saint to walk with a limp, the elegantly attired Inigo covered this first leg of his pilgrimage by mule. Along his route Inigo fell into conversation with another traveler, also riding a mule. The man was "a Moor," that is, a North African Muslim, of whom there were many in Spain. Their conversation soon "turned to Our Lady," the Pilgrim informs us. "The Moor admitted that the Virgin had conceived without man's aid but could not believe that she remained a virgin after once having given birth." The Pilgrim attempted to refute the Moor's arguments but could not; and then the Moor took off and "was soon lost to view." The indignant Inigo resolved to follow him and "give

him a taste of my dagger for what he had said." But because Inigo was slightly unsure as to whether this was the right response, he allowed his mule to decide whether they would keep to the main highway or take the side road that would lead them to the Moor. Thanks to the mule, the Moor's life was spared. It seems unlikely that the voluble Rabelais would have been so lucky.

In time, Inigo's hotheaded temper would cool somewhat—or, what is more likely, he would come to find more conventionally approved outlets for the passion that burned within him. Or, as Meissner puts it, "his ego . . . assimilated [a] new set of values" as he "gained an awareness of the imperfection and inadequacy of the value system that had previously guided his life." He spent a year in a cave, emerging in simple pilgrim's sackcloth and hemp belt, having long since given away his fine clothes and even the mule. (He had left his beloved sword and dagger on the grille of the Monserrat shrine.) His plan was to spend his life helping other poor pilgrims in Jerusalem, a plan which he was certain had been inspired by God but which political realities prevented him from carrying out. Inquisitors then drove him from Spain and into a bachelor's program in Paris. Though Inigo surely liked to torture himself, even he remained but a short time at Montaigu. By the autumn of 1529 he had matriculated at Sainte-Barbe.

On the parchment of his later degree of 1535 as master of philosophy he is named "Ignatius de Loyola" for the first time. Though this was long thought to be a clerical error, it now seems more likely that the new name was part of the man's new identity, less ethnic and more classical than Inigo. It was during his Paris years that he gradually attracted a small company of young men, who would eventually form the nucleus of a new religious order, the Society of Jesus, usually known as the Jesuits, which would play an essential part in the coming Counter-Reformation.

While fasting and beating himself in the cave—near Manresa, just north of Monserrat—Inigo was often beset by "visions" that to the modern reader may appear closer to hallucinations than to forms of divine enlightenment. This is especially true of a frequently seen serpent "in the air close to him," "bright with objects that shone like eyes" and that "gave him great consolation because it was very beautiful." Meissner sees the snake as a manifestation of Inigo's "uncon-

scious libido, the symbolism expressing phallic erotic conflicts." We might put the matter a shade more bluntly: here was a young man who had been deeply in love with his own organ of generation.

Out of the cave experience, however, there also came one of the permanent religious classics of all time, the *Spiritual Exercises of Saint Ignatius Loyola,* which are used to this day by spiritual directors to guide those who go "on retreat," usually in some sylvan setting. Nor are the *Exercises* confined to Roman Catholic retreats; other Christians have come to find them increasingly helpful. The *Exercises* employ a technique that has been widely successful, which Ignatius labeled "composition of place,"* in which the exercitant summons up from his own imagination a scene: say, the birth of Jesus in the stable at Bethlehem, the Crucifixion, even Hell and its torments. In this way, by tying prayer to pictures in one's imagination, a more concrete, more fleshly spiritual life is made possible, leaving an unforgettable imprint on one's memory and perhaps enabling an encounter with God Incarnate.

The *Exercises* take with utter seriousness the existence of Satan, of personal evil at large in the world, as well as of the far greater power of God's grace. The retreatant is urged to examine his or her conscience regularly in the light of these opposing forces and to judge which urges (or inner voices) are from Heaven, which from Hell. The techniques often exhibit the plodding, earthbound nature of their author and his not very imaginative imagination. They can also manifest a sort of military crassness, even at times the sensibility of the bully who intended to kill the Moor, as in the most important of Ignatius's "Rules for Thinking with the Church": "To be right in everything, we ought always to hold that the white which I see is black, if the Hierarchical Church so decides it." Meissner comes to our aid here by speaking of "the tendency of the authoritarian disposition" to "suppress freedom" and asserts that to such a disposition freedom is always "threatening because it allows for unpredictability."

Though many of the pictures in the *Exercises* are vivid, they are not Protes-

* Ignatius did not invent this technique: evidence of it may be found in Ludolph of Saxony's *Jesus,* as well as in the widely treasured *Imitation of Christ* (see pages 132 and 139). In the thirteenth century, Francis of Assisi had used a similar technique in approaching the scene in the stable at Bethlehem. (See *Mysteries of the Middle Ages,* pages 235ff.)

tant. "To be right in everything" must strike today's reader as a hopelessly foolish pursuit that could be entertained only by the most unattractively rigid of personalities. And yet, there are many similarities between Ignatius and not a few of his Protestant contemporaries. "To be right in everything" is often the tone reformers wish to strike, whether they admit it explicitly or not; and a profoundly neurotic fear of Hell and its power haunts the nightmares of leaders on both sides of the widening divide.

1525?–1569: THE ICE IS MELTING

When it comes to making pictures of sixteenth-century life, no one is more bold or more subtle than Pieter Bruegel, the Dutchman who more than any other captured for us the look and feel of ordinary life, while enriching his images with a depth of perception seldom equaled in any art. Bruegel was most likely born in a village in Brabant, now part of the Netherlands, sometime between 1525 and 1530, but we know nothing more than that. When he died in Brussels in 1569, he may have been in his late thirties or his mid-forties. He was by then quite famous, and a number of his paintings had already entered some of the most important collections of his time and place, including the collection of the emperor himself.

Any number of his early drawings and prints, however, have been lost, so we have a somewhat broken narrative of his early development. He appears to have begun in the creative shadow of his fellow Dutchman Hieronymus Bosch, born at least seventy-five years earlier and best understood as a late medieval painter, who provides the viewer entry into a world of dreams and nightmares replete with both delicious and deformed creatures, as in his famous *Garden of Earthly Delights,* which contains, besides the panel of delights, a panel illustrating the torments of Hell. Luther would have had no trouble understanding Bosch, nor would Loyola—though the delights might have made both men more than a little nervous.

Though Bruegel appropriates some of Bosch's medieval-style surrealism, he comes gradually to serve a less sensational, more meditative, more profound point of view. Good examples of Bruegel's Boschian aspects may be found in his earlier images, such as his

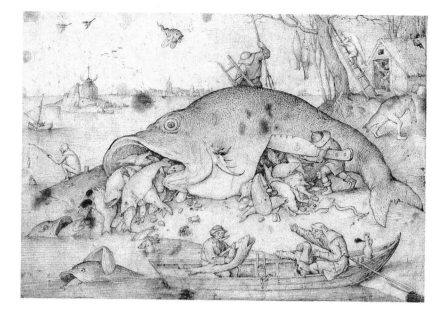

drawing *Big Fish Eat Little Fish,* which illustrates a typical folk saying. Pulsing with activity and a multiplicity of forms, the drawing is a ghoulish nightmare that depends on excess to make its point. But neither sixteenth-century viewers nor we in the twenty-first century could fail to grasp immediately what Bruegel is telling us. The drawing might even be employed to illustrate the predatory nature of certain leading businessmen or churchmen and their collaborating politicians, whether then or now. (What a sensational logo for a super PAC such as the Koch brothers' Americans for Prosperity or Karl Rove's Crossroads GPS.) I particularly admire the detail of the grandfather (in the lower right) lovingly instructing the child in how to go about the depredation of others, and the fish (upper right) that has grown innovative legs to assist him in his spoliating—and this long before anyone had thought of the evolution of species.

When Bruegel made this drawing he was already a resident of Antwerp, then one of Europe's largest cities, and a regular contributor to the press of the famous printer Hieronymus Cock. *Big Fish* was made with the intention of turning it into an engraving, though we have but one extant copy of the engraving,

attributed—wrongly—to Bosch. It's certainly possible that some now-forgotten news item of the day made someone feel that mass distribution of this image was imprudent, or Bruegel himself may have decided not to put his name on it, though his signature and the date, 1556, are clearly seen in the lower right corner of the drawing. (He would later change the spelling of his name from "Brueghel" to "Bruegel.") Or it may be that someone thought the Bosch name would make for better sales.

While in Antwerp, Bruegel studied with a local artist, Pieter Coecke. He also took at least one extended trip to Italy, by now an almost required venture for any ambitious northern artist. And years later he would marry Coecke's daughter, Mayken, who was considerably younger than Bruegel. According to one witness, Bruegel "often carried her in his arms when she was a child." By the time of the wedding, Coecke was long dead, but Mayken's mother insisted, before she gave her consent, that Bruegel agree to move from Antwerp to Brussels "in order to separate himself from his former relationship and forget it," according to the same witness. Bruegel had lived in Antwerp with a young woman whom he loved but who was "niggardly with the truth," which led to their parting. Bruegel was not niggardly with the truth.

The longer he worked, the further he seemed to move away from his early, Bosch-like visions, his images becoming simpler, his scenes less crowded with alien forms. But he never lost his flair for suggesting that the real world is as full of odd, even nightmar-ish realities as are our dreams. *Beekeepers* (facing page), a drawing he made twelve years after *Big Fish,* is, though much pared back visually, full of the feeling that the world is indeed a very strange place. The three faceless beekeepers, lugubriously dressed, silent, and ghostly, could almost be beings from another planet, carrying out some incomprehensible ritual. In the branches of the tree we spot a bird-nester, a character that appears in other Bruegel images. He could not be more earthbound, more usual: he is stealing eggs. The legend in the lower left says in Dutch: "He who knows where the nest is has knowledge, but he who raids it possesses it." Another folk saying, but what does Bruegel mean by it here? Are the out-of-this-world beekeepers, whose work is approved by social convention, not stealing from the bees as the bird-nester steals from

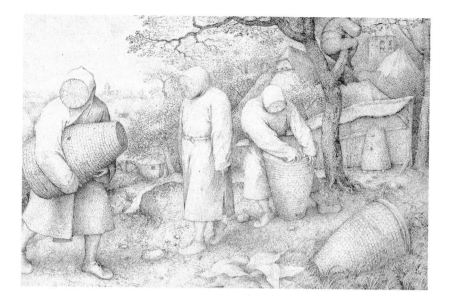

the birds? Does their weird getup somehow render them absolved from the social condemnation that falls upon the scared little bird-nester? Is there something skewed about the way we human beings make our moral judgments? Are we all victims of convention, unable to see straight and judge aright because of differences in costume, class, and convention? Should we rather applaud the pluck of the humble bird-nester and stand back a bit from the conventionally approved but somewhat creepy beekeepers?

Of course, if some busybody, especially some magistrate or religious censor, were to inquire as to the meaning hidden in the drawing, Bruegel could easily claim that there was no hidden meaning. It's just a local scene I happened on, nothing more than that. It is, after all, entirely realistic: no Boschian symbolism, no excess, no challenge intended to anyone's intelligence or spirit. (Had the young antecedent-less Bruegel himself possibly been a bird-nester?)

In the same year that he drew *Beekeepers* Bruegel painted one of his smallest oils, *Beggars* [Plate 54], little more than seven inches square. It would be easy to mistake this panel for a simple genre painting, a slice of contemporary life and nothing more. But the picture is "full o' the milk of human kindness," as Lady Macbeth puts it scornfully. We are shown five crippled beggars, at least three of whom lack feet. They are managing on crutches and assorted

crude appendages. Four of the five wear foxtails, which, in a time when clothes defined who you were and where you belonged, were the badges of beggars and other licensed fools—that is, of those allowed to play the fool in designated public spaces for the occasional penny.

The three whose faces we can see are brutish, probably moronic. Are these their constant expressions or are they playing expected parts? All wear hats, the man on the left wearing a sort of red crown, the man on the right a pretend bishop's miter. Whether we know it or not, we are being asked: Is this the best we can do for these poor souls, one of whom might be our secret king, another of whom might be our spiritual superior? Can our society offer them nothing more? Look, they are human beings. How would you like to be one of them?

Beyond the beggars a woman walks by. She is not handsome but ordinary—but she can walk and go about the normal business of life. What a difference that makes, how lucky is this ordinary woman. Is she a beggar? She carries a plate: will it be used as a beggar's bowl? Her coat looks like the remnant of a torn sack. Whatever her status, she is far better off than the beggars in the foreground.

And beyond the beggars and the woman, who takes no notice, there is an open, arched portal, leading to a lovely orchard and private garden, the very symbol of the good life, a life our beggars can have no part in. There we can just make out the horizon, the place where the earth touches the sky, where our poor, sad human hopes touch God's great cosmos. So take pity on the beggars.

One of Bruegel's most famous paintings is the (supposedly) jolly *Wedding Dance* [Plate 55], which can be viewed at the Detroit Institute of Arts, one of the few Bruegel paintings to be found on American soil.✝ It is a spectacular demonstration of painterly rhythm. Of course,

✝ Besides *The Wedding Dance* in Detroit, there are but two: the breathtakingly "simple" *Harvest* at the Metropolitan Museum of Art in New York and *Landscape with the Parable of the Sower* at the Timken Art Gallery in San Diego. Besides these paintings, there are three Bruegel drawings in the United States, one each at the Fogg Art Museum at Harvard University, Cambridge, Massachusetts, the Bowdoin College Museum of Art, Brunswick, Maine, and the National Gallery of Art, Washington, DC. The great treasuries of Bruegel's art are the Kunsthistorisches Museum in Vienna and the Musées royaux des Beaux-Arts de Belgique, in Brussels.

we are watching people dance, which should be rhythmic. But here the rhythm is in the multiplicity of lines and shapes, coalescing and separating against one another, and in the ballet of colors, clashing and complementing one another. Let your eye follow the eruptions of red, for instance, from foreground to farthest figures, and you will see what I mean. The last grouping to be seen before the horizon is a kissing couple, though not the only kissing couple to be spotted within this assemblage. Are they perhaps the next bridal couple? Well to the right of the kissers, near the horizon, is the traditional place for the bride in front of an unfurled sheet, in this case extended between two trees and bearing the bride's paper crown above her chair. But the bride is not sitting beneath her crown, as would be expected. There, instead, two old crones are conferring, gossiping no doubt; and perhaps they have plenty to gossip about. The bride, after all, is close to the front of the dancers, distinguished by her bare head and flowing bridal hairdo. She is dancing. With her new husband? I don't think so. And where is he? Who knows.

So Bruegel gives us here a complex sociogram, full of questions and possibilities for both happiness and misery. The three strapping lads who occupy the foreground positions sport red, white, and blue erections, seen quite prominently beneath their bursting codpieces. (The codpieces look nearly transparent because so many censors in so many earlier eras tried to disguise or erase these swellings.) Two are dancing with ladies who may or may not be their wives or girlfriends. The third lad is single, playing the pipes, to which everyone else is dancing. Is this single musician, who sparks the joy of all the dancers, the eternal artist, Bruegel himself, the one who gives pleasure but never wholly owns it?

Are the dancers simply full of joy? Rather, they seem a little subdued, certainly less than ecstatic, knowing that the dance will end and the party be over, that tomorrow their usual, dreary lives will resume once more. In most other northern artists, a genre painting like this one would exude a certain contempt: Look at those silly, feckless peasants. But in Bruegel's art, peasants are always people, just like you and me. And don't forget to contemplate that long, mysterious horizon.

Bruegel made many pictures like *The Wedding Dance,* employing scads of individuals, discovered in an immense variety of atti-

tudes. Not a few of Bruegel's larger paintings cannot be reproduced here, requiring as they do a large-format art book if there is to be any hope of presenting them adequately. This is true especially of *Christ Carrying the Cross,* an immense oil panel, nearly seven feet across, hanging in Vienna. Though Christ, fallen under the weight of his cross, is to be found at the exact center of the painting, the viewer is unlikely to spot him right away. He is so small against the foreground figures, and there is so much human activity in this painting to distract the eye. The casual viewer might take away the impression that Bruegel believed that the way to Calvary and the subsequent crucifixion were not all that important. Rather, what is being said is that the most important things happen while we are distracted by unimportant things and fail to take note of the life-altering moments that should claim our full attention.

But there are so many themes pulsating through this complex field that a great many critics have found here proof of Bruegel's subversive political and religious opinions: he hated the Spanish overlords of the Netherlands, sneakily depicted as red-coated Roman soldiers, just as the Spanish mercenaries then occupying the Netherlands wore red; he is anti-Catholic, pro-Protestant, because Mary, prominent in the foreground and acknowledged symbol of the Catholic Church, turns aside from her son, whereas a peddler, also in the foreground (and probably having Protestant tracts in his enormous backpack, as many peddlers had), turns toward Christ. The vivid red coats are undeniable and would surely have sent the imaginations of contemporary viewers in an anti-Spanish direction. The partisan religious intentions are teasingly less certain.

Fortunately, there is a complex Bruegel image—one with very nearly the same theme as *Christ Carrying the Cross,* though depicting an ancient pagan story—that we can reproduce here, *The Fall of Icarus* [Plate 56]. Daedalus, the legendary Greek inventor, made wings for himself and his son Icarus, so that they could fly away and escape their imprisonment by King Minos. Daedalus warned his son to take a middle way, neither too near the earth nor too near the sun, lest the sun melt the wax to which the wings' feathers were affixed. In his pleasure Icarus, young and soaring, forgot his father's advice, flew too near the sun, crashed into the sea, and drowned.

Here is "Musée des Beaux Arts," W. H. Auden's great meditation on the painting:

About suffering they were never wrong,
The Old Masters: how well they understood
Its human position; how it takes place
While someone else is eating or opening a window or just walking dully
* along;*
How, when the aged are reverently, passionately waiting
For the miraculous birth, there must always be
Children who did not specially want it to happen, skating
On a pond at the edge of the wood:
They never forgot
That even the dreadful martyrdom must run its course
Anyhow in a corner, some untidy spot
Where the dogs go on with their doggy life and the torturer's horse
Scratches its innocent behind on a tree.

In Brueghel's Icarus, for instance: how everything turns away
Quite leisurely from the disaster; the ploughman may
Have heard the splash, the forsaken cry,
But for him it was not an important failure; the sun shone
As it had to on the white legs disappearing into the green
Water; and the expensive delicate ship that must have seen
Something amazing, a boy falling out of the sky,
Had somewhere to get to and sailed calmly on.

In the lower right quadrant of the picture between ship and shore, the "white legs" are "disappearing into the green water" with a momentary splash, accompanied by a swirl of feathers.

Icarus was painted sometime between 1555 and 1560. In 1568, Bruegel made what may well have been his final picture, *The Magpie on the Gallows* [Plate 57], which he specified in his will was his gift to his wife. In less than a year he was dead. *Magpie* contains a sort of reprise of *The Wedding Dance,* a peasant woman dancing with two men, the picture's most prominent human feature. Nearby is the inevitable piper, source of the music. But the dancing threesome

lacks a second woman. Ah, well, we do what we can, we humans; we manage in this imperfect world of ours, taking our pleasures where we find them, not expecting everything to be just as we would have it. To the left of the dancers, two men and their dog serve as an enthusiastic audience. To the left of them, another man shits in the woods. That's it, isn't it? Dancing, defecating, dying: they're all necessary human actions.

Where does dying come into it? The center of the picture is not the dancers or the musician but the gallows. That is where we dance, do we not, in the shadow of the gallows? Alighting for a moment on its splintery wooden frame is a magpie, the bird that, when it appears singly, foretells the early death of someone nearby:

One's sorrow, two's mirth,
Three's a wedding, four's a birth,

goes an old rhyme about magpies.

To the right of the gallows is a simple wooden cross (a Protestant-style "old rugged cross"?), something for a condemned man to gaze on while he is being hanged. Well in the distance is a town, bustling with activity. On a promontory high above the town is the extensive castle of the local lord; across the valley atop a cliff is a monastery. In the river valley we can see farms and pastures, fishing boats and seagoing ships, and in the farthest distance another human settlement. We labor as well as we can, conducting our lives with as much merriment as we can muster, always in the shadow of death, always overseen by the forces of church and state, miters and magistracies. But, whether appropriately or inappropriately, we do dance. In the sky above whirl birds of various species, donors of eggs to us poor humans, mediators of a sort between earthlings and Heaven. All this is part of Bruegel's final message to Mayken. Perhaps in the dancing threesome he is even letting her know that he would have no objection to her taking a second husband. You must do what you can, dearest Mayken.

Surely Bruegel did not want to die just then, leaving Mayken with three small children, the youngest, Jan, but one year old. One child was a daughter, and of her we know only her name, Marie. There were also two sons, Pieter the Younger (who would

be known as Hell Bruegel) and Jan (who would be known as Velvet Bruegel). Both sons became artists of considerable skill and reputation, though never surpassing their father, never even coming near him in inventiveness.

In his last days, Pieter the Elder must have felt the forces of social judgment—whether of Catholic inquisition or Protestant reformation—closing in on him. Various European societies were becoming more vigilant, more insistent on utter acquiescence to their norms, less tolerant of any hint of deviation. It was anyone's guess where the "Spanish" Netherlands would end up, which ideological camp it would finally choose to join. If it got to choose at all. Were the sly messages concealed in Bruegel's paintings really so capable of stirring the pot of social upheaval? He certainly thought so. He instructed Mayken—no doubt for her own protection—to destroy all his remaining satirical drawings. Apparently, she followed those instructions.

We can say with some confidence that Bruegel felt the gathering forces of political and religious instability impending around him. Just a couple of years before his death he painted what may be his most subtly beautiful panel, *Winter Landscape with Skaters and Bird Trap* (see endpaper). The skaters are enjoying themselves on the frozen river, while the silent spires of church and state prick the sky. The whole world is aureoled in a golden glow—to such an extent that we can designate this image the world's first impressionist painting. The many birds gathering on the snow-laden lawn to the right have no clue that a trap has been set for them, that some of them at least will soon be flattened and caught as the wooden panel crashes down on them. In the slush beneath the trap we note that the snow is melting. Indeed, the golden glow suffusing everything is a silent warning that the temperature is rising and that soon, out on the rural river, there will be a cracking sound, as the ice disintegrates beneath at least some of the skaters. Passing scenes of unearthly beauty, fleeting coalescences of social happiness, moments of restorative peace are just that—passing, fleeting moments. Though they may portend a very different tomorrow, we may easily miss their message, grateful for the present joys, for the seeds scattered so generously beneath the trap.

VI

CHRISTIAN
VS. CHRISTIAN

THE TURNS OF THE SCREW

———————— ❖ ————————

Then, kill, kill, kill, kill, kill, kill!
King Lear

It may be that artists, because they see further than the rest of us, can occasionally foresee the coming of epochal changes to which the common herd may be blind. But it would hardly have taken much perspicacity to note the changes that were enveloping Europe as it rolled toward the mid-sixteenth century. In a continent full of kings, princes, and dukes, there had always been additional power configurations. In addition to the considerable prince-bishops of the church, in addition to the venerable *stato della Chiesa* surrounding Rome and ruled by the pope, there was the unique role of the Holy Roman Emperor whose uneven powers shadowed the power structures of several countries. There were ancient independent city-states, such as Florence and Milan, and much newer models, such as the Swiss cantons of Zurich and Geneva. Classical, relatively stationary Europe had always looked toward the Mediterranean, but now a larger, venturing Europe was often casting its glances toward the formerly blank Atlantic as it followed the amazing exploits of the rising coastal sea powers of Spain, Portugal, France, Holland, and even islanded England.

As if this subtly reconfiguring, strategically maddening map were not enough, into the constantly shifting tides and tornadoes of power was now thrown what we might call the Religion Bomb. There have always been people in every land and culture who are willing not only to live by their religion but to die by it. But for what seemed untold centuries there had been for Western and Central European Christians only Roman Catholicism. If you wished to be true to something large and overwhelming, it was to this traditional form that you must be true. Some, surely, were aware of the Ortho-

doxy of the Christian East, though Orthodoxy never appeared as threatening to the West, only as a bit off base and generally far away. Some few were aware no doubt of occasional heresies—the Bogomils, say, or (more ambiguously) the Hussites—but these movements operated weakly, usually at the margins of societies, and glimmered only for brief periods. Their threat never loomed large in European imagination.

But now whole towns and cities, dioceses and archdioceses, provinces and countries were embracing what seemed to be radical, permanent changes in their basic religious beliefs and practices. And this astonishing, seemingly overnight religious shift was only exaggerated by the normal, if sometimes quick and radical, shifts and instabilities of European power politics. Singular would be the prince who was simply rethinking his religious beliefs and practices; he was thinking about his power. In which camp will I fare more prosperously and securely? Who is going to prevail in my corner of the world? Will I be on the winning team?

In our day, a fairly close parallel to these early modern religio-political developments may be glimpsed in the unsettling, often boiling changes in the current Islamic societies of the Middle East and North Africa. To quote from a recent dispatch from Doha, Qatar, on the instabilities of Islamic countries:

> The fury has roots in the slow breakdown of religious authority in the Islamic world over the past century or more, an erosion that has allowed self-appointed interpreters to render instant judgment on issues that might once have been left to established, respected figures. In the past, even an insult to the Prophet [Mohammad] would have to be investigated in accord with Islamic jurisprudence before anyone was licensed to take action.
>
> "People used to look to their local imams on matters of faith and interpretation," said Michael A. Reynolds, . . . a professor of Middle East studies at Princeton. "But in a more mobile and transnational world, with more people living in cities and much higher rates of literacy, it's easier for ideologues and extremists to assert their own views."✛

✛ Robert F. Worth, "Struggle for Ideological Upper Hand in Muslim World Seen as Factor in Attacks [in Libya and Egypt]," *New York Times,* September 13, 2012.

If what it takes to tell the truth—from a Christian point of view (or from a Muslim one, for that matter)—is a pure heart, we can expect soon enough to be surrounded by a veritable Babel of conflicting truth tellers, for the pure of heart are just as careful cultivators of their own egos as are painters and princes. And thus it was that Luther's Reformation quickly turned into a nearly endless series of Reformations, each vying for the attention and commitment of masses of human beings, few tolerant of other interpretations, and fewer still willing to abide the flourishing (or sometimes even the continuing existence) of those other interpretations.

1516–1525: FROM ZWINGLI TO THE PEASANTS' WAR

Huldrych Zwingli of Zurich, a Swiss city, was the instigator of the first of these supposedly separate Reformations. He insisted that he "began to preach the Gospel of Christ in 1516, long before anyone in our region had ever heard of Luther" and that his thinking was in no way dependent on the German professor. Though Zwingli, who was "the people's priest," a lowly appointment at the principal church in Zurich, admitted the influence of Erasmus's humanistic contempt for the "silly little ceremonies" of Catholic tradition, he would not hear of his owing any debt to Luther himself. Nonetheless, his foundational theology—of scripture as the only guarantor of theological truth, of the human inability to merit salvation, and of God's freely bestowed forgiveness—sounds exactly like Luther's. As the British historian Euan Cameron put it skeptically, "If Zwingli really did develop the distinctively 'Reformation' message of salvation by free forgiveness, apprehended through faith, simultaneously but entirely independent of Luther, it was the most breathtaking coincidence of the sixteenth century."

But Zwingli did eventually go further than Luther. As early as 1524, all religious images, scorned as expressions of idolatry, were torn from Zurich's churches, and all church organs were destroyed. Art had no biblical warrant and therefore could not be made Christian; and music, like art, distracted the people with its sensuousness from hearing the word of God.

For some, however, neither Luther nor Zwingli was moving fast

enough to satisfy the requirements of scripture. Though both were careful to align their Reformations with the wishes (or at least the consent) of local magistrates, there were young Turks, so to speak, in each of their movements who felt such alliances unnecessary or even ungodly. In Zurich, Konrad Grebel and his followers adopted a slogan of "not waiting on the magistrate," intended to encourage individual inspiration. Their devotion to the New Testament also inspired their conviction that only adults capable of making a commitment in faith could be baptized, something Luther had specifically rejected, though a similarly radical interpretation against both gradualism and images and in favor of limiting baptism to adults began to run through Wittenberg during Luther's absence in the Wartburg, requiring his sudden return. The tug-of-war over these more radical interpretations would continue for generations, as the opprobrious term "Anabaptist" (or rebaptizer) began to be flung about—and rejected by the proponents of adult baptism, who believed that infant baptisms, since they were scripturally illegitimate, had no standing. (*They* weren't engaged in *re*baptizing since no prior baptism had really taken place.) In particular, Luther's formerly admiring follower, Andreas von Karlstadt, began to spout these more radical proposals, gradually turning into an implacable enemy whom Luther dismissed as having swallowed the Holy Spirit "feathers and all."

Soon enough, there arrived in Wittenberg three semiliterate rejects from the large Saxon cloth town of Zwickau, who announced that they, not needing the direction of scripture, were directly inspired by God, who had imparted to them the news that the world was about to end. Philipp Melanchthon, a very young professor of Greek and a staunch admirer of Luther, was impressed, as were not a few other Wittenbergers. But these "Zwickau Prophets" were summarily evicted from their new refuge by an outraged Luther, who classified them and virtually all other innovators who would take reform beyond what he had proposed as *Schwärmer* (gushing nutcases). Not for him the wholesale despising of Christian tradition. He would continue to insist on infant baptism as the New Testament equivalent of the welcoming rite of circumcision and on the real presence of Christ in the Eucharist, as implied by Jesus's so-called words

of institution ("This is my body"; "This is my blood")—another revered doctrine of the old church that the radicals were calling into question.

The sudden hatching of so many figures more radical than Luther was of course laid at his door. Had he remained loyal to the old dispensation, none of this would have happened. His rebellion had encouraged these others, many of them sorely lacking in settled wisdom or even common sense. The conservative Luther, promoter and friend of local magistrates, who had never questioned the role of local or even national political authorities, was appalled.

But the waves of Reformation could not be contained. Peasants of southwest Germany, toiling in the domains of the Black Forest, were now reading Luther's New Testament for themselves, rekindling amid the fields and woodlands of *der Schwarzwald* the same spiritual sparks that had long ago lit the fires of rebellion in Wat Tyler's England (page 27 and following). The uprising of 1524 spread west to Alsace, east across the entire swath of Germany north of the Alps as far as Bohemia, and farther north into Thuringia. The movement began to leap borders as miners struck in Hungary and farmers took up weapons in Switzerland, Austria, and even Poland. At its height, the Peasants' War, as it came to be called, would stand as the largest armed rebellion in Europe prior to the French Revolution. The enemy was the landlord, clerical or lay— whoever exacted taxes and tithes from tenants.

A horrified Luther published *An Admonition to Peace,* but as the emperor's armies began their bloody march north against the ill-equipped and untrained peasants, Luther republished his tract with a hateful appendix, "Against the Robbing and Murdering Hordes of Peasants." "Let everyone who can," cried Luther shrilly, "smite, slay, and stab, secretly or openly, remembering that nothing can be more poisonous, hurtful, or devilish than a rebel!" (Oh, really?) The widespread torture and hideous slaughter administered by the emperor's armies, as well as by the forces of local lords, were without equal in the annals of Christian Europe.

Alone of all his class, Frederick the Wise, on his deathbed, wondered if the uprisings represented divine punishment on European rulers who had for so long treated "common folk" so unjustly. In

the far future, Marxists would dishonestly claim these rebelling, gospel-inspired peasant farmers as their precursors. A far more secure interpretation of these events would show that Luther's known role as a collaborator in official injustice and horrendous bloodshed permanently diminished his standing in the eyes of many: outside militant Lutheran strongholds, he would never again be able to claim the unsullied mantle of Christ-connected leader of the Reformation. All the same, his subjectively framed theological challenge had already altered the face of the earth—or at least of the globally reaching Western world.

1525–1564: FROM PRINCELY CONVERSIONS TO THE SECOND REFORMATION

The bloody crushing of the peasant insurrections, accompanied by the unofficial spiritual demotion of Luther, left the religious direction of whole regions solely in the hands of rulers, whether princes or magistrates. It was in this context—the context of "Who's in charge here?" rather than "What's the right course of faith and practice?"—that Europe assumed its permanent religious divisions. A Latin phrase designating the ruler as the one who decides everything was pithy and apposite: *Cujus regio, ejus religio* (Whose region it is, his is the religion). And so it became.

In the decade of the Peasants' War, such territorial conversions were few, only Prussia, Hesse, and Saxony (under Frederick the Wise's brother and successor, John the Constant) turning themselves into Lutheran states. But in the course of the 1530s, most of northern Germany became Lutheran. In the same decade all of Scandinavia adopted Lutheranism, Sweden having seceded from the Roman obedience as early as 1527. In every case, the change in religious adherence was brought about by the prince of the realm.

Emperor Charles had no desire to stand by while his German subjects altered their religious obedience, even if the alterations were achieved at the behest of their God-appointed princes. But Charles had worse threats than newly converted German Lutherans to occupy his days and nights, especially the astonishing victories

of the Ottoman Turks, advancing relentlessly against Charles's eastern European territories under their seemingly unbeatable sultan, Suleiman the Magnificent. The last thing Charles needed, in addition to this monstrous threat in the East, was a rekindled Peasants' War. Allowing Lutherans to be Lutherans—and thus assuring their loyalty—would surely be a lesser evil. In 1526, the imperial Diet of Speyer issued a decree permitting princely territories and independent cities to decide religious matters on their own. In effect, the condemnations of Worms were suspended. But only three years later, the suspension was suspended, impelling the Lutheran princes to band together in mutual defense in an alliance called the Schmalkaldic League (after the Thuringian town of Schmalkalden, where the alliance was made).

In July 1546, only months after the death of Martin Luther, war erupted between the emperor and the League, ending in Charles's smashing victory at Mühlberg and precipitating a considerable exodus of Protestants to other realms. Such waves of refugees would become an intermittent feature of Europe for the rest of the century. Though the terms of the peace were fairly gentle, alliances again began to shift, many Catholic princes deserting the emperor out of concern for their own autonomy. Meanwhile the French Catholic king, Henry II, joined up with the Lutherans for the sake of reducing Charles's power. In 1555, the Peace of Augsburg was signed, bringing an end to all hostilities and leaving each realm free to adopt either Lutheranism or traditional Catholicism.

But "uneasy lies the head that wears a crown," as Shakespeare will soon have the English king Henry IV observe. Charles, an epileptic whose enormous jaw made chewing difficult, preferred, whenever possible, to eat alone. Now, as painful gout (probably brought on by his difficulties in mastication and digestion) prevented him from leading his troops in battle, he had had enough. He had spent much of his adult life in the saddle, speeding into battles, and much of the rest of it attending to political and religious disputations. He left the Augsburg negotiations to his brother Ferdinand and retired to a Spanish monastery, where there was no religious discord and nothing ever changed. Ferdinand would become Charles's successor as emperor, Charles's very Spanish son

Philip II becoming king of Spain and of its vast and diverse territories, including the Netherlands, southern Italy, and the Americas. One of Charles's bastards, the dashing Don John of Austria, would in 1571 halt at last the advance into Europe of the Turks and their Moorish confederates at the Battle of Lepanto.*

In the second half of the sixteenth century, many Lutherans turned, not only against the *Schwärmer,* but against one another, as various groups arose to insist on their interpretation of the dead Luther's legacy. Though much of this internecine squabbling was put to rest in 1577 by the Formula of Concord, much of the inventive informality of Luther's spirit was lost; and much of Lutheranism turned into the cold, uptight, judgmental sort of society dramatized by Ingmar Bergman in such films as *Winter Light.*

Many of the dissidents whom Luther disdained did indeed turn out to be nutcases, ecstatics predicting the world's end and/or their own messiahhood. To take but two examples: in the Swiss town of Saint Gallen in 1524, women who thought themselves inspired by God cut their hair short—a shocking sight at the time—so as to spare men lustful thoughts; then, after one of their number announced herself the New Messiah (and, subsequently, that she was carrying the Antichrist in her womb!), a separate faction, who believed themselves to have already "passed through death," began to offer their bodies to devout men. There seemed no extreme of interpretation to which some of the newly literate would not go. (The women had begun cutting their hair after reading Paul to the Corinthians.) In the early 1530s, the German city of Münster became a magnet for northern Christian radicals, many of them Anabaptists from the Low Countries. Their leader, John of Leyden, gorged on delicacies while his followers came close to starvation. John also availed

* The Battle of Lepanto, won by a considerable Catholic force called the Holy League, made up mainly of Spanish and Italian troops raised by the pope, also deprived the Islamic powers of permanent control of the Mediterranean. This battle has often been cited, especially by Catholic commentators, as the turning point in preserving "Christian" Europe. G. K. Chesterton wrote a rousing, oft-quoted poem, "Lepanto," praising Don John as "the last knight of Europe." It may be the best pro-war poem ever written in English. (It surely demonstrates eloquently how difficult it is for any commentator to capture the many clashing movements of the sixteenth century.)

himself of a considerable harem of Münster's most attractive young women till the city was surrounded by a joint army of Catholics and Lutherans, who eventually and with sadistic delight put the radicals to the torch.✝

But there were also many supposed *Schwärmer* who were thoughtful, gentle folk, in all likelihood the most thoughtful, gentle people of their era. Among these were the majority of Anabaptists in the Hapsburg territories, as well as similar movements there and elsewhere, notably the Hutterites in the Tyrol and the Bohemian Brethren, who were the descendants of the Hussites. These were all people who so deplored war and any kind of violence that they either tended toward pacifism or espoused it openly, who valued communal living and the sharing of goods, and who were the first human beings in history to encourage universal literacy.

They also endured the most horrifying deaths recorded in this period, for both Protestants and Catholics found their continued existence intolerable. Many were burned at the stake by more ortho-dox Christians or—to make the punishment fit the crime—drowned in deep rivers in the midst of their adult baptism ceremonies. It became a sort of Sunday treat to spy on these sweet souls, find out where they were assembling, surround them in a mob, and hold each heretic under water till he or she stopped moving.

One of their leaders, the humble and poetic Balthasar Hub-maier, who had been tortured for seven months, then banished from Zurich by Zwingli, was again tortured, then burned at the stake in Vienna. He cried out valorously, as his executioners rubbed gun-powder into his beard and hair (so that the fire might have its most spectacularly cruel effects), "Oh salt me, salt me well!" Once his head was blown up and his body burned to a crisp, his admirable wife, Elsbeth, who had stood by him through his worst ordeals, had a stone tied around her neck and was drowned in the Danube. All this in 1528 at the behest of the Catholic emperor Ferdinand. But it must be added that this militant destruction of Anabap-tists was almost the only deed on which Catholics and Protestants could congrat-ulate one another.

✝ One might write a book on the subconscious links between belief, cruelty, and sex in the psyches of religious radicals (and of far more orthodox figures).

. . .

As early as the late 1530s, another pattern of Reformation was already gathering strength and adherents. A Frenchman whose name was Jehan Cauvin (later spelled "Jean Calvin" to both modernize and Latinize it), already an exile on account of his religious opinions, stopped in Geneva en route to Basel. Unlike Luther, Calvin, a lawyer-preacher who never served as a pastor, was one tightly wound dude, pious but calculating, theoretically inclined but sparing of speech (at least outside the pulpit). And also unlike Luther, who shared with us news even of his bowel movements, next to nothing is known about the private Calvin, his habits, inclinations, friends. Calvin was also quite distinct from Luther in his devotion to ecclesiastical detail, to polity, and to government by committee. Geneva's city authorities soon found him such an overweening presence that they threw him out, which brought Calvin to the German border city of Strassburg (one day to become French Strasbourg), where Martin Bucer, a former Dominican, was turning the city into a model of reformed practice and where Calvin picked up valuable pointers. (The Strassburg authorities would eventually throw out Bucer, who would end up in England.)

But the Genevan authorities soon found the clashing chords of reformation more than their ears could bear. They began to despair of sorting out the many do-it-yourself versions of Christianity being proposed by various factions. How would they ever reestablish civic harmony? Then they recalled the quiet, almost scary intelligence and resolve of the exiled Frenchman. However much Calvin might rub them the wrong way with his certitudes and conviction of divine purpose, he would know how to bring order to this chaos. They swallowed their pride and invited him back.

Calvin's one great text, *Institution of the Christian Religion* (or the *Institutes,* as it is commonly known), was his attempt to create a sort of Protestant *Summa Theologica,* and he rewrote and expanded it over a lifetime. "Nearly all the wisdom we possess, that is to say, true and sound wisdom, consists of two parts: the knowledge of God and of ourselves," he begins coolly, then proceeds to a sort of recap of Luther's *Slavery of the Will,* but emphasizing God's predestination of all mankind with a cold precision and exclusiveness that

Luther tended to avoid. God in his infinite wisdom has elected from all eternity to save some (the few) and damn others (the many). But you can sorta know who is saved and who damned, because the saved listen to the Word and act in consequence; everyone else is damned.

Calvin's text is also very un-Luther-like in its attention to church structure, which Luther, the ex-monk who never actually shepherded a congregation, never attended to closely. This attention to structure has resulted in the administrative order of both the Presbyterian and the Dutch (and other similar) Reformed churches, all of which tend to be at least quasi-democratic and layered with committees and a variety of overseeing bodies (companies, consistories, synods, presbyteries).

The most significant theological difference between the Lutheran and Calvinist legacies lies in their division over the Eucharist: for Lutherans, Christ is really present; for Calvinists, the Eucharist may be richly symbolic, but nothing more. These stances proved insurmountable obstacles to forging a unified Protestant front. For Lutherans, indeed, Calvin was as bad as the pope. As a carved rhyme, once displayed proudly on an old Wittenberg house, puts it:

GOTTES WORT UND LUTHERS SCHRIFT
IST DAS BABST UND CALVINI GIFT

GOD'S WORD AND LUTHER'S WRITING
ARE POISON TO THE POPE AND CALVIN[*]

This rigidly intolerant Lutheranism, closely tied to Norse-Germanic ethnic groups, had nowhere to grow. Calvin's Reformation, however, made a point of seeking out forms of agreement with relatively like-minded groups in Germany, the Netherlands, France, Italy, Poland-Lithuania, Transylvania, and even inaccessible Scotland, where the itinerant preacher John Knox established his famously dour Scottish Presbyterianism. Ecumenical documents such as the Heidelberg Catechism and the Second Helvetic

[*] The German word for poison is *Gift*, which in the earliest Germanic languages meant bride-price. Though it's easy to understand how bride-price developed into the current English meaning of "gift," *Gift* as poison seems a bit of a stretch.

Confession assisted in creating a widespread, if loosely binding, unity among diverse populations. This Second Reformation could then go on to attract adherents far beyond its European soil of origin—in the Americas, Asia, and Africa, where converts eventually swelled the numbers of the many churches that place "Reformed," rather than "Catholic" or "Lutheran," in their names.

Perhaps the most significant innovation of Calvinism was the bright line it drew between church and state. Pastors, doctors of religion, church elders, and deacons—the four (biblically supported) ecclesiastical officers of Calvin's scheme—were far more independent of state authorities than they had been for Luther. The churchmen could, for instance, enforce ecclesiastical discipline, such as excommunication and other forms of condemnation, without consulting magistrates or princes. It was just this freedom of the church establishment from political influence that had originally been found so bothersome to Geneva's politicians. But it would also prove to be the first step in the long evolution of the democratic doctrine of the separation of church and state.

Of course, the Calvinist means of enforcing discipline could be pretty harsh. In Scotland, recognized sinners were made to sit separately in church, facing the congregation, so that everyone could stare at them throughout the service. And it didn't take all that much sinning to get yourself assigned to the penitents' bench. In New England, where the Puritans, who were super-Calvinists, held sway, their methodical cruelty is remembered to this day in the vividly chilling stories of Nathaniel Hawthorne. And in Geneva, Calvin himself presided augustly over the burning of Michael Servetus (originally Miguel Serveto of Spain), a brilliant, gentle, and trusting medical doctor, often credited today as the father of Unitarianism, who came to Geneva counting on Calvin's protection. But Calvin, who had read a copy of Michael's book, *Christianismi Restitutio* (*The Restoration of Christianity*), which Michael had sent him, knew that its author questioned the doctrine of the Trinity, which Michael argued derived from the Greek philosophers rather than from the New Testament.[*] Michael also questioned Calvin's

[*] There is much to be said in favor of Michael Servetus's argument: see, for instance, *Mysteries of the Middle Ages,* page 17, on the "Trinitarian" doctrine of Philo of Alexandria, who knew nothing of the New Testament.

cherished doctrine of predestination, insisting that God condemns no one who does not condemn himself by his own evil actions. Indeed, Michael's very title sounded to Calvin like a gong of repudiation to his own *Institution of the Christian Religion.*

Calvin, grinding his teeth over Michael's theological presumptuousness and not wishing anyone to mistake *him* for such a heretic, had already cooperated secretly with Roman Catholic inquisitors in Lyon, whence Michael escaped to Geneva. Throughout Europe, Calvin was praised for the burning by Catholics, Lutherans, and Zwingli's successors in Zurich. Though this was Calvin's only burning, he eventually managed the beheadings of several of his civic enemies on trumped-up charges.

And just as Zurich had destroyed all church art, forbidden all music, and almost all ritual, Calvin did the same. Let the people hear the words of Scripture and his own weighty sermons and sing only the plainest, unaccompanied psalms ("Geneva psalms," as they are known to this day). Geneva became the first European city to ban both prostitution and theater. Dancing, singing, and fortune-telling now brought severe fines or imprisonment on the malefactor; adultery led to execution; laughing during a sermon could put you in danger of criminal punishment, as could making fun of Calvin. In Geneva, there wasn't much left to laugh about, anyway.

Calvin was a difficult man to love. But he has not a few defenders who see him as, at worst, a transitional figure, a stage in the necessary evolution of Christianity from an even more restrictive and airless climate to more open, humane, and appropriate standards. Marilynne Robinson, one of America's most vibrant and alluring writers, sees him this way, pointing out (in her extraordinary essay on Moses in *When I Was a Child I Read Books*) the aspect of Calvin that does not lurk in the shadows but stands in the sun. She even quotes this passage from the *Institutes* in which, as she says, "Calvin establishes a profound theological basis for liberality, openhandedness":

> The Lord commands us to do "good unto all men," universally, a great part of whom, estimated according to their own merits, are very undeserving; but here the Scripture assists us with an excellent rule, when it inculcates that we must not regard

the intrinsic merit of men, but must consider the image of God in them, to which we owe all possible honor and love; but that this image is most carefully to be observed in them "who are of the household of faith" [Galatians 6:10], inasmuch as it is renewed and restored by the spirit of Christ. Whoever, therefore, is presented to you that needs your kind offices, you have no reason to refuse him your assistance. Say he is a stranger; yet the Lord has impressed on him a character which ought to be familiar to you; for which reason he forbids you to despise your own flesh. Say that he is contemptible and worthless; but the Lord shows him to be one whom he has deigned to grace with his own image. Say that you are obliged to him for no services; but God has made him, as it were, his substitute, to whom you acknowledge yourself to be under obligations for numerous and important benefits. Say that he is unworthy of your making the smallest exertion on his account; but the image of God, by which he is recommended to you, deserves your surrender of yourself and all that you possess. If he not only deserved no favor, but, on the contrary, has provoked you with injuries and insults—even this is no just reason why you should cease to embrace him with your affection and to perform to him the offices of love. He has deserved, you will say, very different treatment from me. But what has the Lord deserved? Who, when he commands you to forgive all men their offenses against you, certainly intends that they should be charged to himself.

I agree that the above is beautiful, elegant, eloquent (even if momentarily parochial, in the way it refers—by way of Paul—to those "of the household of faith"). And it certainly highlights an aspect of Calvin that I have failed to spotlight. And even though I acknowledge that we are all composites of good and evil, that (like Luther) none of us is ever capable of complete consistency, how is this passage to be reconciled with the burning of Michael Servetus, the self-justifying, blind, and bullying betrayal of Michael Servetus, who is rightly revered today as an early martyr to freedom of religion and freedom of conscience and a distinguished forebear of the Declaration of Independence? For this question I have no answer.

1545–1563: CATHOLICS GET THEIR ACT TOGETHER

In 1545, Pope Paul III called an ecumenical council, intended as a plenary meeting of the bishops of the Catholic Church. Such a council had been seen as a necessary step toward reforming Catholicism long before Luther had been heard from. But the Lutheran challenge and the several subsequent forms of doctrinal and political challenge had only increased the calls for a universal council, especially from those who saw that, without such an instrument, the very necessary Catholic reformation would remain impossible.

The popes had delayed and equivocated, fearful that the old bugaboo of Conciliarism—the theory that the pope was subservient to an ecumenical council—would again raise its head. Not a few of the popes were far too sunk in more worldly concerns—their political power, their art collections, their fortunes and those of their children, their sensual pleasures—to be bothered thinking about a council. In fact, even by the rather low standards that the papacy set for itself, there had not been a saintly pope since 1370, when (subsequently Blessed) Urban V had died in Avignon, hardly an appropriate home for the bishop of Rome (see page 177). Over the centuries, indeed, few saints had occupied the supposed throne of Saint Peter, whereas the number of papal rascals and knaves had almost always outpaced the holy fellows. As the Renaissance dawned, the papacy had, as we saw earlier (page 52 and following), fallen into the clutches of one scoundrel after another. Because many princes had a hand in appointing their bishops and controlling them, the choice of a site for the council became a major obstacle. The emperor wanted the council to meet inside the Empire; the French king wouldn't hear of it. At last, the Tyrolean town of Trent was chosen, just outside imperial territory and at the very edge of Italian influence.

Looking backwards from the twenty-first century, the results of this Tridentine council look shabby. The long-cherished hopes that such a council would find a way to reconcile the innovations of the reformers with Catholic traditions—or, at the least, open a dialogue with Protestants—proved wholly empty. Had the council met years earlier, such outcomes might have been possible. By the time the

council fathers assembled amid the hills of the Tyrol, too much had happened too long ago and too many modes of dissent had turned into establishments of their own. It was probably impossible now to bridge the divisions. In any case, the bishops at Trent did not try.

Rather, without conceding anything to any dissenter, they proceeded to defend Catholicism in its most anti-Protestant and pro-Roman form. Against Protestant doctrine of *sola scriptura,* Catholic tradition was also held to be a valid source of belief and practice. A human being's justification was not by faith alone; good works were necessary. The true church, founded by Christ, was the Roman Catholic Church, a hierarchical institution with the pope at its summit. The role of the Catholic clergy was to interpret scripture and tradition; the laity's role was to pay and obey. This true church rejoiced in its seven sacraments (no more, no less). Its central act was the mass, celebrated only by a validly ordained priest, in which the Sacrifice of Christ on the cross was mystically repeated, as it would be by priests throughout the world till the end of time in the supposedly sacred but increasingly unintelligible language of Latin.✠

But even the conciliar bishops and their theological advisers realized that the bald reassertion of all traditional Catholic theological positions in their most extreme forms would not be enough. There needed to be a reform of clerical life if anyone was to take seriously this Counter-Reformation. So, strict and even punitive standards were set in place for the formation of clergy and vowed religious. Gradually, over succeeding decades, these reforms would be implemented to the letter, thus rooting out the more public forms of sexual laxity and worldliness that had afflicted the Church for so long. By the close of the council, it was inconceivable that a sitting pope would ever again create his bastards cardinals—though popes would, for several decades to come, continue to sire bastards. (Upon his election in 1534, Paul III had made two of his teenaged grandsons cardinals and awarded them lucrative ecclesiastical benefices, but once the

✠ Latin is certainly a good language for lawyers, but why it should be considered sacred I have no idea, unless usage by popes—in their fanciful role of replacing the Roman emperors—makes for sacredness. Hebrew, Aramaic, and Greek have far better qualifications.

Tridentine decrees were promulgated, such appointments began to be disdained as *de trop*.)

Henceforth, the pope and his bishops would permit no quarter to dissent from the Tridentine decrees. Bishops and theologians who had hoped for compromise were marginalized. Pope Paul saw to it that within the papal bureaucracy a new office was established called the Roman Inquisition, and its mission was to sniff out and extirpate heresy wherever it might take root. Eventually, the work of this gruesome body would be supplemented by a further instrument, the Index of Forbidden Books, which listed all the books one could not read without attracting the interest of the Inquisition.

The Council of Trent met off and on for nearly two decades, long after the pontificate of Paul III. When it opened, only thirty-odd bishops were in attendance. Attendance remained spotty throughout its infrequently summoned sessions. One might even question whether Trent could be called an ecumenical council in anything but name. Certainly, the Second Vatican Council, called by Pope John XXIII in 1962, presented a very different face to the world, as it refused to condemn anyone and insisted on input not only from the entire Christian spectrum but even from non-Christian religious figures, especially from the monotheistic faiths of Judaism and Islam. Its participants numbered in the thousands, splendidly accommodated not in a minor alpine town but for all the world to see—in the great nave of Saint Peter's basilica, the building of which precipitated Luther's original protest.

From a geopolitical perspective, the most astonishing difference between these two councils may lie in the national origins of their participants. Trent was a wholly European affair, reflecting Christianity as the exclusively European concern it was then thought to be. But even during the years of the Tridentine council, the map of Christianity was beginning to be redrawn in radical shifts that would make Catholicism the first worldwide religion. Missionary priests and brothers had already begun to sail on the ships that would eventually bring Europeans to every corner of the globe. The newly formed Jesuits, spiritual sons of Ignatius Loyola, were particularly keen to rack up conversions among the pagans of the world, setting up utopian sanctuaries for the horrifically hunted

"Indians" of the New World, learning the obscurest languages of the Far West and the Far East, even inserting themselves into xenophobic East Asian courts as astrological wise men. One of their number, the Spaniard Francis Xavier, blazed a trail of baptisms through India, Malaysia, and Japan and died at the gates of China in 1552. In the seventeenth century, French Jesuits were tortured and martyred by Iroquois and Mohawk tribesmen in what is today upstate New York. Throughout this entire period, Catholics were the world's only missionaries, showing up in one impossibly distant port after another, Jesuits and other priests of newly founded orders, Franciscans and other friars bound by medieval rules, all helping to create the worldwide numbers that would make Catholicism a religion of more than one billion souls, while neither Protestantism nor Orthodoxy would ever reach even half that number.

This aggressive global initiative on the part of reforming forces within Catholicism would also go a long way toward making up for losses of obedience within Europe itself. For by the close of Trent's council, a wide arc of northern Europe—most of Germany, much of Austria, whole regions farther east, all of Scandinavia, all of Britain, most of the Netherlands, much of France—appeared to be permanently lost to the old faith and order. There would, however, be one additional shift within Europe, a shift that would depend principally on the undamming of vast rivers of blood during the continent-wide conflict we call the Thirty Years' War. Before that horror occupies us, however, let's have a look at England, where a sort of religious compromise was in the course of being built, if somewhat intermittently.

1558–1603: THE RELIGIOUS ESTABLISHMENT OF A VIRGIN QUEEN

As a boy in the Bronx, I was taught this quatrain by an ancient Irishman:

> *Oh, trouble me not with your clergy,*
> *Nor speak to me of your faith.*
> *For the Church of England was founded*
> *On the ballocks of Henry the Eighth.*

There are several folkloric versions of this ditty, one of them occasionally attributed to Brendan Behan, though the rhymed thought must predate him by generations. The lines are of course intended as insult and provocation. Don't count on the Irish for peacemaking.

The first two lines may be haughtily dismissive, but there is undeniable truth in the last two. Careful scholarship[*] in recent decades has established rather conclusively that the English Church in the reign of Henry VIII was not in desperate need of a reformation; rather, it may have been the most devout, serious, and well-functioning branch of European Catholicism. Henry's willfulness was an expression of his own personal needs—for a male heir, for a younger wife, for congress with Anne Boleyn—not a reflection of the desires or needs of the English people.

Henry was not much interested in the particulars of reformation, certainly not in applying them to his own realms. He loathed Luther—which loathing was entirely mutual—and he had no higher opinion of the subsequent continental reformers. He loved the Latin mass and the Latin Bible and was suspicious of ordinary people reading the Bible by themselves in the crude tongue of English. He simply wanted to do what he wanted to do, and if that entailed cutting England off from the larger church, so be it. He and his people were ill served by the pope, who, because Henry's first wife, Catherine of Aragon, was aunt to the Emperor, did not see fit to annul Henry and Catherine's marriage, having earlier provided the necessary dispensation for it to take place. Henry was right to assume that the pope normally had no problem bestowing royal annulments. Too bad that Henry was wed to Charles's aunt and that the pope was at the time Charles's prisoner in all but name.

It was such complicating political considerations, rubbing raw the massive ego of the king, that brought about the English Reformation. When Henry married for the sixth time, Luther summed it up thus: "Squire Harry means to be God and do as he pleases." The German professor would have enjoyed the Irish quatrain.

The story of the permanent separation of England from Catholic unity hardly ends with Henry. His three children were the paltry result of so much marrying (though as a progenitor the king almost certainly labored under

[*] See especially Eamon Duffy, *The Stripping of the Altars: Traditional Religion in England 1400–1580.*

the impediment of a royal case of syphilis). Each child in turn occupied the throne after Henry, each loyal to the religious preferences of his or her dead mother (or maternal family of origin). First came Henry's only son, Edward VI, a frail nine-year-old whose mother, Jane Seymour, had expired weeks after his birth. Edward favored a Calvinistic Reformation and introduced the eloquent Book of Common Prayer, edited and mostly written by Thomas Cranmer, appointed archbishop of Canterbury by Henry (who knew little of Cranmer's Calvinistic theology—and nothing of Cranmer's hidden wife—and was simply satisfied with the careful Cranmer's political inventiveness).

Edward died of consumption at fifteen and was succeeded (after some bizarre high jinks)* by his half sister, Mary, in accordance with Henry's will. Loyal to her mother, Catherine, Mary brought the realm back to the Catholic fold and burned Cranmer and a number of others who refused to resume their Catholicism, thus winning for herself the appellation Bloody Mary, though this tragic woman, a humiliated pawn for most of her life, was relatively pacific, even kind, by the standards of her day. But her reign was slightly shorter than her brother's.

As a child, Mary, whose very existence had been a continuing embarrassment to her father, had been hidden away in various country castles and deprived of her mother's loving presence. Whatever she may have been taught in these years of being shunned, she possessed scant sense of statecraft. She made the great mistake of marrying her cousin Charles's son, the king of Spain. The last thing the English people wanted was a Spaniard in the works, a man who could eventually claim the English throne. So, by this marriage—not by her Catholicism—Mary forfeited the previously warm allegiance of her subjects. Her inattentive Spanish consort, eleven years her junior, could hardly wait to get away to more agreeable realms once

* The wily Duke of Northumberland had pressured the dying Edward to sign a will countervailing his father's and establishing his fifteen-year-old cousin, Lady Jane Grey, as his successor. Northumberland then had Jane married to his son Guildford Dudley. The unfortunate Jane reigned for nine days, after which Mary was proclaimed queen. Jane was later beheaded, along with her husband and her father-in-law. The English preferred as their sovereign a famously loyal Roman Catholic Tudor to a pious Protestant of more questionable pedigree.

the marriage ceremony had taken place. Mary, thinking she was pregnant, soon discovered she had stomach cancer. The continuing bonfires of heretics eventually erased all her subjects' previous love for her. Why should men be incinerated for adhering to beliefs that so recently had been required of them?

Mary's death in November 1558 brought her half sister, Elizabeth, the last of the Tudors, to the throne. Elizabeth was the daughter of Anne Boleyn, Henry's second wife, who had been decapitated on trumped-up charges of adultery and witchcraft, as Henry had tired of her charms and was disappointed that she had not presented him with a male heir. He who was so sure that God disapproved of his marriage to Catherine (why else had *she* not provided the male heir?) now understood that God disapproved of Anne, as well. As she was a slut and a witch, they had not had a real marriage—and Elizabeth, like Mary before her, was declared a bastard.

Unlike Mary, Elizabeth was a natural politician. She knew she was expected to be Protestant. What else could possibly be in prospect from the only child of the very Protestant Anne? And in any case, Elizabeth had been viewed as a bastard, not only by her own father, but by the pope, who could hardly have sanctioned Henry's second union as a lawful marriage after militantly refusing to allow it altogether. In Rome's view, Mary had been a queen; Elizabeth was an imposter.

These things being so, Elizabeth returned England to Protestantism in a series of moves that revealed not only keen intelligence but skill in political and diplomatic maneuvering that few women—or men—have ever equaled, or even approached, in the long history of the Western world. Henry had ascended the throne in 1509 as an eighteen-year-old. Between his declaration in 1534 that he himself was "Protector and only Supreme Head of the Church" of England and the day of his daughter Elizabeth's ascent, thirty-four years had passed. In that time, the English populace had been jerked hither and yon, first to a Catholicism without the pope, then to a Calvinism that kept the un-Calvinistic office of bishop in place and an order of service that looked very like the mass, if in English. Under Edward, the Calvinistic and un-Catholic elements became even more pronounced. Under Mary, all this was swept aside and the churches were returned to Catholicism, and statues

and icons, so recently jeered at, defaced, and removed, were put back in place.

Elizabeth drove a middle course, establishing a form of Christianity that would one day be called Anglicanism, somewhere between a factionless Catholicism and the less fanatical forms of Protestantism. Henceforth, fanaticism would be frowned upon; and even untempered displays of enthusiasm would be discouraged. Individual conscience would be respected, so long as it in no way threatened the security of the state. The queen did not seek to make windows into men's souls, as Francis Bacon would say of her. She could certainly be impatient with theological arguments. "There is only one Jesus Christ," she declared, "and all the rest is a dispute over trifles."

She was hardly encouraged to sign herself in to either camp. In 1570, Pope Pius V excommunicated her and absolved her subjects from all obedience. This bald papal attempt to alter the government of England (and Ireland), though it caused an awful lot of trouble, casting a suspicion of treason over all of Elizabeth's many Catholic subjects, did not succeed. Nor did the gratuitous insults of Calvin and his Scottish disciple John Knox warm her heart toward their form of Christianity. Calvin presumed to send her advice as if she were an inexperienced girl who could not possibly understand the great male world. Knox lost her attention even before her accession when, during her sister's reign, he published *The First Blast of the Trumpet Against the Monstrous Regiment of Women,* his attack on women rulers, a phenomenon Knox considered not only unfortunate but unnatural.

Elizabeth could be wittily dismissive of theological earnestness. Asked her opinion about the real presence of Christ in the Eucharist, she replied:

> *'Twas God the Word that spake it,*
> *He took the Bread and brake it;*
> *And what the Word did make it*
> *That I believe, and take it.*

In moments like these she seems almost a figure in a play by Shakespeare. Indeed, she loved his plays, she loved art and music, both

sacred and profane, she loved courtly dancing, and she made fun of Calvin's simple little psalm tunes. Her preferences and her patronage helped to set England on a course to cultural greatness.

Even more than for her promotion of the arts, however, it is for her political intelligence and her steely resolve that she is remembered. She appointed as her secretary of state William Cecil, just about the best royal appointment ever made in the history of the English monarchy, with these words: "This judgment I have of you that you will not be corrupted with any manner of gifts and that you will be faithful to the State." When Mary's widower, the king of Spain, decided that he should rule England, he sent off his supposedly unbeatable armada to conquer her realm. Elizabeth addressed her troops before the great battle with these words: "I know I have the body of a weak and feeble woman, but I have the heart and stomach of a king, and of a king of England, too; and think foul scorn that Parma or Spain, or any prince of Europe, should dare to invade the borders of my realm."

She knew who she was. As she put it, "I am your anointed queen. I will never be by violence constrained to do anything. I thank God I am endued with such qualities that if I were turned out of the realm in my petticoat, I were able to live in any place in Christendom." Her motto was *Semper eadem* ("Always the same" or "Always herself"). Her vaunted virginity may, however, have had dark origins in unwanted attentions suffered as a teenager at the greedy hands of the second husband of Catherine Parr, who had been her father's last wife and in whose household she lived after Catherine's second marriage. (Nor could Mary's example have encouraged Elizabeth to consider a dynastic marriage.)

She asked that her epitaph be brief, recording only "my name, my virginity, the years of my reign, the reformation of religion under it, and my preservation of peace." The last item was rightly the most important. But she was hardly perfect, as she herself knew and as any ancient Irishman would be happy to remind you.

The unhappy consequences of the Tudors' presumptuousness toward Ireland would endure for many poisonous centuries, even into our present.[*] Nor should we fantasize that English life during Elizabeth's reign was a sort of Shakespearean frolic.

[*] See *How the Irish Saved Civilization*, pages 213–15.

The visible wounds opened everywhere by the ravenous policies of Henry and his children would take centuries to heal. Evelyn Waugh in his biography of Edmund Campion, one of several Jesuit priests who operated illegally within Elizabeth's realms and were brutally executed as traitors, describes the proximate consequences of the spoliation of the monasteries, which had served for centuries as refuges of peace and civilization. Though the justification of the Tudors for the plunder of wealthy monastic foundations throughout their realms was Reformation, the real motives were greed and the needs of a chronically cash-strapped monarchy. Waugh refers to scenes that could be seen everywhere that the Tutor crown held sway: "the buildings of the old monasteries, their roofs stripped of lead and their walls a quarry for the new contractors. The ruins were not yet picturesque; moss and ivy had barely begun their work, and age had not softened the stark lines of change. Many generations of orderly living, much gentle association, were needed before, under another Queen, the State Church should assume the venerable style of Barchester Towers."

The Virgin Queen lived almost to her seventieth birthday, a great age for her time. Her last days were sad and lonely, for all her friends, including Cecil, had preceded her in death. But though her physical weakness was becoming ever more apparent, she refused to take to her bed. When Cecil's son visited her, he tried to coax her, saying, "Your Majesty, to content the people, you must go to bed." Elizabeth, showing some of her old spirit, replied, "Little man, little man, *must* is not a word to be used to princes. If your late father were here he would never dare utter such a word."

Long after her pitiable demise, Anglicanism would become a global phenomenon (at least in those many lands where the English have at one time or another planted their flag), and its outward appearance would put it much closer to liturgically serious, bishop-led Catholicism than to any form of Protestantism; but it would be Catholicism without a pope and with a grave appreciation for bishops as representatives of their people—and, more recently, Catholicism with female priests and (at least in some provinces) even female bishops, Catholicism with (at least in some provinces) welcome, even ordination, for gays and lesbians, even marital bless-

ing on single-sex couples.* It would not be entirely unwarranted to speculate that a noncelibate priesthood may have eventually enabled Anglicanism to address sexual issues with more realism and wisdom than the formally celibate Catholic hierarchy has been able to achieve.

1562–1648: LET'S KILL 'EM ALL!

In John's Gospel, Jesus articulates the norm by which his true disciples may be identified: "By this shall all men know that ye are my disciples, if ye have love one to another." Christians seem to have followed this norm even as late as the early third century, if we are to credit the testimony of the early African theologian Tertullian, who describes the surprise of the pagans of the Roman empire in their encounters with contemporary Christians: " 'Look,' they say, 'how they love one another' (for they themselves hate one another); 'and how they are ready to die for each other' (for they themselves are readier to kill each other)."

Alas, the norm of inter-Christian love would finally give way to internecine warfare. At first, there would be strident arguments over theological formulations. One of these conflicts would whack Tertullian himself, leaving him labeled a heretic, principally on account of his minority position on formulating an adequate technical description of the Trinity. But soon enough, blood would flow in the streets of Constantinople, as warring factions of monks, each devoted to a different theological formulation, tried to cut one another down. I suppose if you had decided your opponent was a counterfeit Christian, you would think yourself relieved of any responsibility to treat him kindly.

Verbal and physical sparring, tracking down heretics, putting whole communities to the sword, the very public

* It is on sexual issues, starting with contraception, that Anglicanism differs most strikingly from Roman Catholicism. The gulf may be examined by comparing recent papal documents (Pope Paul VI's notoriously ill-considered anti–birth control encyclical, *Humanae Vitae,* and Pope John Paul II's painfully abstract and nearly interminable series of talks, *The Theology of the Body*) with *The Body's Grace,* a realistic, uncondemning, and theologically innovative essay by Rowan Williams, recently retired archbishop of Canterbury.

(and insanely cruel) burning of supposed heretics—all these activities grew slowly, intermittently, and regionally over the course of the medieval centuries, Europe's avowedly Christian centuries. But in the sixteenth century, the inter-Christian violence grew exponentially. Open-air burnings became more common and more elaborate liturgically: comfortable, curtained boxes would be provided for local lords and higher clergy; colorfully vested bishops and priests (or severely vested reformed ministers), often assisted by acolytes or other lesser ecclesial servants, would process about as if engaged in a service in a church sanctuary; a preacher would mount a specially constructed pulpit to sermonize the condemned and terrify the spectators, for whom temporary stadium seats had been constructed; the condemned prisoners would be paraded in their dunce's hats; the ghoulish conclusion, anticipated by all, would be public torture by fire, ending in horrifying death. Why burning, rather than, say, hanging or decapitation? Because the great Christian promise, the hope of all believers, was physical resurrection at the end of time—and you couldn't be resurrected if you had no body, could you? The promise of the waking of the dead and their rising from their graves must not be permitted to heretics.

And now, as whole regions, whole kingdoms even, were in the course of adopting "heretical" beliefs (or recommitting themselves to their traditional "heretical" beliefs)—and as princes and other political lords and leaders saw that land grabs and even more subtle, more fully compassing modes of political domination could be ascribed to pious religious motives—the occasional conflict of Christian against Christian progressed swiftly to bloody regional clashes and thence to unforgiving national wars, a state of affairs that Europe would hardly attempt to forsake till the bleak period of unavoidable reflection that would follow the global disaster of World War II. Let's draw our swords and kill all the Others—all the heretics, all their spouses, all their children, for all these are hopelessly compromised by their invincible wrongheadedness and their perverted commitments.

No epitome of the conflicts that wracked Europe from the 1560s to the middle of the seventeenth century could possibly account for the needless suffering that men inflicted on their fellow men and on the women and children trapped in these hostilities. So I shall not

THE TURNS OF THE SCREW

try. We pause briefly only to bow our heads in the direction of a few glaringly unavoidable highlights.

In our appreciation of Rabelais, we had occasion to note that, though he had a naysayer's spirit, he had little or no access to the company of men like Luther. By the time of Rabelais's death in 1553, such contact was becoming more feasible for a Frenchman. In fact, less than a decade after Rabelais died, the first of the French Wars of Religion commenced. By the usual count there would be seven more of these throughout the century, though it is also possible to view them as one nearly continuous war.

The wars (or war) were partly made possible by a continuing weakness in the French monarchy of this period: a series of kings were underage or ill or ineffective. This continuing intergenerational weakness permitted powerful lesser lords to grow ever more powerful, asserting their rights against one another as the royal family, the House of Valois, stood helplessly by. Though there were many lords involved in many clashes, the two leading families were the Bourbons and the Guise, neither of which intended to cede anything to the other. The Valois were religiously and temperamentally moderate, Catholic by tradition but humanistic and intellectually open. Their leader and the source of their continuity was the widowed queen mother, the durable Italian Catherine de' Medici, who, sometimes serving as regent, did her best to protect the king of the moment but who also got a great chortle out of reading aloud from the most outrageous Protestant propaganda, which assaulted her mercilessly. The France from which Calvin had had to exile himself was becoming an increasingly fruitful field for Protestantism of the Calvinist variety, thanks especially to operational planning initiated by the well-organized Calvin himself.

The Bourbons saw themselves as championing their fellow Huguenots, which is how French Calvinists were then designated (though no one today is entirely certain of the origin of the designation). Huguenots were suddenly everywhere, accounting for more than half of all the nobility, who worshipped in more than a thousand Huguenot churches in the company of two million of their fellow Calvinists.

The Guise were exceedingly aggressive and self-righteous super-Catholics. Though Catherine had reason to distrust both fac-

tions, the Guise gave her nightmares. In early 1562, Guise retainers, opposed to concessions the crown had made to Huguenots, surrounded a worship service in Champagne and massacred all the people at prayer, who, in conformity with the king's edict of limited toleration, had assembled outside the walls of their town.✝ In the course of the melee, the Duke of Guise was accidentally cut on his cheek. His followers, seeing this, became enraged and set off through the town, Wassy-sur-Blaise, killing every human being they could find.

This was not the first French massacre of Protestants, nor would it be the last. Nor would violence be perpetrated only by Catholic partisans, though the Protestant violence tended to be less frequent and less extreme. Fear of intervention by outside powers—Spain and the papacy on the Catholic side, the English and the Dutch on the Protestant side—was not without foundation and added to the increasing paranoia of all parties. The most infamous massacre of all, beginning in Paris on August 24, 1572, Saint Bartholomew's Day, and continuing for days afterward, resulted in the murders and mutilation of untold thousands of Huguenots in the capital and in a dozen provincial cities.

The precipitating incident was the murder of the Huguenot leader Admiral Gaspard de Coligny by the Duke of Guise and his men. Coligny was an ally of the young king, and the Guise party afterward claimed that they feared Coligny was about to stage a coup. The outrages to which they subjected the admiral's dead body—castration and other mutilations, suspension from a public gallows, burning—suggest that Guise's fears were ineradicably mixed with the vengeful hatred of the classical tyrant. Certainly, his example stoked up the fears and rage of the Catholic partisans, who repeated their horrifying butchery throughout France, having been given leave to enact the worst nightmares that human beings are capable of. Both Philip II of Spain and Pope Gregory XIII, relying on the intelligence that a Protestant coup had been frustrated, ordered bells to be tolled, Te Deums to be sung, festivals to be celebrated.

✝ Whether or not the worshipping Huguenots were in strict conformity with the king's wishes remains a point of some contention.

Though Gregory was hardly the worst of popes, his blessing of the Saint Bartholomew's Day Massacre, along with

his strong encouragement of Philip II's invasion of England (and, following the failure of the Spanish Armada, the papal plots to assassinate Elizabeth), gave him the reputation of a depraved monster in Protestant Europe. It is not surprising that the Protestant countries refused to accept his (very necessary) reform of the Julian calendar, thus initiating a long period of confusion in which different countries kept different calendars.

The French war(s) did not end with the infamous massacre but continued through five additional and consistently bloody phases, ending only after the "War of the Three Henrys." Catherine de' Medici's sole surviving son, Henry III, was king. With no issue at hand, Henry knew that, in accordance with the Salic law of France, the crown should pass to his Bourbon cousin Henry of Navarre, a Huguenot. Knowing also that Paris, in particular, would never accept a Protestant king, King Henry tried to convince his cousin to convert to Catholicism but was unsuccessful in his attempts. A third Henry, Duke of Guise, militant leader of the militant Catholic League, was certain to stand against Henry of Navarre's accession, no matter his formal adherence. So the king had Henry of Guise killed, after which he himself was fatally knifed by a sneaky Dominican.

The war that followed was a seesawing conflict between Henry of Navarre's forces and those of the Catholic League. Huguenot Henry, a keen and courageous cock of the walk, gradually realized that his royal cousin had been right: he would never gain Paris unless he was Catholic. So, with the warm encouragement of his favorite mistress, he shrugged and became a Catholic, saying (or so legend would have us believe), *"Paris vaut bien une messe"* ("Paris is worth a mass"). As Henry IV he would reign vigorously and skillfully for more than two decades, establishing freedom of religion under the Edict of Nantes and bestowing peace and its benefits on his previously divided country. But in 1610 he was assassinated by a Catholic fanatic (and failed Jesuit) named Ravaillac. The Catholic League had tried repeatedly to end Henry's life. As Diarmaid MacCulloch has written, "With one major assassination attempt a year, the murderous persistence of their religious zeal would have won admiration in the 1990s from devotees of the Ayatollah Khomeini's fatwa against Salman Rushdie."

The peace that fell on France, thanks to a king who was Huguenot, Catholic, and very smart, would now fail by degrees, as France would be pulled back and forth by conflicts beyond its borders. Europeans had long specialized in interminable wars. The late Middle Ages had witnessed the Hundred Years' War between England and France. Even now, as Henry of Navarre's son, Louis XIII, ascended the French throne, the Spanish and the Dutch were in the midst of their Eighty Years' War (1568–1648) over the religious destiny of the Netherlands. And less than a decade after the assassination of Henry, the Thirty Years' War would start up, involving most of Europe in bloody disputes over religion and territory—or, rather, starting with religion and ending in territory, ending indeed in 1648 with no one among the exhausted combatants able to articulate persuasively why they had been fighting each other for thirty years. In battles too numerous to name, Catholic forces had gradually won back some territories—such as Bohemia, the lower Netherlands (now Belgium), parts of Germany, even parts of France—that had been previously ceded to Protestants. With few exceptions, the results established the map of Europe as it stands today. But no one will ever be able to begin to account for the blood that was shed.

Even though Julius II in the time of Michelangelo was the only pope to ride armed into battle, many of the popes and other bishops continued to affect a warrior stance toward the designated heretics of their moment; and many of the Protestant leaders followed suit. Zwingli, for instance, clad like Julius in full armor, was cut down in a battle with Swiss Catholics, whom he had made desperate by imposing an economic blockade. Jesus's blessing on "the peacemakers: for they shall be called the children of God" (Matthew 5:9) was hardly the most frequently quoted biblical text of the sixteenth century. Indeed, except among the universally reviled Anabaptists, the notion of peacemaking was hardly mentioned. Looking back, one might wonder why it never occurred to the war makers that they should be called the children of Hell.

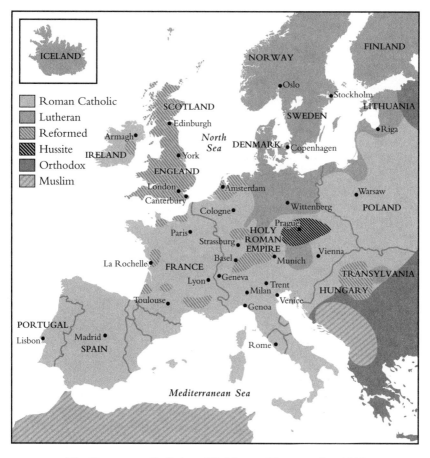

The Permanent Religious Divisions of Europe after 1648

VII

HUMAN LOVE

HOW TO LIVE ON THIS EARTH

———————— ❖ ————————

What's past is prologue.

The Tempest

I fear that, despite my best efforts, I have subjected my readers to an awful lot of know-it-alls, men (almost always men) who know what is best for everyone, prescribers and proscribers who can articulate exactly what we all must think, believe, do, and avoid. Though the period of Reformation and Counter-Reformation is especially rife with such types, there are others whose welcome heads peek through the soil of history as if they were the first buds of spring. To them we will now turn, if briefly.

There is an aspiration that runs through religious history, no matter which religion is being studied, that we might call the desire to limit membership—and limit it severely. I recall attending a religious publishing convention many years ago during which I was asked several times by people I was just being introduced to—and with all the unsmiling seriousness of a CIA inquiry—"Have you accepted Jesus Christ as your Lord and Savior?" To these questioners there was no point in further discussion of anything if I could not answer this question affirmatively. Such people are excluders, who want their circle—the circle of the saved—to be exclusive, as small and as (uncomfortably) intimate as possible. (Luckily for me, the convention was held in late-twentieth-century America, so I had no fear of being burned at the stake if I fumbled my answer. Still, I fancied I could see the licking flames in the eyes of my interlocutors.)

But there also runs through each religious tradition an opposite aspiration: to include as many as possible, to open the windows to fresh air and the doors to all comers. Of course, to do this one must lower one's standards—at least, in the eyes of the excluders. But from another perspective—the perspective of the includers—one is

merely opening one's arms to everything and everyone; one is act-
ing as Jesus advises in the Sermon on the Mount (Matthew 5–7) and
as Mohandas Gandhi advised in his repeated meditations on that
sermon: "How can we, little crawling creatures, so utterly helpless as
He has made us, how could we possibly measure His greatness, His
boundless love, His infinite compassion, such that He allows man
insolently to deny Him, wrangle about Him, and cut the throat of
his fellow-man? How can we measure the greatness of God who is
so forgiving, so divine? Thus, though we may utter the same words
[as Jesus did] they have not the same meaning for us all."

In the sixteenth and seventeenth centuries, there were many
who yearned to cut the throats of "heretics," and not a few who
succeeded in doing so. There was also a growing procession of
those who longed to include and embrace as many human beings
as possible.

1531–1540: NUNS WITH GUNS

Their weapons weren't actually guns; and, at least to start with,
they weren't even nuns. They were a group of well-born Lombard-
ian ladies, led by Angela Merici, who came together to educate poor
girls in the northern Italian city of Brescia. So far as I can ascertain,
no one had ever thought to do this before them. In the same period,
Anabaptist communities in Germany, Switzerland, and Holland
were beginning to encourage universal "biblical literacy," but this,
often enough, referred to memorization of biblical texts rather than
to actual literacy—and, in any case, the Anabaptist program was
not especially directed toward poor girls. As we saw in the story of
Thomas More, the education of girls, even those of educated house-
holds, was not a value in European society. The education of poor
girls was an unthinkable innovation. What society had against the
education of females was, of course, that it would put the weapons
of knowledge into their hands: it would make them too much like
males, able to hold real power over others.

One recalls the remarkable result of the second communica-
tions revolution (page 32), in which, because of the simplicity of
the alphabet, it became possible for anyone, even a slave, to learn to
read. So even slaves learned to read in the time of Moses and after,

but another three thousand years would pass before the daughters of the poor would have the treasures of literacy opened to them. Their champion was a most unlikely warrior: a tiny, though pretty and charming, spinster.

Angela Merici wished to form an elective association of women like herself, whose life experiences gave them sympathy for others, especially for other females of scant means. Angela, orphaned at ten, had lost her last remaining protector, her beloved elder sister, when she was thirteen. These losses, which might have turned a psychologically weaker girl into a broken woman, strengthened Angela: she sought solace in prayer and in dedication to others in need. She became a visionary in the strict sense: one who saw in advance the work that God had assigned her, as well as others, to accomplish. Her meeting with Pope Clement VII in 1525 resulted in his inviting her to lead a congregation of nursing nuns. Angela turned him down, something a lady, well born or not, was hardly in a position to do; but she knew the pope's proposal wasn't what God had in mind for her.

Angela's association in Brescia took as its spiritual patron Saint Ursula, a wholly legendary figure who served nonetheless as the medieval patron of universities. It was this connection of a female figure to university education that attracted the women, who came to be called Ursulines. Angela died in 1540, and in subsequent centuries, under subsequent popes, the Ursulines would be hemmed in by many papal rules about the conduct of their lives. Eventually, they were forced to assume the strict identity of nuns, which had not been their original intent. But their connection to the education of girls and women would never falter. Throughout Europe and at many of the sites of the new worldwide Catholic missions, the Ursulines built and staffed schools and universities for women, never entirely abandoning their original focus on the education of poor girls.

1572–1616: MEN IN THE MIDDLE

The sixteenth century witnessed the novel phenomenon of men who, like Gandhi, were not team players, who declined to be heated partisans of any one religious camp. Preeminent among

them was the warmhearted Henry IV, who saw that the peace of a whole country—a country as unique and precious as France—did not require either an unyielding Protestant or a fanatical Catholic at its helm, just a king who loved his country and would look favorably upon his subjects, whatever their religious allegiance. Though such lack of partisanship was an abomination to zealots (and finally resulted in Henry's murder), it was a supremely rational and balanced course, a sort of grander French flowering of the very virtues that had earlier distinguished the estimable Saxon prince Frederick the Wise, pious Catholic and protector of Protestants.

Niccolò Machiavelli's *The Prince,* full of Machiavellian advice for rulers, was published in 1532. The advice is both profoundly realistic and deeply cynical, much of it modeled on the sterling example of the Borgias. The most cynical princes had little need of *The Prince,* of course, for they were already experts in ruthlessness. Far closer to the playfulness of Henry IV are the musings of his fellow countryman Michel de Montaigne, who in his still refreshingly modern essays, published in three volumes over the last two decades of the sixteenth century, urged self-knowledge before all else and a sense of proportion regarding one's own importance: "Even if we mount on stilts, we still must walk on our own legs. And on the highest throne in the world, we still sit on our own backside." (If I am not mistaken, this is especially meant as a humorous, if indirect, reference to His Holiness the Pope.)

When it comes to the subject of kings and their ilk, however, there is probably no writer in the world who thought about them more penetratingly than William Shakespeare, who even knew a couple of them (Elizabeth I and James I). Shakespeare hides within his plays, standing behind his great and rounded characters. From these plays we know that Shakespeare understood as much about the inner human landscape as any writer who has ever written. His characters range across the entire gamut of human responses. Is there a note that he does not somewhere sound? I think not.

These things being so, can you tell me what side Shakespeare was on in the religious wars of the sixteenth century? Was he a Catholic like his father, or was he a supporter of Elizabeth's Church of England, or was he a dissenter of some sort? Though many books

have been written on the subject of Shakespeare's religious convictions, in truth no one knows the answer. That's because he didn't want us to know. Like Bruegel, he was politically smart enough to keep his religious opinions to himself—or at least to disguise them in such a way that no one could say for certain that he stood here or there on any controversial religious question.

Does this mean that he was agnostic, a skeptic like so many educated men and women of the twenty-first century? Rather, I'd say he was a believer of a kind—of the kind that could, for instance, imagine himself into the fated druidic mysticism of prehistoric Britain, as he does so deftly in *King Lear.* To my ear, he has more in common with the religiousness of Gandhi than he does with the new scientific atheism of men such as, say, Richard Dawkins.

But perhaps more important, Shakespeare tends to limit himself to this world and its dilemmas. He recognizes the similarity between himself and any king: "I think the King is but a man, as I am. The violet smells to him as it does to me; the element shows to him as it doth to me; all his senses have but human conditions. His ceremonies laid by, in his nakedness he appears but a man; and though his affections are higher mounted than ours, yet when they stoop, they stoop with the like wing." This is King Henry V speaking, while visiting his troops in the night before the great battle of Agincourt and unrecognized by them. Shakespeare's religious vision embraces everyone, enfolds humanity itself, recognizing that the differences between one human being and another are as nothing when compared to their similarities. He may not be an orthodox believer, but he is surely some sort of proto-democrat—not an insignificant advance in a society of royalists, so many of them adherents of the divine right of kings.

After the English have conquered the French—for they are in the midst of the Hundred Years' War—King Henry V (in Shakespeare's play of the same name) goes a-wooing the French princess Katherine. He begins by claiming to lack eloquence and warning her that if she accepts him, she will have to put up with his plain speech and inelegant manners: "For these fellows of infinite tongue, that can rhyme themselves into ladies' favors, they do always reason themselves out again. What? A speaker is but a prater, a rhyme is but

a ballad; a good leg will fall, a straight back will stoop, a black beard will turn white, a curl'd pate will grow bald, a fair face will wither, a full eye will wax hollow; but a good heart, Kate, is the sun and the moon, or rather the sun and not the moon; for it shines bright and never changes, but keeps his course truly."

This, I rather think, is William Shakespeare's very earthly religion—the Religion of the Good Heart—spoken as plainly and with as little distracting decoration as he can manage. It is a religious expression that would have found favor with France's Henry IV and Montaigne, as well as with another Shakespearean contemporary, the adventurous Spaniard Miguel de Cervantes.

Cervantes had an exciting youth, fighting in his early twenties at the decisive Battle of Lepanto (page 264). He was remembered by his fellow soldiers as a daring combatant who risked his own life without hesitation and lost the use of his left hand, for which loss he was given the admiring nickname of *el manco de Lepanto* (the one-armed man of Lepanto). Sailing back to Spain, Cervantes and his brother were intercepted by Barbary pirates and sold into slavery in Algiers, where Cervantes spent five years in captivity. His eventual ransom and return to Spain, however, brought him little recognition, two stints in prison, and years of bleak poverty, only alleviated well after the 1605 publication of Part I of his masterpiece, *El ingenioso hidalgo Don Quijote de la Mancha* (*The Ingenious Gentleman Don Quixote of la Mancha*).

Don Quixote is the world's first modern novel and, by common assent, the greatest. Its marvelous—and hilarious—doings, its intricate meshing of reality and fantasy, idealism and absurdity, the subjective and the objective, leave us both exhausted and craving more. But, despite more than nine hundred pages of prose, it is impossible to place Cervantes in any known camp or club. His philosophical, religious, and even political opinions, like those of Shakespeare, remain obscure. His themes of self-deception and foolish (but commendable?) idealism give us no entrance into his personal faith, if such he had.

But Shakespeare and Cervantes were knowledgeable gentlemen of the world, who lived through the years that saw Giordano Bruno, a Dominican priest who was a sort of Lutheran Catholic,

burned at the stake in Rome's Campo dei Fiori for daring to suggest that a new model of the cosmos was needed if we were to appreciate its infinite extent. In 1616, the year of the two writers' deaths (for both men died on April 23, 1616), Galileo Galilei suffered his first papal condemnation for daring to assert that the Earth revolved around the sun. This was a good time for the expansiveness of writers, free to write and stage many plays for eager audiences, free to fill many printers' pages with the vagaries of their imaginations, so long as they stayed clear of certain topics that could get them killed or confined.

1615–1669: THE DEEPENING

In the seventeenth century we come upon extraordinary examples of believers who have internalized their faith so personally and deeply that it has lost all comradeship with the combative religious assertions of the partisans who waged the Thirty Years' War. In these later figures there is also no verbal indirection, no hiddenness. Their faith is boldly stated, yet utterly lacking in aggression.

When last we met John Donne (pages 66–67), he was a young, lascivious poet stripping his mistress of her garments. He was also a convinced Catholic (related to Thomas More on his mother's side), who lived with a notable lack of security on account of his known affiliation. He was deeply affected by the sad fate of his younger brother Henry, imprisoned for harboring a Catholic priest, horribly tortured, dying of plague while confined to Newgate Prison. The poet began to question some of his family's religious convictions.

He married for love, incurring the enmity of his powerful father-in-law, and was reduced to penury. His wife, Anne, bore twelve children, two of whom were stillborn, three of whom died in childhood. After sixteen years of marriage, always pregnant or nursing a child, Anne died. The carefree, even reckless lover—called "Jack" by his friends—gradually turned into a thoughtful, even grave older man whose only evident links to his younger self were his razor-sharp mind and lightning-quick wit. When he was nearly fifty, having been ordained an Anglican priest at the insistence of King James, Donne was named dean of Old Saint Paul's Cathedral

in London. His sermons there were as dazzling as his poems had
been and laid the foundation stones for an Anglicanism built on
Catholicity.

Perhaps nothing reveals the inner Donne more nakedly than his
famous meditation on death:

> Now this bell tolling softly for another, says to me, Thou must
> die. Perchance he for whom this bell tolls may be so ill as that he
> knows not it tolls for him. And perchance I may think myself so
> much better than I am, as that they who are about me, and see
> my state, may have caused it to toll for me, and I know not that.
> The church is catholic, universal, so are all her actions; all that
> she does, belongs to all. When she baptizes a child, that action
> concerns me; for that child is thereby connected to that head
> which is my head too, and ingraffed into that body, whereof I am
> a member. And when she buries a man, that action concerns me;
> all mankind is of one author, and is one volume; when one man
> dies, one chapter is not torn out of the book, but translated into
> a better language; and every chapter must be so translated; God
> employs several translators; some pieces are translated by age,
> some by sickness, some by war, some by justice; but God's hand
> is in every translation, and his hand shall bind up all our scattered
> leaves again, for that library where every book shall lie open to
> one another; as therefore the bell that rings to a sermon, calls not
> upon the preacher only, but upon the congregation to come; so
> this bell calls us all: but how much more me, who am brought
> so near the door by this sickness. . . . The bell doth toll for him, ·
> that thinks it doth; and though it intermit again, yet from that
> minute, that that occasion wrought upon him, he is united to
> God. Who casts not up his eye to the sun when it rises? But who
> takes off his eye from a comet, when that breaks out? Who bends
> not his ear to any bell, which upon any occasion rings? But who
> can remove it from that bell, which is passing a piece of himself
> out of this world? No man is an island, entire of itself; every man
> is a piece of the continent, a part of the main; if a clod be washed
> away by the sea, Europe is the less, as well as if a promontory
> were, as well as if a manor of thy friend's or of thine own were;
> any man's death diminishes me, because I am involved in man-

kind, and therefore never send to know for whom the bell tolls;
it tolls for thee.

Hemingway stole from this meditation, as did Thomas Merton.
As do we all.

Holland is the home of genial, fair-haired, red-cheeked people
whose genius for business and whose general inventiveness have
always been admired by outsiders. Dutchmen are skilled, sensible,
down-to-earth doers; they do not encourage fantasy and they dis-
courage wildness of any kind. There are, therefore, among them
logicians, mathematicians, and practical, thoughtful, mildly humor-
ous folk (like Erasmus and Santa Claus); but there are not among
them many famous painters and sculptors, poets and dramatists, or
even composers (though the Dutch excel at performing the musical
compositions of others).

The monumental exception is Rembrandt van Rijn, a painter
who genially inhabits the exclusive circle of the colossi. There is
no way to approach Rembrandt adequately as this book draws to
its close, but I wanted at least to bow deeply in his direction, for
he is a prime example of the quiet and uncombative deepening of
personal belief that begins to manifest itself throughout the seven-
teenth century.

Born in Leiden, Rembrandt lived most of his life in Amsterdam,
already in his time the most tolerant city in Europe, tolerant not so
much of extravagant eccentricity as of personal privacy: in Amster-
dam one could quietly be whatever one wanted to be. Because of
this we have no idea whether Rembrandt considered himself Cath-
olic or Protestant. Some have, not without reason, tried to assign
him to the Anabaptists, but that assignment runs up against the
significant difficulty that he allowed his children to be baptized.
His life, like Donne's, was beset with sadness (his wife died after
eight years of marriage; three of his four children died in infancy)
and financial woes (which included bankruptcy). His art has many
subjects: his landscape drawings, according to John Walker, "mark
a limit of Western art. Only the Chinese have gone further." His
paintings, especially the late ones that lost him his early popularity

with Dutch buyers, reveal a grasp of physical reality suggesting, in Walker's words, "the touch-resistance of compact atoms, the density of substance Rembrandt renders so irresistibly that one's finger tips tingle with the same intense tactile impulse one feels before certain pieces of sculpture, the bronzes of Donatello, for example." This Dutchman is at heart an Italian.

Throughout his life as a painter he was himself his favorite subject. Reproductions of four of his many self-portraits are given here. The first, of 1627 [Plate 58], shows us Rembrandt as a serious twenty-one-year-old, but in shadows, suggesting that the young man was then a mystery even to himself. The second, of 1634 [Plate 59], shows us a self-assured, successful painter, nearing thirty. The third, of 1659 [Plate 60], reveals a resigned middle-aged man, who has been battered by life. In the fourth, finished perhaps in 1669 [Plate 61], the year of Rembrandt's death, we behold a laughing subject, not cynical but surely not merely happy-go-lucky or pleased with himself. Rather, this last Rembrandt is a man who has found the comedy even in his tragedies, not so much a man who simply accepts his reverses as an old codger who shakes his head, and can even chortle, at the absurdities of life.

The painter, in addition to relying on his own image, returned again and again to the Bible for complex and dramatic subjects. His scenes from the Old Testament are many, often modeled by Jewish neighbors who were Rembrandt's friends and acquaintances. Perhaps the most profound of these many arresting canvases is *The Return of the Prodigal Son* [Plate 62] painted, like Rembrandt's laughing portrait, in the last year of his life and based on one of Jesus's most affecting parables. In Luke's Gospel, Jesus replies to his critics, who have been speaking against him for welcoming "sinners" and even entertaining them, by informing the critics of the "joy that shall be in heaven over one sinner that repenteth, more than over ninety and nine just persons, which need no repentance."

By way of illustration Jesus narrates three parables, the last about the Prodigal Son:

> A certain man had two sons: And the younger of them said to his father, Father, give me the portion of goods that falleth to me. And he divided unto them his living. And not many days after

the younger son gathered all together, and took his journey into
a far country, and there wasted his substance with riotous living.

Having spent all his father's money, the Prodigal ends up feeding
pigs and sharing their food, which leads him to think a new thought:

> How many hired servants of my father's have bread enough
> and to spare, and I perish with hunger! I will arise and go to
> my father, and will say unto him, Father, I have sinned against
> heaven, and before thee, And am no more worthy to be called
> thy son: make me as one of thy hired servants. And he arose, and
> came to his father. But when he was yet a great way off, his father
> saw him, and had compassion, and ran, and fell on his neck, and
> kissed him. And the son said unto him, Father, I have sinned
> against heaven, and in thy sight, and am no more worthy to be
> called thy son. But the father said to his servants, Bring forth
> the best robe, and put it on him; and put a ring on his hand, and
> shoes on his feet: And bring hither the fatted calf, and kill it; and
> let us eat and be merry: For this my son was dead, and is alive
> again; he was lost, and is found. And they began to be merry.

The tenderness of the scene as imagined by Rembrandt is exceed-
ingly physical: the head of the tattered, shamed, kneeling son
pressed against the father's chest, the father's prominent hands press-
ing down on his son's shoulders, the father's face, full of both ten-
derness and ecstasy. Everything else on this earth, including the
three detached observers, is beside the point; only this embrace,
this very physical embrace of reconciliation, matters. When the
(typical) older sibling has a hissy fit about the party in progress
for his unworthy younger brother, who "transgressed" the father's
"commandment" and "devoured thy living with harlots," the father
quickly sets him straight: "It was meet that we should make merry,
and be glad: for this thy brother was dead, and is alive again; and
was lost, and is found."

The picture doesn't tell us whether Rembrandt was a Catholic
or a Protestant. But it may have a message for all religious contro-
versialists: the only thing that matters in this world is forgiveness,
which God gives freely, as should we.

POSTLUDE

HOPE AND REGRET

—————— ❖ ——————

It is a heretic that makes the fire,
Not she which burns in 't.

The Winter's Tale

Here at the book's end, I regret many things I have had to leave out. This was meant to be a full treatment of neither Renaissance nor Reformation, but an investigation of how each of those immense movements has given us a part of the mechanism of our functioning contemporary selves. Though Renaissance and Reformation occur in roughly the same period, and though each may spring initially from the scholarly, and especially the linguistic, interests of the early humanists, each morphs quickly into a very different beast, requiring separate tracking and separate analysis.

There is in this book almost nothing about the Scandinavian countries, which cry out for more attention, especially to the ways in which their very Lutheran societies developed so very differently from Germany, leading to essential religious philosophers such as Søren Kierkegaard and to a politics of social welfare rather than of fascism. Even within the story of German Lutheranism, we have had to leave Luther before his very happy, if exceedingly conventional, marriage to an ex-nun, and before his hateful rants against Jews.

A far more serious absence from this book is the thrilling story of the development of music over the course of the fifteenth, sixteenth, and seventeenth centuries, led by such religion-inspired composers as Josquin des Prez, Palestrina, Byrd, Purcell, Handel, and Johann Sebastian Bach, to name but a few. Bach, in particular, nearly edged himself into the last chapter as part of "The Deepening," but his period is a little late for this book. Perhaps, *Deo volente,* he will find himself in the next and last (planned) volume of this series. Bach is so wonderfully Lutheran, sounding in music every note that Luther played in rhetoric but raising the conversation to a wholly transformed and even transcendent level.

Beyond the Lutherans, I regret that so little attention could be devoted to the new Catholic religious orders, which had so much to do with raising Catholic numbers throughout the world. My moments of attention to the Jesuits and the Ursulines can scarcely be considered sufficient. All religious orders are now on the wane, but for centuries they supported and kept strong the spirit of the Counter-Reformation.

The Anabaptists are another near omission. They became in time the Mennonites, the Bruderhof, the Quakers. Though universally despised in the early modern period, persecuted, and often drowned by both Catholics and Protestants, their main reforms beyond adult baptism—that is, a heightened sense of community, compassion for the poor, prison reform, elimination of the death penalty, refusal to take up arms, peacemaking—are now the ideals of almost all their former persecutors, whether Catholic or Protestant. From a historical point of view, this is an astounding reversal. Today, in a way we are all Quakers. We are certainly not the religious vigilantes who took up arms and murdered as many of their religious opponents as could be found.

So much for regrets. But I would leave you to contemplate three figures of hope, one a German Protestant in the Lutheran tradition, one an Italian Catholic, the third an American Episcopalian—all three catholic with a small "c." The first figure, hanged by the Nazis in 1945, is Dietrich Bonhoeffer, the second is Pope John XXIII, born Angelo Roncalli, a Lombardian peasant who died of stomach cancer in 1963, the third is Muriel Moore, a New York woman not famous like the other two but known to many nonetheless.

In the years leading up to the rise of Hitler and World War II, Bonhoeffer was a young German theology student, acknowledged by his teachers to be of extraordinary scholastic ability and astonishingly penetrating mind. His high bourgeois family members, who were only occasional churchgoers, were shocked when he chose to study theology and seek ordination. His initial interest in the nature of the Christian Church developed into his thesis, *Communio Sanctorum* (Communion of Saints), for which he was awarded his doctorate at the age of twenty-one. Although he was already mov-

ing in the direction of a broadly ecumenical path, his visits to Italy, Spain, Switzerland, Scandinavia, the United States, Latin America, England, and North Africa opened Bonhoeffer even more to engaging in fellowship with non-Lutheran Christians. While pursuing postgraduate study at New York's Union Theological Seminary, Bonhoeffer taught Sunday school at the Abyssinian Baptist Church in Harlem, where he heard for the first time the African American spirituals that would become a passion of his.

In January 1933, about fourteen months after Bonhoeffer's ordination, Hitler became chancellor. Two days later, Bonhoeffer, just days before his twenty-seventh birthday, delivered an anti-Hitler national radio address in which he was cut off the air in mid-sentence. Thereafter, Bonhoeffer initiated a movement to oppose the gradual nazification of the Lutheran churches, to speak out against the persecution of the Jews, and even to find ways to thwart the broader nazification of German society. Speaking of the persecution of Jews, Bonhoeffer insisted that Christians must not only "bandage the victims under the wheel, but jam the spoke in the wheel itself." His new organization came to be called the Confessing Church.

But as Nazism clamped an ever firmer grip on Germany, Bonhoeffer was moved to establish an underground seminary to train students who would be genuine Christians, rather than Nazis. Soon thereafter, his authorization to teach at the University of Berlin was revoked and he was denounced as a "pacifist and enemy of the state," both of which he was. In 1937 he published *The Cost of Discipleship,* his meditation on Jesus's Sermon on the Mount, disparaging the "cheap grace" of the majority of German Christians in favor of the "costly grace" that linked Christian belief to social courage. The Gestapo found his seminary and closed it down.

In April 1943, Bonhoeffer was arrested. More than a year later, the Gestapo uncovered documents that linked him to a high-level conspiracy to assassinate Hitler, which Bonhoeffer had indeed taken part in, casting aside all Lutheran qualms about obeying the prince. He was condemned to be hanged and was marched naked to his execution at the Flossenburg concentration camp on April 9, 1945, just two weeks before two divisions of the United States Infantry would liberate the camp. The camp doctor who witnessed the execution testified that he was "deeply moved by the way this lov-

able man prayed. . . . I have hardly ever seen a man die so entirely submissive to the will of God."

Another lovable Christian was Angelo Roncalli, Pope John XXIII, a man from the other side of the Alps, but one who had also lived most uncomfortably under a fascist dictatorship. A historian rather than a theologian, and for long a faithful servant in the papal diplomatic service, Angelo, though no mouse, had seldom been noted for renegade opinions that clashed with the papal party line of the moment. He was full of such opinions, but these had all been couched in such diplomatic language that virtually everyone had missed them.

At Pentecost 1944, for instance, he had spoken to his congregation in the tiny Catholic cathedral of Istanbul—to which he was then the Vatican's ambassador (or apostolic delegate)—about the Holy Spirit and how necessary its presence is to humane life. Left to itself, said Angelo, the human race resembles "one of those iron-age villages, in which every house was an impenetrable fortress, and people lived among their fortifications." It was, said he, so easy to stay within one's group, especially for Catholics, cutting ourselves off from "our brothers, who are Orthodox, Protestant, Jewish, Muslim, believers in other religions, or non-believers." But, he added, "I have to tell you that in the light of the Gospel and Catholic principle, this logic of division makes no sense. Jesus came to break down barriers; he died to proclaim universal brotherhood; the central point of his teaching is charity—that is, the love that binds all human beings to him as the elder brother and binds us all with him to the Father." Angelo said that he hoped for "an explosion of charity," in which the word "Catholic" would no longer carry any exclusive connotation but would signify universal unity.

In late October 1958, Angelo, already in his late seventies, was elected pope, expected to play his part in a quiet, interim pontificate between that of Pius XII, a know-it-all control freak, and whoever (and whatever) might come next. The conclave cardinals who elected Angelo wanted less excitement. It was not to be. As John XXIII, Angelo called a council of the universal church for the purpose of "updating." He laid out very few specifics, except that his council was to condemn no one. Rather, he said, he wanted to open the windows and let in some fresh air. Oh, and he wanted to

invite representatives of all Christian churches and communities, Orthodox, Protestant, everyone.

It took the assembled bishops about a year to realize that the new pope was not about to tell them what to do (or think). He actually meant for it to be their council; they were to decide. When he spoke to the non-Catholic Christian observers at the council, he told them that he "felt comforted by their presence" and reassured them that he didn't "like to claim any special inspiration. I hold to the sound doctrine; everything comes from God." So much for the late, embarrassing doctrine of papal infallibility. I even believe John wanted these observers to be upgraded to voting members of the council but was waiting for the council fathers to issue that invitation, which never came.

What has followed since the death of Angelo/John in June 1963 is a massive retreat from his stance of open embrace. There is no need for me to repeat what I have written elsewhere (a biography, *Pope John XXIII,* and a *New York Times* op-ed on the death of Pope John Paul II, highly critical of his pontificate). Not long before he died, a dear old friend, David Toolan, then an editor of *America,* the Jesuit weekly magazine, said of John Paul that "it will take the Church two hundred years to recover" from his pontificate. I hope Dave was right and that it takes no longer than that.

A third lovable Christian was Muriel Moore, a woman who grew up in the 1930s in the old Chelsea neighborhood of Manhattan, who spoke like a real Noo Yawker, lacking any of the cultivated purr of the Brahmin WASP. Not only was she a plain woman, she was a hunchback who in her later years required a walker, which she referred to as "my Mercedes." Though she never talked about it, I suspect she was seldom if ever without pain. But this did not slow her down. Rather, she barreled forward, smiling and greeting everyone, as if the world were her oyster (as Pistol says in *The Merry Wives of Windsor*).

All her life she attended the same Episcopal church in Chelsea where she had been baptized, Holy Apostles, and was quietly instrumental in establishing it as the largest daily provider of free meals for poor people in the entire city of New York. Thousands showed up each day for food, fellowship, and various forms of continuing assistance. Muriel talked the same way to each soup kitchen

guest as she would talk to a visiting bishop—with playful humor, delight, and sympathy. Someone once overheard her telling one of the guests, "We are all the same." That was Muriel's credo.

Muriel never went to college and spent many years caring for her invalid mother, who had been widowed early. Muriel also worked for forty years in the payroll department of an insurance company. But after her mother died in 1983, her best friend in the payroll department, Eileen McCarthy, invited Muriel to spend the very American holiday of Thanksgiving in Killarney, Ireland, where Eileen hailed from. Muriel fell instantly in love with Ireland, and the Irish loved her back. For the rest of her life, till her death in 2011, she would visit Killarney twice yearly. "Welcome home, Muriel!" everyone would say. In Killarney, Muriel attended the local Catholic church with her friends, it being the only church in walking distance. "What else would I do?" she asked me once. "Anyway, we're all the same."

Muriel's funeral at Holy Apostles on July 30, 2011, was an immense gathering. So many of her old friends from the soup kitchen were there, as was a substantial body of regular parishioners, many of them gay or lesbian in keeping with the recent population changes in Chelsea. And standing among all these were scores of Irish friends, men, women, and children, who had flown to New York just to participate at Muriel's funeral. All of the Irish visitors were Roman Catholic—and almost all of them came forward that day to receive consecrated bread and wine from the hands of female and gay priests of the Anglican Communion in a ceremony the validity of which is not recognized by the Roman Catholic Church. It was a massive act of defiance, I suppose, but it was all done for Muriel—"Auntie Moo," as she was known to the Irish children—a woman who knew in her aching, brittle bones that we are all the same.

If Christians like Dietrich Bonhoeffer, Angelo Roncalli, and Muriel Moore could sit down together and converse for an hour or two, without interference from careerists, time-servers, and assorted fanatics, the rending of Christendom would be over, and Christians would achieve their long-sought goal of reunion.

Perhaps the three have already had that conversation.

The reader is invited
to experience more deeply
the art and music
of the Renaissance and the Reformation
by visiting the author's Web site,
thomascahill.com,
where additional explorations
on related subjects
will also be found.

NOTES AND SOURCES

In this section I try to provide, not an exhaustive bibliography (which might threaten to go on forever), but suggestions for further reading to those who may wish to pursue a given subject more deeply.

PRELUDE

This is my fourth attempt in this series to limn the influence on Western thought of the great philosophical schools of Plato and Aristotle and their intellectual descendants. Some readers may wish to consult my earlier, more conventional treatments in *How the Irish Saved Civilization,* Chapter II (Plato and Augustine); *Sailing the Wine-Dark Sea,* Chapter V (Plato and Aristotle); and *Mysteries of the Middle Ages,* Chapter III (Aristotle, Abelard, and Aquinas).

INTRODUCTION

The classic study of the Sicilian uprising of 1282 is Steven Runciman, *The Sicilian Vespers: A History of the Mediterranean World in the Later Thirteenth Century* (Cambridge, 1958), and a wonderful read it is.

There are many English translations of the *Decameron,* but none of them sounds much like the original. For sheer readability, I'd recommend the Mentor paperback (1982), translated by Mark Musa and Peter Bondanella. The translations in the text are mine, an attempt to imitate some of the conversational meanderings of Boccaccio's prose a little more closely than what I found in other translations. I confess, however, to having borrowed Musa and Bondanella's translation of what the abbess put on her head. Normally, she is said to have thrown on her lover's "breeches," their "stays hanging down"—closer to the medieval Italian. But I prefer Musa

and Bondanella's "pants," their "suspenders dangling down"—a funnier line to our ears.

The quotation from Terry Eagleton is from his vigorous *Reason, Faith, and Revolution: Reflections on the God Debate* (Yale, 2009), page 82.

There are many good books on the Black Death, one of the most recent and readable being John Kelly, *The Great Mortality* (HarperCollins, 2005). Probably the best recent account of Wat Tyler's Rebellion and John Ball's involvement in it is to be found in Alistair Dunn, *The Great Rising of 1381: The Peasants' Revolt and England's Failed Revolution* (Tempus, 2002). For further reading on John Wyclif and the Lollards, you might try Anne Hudson, *The Premature Reformation: Wycliffite Texts and Lollard History* (Oxford, 1988), a highly scholarly rendering, or Hudson's more popularly geared entry on Wycliffe (alternative spelling) in the current *Oxford Dictionary of National Biography* (2004). As for Jan Hus, the only biography in English is Matthew Spinka, *John Hus* (Princeton, 1968). A current view is sorely needed. When it comes to Joan of Arc, the best biography, hands down, is Donald Spoto, *Joan: The Mysterious Life of the Heretic Who Became a Saint* (HarperCollins, 2007).

Concerning recent finds relating to the earliest Egyptian hieroglyphs, David O'Connor, *Abydos: Egypt's First Pharaohs and the Cult of Osiris* (Thames and Hudson, 2009), is illuminating.

The classic interpretation of the historical ramifications of Gutenberg's invention is Marshall McLuhan, *The Gutenberg Galaxy: The Making of Typographic Man* (Toronto, 1962; reissued by Routledge). For a more recent treatment, see Elizabeth Eisenstein, *The Printing Revolution in Early Modern Europe* (Cambridge, revised 2005). Our current unstable transition from printed books to the Internet is eloquently evoked by Anthony Grafton, *Worlds Made by Words: Scholarship and Community in the Modern West* (Harvard, 2009). A helpfully annotated listing detailing the whereabouts of surviving copies of the Gutenberg Bible may be found under the Wikipedia entry for "Gutenberg Bible." For the quotation from Sarah Bernhardt and the references to early filmmaking, see Arthur Knight, *The Liveliest Art* (New American Library, 1957), pages 19ff. The quotation from Professor Yoffie may be found in Steve Lohr, "The Apple in His Eye," *New York Times,* January 31, 2010, "Week in Review," page 6.

I: NEW WORLDS FOR OLD

The quotation from W. H. Auden is from the opening of his *For the Time Being: A Christmas Oratorio,* available in several editions.

As for biographies of Columbus, Samuel Eliot Morison, *Admiral of the Ocean Sea* (Little, Brown, 1942), still has much to recommend it, even if Morison's Columbus sometimes seems more a twentieth-century Harvard man who served in the U.S. Navy than a Genoese sea captain of the late fifteenth century. Corrections of tone that bring us closer to Columbus as he was are to be found in two volumes by Felipe Fernández-Armesto, *Columbus and the Conquest of the Impossible* (Weidenfeld & Nicolson, 1974), and a more ambitious full-scale biography, *Columbus* (Oxford, 1992).

For more on the peoples that Columbus and later European explorers encountered, I have three recommendations: Charles C. Mann, *1491: New Revelations of the Americas Before Columbus* (Vintage, 2006); David Abulafia, *The Discovery of Mankind: Atlantic Encounters in the Age of Columbus* (Yale, 2008), which also discusses the European conquest of the Canary Islands; and Eduardo Galeano, *Open Veins of Latin America: Five Centuries of the Pillage of a Continent* (Monthly Review Press, 1973, 1997). This last (and most controversial, as may easily be deduced from its title and subtitle) is full of startling information. It was originally published as *Las venas abiertas de América Latina* (Siglo XXI Editores, Mexico, 1971).

The quotation from William McKinley is widely cited, though sometimes disputed in its particulars, and may be found in an admirable book by Evan Thomas, *The War Lovers: Roosevelt, Lodge, Hearst, and the Rush to Empire, 1898* (Little, Brown, 2010).

The New Catholic Encyclopedia (Gale, 2003) contains excellent entries on such subjects as the Spanish Inquisition, Torquemada, Ferdinand and Isabella, and the reigns of various popes. On the issue of when racism became a factor in Christian Europe, a recent book, *The Origins of Racism in the West* (Cambridge, 2009), edited by Miriam Eliav-Feldon, Benjamin Isaac, and Joseph Ziegler, attempts to push the origin back into the twelfth or thirteenth century, but I do not find the authors' few examples conclusive. To my eyes the collection tends to lack an appropriate judiciousness while exhibiting little feeling for the ages under consideration.

Christopher Hibbert has written a long series of entertaining (and accurate) narratives on historical subjects, virtually all of them concerning Britain or Italy. These include *The House of Medici: Its Rise and Fall, Florence: The Biography of a City,* and *The Borgias and Their Enemies,* all available in paperback editions from various publishers.

The principal poems of Lorenzo de' Medici are collected in *The Oxford Book of Italian Verse* (Oxford, 1910), where they may be compared with the Italian poetry of Petrarch and not a few others.

II: THE INVENTION OF HUMAN BEAUTY

The world is so full of beautifully produced art books, most with excellent commentaries by appropriate experts, that there is no hope of assembling a list of modest size. For my money, however, the very best commentaries in English on Renaissance art have almost invariably been written by Kenneth Clark. In this context, I would especially recommend two: *The Nude: A Study in Ideal Form* (in several editions, all out of print), which takes us from the ancient Greeks, through the Renaissance, to twentieth-century artists; and *Leonardo da Vinci* (in its most recent reissue from Penguin, 1989).

The fine old study *Michelangelo* by Howard Hibbard (Icon Editions/ Westview Press, 1974) labors under an unfortunately indifferent set of black-and-white reproductions (including, however, a picture of Michelangelo's *Christ with His Cross* before the fig leaf was added).

Of the many beautifully bound editions that span the whole of the Renaissance in excellent color reproductions, I found especially moving the enormous two-volume boxed edition of *The Art of Florence* (Artabras, 1988) by Glenn M. Andres et al., though its weight renders it scarcely movable. Other less weighty but substantial and easily obtainable volumes include *The Renaissance Complete,* edited by Margaret Aston (Thames & Hudson, 1996), and a three-volume series from Yale (2007)—*Making Renaissance Art, Locating Renaissance Art,* and *Viewing Renaissance Art*—a carefully constructed multiauthor project.

In recent years, the works of Caravaggio, once ignored, have been gaining immensely in reputation. A lovingly produced Italian volume, *Caravaggio: la vita e l'opera* by the Italian historian and art critic Mia Cinotti, was brought out by Edizioni Bolis in 1991; a newer publication, *Caravaggio: The Complete Works* (Taschen, 2009) by Sebastian Schutze, is so spectacular that it may bring tears to your eyes. It surely makes up for any German slurs the Italians have endured over the centuries. A leaner but almost as impressive production is *Caravaggio: The Final Years* (Electa Napoli, 2005), a work of many hands, available in several European languages, including English. It is the fruit of a historic exhibition in Naples, subsequently installed at the National Gallery, London. Both these books contain faithful reproductions of Caravaggio's overwhelming masterpiece, *The Seven Works of Mercy,* which hangs in the Neapolitan Church of Pio Monte della Misericordia and is too complex to be reproduced adequately here. A recent biography of the painter, *Caravaggio: A Life Sacred and Profane* (Norton, 2010) by

Andrew Graham-Dixon, replete with rather good, if small-scale, repro-
ductions, can also be highly recommended.

One non-art book bears mentioning: Michael Rocke, *Forbidden Friend-
ships: Homosexuality and Male Culture in Renaissance Florence* (Oxford, 1996).

III: NEW THOUGHTS FOR NEW WORLDS

For those who would learn as much as possible about Erasmus, Cor-
nelis Augustijn's biography, *Erasmus: His Life, Work, and Influence* (Toronto,
1991), will prove indispensable. For those who take a less systematic
approach, *The Erasmus Reader* (Toronto, 1990), edited by Erika Rummel,
makes a fine beginning, as does the introduction to Erasmus's *Praise of Folly*
(Penguin, revised 1993).

When it comes to Luther's life, there is an embarrassment of riches.
The standard biography is probably Heiko A. Oberman, *Luther: Man
Between God and the Devil* (Yale, 1989), though I prefer many of the insights
in Richard Marius, *Luther: The Christian Between God and Death* (Harvard,
1999), a sort of reply to Oberman, as may be gleaned from the subtitles.
There is also a splendid short and sympathetic biography by Martin Marty,
Martin Luther (Viking Penguin, 2004), that ends with an excellent biblio-
graphical note. As for Luther's voluminous writings, there is the astonish-
ing fifty-five-volume American edition of *Luther's Works on CD-ROM,*
edited by Jaroslav Pelikan and Helmut T. Lehmann (Fortress and Con-
cordia, 2001). Most readers will be grateful for the somewhat more com-
pact *Martin Luther's Basic Theological Writings* (2nd edition, with CD-ROM,
Fortress, 2005), edited by Timothy F. Lull.

IV: REFORMATION!

In addition to the biographies and writings of Luther, there looms the
larger subject of the Reformation itself, as well as the considerable cavalcade
of reformers riding out singly and in groups across the European continent
over the better part of two centuries. No one work can hope to contain all
this—except for one that succeeds as well as anyone might hope: Diarmaid
MacCulloch, *The Reformation: A History* (Viking Penguin, 2003). Before
such an achievement—at slightly less than 800 pages—we can only stand
in awe. MacCulloch's more recent work, *Christianity: The First Three Thou-
sand Years* (Viking Penguin, 2009), taking in the whole of Christian history
and weighing in at 1,161 pages, is also an amazing triumph.

A more simply focused account, limited to the relationship between
churches and state within Germany and of considerable merit, is Thomas

A. Brady Jr., *German Histories in the Age of Reformations, 1400–1650* (Cambridge, 2009). A fine study that limits its focus to publishing is Lucien Febvre and Henri-Jean Martin, *The Coming of the Book: The Impact of Printing, 1450–1800* (Verso, 1976).

INTERMISSION

Is religion for or against violence? This enormous question, which I despair of answering, is given opposing answers in two engrossing books, John Teehan, *In the Name of God: The Evolutionary Origins of Religious Ethics and Violence* (Wiley-Blackwell, 2010), and William T. Cavanaugh, *The Myth of Religious Violence: Secular Ideology and the Roots of Modern Conflict* (Oxford, 2009).

The portraits in this section come from several countries and represent many styles, the purpose being to give the reader a feeling, as tangible as possible, for people of this period, whether high or low. Two picture books that can extend this feeling even further, both published in 2011, are *Renaissance People: Lives That Shaped the Modern Age* (J. Paul Getty Museum, Los Angeles) and *The Renaissance Portrait from Donatello to Bellini* (Metropolitan Museum of Art, New York).

V: PROTESTANT PICTURES

In this chapter we encounter seven or so major figures, each one eminently worthy of further study.

Albrecht Dürer: A fine collection of *The Complete Woodcuts of Albrecht Dürer,* edited by Willi Kurth, is available from Dover. Many of Dürer's paintings, as well as works of other German artists, are reproduced (in black and white) in a fascinating study by Joseph Leo Koerner, *The Moment of Self-Portraiture in German Renaissance Art* (Chicago, 1993). The quotation from Paul Tillich about Dürer's engraving *Knight, Death, and the Devil* is found on page 161 of his *The Courage to Be* (Yale, 1952).

Thomas More: Though there are a number of good biographies of More, my choice falls to the sensible and moderate Peter Ackroyd (Anchor, 1999). *Utopia* is available in several editions. There's a superbly evocative new novel by Jim Crace, *Harvest* (Nan A. Talese/Doubleday, 2013), describing the unjust enclosure of English farmlands against the peasants—a matter of grave concern to More. This massive injustice, eventually carried out against peasants in many European countries, continues to this day, now being perpetrated by Western and Middle Eastern capitalists against poor people in many third-world countries. See Michael Kugelman, "The Global Farmland Rush," *The New York Times,* February 6, 2013.

William Tyndale: The heroic translator is vividly placed in context by Benson Bobrick in *Wide as the Waters: The Story of the English Bible and the Revolution It Inspired* (Simon & Schuster, 2001). Almost set against this view is the decidedly less heroic but pointed treatment of the Protestant translators to be found in James Simpson, *Burning to Read: English Fundamentalism and Its Reformation Opponents* (Harvard, 2007). Tyndale's own unadulterated voice is to be found in *Tyndale's New Testament* (Yale, 1989, 1995) and in his *The Obedience of a Christian Man* (Penguin, 2000).

Ignatius Loyola: The biography I refer to in the text is W. W. Meissner, *Ignatius of Loyola: The Psychology of a Saint* (Yale, 1992). Loyola's *Spiritual Exercises* are available in several English editions and many languages.

François Rabelais: In addition to the considerable variety of editions of *Gargantua* and *Pantagruel* offered in both the original texts and translations into modern French, there is an exhaustive new English translation of both books (and their sequels) in a single hefty volume by M. A. Screech (Penguin, 2006). A fascinating critical study, *Rabelais and His World* by the great and controversial Russian critic Mikhail Bakhtin, is available from Indiana University Press. It links Rabelais to the larger carnivalesque culture of late medieval Europe. The translations from Rabelais's works are mine.

Pieter Bruegel: The literature on Bruegel has grown to daunting proportions. A good place to begin is the selective (!) bibliography that concludes Wilfried Seipel, ed., *Pieter Bruegel the Elder at the Kunsthistorisches Museum in Vienna* (Skira Editore, Milan, 2007).

VI: CHRISTIAN VS. CHRISTIAN

For this chapter I refer the reader to MacCulloch's *The Reformation* (listed above). Another delicious source is Robert J. Knecht, *The French Renaissance Court* (Yale, 2008). (As the reader may have noted, Yale has one of the most admirable publishing programs in the world.)

On the subject of Calvin, there is a brilliant new biography by Bruce Gordon (Yale, 2009). Marilynne Robinson's essay, "Open Thy Hand Wide: Moses and the Origins of American Liberalism," is found in her collection *When I Was a Child I Read Books* (Farrar, Straus and Giroux, 2012). Another compelling collection by Robinson is *The Death of Adam: Essays on Modern Thought* (Picador, 1998, 2005).

VII: HUMAN LOVE

Shakespeare has been well served by a variety of contemporary authors (e.g., Peter Ackroyd, Jonathan Bate, Stephen Greenblatt), most notably, in

my reckoning, by James S. Shapiro in *1599: A Year in the Life of William Shakespeare* (HarperCollins, 2009). The passage from John Donne comes from his Meditation XVII. There is a good new biography, *John Donne: The Reformed Soul* by John Stubbs (Norton, 2007). Kenneth Clark long ago wrote the fine *Introduction to Rembrandt* (John Murray, 1978). Simon Schama's massive appreciation, *Rembrandt's Eyes* (Knopf, 1999), offers the most faithful reproductions of Rembrandt's art, as well as the most complete collection, to be found anywhere.

POSTLUDE

All of Dietrich Bonhoeffer's writings are in the process of being published by Fortress. His most famous work, usually referred to as *The Cost of Discipleship,* has been published by Fortress in a critical edition under its original title, *Discipleship* (2000). The same publisher offers the most praised biography: Eberhard Bethge, *Dietrich Bonhoeffer: Theologian, Christian, Man for His Time* (2000).

For John XXIII I am bold enough to recommend my own *Pope John XXIII* (Penguin, revised 2008).

Some of the information about Muriel Moore is taken from the engaging sermon preached at her requiem eucharist by the Reverend Elizabeth G. Maxwell, now pastor of St. Michael's Episcopal Church, New York City.

ACKNOWLEDGMENTS

Each volume in the Hinges of History series has presented its own challenges to the author, but no volume has been so challenging as this one. I might have despaired of ever finishing my task had it not been for a heavenly choir of early readers, each expert in one field or another, who were able to review my drafts and make essential corrections and improvements to the text. The members of this choir (who do not always sing with one voice) are my wife Susan Cahill, John E. Becker, Lawrence W. Belle, Michael D. Coogan, Paul Dinter, Susann Gruenwald-Aschenbrenner, Benjamin Larzelere III, Mario Marazziti, Martin E. Marty, James M. Morris, Gertrud Mueller Nelson, Gary B. Ostrower, James S. Shapiro, John Shinners, Donald Spoto, Burton Visotzky, and Robert J. White. Pastor Larzelere's wife, Bev, contributed the "Good Ol' Marty Luther" song, which she sang unashamedly in a New York City diner. What errors and flaws remain, however, are mine alone, and may not be laid at the door of any of my readers and contributors.

My publisher/editor, Nan A. Talese, shepherded all matters with her customarily graceful aplomb. The editorial interventions of my paperback publisher, LuAnn Walther, were also of profound importance. Nan's assistant editor, Ronit Feldman, and editorial assistant, Dan Meyer, were essential players. I was particularly blessed in Barbara Flanagan and Rosalie Wieder, my copy editors; Nora Reichard, my production editor; Emily Mahon, the jacket designer; and Maria Carella, the text designer. Jen Marshall, my publicist, and John Pitts, my marketing director, are both old friends, neither of whom I could possibly do without. All authors are in the debt of their publisher's sales force, but none more than I.

My literary agent, Lynn Nesbit, and her able colleagues, Bennett Ashley and Cullen Stanley, will always have my profound gratitude, as does my preternaturally able assistant, Sarah Palmer.

Insert 2

Plates 30, 34, 45, 54: copyright © RMN-Grand Palais / Art Resource, NY. Plates 31, 40: copyright © The Metropolitan Museum of Art / Art Resource, NY. Plate 32: Alinari / Art Resource, NY. Plates 33, 38, 56, 57, 59: Scala / Art Resource, NY. Plates 35, 39, 46, 49, 51, 52: Erich Lessing / Art Resource, NY. Plate 36: bpk, Berlin / Alte Pinakothek, Bayerische Staatsgemaeldesammlungen, Munich, Germany / Art Resource, NY. Plate 37: bpk, Berlin / Alte Pinakothek, Bayerische Staatsgemaeldesammlungen Augsburg, Germany / Art Resource, NY. Plate 41: Scala / Ministero per i Beni e le Attività culturali / Art Resource, NY. Plate 42: copyright © The Frick Collection. Plate 43: bpk, Berlin / Kunstmuseum, Basel, Switzerland / Art Resource, NY. Plate 44: Courtesy of National Museums Liverpool, Walker Art Gallery. Plate 47: copyright © The Trustees of the British Museum. All rights reserved. Plate 48: Anthonis Mor Van Dashorst, *Knight of the Spanish St. James Order,* 1558; Courtesy of the Museum of Fine Arts, Budapest. Plate 50: Worcester Art Museum, Worcester, Massachusetts, Austin S. and Sarah C. Carver Fund, 1948.22. Plate 53: Wikimedia Commons. Plate 55: Detroit Institute of Arts, USA / City of Detroit Purchase / The Bridgeman Art Library. Plate 58: bpk, Berlin / Museumslandschaft Hessen Kassel, Kassel, Germany / Art Resource, NY. Plate 60: Courtesy of the National Gallery of Art, Washington, D.C. Plate 61: bpk, Berlin / Wallraf-Richartz-Museum—Fondation Corboud, Cologne, Germany / Jochen Remmer / Art Resource, NY. Plate 62: Album / Art Resource, NY.

Illustrations in the Text

Pages 94, 97: Scala / Art Resource, NY. Page 96: Alinari / Art Resource, NY. Page 106: copyright © The Trustees of the National Gallery of Art 1956. Page 117: Royal Collection Trust / copyright © Her Majesty Queen Elizabeth II 2012. Pages 195, 204 (bottom, left), 206, 209: copyright © The Trustees of the British Museum / Art Resource, NY. Pages 196, 199: copyright © RMN-Grand Palais / Art Resource, NY. Pages 200, 201 (bottom), 202 (top), 207 (top), 207 (bottom): copyright © The Metropolitan Museum of Art / Art Resource, NY. Page 201 (top): Erich Lessing / Art Resource, NY. Page 202 (bottom): V&A Images, London / Art Resource, NY. Page 204 (top): Bridgeman-Giraudon / Art Resource, NY. Page 204 (bottom, right): Klassik Stiftung Weimar, Weimar, Germany. Page 245: The Art Archive at Art Resource, NY. Page 247: bpk, Berlin / Kupferstichkabinett, Staatliche Museen, Berlin, Germany / Jörg P. Anders / Art Resource, NY.

INDEX

A NOTE ABOUT THE TYPE

This book was set in a version of the well-known
Monotype face Bembo. This letter was cut for the celebrated
Venetian printer Aldus Manutius by Francesco Griffo, and first
used in Pietro Cardinal Bembo's *De Aetna* of 1495.
The companion italic is an adaptation of the chancery script type
designed by the calligrapher and printer Lodovico degli Arrighi.

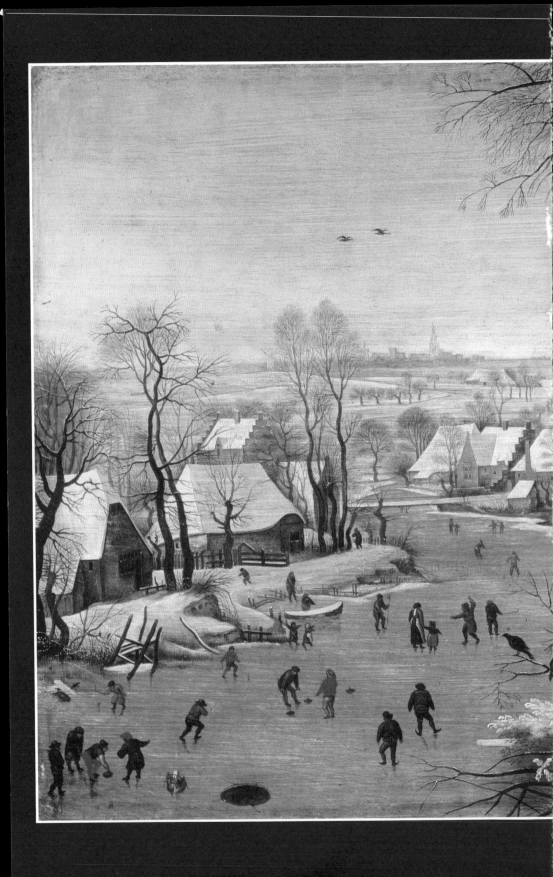